Art and Spirituality

Art and Spirituality
The Visual Culture of Christian Faith

Edited by Herman du Toit and Doris R. Dant

The 2006 Art, Belief, Meaning Symposium at Brigham Young University

BYU Studies
Brigham Young University
Provo, Utah

Cover art: Rembrandt van Rijn, *The Disciples at Emmaus*, 1648. Oil on wood, 68 x 65 cm. Louvre, Paris, France; photo by Erich Lessing / Art Resource, NY.

Cover design by Jeff Barney.

Produced by BYU Studies
Art and Spirituality: The Visual Culture of Christian Faith
© 2008 BYU Studies. All rights reserved.

ISBN: 978-0-8425-2707-1

Contents

Acknowledgments

We wish to thank Brigham Young University students Nirati Agarwal, Brandy Alles, Alexis Armstrong, Lori Ann Bruton, Jenny Curlee, Sarah Cutler, Holly Daley, Marquita Dowler, Robert Gibbons, Diana Harter, Kate Hunsaker Robbins, Mandy Miller, Natalie Ross, Liza Salazar, Jennifer Showalter, Rachel Skaggs, Shelsea VanOrnum, and Rachel Whitaker for editing assistance. We thank Professor Melvin J. Thorne, Martha A. Parker, and Jennifer Hurlbut for editing, Catharine Verhaaren for typesetting and layout design, and Jeff Barney for cover design. We are also grateful to the BYU Museum of Art and the BYU Visual Arts Department for their financial support of this publication.

Preface

Religious imagery is always highly charged with significance. The devotional and instrumental value of religious works of art have the power to stir people up to acts of piety and devotion by serving as catalysts for deep inquiry and soul searching. The power that religious images have to capture and articulate the spiritual has resulted in a renewed focus of attention by scholars, clerics, and laypeople alike on the visual culture of religious belief. The way we look at religious images, and the manner in which we have been historically conditioned to see them, has become the subject of inquiry, speculation, and even exploitation by institutions as diverse as the Hollywood film industry and the arcane world of academia.

This anthology compiles a selection of papers presented at the *Art, Belief, Meaning* symposium held at the Brigham Young University Museum of Art, in Provo, Utah, on November 16 and 17, 2006. This year's symposium was held in conjunction with the opening of the museum's premier exhibition *Beholding Salvation: Images of Christ* that showed over 170 works—primarily from the museum's collection of religious works—from the fifteenth century to the present. The theme of the symposium, *Pious Pictures: Christian Iconography and Personal Expression in the Production of Faith-Based Art,* attracted a significant number of proposals for presentations, both from the

local community and from further afield. The BYU Visual Arts Department partnered with the museum in hosting this symposium, and their contribution to the success of the symposium is greatly appreciated. In the selection of papers for this anthology, no distinction was made among contributions by BYU faculty members, undergraduate students, graduate students, or members of other faiths and educational institutions.

The keynote address of the symposium was delivered by Dr. David Morgan, the Phyllis and Richard Duesenberg Professor in Christianity and the Arts at Christ College, Valparaiso University, and one of the world's foremost contemporary commentators on the visual culture of Christian religious belief. His insightful and sensitive scholarship is rooted in the social construction of meaning that informs the process by which religious images and artifacts become instrumental in defining their viewers' experiences. In his article, he accepts the fact that every individual's way of approaching the act of viewing is different and explores four general categories of "seeing." Morgan is also concerned with revealing the broader conceptual framework that viewers employ in approaching the underlying truths that inform images of devotion. In recent years we have come to understand that art has the capacity to create new meaning in the mind of the viewer, often by nondiscursive means; as M. Russell Ballard once noted: "Inspired art speaks in the language of eternity, teaching things to the heart that the eyes and ears can never understand."[1]

In his writings Morgan maintains that the viewer needs to enter into a special relationship with a work of devotional art in order to access its intended meanings. The image cannot work on its own without what Morgan calls the "covenant"[2] between the viewer and the work itself. According to Morgan, the viewer needs to be submissive to the work or to what it stands for in order to truly view it—a poignant reminder that things of the Spirit are best understood by the Spirit and that we need to seek the Spirit before we can fully behold the subject of a truly devotional work of art. The natural man stands in the way of understanding by the Spirit and therefore we must overcome the natural man first: "But the natural man receiveth not the things of the Spirit of God: for they are foolishness unto him: neither can he know them, because they are spiritually discerned" (1 Cor. 2:14).

According to Colum Hourihane, director of the Index of Christian Art at Princeton University, "One of the most important functions that an image can have is as a mediation between the physical or earthly and the unseen or spiritual through the practices of revealing and concealing."[3] This reminds us that what a work of art leaves out can be just as important as what it

includes and that the most significant content of an artwork can often be invisible. Morgan's contribution to this anthology probes the reasons why modern secular artists tend to have such a troubled relationship with the concept of God in their art. Morgan uses as reference 100 Artists See God, an exhibition of works by contemporary artists that opened Spring 2004 at the Contemporary Jewish Museum in San Francisco.

The other authors in this anthology have drawn variously from scholarship in art history and the humanities, using examples from the past and present to press their case for inherent significance in devotional art. The essays confirm repeatedly the degree to which artists and viewers over the ages have found significant meaning through their apprehension of the Divine. The essays range from Jay Fox's discussion about how images of the character of Jesus in film have varied over time to Elliott Wise's incisive account of the remarkable role that the Black Madonna played in Poland's struggle against communism.

Again, as in previous *Art, Belief, Meaning* publications, the intention is to provide a rich context for readers to find meaning and evaluate their own responses to religious imagery, across a range of media, within the context of the restored gospel. This symposium provided just such an opportunity.

Herman du Toit, Ph.D.
Head of Museum Research
Brigham Young University Museum of Art
Provo, Utah

Notes

1. M. Russell Ballard, "In the Language of Eternity," *New Era* 26 (August 1996): 6.

2. David Morgan, *The Sacred Gaze: Religious Visual Culture in Theory and Practice* (Berkeley: University of California Press, 2005).

3. Colum Hourihane, "Did Mom Make the Stars and Stripes a God?" review of David Morgan, *The Sacred Gaze: Religious Visual Culture in Theory and Practice*, in *The Art Newspaper* 167 (March 2006): 44.

David Morgan is Professor of Religion at Duke University.

The Fitful Career of God in the Art of the Modern Age

Reflections on the History of "Seeing"

David Morgan

THE FATE OF GOD IN MODERN ART IS ERRATIC AT BEST. And I'm not going to help matters by passing almost immediately to the last twenty years or so. If Romantic artists were obsessed during the opening decades of the nineteenth century in Europe and North America with glimpsing the traces of divine mastery in the awesome scenes of nature and natural disaster, they were roundly eclipsed by Realist artists' interest in describing the here and now at the complete expense of anything remotely metaphysical. Think only of Gustave Courbet's memorable quip, "Show me an angel and I'll paint one."[1] Manet actually painted one, even two, but the Jesus to whom these costumed demimondes minister is so cadaverously, hopelessly dead that one misses the traditional message of death followed by resurrection (fig. 1). Even the symbolic snake squashed between two rocks in the foreground seems contrived, a Realist vulgarization of an iconographical language that Manet has cribbed from an emblem book. But with the rise of a neo-Romantic penchant for moody otherworldliness in Symbolist art late in the nineteenth century, God, or at least a spiritualized aesthetic, returns to the fore, flowering in the early twentieth century. This art especially flourished during European Expressionism's fascination with primitive and folk art as authentic traces of the spiritual in art, which Wassily Kandinsky was fond of

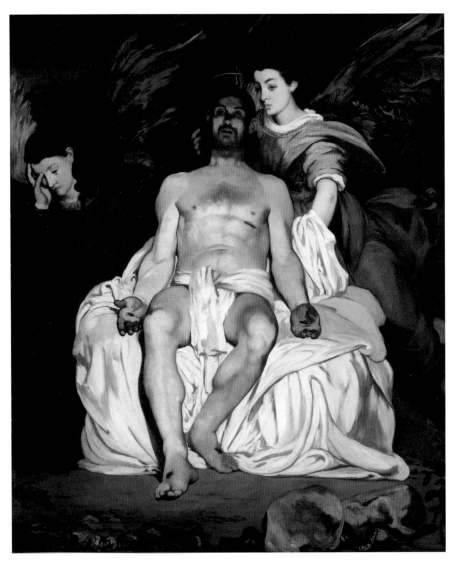

Fig. 1 Edouard Manet, *The Dead Christ and the Angels*, oil on canvas, 70.5" x 59", 1864. © The Metropolitan Museum of Art / Art Resource, New York.

contrasting with academic art no less than naturalistic work. American art in the twentieth century flip-flopped between transcendentalism and immanence, sublimity and matter-of-factness, spirituality and materialism. While Barnett Newman called for the return to monumental myth, in which spiritual symbol played a central role in his painting as well as in the canvases of Mark Rothko, Andy Warhol adored the sheer superficiality of popular

celebrity culture. And the contradiction only compounded: if the sublime transcendence of the New York School could also seem self-indulgent, Warhol lurked at Catholic Mass with the adherence of a self-effacing devotee. His many iterations of Leonardo's *Last Supper* suggest an obsession with a religious motif that was more than aesthetic.

It should be clear from this brisk tour that God never really, or at least finally, died. Gods, after all, have a way of coming back. And if one god or another did not always enjoy a robust presence in twentieth-century art, now he seems to have returned to greater notice, at least for a time, as baby-boomer artists age and begin to wonder what their lives add up to. In doing so, many look back to their early days when they were part of traditional religious families. I think, for instance, of Chicago painter Ed Paschke's series of self-portraits from 1993, one of which is entitled *Hope*, another *Eternity*. Paschke told me these were eventuated by an "identity crisis" as he reached the age of sixty. He'd never produced self-portraits until then but did so on several occasions thereafter. When I remarked on the unprecedented appearance of Christian symbols in the images, he pointed out that he'd been a Catholic altar boy and had attended a Catholic school.[2]

But Ed Paschke never told me more than that. The images did not solve his problem in any way so simple as adducing God. They were nothing like faith statements. Such a quaintly Protestant formulation of image as creedal assertion is not a possibility for modern artists because, in spite of their many differences, artists generally do not think of images as ersatz texts, as visual encodings of ideas, as emblems or symbols to be neatly deciphered with a theological key in hand. Images are much more powerful, much more unruly, much more demanding than that, which is precisely why Protestants, Jews, Muslims, and many Catholic theologians have perennially expressed concern about them. To be sure, texts can be as ambivalent and open-ended as images. Consider the stark, graphic presence of Scott Grieger's placard, *Beware of God* (fig. 2). Is this a warning comparable to "Beware of Dog," the neat inversion of g-o-d, or is it a stern motto meant to alert one to the need to take God very seriously, as if one has strayed into a dangerous precinct of the holy? The text does not answer these questions—it poses them. But this ambivalence is not the sort of textuality I have in mind. I refer to the dogmatic formulae of official church statements, the normative utterances prescribed by catechisms, apologetics, systematic theology, and creeds. I am fond of a work by Guy Chase, entitled *The Spirit in the Text*, which appropriates a popular theological book (*The Cross in Faith and Conduct*[3]) and imposes on it the hackneyed black shape of Casper the Ghost, or something of the sort,

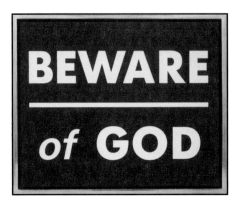

Fig. 2 Scott Grieger, *Beware of God,* acrylic on canvas with gold leaf frame, 17.5" x 21.5", 1996. In private collection, courtesy Patricia Faure Gallery, Santa Monica, California.

overlaid on gold paint, moving one to wonder about, even deconstruct, the privileged relationship between a series of highly charged couplings: spirit and text, faith and text, word and faith, word and image, art and faith. Chase's image literalizes the spirit-text connection in order perhaps to call attention to its strongly metaphorical nature, that is, its poetic, evocative power. Thereby Chase frees us from the bond of the literal-minded dogmatics that church authority finds so irresistible. Chase, an artist who is also a Christian, intends his work for Christian viewers, and therefore raises a question I'd like to include here. By accenting the relation of word and image, I intend to highlight the difference between the practice of investing words with institutional power in order to keep those who ritually perform them under control and the countervailing, possibly prophetic power of revelation that discovers something beneath appearances and authority. Guy Chase may be urging Christians not to allow the power of official verbal formulae to shape and maintain community to eclipse the power of words, buildings, images, songs, and dance, and to crack open ritual and authority in order to find what is hidden there.[4]

My interest today is not to critique religious establishments but to try to understand why God and modern art have often had such a troubled relationship. I think that it has a great deal to do with the interpretation of authority as it is invested in symbols and their use. It's not that artists are rabid atheists or rigorous secularists. It is that their brief or warrant as artists clashes head on with the practice of authority exercised by most religious institutions and communities. Many artists do not understand themselves principally as members of communities to which they owe creative work domesticated by and applied to a common purpose—unless that community is the art community, whose causes tend to be countercultural. Most artists prefer to keep institutional religion at a distance, even if they engage its members antagonistically.[5]

Instead of affirming shared belief, most modern artists, it seems to me, probably believe they are charged by conscience and history to challenge

reigning assumptions. The ideology of the avant-garde has long derogated to itself such a countercultural task. Perhaps in light of this anti-conventional, anti-bourgeois view of the artist's vocation, we should be surprised that God has received even intermittent attention in the art of the last two centuries. Many artists, art critics, and art historians have been deeply shaped by a prevailing secularization thesis, which regards the European Enlightenment as a turning point: in its wake, religion has become an anachronism, a vestigial routine that no one seized by the progressive liberation of the human mind should take seriously. And if they do recognize the very real persistence of religion in the modern world, proponents of secularization believe that its proper domain is private life, since any incursion into the public square must entail an infringement of civil liberties. The religious convictions of some groups do exert constraining influences, but not always; indeed, on occasion, public religion actually secures and expands civil rights, as in the career of Martin Luther King, Jr. Church and state, at least in my view, can be volatile in combination but are also too much a part of the American experiment to enforce the myth of complete separation. Church and state have always been engaged in a contested relation and probably always will be. In fact, the First Amendment was not meant either to resolve or to certify their relationship but to forever charge it with national significance. The result is a mess, but it is *our* mess and one whose ramifications for the creative life ought to be taken seriously.

In order to do that, I'd like to consider a recent exhibition. In the spring of 2006, I traveled to the Cheekwood Museum in Nashville to see an exhibition entitled 100 Artists See God—an assembly of just over one hundred paintings, photographs, drawings, objects, and videos that were sent by that many artists at the invitation of curators Meg Cranston and John Baldessari. What struck me as I walked through the exhibition was that the items gathered under the rubric of seeing God seemed to argue that nobody ever really does so in any untrammeled sense. What people actually see is their *representation* of the divine. They see what their worldviews and needs predispose them to see. One need not take this as an attack on religious belief. It is comparable to speaking about God. Listen to people talk about their god(s) and what you will hear first and last is their language, their words, their expressions, their accents. You will hear snippets of scriptures and liturgies and hymns, portions of creeds and catechisms, recycled memories, unexamined assumptions. The exhibition reflected a broadly held view among social constructivists and phenomenologists that everyone lives within systems of representation, value, and belief. These systems or bodies of shared thought and

feeling shape one's experience of God no less than they shape one's perceptions of home, friends, enemies, neighbors, and nation. With this in mind, it is important to recognize that the emphasis of the title, 100 Artists See God, is on the verb, *see*, as much as on the object, *god*.

Constructivism is a persuasive thesis to me. I viewed the exhibition as a fascinating exploration of ways of seeing. People see things differently and the ways they see are themselves capable of being studied as social and historical phenomena. That is precisely what I understand the purpose of visual culture studies to be. If art history has traditionally focused on objects of art, the study of visual culture means focusing on the practices of using those objects—in religious ritual, in collecting and displaying objects of value, in taking school kids to museums to learn about the past. Each of these practices engages a different way of seeing that needs to be carefully analyzed in order to understand its cultural work.

What people see and how they see it are questions that visual culture studies begin with. So the starting point for me in seeing this exhibition was noting the lack of devotional religious imagery. There was a great deal of art, but no icons or holy cards or devotional portraits or cult imagery or amulets or religious totems. There was a small plastic lavender casting of St. Nicholas by the German artist Katharina Fritsch (fig. 3), but this artistic simulacrum of devotional imagery was a copy of an ecclesiastical statue, or perhaps a copy of a copy of one, which the artist may regard as one link in a genealogy that spans from an actual religious statue to a work of fine art. In other words, Fritsch's single reference in the show to authentic religious imagery underscored its absence. Of course, I did not expect devotional or liturgical imagery to be included. But I began to wonder what their absence could mean for the exhibition's considerations of seeing the divine, since visual piety accounts for so much in the history of images. In fact, the very absence prompted me to think with renewed vigor about the compound claims of vision and belief. What is it to see something one believes one sees? As I thought about this and looked at the work, four ways of seeing emerged as present in, implied by, or missing from the exhibition. These are "just seeing" in the sense of uncomplicated apprehension; "seeing as" in the sense of vision as metaphor; "not seeing" in the sense of the impossibility of seeing certain things, such as God; and "close seeing," which is seeing as bodily participation, where seeing begins to turn into what is seen. I'd like to explore each of these and corresponding images in contemporary art and religious practice.

Just Seeing

Some visitors to the exhibition, apparently devout, missed representations of the divine that suited their faith. One visitor in Nashville wrote in the museum's visitors' book, "To be a balanced exhibit you should have balanced believers with unbelievers." Another objected that "only one artist represented God positively. . . . The rest indulged themselves in poking fun at their creator." Still another expressed dislike for the exhibition by asserting that "the artists used pseudo-philosophical ideologies to justify their misconstrued view. Other, more conventional views of God were not well represented. It was unfair and gives people a one-sided view of God." And perhaps most pointedly, one writer dismissed the entire exhibition as "politically motivated garbage," then offered a therapeutic reading of the artists: "These people don't know or love God; they have unresolved anger issues with God and religion." It is striking in all of these comments, and several others recorded in the comment book, that those who were offended by the exhibition felt their beliefs about God were being misrepresented, as if the institution had a public responsibility to offer an evenhanded treatment. If it were a public museum dedicated to history and relying on taxpayer funds, that might be a compelling criticism. But it is a private art museum, so the director, Jack Becker, dismissed complaints about the lack

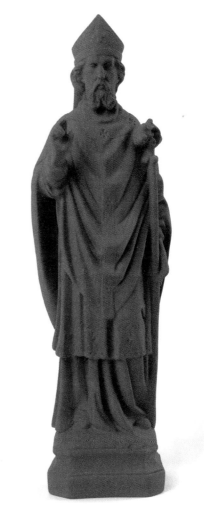

Fig. 3 Katharina Fritsch, *St. Nicholas*, polyester and paint, 12" x 3.5" x 2.5", 2002. © Katharina Fritsch, courtesy Matthew Marks Gallery, New York, and © 2007 Artists Rights Society (ARS), New York/ VG Bild-Kunst, Bonn.

of art by believers for believers, saying that the criticism "misses the point of the show. . . . In many ways those who criticized the exhibition as one-sided or the artists as non-believers may not be open to contemporary art. I think that any criticism of the show is as much about contemporary art as it was about religion."

Viewers at this exhibition wanted to see art that conforms to and affirms what they believe about God—whatever that may be. There is, in the category I'm calling "just seeing," a strong preference for immediate apprehension of what viewers believe. Such viewers don't want to have the simplicity and directness of vision complicated or undermined by artistic irony or critique or by any critical reflection on seeing itself. For many Christians this might mean seeing God in the sense of a devotional picture of Jesus such as Warner Sallman's *Head of Christ*, which is for many people a "photograph of Jesus"; or, among many Latter-day Saints, Del Parson's official portrait, *The Lord Jesus Christ*.[6] A comparable image in the Catholic tradition would be that on the Veil of Veronica. We see a picture of Jesus that is like a snapshot or a portrait painting, presenting him as he "really" looked. We see Jesus looking back at us. In each case, seeing is direct and empirical: what you see is what you get, which is what you want to get, which is what you believe is already there to be seen as if it were simply showing itself to our direct perception. This is seeing and nothing more. It's just seeing.

But seeing is never so simple as that. Seeing is actually more than "just seeing." Even the most mundane devotional imagery demonstrates that very interesting things are happening in the way pictures are constructed, displayed, and used. Popular visual piety is engaged in making vision *look* simple. But in reality, pious images do far more than just deliver the visual fact of salvation. They collaborate with the biblical text and with church teachings to interpret it, to make it speak to people living long after biblical authors, as in popular portraits of Jesus which variously envision the Christian savior as if he were a manly hunk or a pious lad or a solemn fellow or a black nun or a beefy comic book hero or a Hollywood actor. Such images, drawn from popular piety, negotiate the difference between the scripture and the lifeworld of believers far removed in time and place from ancient worlds. In addition to history and culture, they bridge differences in race, gender, sexuality, and ethnicity. The cultural work of these images is to tailor a "direct" connection between believers and their God by shaping self, society, deity, and sacred narrative into a compelling meeting point. Even though some critics, especially fine art critics, may consider the aim of such images

naïve, how the images go about achieving this rendezvous is not lacking in complexity or social interest.

But if believers do not "just see" what their images envision, how shall we designate their way of seeing? To see with the eyes of faith suggests a form of vision assisted by a way of thinking or feeling that allows believers to see something others do not. So we might dub the vision of faith "seeing with or by means of." This preserves the matter-of-factness that seems to characterize faithful seeing in just the way that looking at something with the aid of binoculars or a telescope brings something blurry or even unseen into the field of vision as if it were standing before us. I'd like to keep the rubric "just seeing" in place, however, since it captures the experience and the effect of religious vision of many believers. But I mean by it something more like "seeing with," since belief powerfully shapes what people see—even in non-religious visual experience. Expectation, desire, fear, or foreknowledge each predispose viewers to see something that others standing beside them may not see.

Why weren't images made for religious devotion or ritual included in 100 Artists See God or most other major fine art exhibitions? No doubt because curators in the art world do not want to create an exhibition about faith, about how pious vision depends on belief in order to take place. Instead, to focus on the exhibition in question here, Meg Cranston and John Baldessari wanted to mount an exhibition that was about the creative dynamics of seeing and the cultural politics of representation. But I'm not sure the faithful act of seeing God is altogether absent from the exhibition, since several works can be taken to treat seeing as a matter of witnessing the supernatural, which certainly draws from the tradition of Christian visual piety, even if the intention is not in most cases to endorse it. For example, Ed Ruscha's *Miracle #67* uses light as a signal to imagine God and to stage a theatrical display of epiphany. There is also *The Holy Artwork* video by Christian Jankowski, which seems to make the artist into the conduit of an Evangelical message, where we hear a pastor ask God to bless art and video as the means for evangelization. This pastor, Peter Spencer (who collaborated with Jankowski in making the video), wants to turn video into a pipeline from himself to us and from the Lord to the world. In this view, a medium is a kind of Protestant version of the Veil of Veronica. Rather than getting a glimpse of the visual grace of the Lord, the video operates as an uncomplicated channel for delivering sacred information, the all-important message of evangelical Christianity—the message that people are saved if they accept the Lord Jesus. It's all quite simple and not to be mucked up by

paradox and critical reflection about knowledge, sensation, and the vicissitudes of mediation.

Seeing As

The exhibition was organized in sixteen categories along these lines: "Artists see God as Architect," "as Light," "as Love," "as Mother," "as Tyrant," "as Someone who suffers," "as Word." Virtually all of the categories as presented in the catalogue invoked sacred scripture, religious doctrines, or important themes in the history of religious art. This suggests that the curators see contemporary art as deviating from, riffing on, varying from, or responding to conventional religion and sacred art. They understand that the artists' ways of seeing consist of "seeing as," that is, as visual metaphor, as troping sacred art in order to see it as a distinct way of seeing. Contemporary art does not do religion but transforms it into ways of thinking about or imagining something else.

Most of the work in the exhibition posits that "seeing" is more than an optical experience. As a sketchy metaphor for representation, it means touching and hearing, but also smelling, tasting, feeling, and remembering. Seeing can also mean dreaming, understanding, and demythologizing. It can mean believing, but also not believing. And seeing means many other things. In every case I have in mind, seeing actually means "seeing as," that is, seeing as something else than just seeing. Seeing is inextricably bound up with other forms of sensation.

For instance, vision takes the form of tasting in Alexis Smith's collage, *Buddha's Feast*, where the small image of a Buddha trinket sits on a lettuce/lotus leaf, where oneness becomes the hungry consumption of a hamburger. The image wonders about the relationship between truth and advertising, but also about belief and consumption. What is the fate of religion in the marketplace of culture? The Buddha in Smith's image, a cheap trinket, signals the commodification of enlightenment, contending perhaps that what we think we see is really seeing something else. Smith may be prompting her viewers to consider a Buddhist perspective such as "one must stop wanting to see in order to start seeing." But that is not clear, nor does it seem necessary to identify a single meaning. The art of "seeing as" expects the viewer to shoulder the burden of ambivalence. Meaning remains fluid. It never definitively arrives.

Not Seeing

Several artists in the exhibition are humorless in their rigorous dismantling of any claim to see God. Looking at Gerhard Richter's somber oil painting listlessly entitled *Gray*, viewers may readily feel as if they face a wall of indifference. "A monochrome gray painting," he states in the catalogue, "oil on canvas, in any common size, is simply the only possible representation/image of God." Richter selected this image of 1973 for the exhibition, and pointed out in his brief statement that the image does not bear any intention, is not charged with the grandeur of a divine idea: "When I made this gray painting I neither intended to express a conception of God nor would I be able to make such a painting."[7] Yet he conceded that the image was "obviously very simple, too simple." With that proviso, it seems, Richter does not close the door on seeing God. The artist may be luring us into a state of abeyance, a condition of not-saying, of not-seeing, of not-knowing since anything positive would necessarily be other than true.

James Hayward's *Automatic Painting 33 x 33 White #7* shows us nothing more than a white square. What he may have in mind by this extreme minimalism is something more than Richter's gloom, since Hayward would not appear to have us sink ourselves in gray oblivion for the sake of preserving God's infinite otherness. In the catalogue he appends to his work a poem by John Lennon, which is a series of statements about God: "God is a belief in higher order, God is a reason for art, God is a justification for violence," and so forth.[8] Lennon did not single out any of his propositions as truer than the others. Indeed, he probably thought religion was all of these because he situated religion in the minds and lives of those who live it, whose imagination of religion becomes a personal reality. Hence the white screen of Hayward's painting: to see God is to see the projection of one's own imagination. Whereas the gray pigment descends like an opaque curtain of coarse, vertical brushstrokes over Richter's panel, an act of concealment or iconoclastic negation, Hayward's canvas is a mirror that reflects whatever is projected onto its surface.

You get the god you want, even if it's not the one you need, which is the grim assessment of Damien Hirst's *god*, a life-sized construction of a cabinet of pharmaceutical products. Yet one wonders if Hirst has more in mind than merely a pun on Marx's view of religion as the "opiate of the masses." He titles the piece *god*, in lowercase, as if to suggest that the delusion of drugged bliss is not to be mistaken with the far more complex and demanding traffic with a transcendental reality.

Close Seeing

Believers of many kinds engage in close seeing whenever they rely on vision to draw them into an intimate, embodied relation with their gods. Christians absorbed in contemplation of Christ's suffering do so, such as the millions of Roman Catholic and Evangelical Christians who flocked to see Mel Gibson's *Passion of the Christ*. They did not want to see pretend pain. They did not want to see drama. They wanted to see the real thing, and that is what they did, with the gaze they trained on the film. Jesus' pain was visceral to them. It was close seeing—seeing that personalized what was happening. In cases of visual piety like this, believers do not stand back and gaze quietly or disinterestedly on the holy, but attend to it with their bodies, up close. Seeing in the manner of an aestheticized gaze implies distance, silence, contemplation. Close seeing is where vision turns into touch, where one sees with one's viscera. Consider Matthias Grunewald's Isenheim Altarpiece (fig.4), a powerful

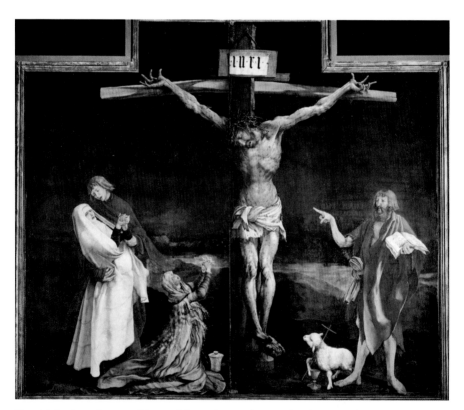

Fig. 4 Matthias Grunewald, panel from the Isenheim Altar, limewood, 102" x 256", circa 1515. Musee d'Unterlinden, Colmar, France; photo by Erich Lessing / Art Resource, NY.

visualization of what Martin Luther meant by the "theology of the cross," which recognizes God's redemptive presence as taking place in the moment of extreme degradation, of abject failure. Paradoxically, Luther understood God to be most powerfully at work in the humiliating and scandalous death of a criminal rather than principally in the glory and triumph of the resurrection or the mysterious grandeur of the incarnation or the sweetness and innocence of the nativity. But the achievement of Grünewald's work is that he unites all of these into a single vision.

This mode of vision has a direct analogue in contemporary artistic practice, but one that is not represented in the exhibition—performance art. I do not mean a theatrical performance captured in the still from Eleanor Antin's *The Last Days of Pompeii*, in which a female figure stares blankly at the viewer from a staged setting. I have in mind rather something like Chris Burden's crucifixion to a Volkswagen or Ron Athey's bloody, self-mutilating performances recalling his abused Pentecostal youth in a severely dysfunctional family. These forms of performance viscerally cancel the distance that traditional aesthetic experience lodges between viewers and the work in order to allow them a disinterested gaze, a contemplative relation that marks off artifice from actuality. This distinction breaks down entirely when viewers are subjected to blood-letting in personal religion, to rituals that do not represent, that is, do not act as fictions, *as if* they were real, but blur work and reality in a way that offends, embarrasses, revolts, horrifies, even nauseates the viewer. Most work in 100 Artists See God tended to reinforce a traditional aesthetic of distance. Aristotle said that tragedy purges the soul of emotions like pity and fear by arousing them in its imitations, but only by pretending to be real within the strict conventions of classical Greek tragedy.[9] One can imagine this when looking at Antin's video still, where people perform suffering and despair, but only as actors portraying roles. If their pain were real, it would generate fear, rather than offer a vicarious purging of it.

By leaving out art that engages in what I've called "close seeing," the curators appear to prefer a more traditional Modernist understanding of art as something gazed upon at the safer distance of metaphor, ambivalence, and irony, or what aestheticians have long called disinterestedness. This is one way of reading the cover of the exhibition catalogue, which shows a telescope trained on the heavens. It's not so much about seeing God as it is about positing the difference that separates artists from the people who say they see God. If so, those in Nashville who complained about the exhibition were not incorrect to do so: the show did not offer them their kind of seeing.

Of course, the curators had no intention of doing so. Yet one work in the exhibition may begin to engage "just seeing" with "close seeing": Jankowski's video. This piece may be a place where believers and artists could have some substantive conversation with one another, since the video urges viewers to consider how blurry the borders between artistic seeing and religious believing may be. If that's true, the fitful career of God in modern art is deeply rooted in conflicting paradigms of vision. How people see really matters and must not be severed from what they claim to see—because seeing, it turns out, *is* believing.

Notes

1. Gustave Courbet, quoted in Richard G. Tansey and Fred S. Kleiner, *Gardner's Art through the Ages*, 10th ed., 2 vols. (Fort Worth, Tex.: Harcourt Brace College, 1987), 2:966.

2. See David Morgan, "Ambiguous Icons: The Art of Ed Paschke," *Image* 17 (Fall 1997): 31–44.

3. Gordon Watt, *The Cross in Faith and Conduct* (Philadelphia: Sunday School Times, 1924).

4. On Chase and other contemporary Christian and Jewish artists, see the exhibition catalog *Like a Prayer: A Jewish and Christian Presence in Contemporary Art, January 31st–June 1st, 2001*, ed. Theodore L. Prescott (Charlotte, N.C.: Tryon Center for Visual Art, 2001).

5. For a fascinating set of critical reflections on contemporary artists of international significance who were shaped by Catholic ethos, see Eleanor Heartney, *Postmodern Heretics: Catholic Imagination in Contemporary Art* (New York: Midmarch Arts Press, 2004).

6. On Protestant imagery including Sallman's, see David Morgan, *Visual Piety: A History and Theory of Religious Images* (Berkeley: University of California Press, 1998); on Mormon imagery, see Noel A. Carmack, "Images of Christ in Latter-day Saint Visual Culture, 1900–1999," *BYU Studies* 39, no. 3 (2000): 19–76.

7. John Baldessari and Meg Cranston, *100 Artists See God* (New York: Independent Curators International, 2004), 56.

8. Baldessari and Cranston, *100 Artists See God*, 54.

9. Aristotle, *Poetics*, 1.6.

Charlotte Poulton is completing a doctoral degree at the University of York and is presently a member of the art history faculty at Brigham Young University. She has special expertise in Renaissance painting.

Stephen L. Tanner is Ralph A. Britsch Humanities Professor of English Emeritus at Brigham Young University. He is the author of four books and nearly 200 articles and chapters dealing primarily with American literature. He was the 2004 recipient of the Karl G. Maeser Distinguished Faculty Lecture award.

Wallace Stegner

Portraying Goodness in Art

Charlotte Poulton and Stephen L. Tanner

CROSSING TO SAFETY, PUBLISHED IN 1987, was Wallace Stegner's final novel. (He died in 1993 at age eighty-four as the result of an automobile accident.) The novel is highly autobiographical and consequently explores themes of deep personal interest to him and reflects the wisdom of an author known for integrity, generosity, and inner strength. Most notably, Stegner blends the themes of adult friendship, which the novel calls *amicitia*, and the challenges of portraying goodness in art to produce a novel of quiet realism that many readers find rich and satisfying. In contrast to the dramatic, often sordid, sensationalism fashionable in much contemporary fiction, the novel is the story of a rewarding and enduring friendship between two married couples. Its events are no more dramatic than the ordinary ambitions, domestic tensions, joys, and adversities common to mortality. The novel is an understated assertion of "how touching and attractive the gestures of human affection are."[1] Upon reading it, the distinguished critic Malcolm Cowley wrote his friend Stegner, "Virtues have not been celebrated in recent prose fiction, but you make them persuasive: unshakable loyalty and all the others. Nobody else could do it."[2]

Stegner took chances in writing the novel. He had little plot and little that could be called exciting, adventurous, or sensational—only the prospect

of writing as honestly as possible about the relationship of four unextraordinary people. Looking back, he said:

> There was nothing very dramatic in those lives . . . so that I was taking risks, I was quite aware. The contemporary novel deals commonly in sensation, but there was not much sensation in this story to deal with [only the ambiguities of the relationships]. And also, I suppose, I had the muleheaded notion that it ought to be possible to make books out of something less than loud sensation.[3]

Stegner carries out his "muleheaded notion" of making a book out of less than loud sensation, and specifically out of the goodness of friendship, by brilliantly employing some mutually reinforcing techniques.

Self-Conscious Narration

First of all, he presents the problem of portraying goodness in art as a self-conscious element in the narration. Larry Morgan, the narrator, is a fiction writer who reflects on the relation of art and life and particularly on the challenges of writing about good lives:

> How do you make a book that anyone will read out of lives as quiet as these? Where are the things that novelists seize upon and readers expect? Where is the high life, the conspicuous waste, the violence, the kinky sex, the death wish? Where are the suburban infidelities, the promiscuities, the convulsive divorces, the alcohol, the drugs, the lost weekends? Where are the hatreds, the political ambitions, the lust for power? Where are speed, noise, ugliness, everything that makes us who we are and makes us recognize ourselves in fiction?[4]

Together in Italy, Larry, his wife, Sally, and their friends Sid and Charity Lang visit the church of Santa Maria del Carmine to view Masaccio's *Expulsion from Paradise* (fig. 1). As they study Eve, "clumsy with woe, stricken with desolate realization, and Adam stumbling beside her with his hand over his eyes," one of them wonders if an artist could portray as expressively the reverse situation: "Could a painter capture in expression and posture the delight-touched-with-humility, the almost tearful gratitude and thankfulness, that ought to mark paradise regained?" Larry notes that more people have read Milton's *Paradise Lost* than his *Paradise Regained*, and that Dante's *Inferno* boils with more vitality than his *Paradiso*. "The wicked and the

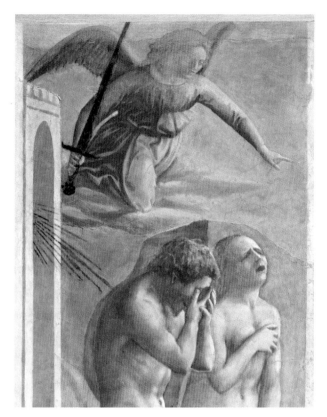

Fig. 1 Masaccio (1401–1428), detail from *Expulsion from Paradise*. Brancacci Chapel, Santa Maria del Carmine, Florence, Italy. Photo © Scala/Art Resource, NY.

unhappy always stole the show," he says, "because sin and suffering were the most universal human experiences. . . . Fallen grandeur was always more instructive than pallid perfection. . . . Saintliness had no possible expression but a simper."[5] He is expressing here what Tolstoy implies in the first sentence of *Anna Karenina:* "Happy families are all alike; every unhappy family is unhappy in its own way."[6]

In another section of self-conscious narration, Larry remarks that "human lives seldom conform to the conventions of fiction." Fiction requires drama, and "drama demands the reversal of expectation." "Since this story is about a friendship," he says, "drama expects friendship to be overturned." Given "the usual direction of contemporary fiction and the usual contemporary notions of human character and conduct," he recognizes the novelist's temptation to create a variety of sexual relations among his four characters: "We could get

very Bloomsbury in our foursome. Anything to get this equilibrium of two-and-two overturned. Well, too bad for drama. Nothing of the sort is going to happen. Something less orthodoxly dramatic is."[7]

The point to be drawn from this self-conscious narration is that Stegner was acutely aware that representing goodness in art is a daunting and, particularly nowadays, unfashionable task. Nevertheless, he was willing to undertake it—not because his appreciation of life's bleakness and evil was deficient, for as a matter of fact, his understanding of the bitter implacability of fate was profound. His narrator puts it this way: "Good fortune, contentment, peace, happiness have never been able to deceive me for long."[8] But as a writer in the tradition of realism, he felt that minimizing or eliminating the artistic portrayal of goodness had become a convention that slighted a very real part of human experience. Saul Bellow, in a Library of Congress address, once described this convention:

> Writers have inherited a tone of bitterness from the great poems and novels of [the twentieth century], many of which lament the passing of a more stable and beautiful age demolished by the barbarous intrusion of an industrial and metropolitan society. . . . There are modern novelists who take all of this for granted as fully proven and implicit in the human condition and who complain as steadily as they write, viewing modern life with a bitterness to which they themselves have not established clear title, and it is this unearned bitterness that I speak of.[9]

In *Crossing to Safety*, Stegner counters such unearned bitterness, such orthodoxy of despair, with the view that life, in addition to its bitterness, contains considerable goodness and happiness. This is clear when Larry compares himself, Sally, and the Langs with the generation of Americans who discovered Paris in the twenties, the so-called Lost Generation,[10] some of whom, as Larry notes, "were infected with fashionable literary despair":

> We thought them luckier. They had had only a war to damage them, and war's damage is, when it isn't fatal, likely to be stimulating rather than the reverse. Living through a war, you have lived through drama and excitement. Living through what we had been given to live through [for example, the Depression and Sally's being permanently crippled after her first child], we had only bad luck or personal inadequacy to blame for our shortcomings.[11]

The irony here is typical of his attitude in treating the notion that art demands the drama and sensation of bitterness and despair. "We did not feel any despair, literary or otherwise," says Larry. "We were no lost generation, despite our losses." They were not searching for "Dada Nada" in Europe, but for something "humanized, something related to mind and order, and hence to hope; something that, as we kept reminding ourselves, was the dream of man."[12] During their hard times, they had adopted a motto from William Faulkner: "They kilt us but they ain't whupped us yit." Enjoying themselves in Florence, they swap this motto for one from Dante: "Think who you are. You were not made to live like brutes, but to pursue virtue and knowledge."[13] According to Stegner, a realistic view of life, for individuals and art, must meld joy and pain, virtue and vice. Many writers of our day have written about the need for love, empathy, and kindness by graphically portraying their absence. Stegner's achievement in this novel lies in portraying their presence. The book's aesthetic and popular success results from the very quietness that he worried about. It is significant that a collection of tributes to Stegner published after his death is titled *The Geography of Hope*.[14]

Bible Iconography

The relation of life and art is an important concern for Stegner and his narrator. The unusual number of allusions to literature and art reinforce this theme by heightening our awareness that life lived and life represented are never far apart. Larry makes particularly significant use of biblical imagery and iconography. The numerous references to Eden suggest that life has its paradisiacal moments. The Morgans and the Langs, for example, have Edenic times in rural Vermont. But, as Larry points out, "No Eden valid without serpent."[15] There is a serpent in their Eden, although a small one. It is that part of Charity's character that insists on total control: "She has to be boss. . . . I don't suppose she can help it."[16] This relatively inoffensive serpent conforms with Stegner's artistic goal of making a book "out of something less than loud sensation." His focus is on the blend of happiness and suffering that constitutes most ordinary lives and that he feels is worthy of portrayal in realistic fiction. Charity's compulsive domineering is a blight on her marriage and on the friendship, but it is inextricably joined with the quality her name proclaims. Sally, the beneficiary of Charity's kindness and generosity, says, "Except for Charity, I wouldn't be alive. I wouldn't have wanted to be."[17]

Bible iconography is at the center of the section in which Stegner brings the theme of portraying goodness in art to a climax. This climax occurs

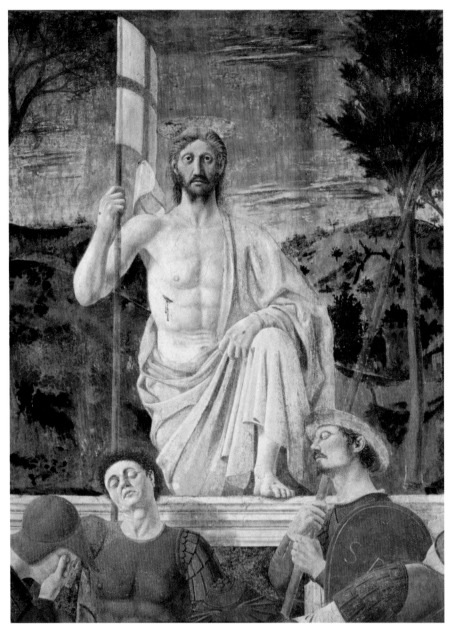

Fig. 2 Piero della Francesca (c. 1420–1492), *Christ Risen*, detail from *Resurrection of Christ*, fresco, after 1460. Pinacoteca Comunale, Sansepolcro, Italy. Photo © Alinari/Art Resource, NY.

when the Langs and the Morgans travel through Tuscany and stop to see the frescoes by Piero della Francesca in Borgo, Sansepolcro. The couples had been enjoying a "good deal of frivolity," but when they saw *Resurrection of Christ* (fig. 2), the image of Christ "knocked it out of us like an elbow in the solar plexus."[18] Three of the four friends are awed by the "gloomy, stricken face" of the resurrected Christ, who communicates a curious uncertainty rather than joy in his triumph over death. The exception is Charity, who is so insistent that life conform to her wishes that she dismisses the work as an "arrogant painting" by an artist who is "anti-God in his portrait of Christ." For her, the only art worth producing is art that portrays pleasant subjects. In sharp contrast, Larry watches his polio-stricken wife, Sally, intently study the fresco "with something like recognition or acknowledgment in her eyes, as if those who have been dead understand things that will never be understood by those who have only lived."[19]

This encounter with Piero's *Resurrection* is dramatically juxtaposed with an unsettling occurrence on the return journey to Florence. Their car is stopped in the road by a group of men who seek help for one of their companions with a severely smashed, bleeding hand. The Americans drive him back to his village to seek medical attention; at the foot of the hill up to village, however, the man insists on being let out of the car. When he turns to acknowledge the help, Larry has the tingling sensation that the man has "the eyes of Piero's Christ."[20] Later that evening, Larry asks Sally, "When you remember today, what will you remember best, the spring countryside, and the company of friends, or Piero's Christ and that workman with the mangled hand?" Sally replies thoughtfully, "All of it. . . . It wouldn't be complete or real if you left out any part of it, would it?" Her husband responds, "Go to the head of the class."[21] This brief exchange culminates the theme of portraying goodness. It has weight because we respect the opinions of these two people. Larry's sixty-four years and his thorough acquaintance with human nature and art have produced a wise, balanced view of life. Moreover, this period in Italy was for Larry a time of "almost unbearable stimulation, or daily and even hourly growth. . . . Everything had something to teach me. I say *me*; I think I mean *us*."[22] Of Sally we are told, "Long-continued disability makes some people saintly, some self-pitying, some bitter. It has only clarified Sally and made her more herself."[23] Sally's wise resignation contrasts sharply with Charity's attitude that life's adversities can and must be confronted by taking charge and trying to manipulate the situation.

Stegner's selection of Piero's *Resurrection* as the subject for this revealing exchange between husband and wife is by no means arbitrary. Piero's

profound depiction of Christ in an image that speaks to the potential for humankind's redemption embodies the dualities explored in Stegner's narrative. The subject of the *Resurrection* presents the dilemma raised by Hegel of representing the divine nature of Christ. There are plenty of images that show Christ as a mortal man: as a teacher, leader, and one who endures intense suffering. But as Hegel points out, in portraying Christ in events such as the Resurrection or the Ascension, "where his Divinity should break out from his human personality, painting comes up against new difficulties."[24] Piero's conception of Christ reconciles the mortal and divine and shows us, according to Arthur Danto, "what it must have felt like to be the subject of a resurrection, and expresse[s] it in a way that each of us, whatever our religious convictions, can understand."[25] Christ assumes a powerful stance, with his left leg planted firmly on the sarcophagus and his right hand bearing the standard of Christianity. He is painted with a monumental solidity like the soldiers in the foreground. His face registers, in Kenneth Clark's words, "the doomed and distant gaze of a somnambulist,"[26] and yet he is still a man whom Danto sees as "alive in a new dawn, and in a barely imaginable way."[27] Though humanized, however, this Christ is no mere mortal. Stegner's recognition of the painting's ability to speak to our soul echoes the 1877 description by the English scholar John Addington Symonds:

> Those who have once seen his fresco of the Resurrection . . . will never forget the deep impression of solitude and aloofness from all earthly things produced by it. It is not so much the admirable groupings and masterly drawing of the four sleeping soldiers, or even the majestic type of the Christ emergent without effort from the grave, as the communication of a mood felt by the painter and instilled into our souls, that makes this by far the grandest, most poetic, and most awe-inspiring picture of the Resurrection.[28]

The initial awe sensed by Larry and, especially, Sally upon viewing the *Resurrection* leads to contemplation and a deeper understanding of life's variegated threads of joys and sorrows. By this time in their lives, the Morgans had experienced both extremes. Their early years at the University of Wisconsin at Madison were defined by their optimism as young professor and wife who were "poor, hopeful, happy"[29] and anxious to leave their mark on the world. They shared Charity's outlook on life: "Don't you think of this place as an *opportunity?* . . . Don't you feel the way we do, how young and promising it is, and how much there is to be done, and given, and taught, and learned?"[30] It was difficult to resist Charity's infectious enthusiasm.

Disappointments and illness, however, soon encroached on the paradise of these couples. Larry faced professional and financial uncertainties when his university position was not renewed; Sid was obliged to continually put aside his aspirations to be a poet in order to pursue the academic track Charity mapped out for him; and Sally was tragically crippled by polio. Yet through it all, they raised their families, forged lifelong friendships, enjoyed evenings of music and poetry, and relished summers in Vermont.

In *Crossing to Safety*, Stegner skillfully highlights the difficulties of portraying goodness in art while simultaneously overcoming those difficulties in creating his own novel. In accomplishing this, he strategically uses biblical iconography associated with the extremes of the human condition according to the Judeo-Christian worldview—humanity's fall and redemption. His novel implies that the cosmic patterns of paradise lost and paradise regained are mirrored in humanized forms in the patterns of ordinary life, and that art that attempts to imitate life should include both. Saul Bellow believed many contemporary fiction writers shortchange us with their unearned bitterness: "They have told us, indignantly or nihilistically or comically, how great our error is, but for the rest they have offered us thin fare."[31] Stegner offers us more substantial fare.

Notes

1. Wallace Stegner, *Crossing to Safety*, Modern Library Paperback ed. (New York: Modern Library, 2002), 200.

2. Malcolm Cowley, Letter to Wallace Stegner, August 7, 1987, quoted in Jackson J. Benson, *Wallace Stegner: His Life and Work* (New York: Viking Penguin, 1996), 412.

3. Richard Etulain, *Conversations with Wallace Stegner about Western Literature and History* (Salt Lake City: University of Utah Press, 1983), xii.

4. Stegner, *Crossing to Safety*, 231.

5. Stegner, *Crossing to Safety*, 255.

6. Leo Tolstoy, *Anna Karenina* (New York: Signet, 2002).

7. Stegner, *Crossing to Safety*, 163–164.

8. Stegner, *Crossing to Safety*, 195.

9. Saul Bellow, "Some Notes on Recent American Fiction," *Encounter* 21 (November 1963): 26.

10. The group of American expatriate writers attracted to Paris in the 1920s.

11. Stegner, *Crossing to Safety*, 257–258.

12. Stegner, *Crossing to Safety*, 258.

13. Stegner, *Crossing to Safety*, 257.

14. Page Stegner and Mary Stegner, eds., *The Geography of Hope: A Tribute to Wallace*

Stegner (San Francisco: Sierra Club Books, 1996).

15. Stegner, Crossing to Safety, 163.

16. Stegner, Crossing to Safety, 176.

17. Stegner, Crossing to Safety, 8.

18. Stegner, Crossing to Safety, 261–262.

19. Stegner, Crossing to Safety, 262.

20. Stegner, Crossing to Safety, 265.

21. Stegner, Crossing to Safety, 267.

22. Stegner, Crossing to Safety, 7; emphasis in original.

23. Stegner, Crossing to Safety, 257.

24. G. W. F. Hegel, Aesthetics: Lectures on Fine Art, trans. T. M. Knox, 2 vols. (Oxford: Clarendon, 1975), 2:821.

25. Arthur C. Danto, Embodied Meanings: Critical Essays and Aesthetic Meditations (New York: Farrar Straus Giroux, 1994), 167.

26. Kenneth Clark, Piero della Francesca, 2nd ed., rev. (London: Phaidon, 1969), 257.

27. Danto, Embodied Meanings, 168.

28. John Addington Symonds, Renaissance Italy: The Fine Arts (New York: Henry Holt, 1877), 234.

29. Stegner, Crossing to Safety, 16.

30. Stegner, Crossing to Safety, 45; emphasis in original.

31. Bellow, "Some Notes on Recent American Fiction," 29.

Josh E. Probert is a PhD student in the Program in the History of American Civilization at the University of Delaware in cooperation with the Winterthur Museum. He is a graduate of the Program in Religion and the Arts at Yale Divinity School and Yale Institute of Sacred Music.

Inculturating Christ

Images of Jesus throughout History

Josh E. Probert

CHRISTIANITY WAS BORN INTO A PREEXISTING CULTURE with multiple political, religious, social, and artistic layers within the religious complexities of first-century Judaism and the Hellenistic Roman Empire. The ways that Christian narratives and Christian theology were influenced by Greek philosophy, Judaic scripture, and other influences have been studied endlessly by learned exegetes both lay and professional, especially in the twentieth century. This paper leaves the terrain of Christian texts to experts of them and turns to a short discussion of Christian images, most specifically to images of Jesus Christ.

My friend and mentor Jaime Lara taught me how to think exegetically about religious images. In addition to the traditional study of Christian iconography and understanding its contexts, he stressed "visual Christology"—using images to unpack the theology of the Christian community who produced them and communities who incorporated it in their visual world. This paper aims to do this by focusing on artistic inculturation, the process in which the person of Jesus, the acts of Jesus, the attributes of Jesus, and the power of Jesus have been visually communicated. Different than enculturation, inculturation is described as

the incarnation of Christian life and of the Christian message in a particular cultural context, in such a way that this experience not only finds expression through elements proper to the culture in question, but becomes a principle that animates, directs and unifies the culture, transforming and remaking it so as to bring about "a new creation."[1]

I will first discuss inculturation and the relationship of religion to culture, after which I will briefly illustrate these ideas with examples drawn from different eras of the Christian epic: the Early Christian period, the Renaissance, and the modern era.

Culture and Religion

Religions exist in and through the cultures by which they are surrounded. The preexistent societal norms of the host culture profoundly affect the contours of the religious life of a believing community. Minority religions—Sikhism in Sweden or Methodism in Malawi, for example—are set at greater odds with the host culture than majority ones. On the other hand, a religion can become so dominant within the host culture that it is no longer set against the backdrop of it but becomes the host culture itself—Catholicism in the Papal States or the Pilgrims at Plymouth, for example. Regardless of size and influence, religions "interpenetrate" with their surroundings both affecting and being affected.[2] Thomas Tweed alludes to this in his definition of religion: "Religions are confluences of organic-cultural flows that intensify joy and confront suffering by drawing on human and suprahuman forces to make homes and cross boundaries."[3]

Christianity has proved to be among the more malleable of the major world religious traditions. Its beliefs, liturgies, art, and architecture have been shaped by the cultures through which the gospel has been preached. Christianity has never adopted a *lingua sacra* (the Roman office excepted).[4] And while Calvary, Bethlehem, and the Temple Mount have been visited by millions of pilgrims over the centuries, these sites and their surrounding cultures do not shape the Christian message in the same way sacred centers do in Judaism, Islam, and other religions that privilege locales and languages.

Sensitivity to native cultures became an issue of concern to more and more Christians as postcolonial viewpoints found offensive the hegemony that Western European culture held over missions. A catechumen in Africa or South America received more than the scriptures and sacraments: he or

she received the packaging of Western European Christianity, including the art, architecture, dress, customs, and liturgies. The issue came to a head in the Catholic Church during the Second Vatican Council (1962–65), when permission was granted for the mass to be celebrated in the languages of the native celebrants and communicants instead of being restricted to Latin.

Regardless of cultural sensitivities, inculturation occurs whether we want it to or not. Christian worship, liturgy, and other religious experiences are understood, expressed, and shaped within a particular moment regardless of ethnicity or locale. No meta-Christianity is to be found within mortal time and space. We never receive God, scripture, or sacraments outside of ourselves, outside of our cultural binding.

This shaping of Christianity goes back to the earliest Christian narratives. When Paul preached the gospel at the Areopagus in Athens, he told those assembled that the unknown god whom they worshiped was the god he was preaching to them. He used the temples and statues of the Roman pantheon to describe what the Christian God was not: "God does not live in shrines made by human hands" (Acts 17:24); and, "We ought not to think that the deity is like gold, or silver, or stone" (17:29).[5] The Doctrine and Covenants affirms this process: "These commandments . . . were given . . . after the manner of their language" (1:24). And language is much more than the nouns and verbs that we use to create sentences and paragraphs. In its broadest sense, language is the fluid symbol system through which one makes sense of sensory phenomenon and orders his or her universe.

From the viewpoint of traditional Christian theology, one might argue that the inculturation of Christianity did not begin with the preaching of the gospel through a Jewish and Roman worldview but with the incarnation of the Son of God himself. God revealed himself in the form of man. The *logos* became flesh (John 1:14).

The way that Christ has been depicted has also been shaped by inculturation. Paul Tillich described in his *Systematic Theology* how a religion's "surrounding culture provides the *forms* for any religious community with it: forms of speech and dress, of course; forms of social relations in and out of church; manners and customs; notions of good and bad."[6] Images of Jesus throughout history bear out Tillich's insight. Christ has been portrayed in myriad colors, costumes, and ethnicities—last of which is as a first-century Palestinian Jew. Nowhere is the inculturation of Christ more evident than in the earliest images of him.

Inculturation and the Early Christian Period

Most depictions of Christ during the early years of Christianity were not illustrations of an actual person, but were symbols, sometimes coded symbols. Similar to the use of *gematria*-coded Hebrew words, like the number 666 in the book of Revelation that "those who had ears to hear" would recognize as a reference to the Roman emperor, multiple, coded images of Jesus would also be understood by Christian adherents. These images include the fish, the anchor, and the Chi-Rho monogram.

Because YHWH was not visualized (although some scholars suspect that he may have been depicted as a bull at some point), depicting deity would have been a new concept for Jewish-Christians. Yet, the story was different for Gentile-Christians. They were surrounded with idealized anthropomorphic gods who were depicted in statues, bas-reliefs, mosaics, and paintings.

Because the Word had been made flesh, Christians eventually began depicting the person of Jesus, but likely not for hundreds of years. Because of the strong influence of Greco-Roman deities on the early Christian culture when the Apostle Paul preached of Christ and his crucifixion, the concepts of half-god, half-deity, wonder worker, and the Son of God were not new. And the early converts to Christianity visually framed Christ in a pre-existent iconographic vocabulary—using language in its broadest sense as the symbols and systems through which one labels, categorizes, and creates meaning from sensory phenomena. Therefore, Jesus became inculturated into early Christianity as early Christians depicted Christ as Apollo, Helios (Sol), and Jupiter.

The historical accuracy of the appearance of the man Jesus of Nazareth was clearly not of much concern to the earliest Christian artists. Only later would images such as Veronica's Veil, the Mandylion, and the Shroud of Turin reveal an underlying desire on the part of Christians to know the true likeness of their man-deity. Much more often than not, Jesus of Nazareth has been depicted ahistorically. And in this ahistoricity, the Hellenistic depictions of Christ became templates that have traveled throughout time. These templates—a combination of the images of Jupiter, Helios, Apollo, philosophers, and the Hellenistic Good Shepherd—were dressed in different clothing, set in different cities, and depicted in different artistic styles to create objects of personal and communal devotion that resonated with the believing community that viewed them. But in almost none of them is Jesus a first-century Jewish rabbi living in Roman Palestine.

The image of the good shepherd was a common motif that was used in religion and politics in the Ancient Near East (ANE). Declaring himself as the "good shepherd" (John 10:11), Jesus became a new lawgiver, similar to Hammurabi—the great lawgiver of Mesopotamia—who also declared himself as the shepherd.[7] Young S. Chae has insightfully written:

> Shepherd imagery is often associated with kingship in the ANE where it was commonplace for shepherds to care for flocks. Kings and gods alike were described repeatedly as shepherds because of their ruling position; thus kingship is rooted deeply in the portrayal of rulership as typified in the figure of a shepherd. Likewise, to speak of YHWH particularly as a shepherd is to speak of YHWH's kingship and his kingdom.

Many other ancient religions used the tradition of shepherd imagery as well. It was used to describe the Hittite man-god Gilgamesh, the Babylonian fertility god Bel-Marduk, and the Ugaritic god Had Ba'lu. Shepherd imagery was also used to depict political leaders. As early as 2500 BC, Lugi-zaggissi, the king of Umma, was referred to as "the shepherd at the head of the flock." The tradition continued throughout Egyptian, Assyrian, Babylonian, and Greek societies.[8] In the Greco-Roman world, the shepherd also had relationship to Hermes and a blissful afterlife. The trope also held associations to generosity and humaneness. And the styles of Good Shepherd sculptures and mosaics in Greco-Roman art were imported by Christians to illustrate Jesus.[9]

Depictions of Apollo, Helios, and Jupiter are the three most-often imported representations of deity in Christian iconography. Robin Jensen argues that images like this were not syncretized, but instead were converted or appropriated for Christian use.[10] Apollo was a god of youth, light, and health. He was "perpetually adolescent," and a nude adolescent at that, revealing his body to be at its developmental peak.[11] Helios was the Greek personification of the sun—a god of light. He flies across the night sky being pulled by fire-darting steeds. In Roman mythology, Helios became Sol, the sun god. His figure was later syncretized with Apollo, becoming a youthful God of light.[12] The most famous depiction of Jesus as Helios is found in a mausoleum underneath St. Peter's Basilica in Rome—a third-century mosaic, commonly called the *Sol Invictus-Christus* (fig. 1). Jews had made a similar move by including Helios in their synagogue iconography. In the fourth-century synagogues of Beth Alpha and in the synagogue mosaic of Hamath Tiberias, Helios is in the center of a zodiac. Here, though, astrology

Fig. 1 Christ as Sun God Apollo, mosaic, Early Christian era, mid third century. Grotte, St. Peter's Basilica, Vatican State. © Scala / Art Resource, NY.

and Roman deities don't seem to have replaced YHWH but were included in the mystical life of Talmudic Jews.

A clear example of how Greco-Roman deities were appropriated for Christian use is in the depictions of Jesus' hair. Late Christian images depict Jesus with long hair. But short hair and a shaved face were very much the style in Jesus' day. Some Jews resisted this Hellenistic appearance, but we have no reason to believe that Jesus did, unless he was too poor as a wood-worker to afford to go to the bath and barber. Some have argued that he was a Nazarite, who would have retained his hair. This will never conclusively be known.[13] But if Christ had long hair, the teachings of Paul seem odd. Remember, Paul to the Corinthians, "Does not nature itself teach you that if

a man wears long hair, it is degrading to him?" (1 Corinthians 11:14). Later, Clement of Alexandria wrote, "Let men's heads be shaved unless they have curly hair. . . . Do not let curls hang far down from the head."[14]

So, why do later images of Jesus depict him with long hair? The reason is that long hair was a sign of divinity in the ancient Greco-Roman world, as were beards. Thus in later images of Jesus as the Good Shepherd, the shepherd motif changes in one important way—the boy's hair was lengthened. This transforms the good shepherd into a god-shepherd. Later, images of the bearded Jupiter were imported to depict Christ. As Robin Jensen has written, "A full-bearded face suggests authority, majesty, and power and may be seen in the portraits of the senior male deities of the Roman pantheon— Jupiter and Neptune."[15] Images of Jupiter sitting upon his throne mirror those of the *Pantokrator* Christ, reigning in majesty. And it is this bearded Jesus who has come down to us today as the most popular template.

In discussing enthroned deities, much has been written on the relationship between the throne of Jesus and the throne of the Roman emperor in Christian iconography. The argument is that Christians were directly questioning the reality of the emperor's power in the broader scope of history. The book of Revelation is replete with this leitmotif. And so, seeing images of Jesus as a new emperor is not without merit. But as Thomas Matthews has shown, Jesus is, more often than not, imported through images of Greco-Roman deities than he was through images of Roman emperors. In the end, though, this differentiation may break down. After all, Caesar Augustus was called "the son of God," Julius Caesar being the deified god. Other emperors of the first century also adopted some formula of the title "Son of God." And several emperors had declared themselves to be gods. Domitian even built a temple for himself in Asia Minor while alive. Furthermore, emperors depicted themselves as Apollo and other deities.

Michelangelo's Christ and the Renaissance

The visual world of ancient Greece and ancient Rome was retrieved by the artists of the Italian Renaissance. Classical sculpture, painting, portraiture, narratives, and idealized bodies were all brought back into artistic use. The most powerful examples of this trend come down to us from Michelangelo. Three of Michelangelo's works reveal the way he inculturated Christ through the Renaissance mind: his 1493 *Crucifixion*, his *Christ Descending into Hell*, created in the early 1500s, and, most striking of all, *Risen Christ*, finished in 1520.

Clearly, *Risen Christ* is a formalistic retrieval of classical sculpture. A nude Jesus stands holding a large cross. He stands in *contrapposto* looking off into the distance with a perfectly sculpted body. The person of Jesus has been inculturated into the classical concern for idealized bodies. When this work is compared with the Isenheim Altarpiece by Grunewald, discussed below, one sees the drastic contrast in concern for depicting a deity of physical beauty. The idealized form of *Risen Christ* is distant from the viewer, whereas the diseased Christ of Grunewald collapses the distance.

But the nude, heroic Jesus in *Risen Christ* is more than just a pastiche of Classical styles. It imports the styles to communicate Christian theology. Remember the narrative in Genesis about the Garden of Eden. After Adam and Eve partook of the forbidden fruit, the narrative says, "The eyes of both were opened, and they knew that they were naked; and they sewed fig leaves together and made loincloths for themselves" (Genesis 3:7). Before the fall, the narrative said, "And the man and his wife were both naked, and were not ashamed" (2:25). St. Augustine would later write, "We are ashamed of that very thing which made those primitive human beings [Adam and Eve] ashamed, when they covered their loins. . . . It is this which makes us ashamed, and justly ashamed."[16]

Christ reversed the fall of Adam. As Paul wrote to the Romans, "For just as by the one man's disobedience the many were made sinners, so by the one man's obedience the many will be made righteous" (Romans 5:19). So, if Christ reversed the fall of Adam, he reversed the tradition of shame associated with the human body, especially the reproductive organs Augustine found so shameful. This victorious Christ is not ashamed of his body. He stands holding the eschatological cross with Garden of Eden innocence. As Leo Steinberg describes the work, it is "the eschatological promise of sinlessness concretely embodied." Steinberg goes on to say, "Where but in ancient art would [Michelangelo] have found the pattern of naked perfection untouched by shame, nude bodies untroubled by modesty? Their unabashed freedom conveyed a possibility which Christian teaching reserved only for Christ and for those who would resurrect in Christ's likeness: the possibility of a human nature without human guilt."[17]

The Concerns of the Believing Community— The Isenheim Altarpiece

As Christ became as much a concept as a historical person, his image was malleable enough to be shaped to meet the needs of believing communities.

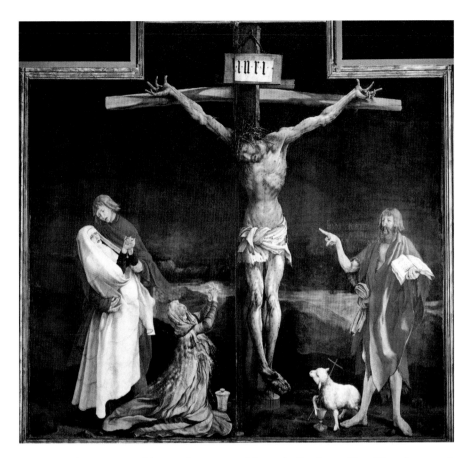

Fig. 2 Matthias Grunewald, *Crucifixion*, a panel from the Isenheim Altar Piece, limewood, 260 x 650 cm., circa 1515.

What did a believing community expect from the image of Christ? What did it do for them? This question can be asked of every image of Christ. One image is especially revealing—the Isenheim Altarpiece, painted in 1515 by German artist Matthias Grunewald for the Monastery of Saint Anthony (fig. 2).

Most of the people who viewed the altarpiece were seriously ill with what was called St. Anthony's fire, a sickness that was later discovered to have been caused from a mold in rye bread. No cure was found until the nineteenth century. The effects of St. Anthony's fire were tortuous. The disease caused severe hallucinations similar to the effects of an LSD drug trip. Accompanying the hallucinations, bleeding sores and itching skin caused the patients to scratch themselves until they profusely bled. A specific order,

the Antonins, was founded to take care of these people. Their monastery became a psychiatric and medical hospital.

Notice that Christ has blue lips and bleeding boils and is in utter agony. The altarpiece is a clear example of Christ being inculturated. He has not only been brought into the monastery on an altarpiece, but he has been brought into the appearance of those in the monastery. Christ has St. Anthony's fire. The altarpiece was created to use in what we would today call therapy for these diseased people. Theologically, Grunewald's work offered the sufferers two things: First, the piece offered them empathy. The pain of the sufferers has been projected onto and interpreted through the suffering of Christ at Calvary. He feels their pain—a unique characteristic of the Christian God. That Jesus feels the pain of his followers and suffered for them stands in stark contrast to other deities of the ancient world. Zeus did not feel anybody's pain.

Second, the piece offered the sufferers the assurance of resurrective release from their itching, bleeding, and hallucinating through Christ's itching, bleeding, and hallucinating. Their bodies would look like Christ's resurrected body, seen healed and glorified in a different register of the altarpiece. Their skin would be clear and clean, and their minds would no longer be tormented. Therefore, the narrative of Christ's suffering and resurrection became a template whereon other Christian sufferers could project themselves, thus inculturating Christ not only in the physical trappings of those tormented by St. Anthony's fire collectively, but also into the mind and diseased body of each believer.

The Black Christ

For centuries, Jesus was depicted solely as what we would call today a white male, although of varying nationalities. This changed when the gospel was preached in non-Western nations. Artists and theologians of these non-European nations inculturated the Christian message in the same way Paul's listeners in Athens did—through their worldview. As a result, images of Jesus draw from Japanese, Chinese, Indonesian, Native American, African, and many other traditions.

Over centuries, many but not all European and American Christians came to cast blacks as intrinsically inferior. These biblical interpreters linked the "curse" of Cain, Ham, and Egypt (with several variations) to the black peoples of Africa. This link did not originate in seventeenth-century America, but much earlier in ancient and medieval Jewish cosmology, which divided

the world into three continents and assigned one of the sons of Noah to each. Ham was assigned to Africa. The differentiation did not carry ethnic implications for Jewish interpreters; the division was largely geographical. But in the Middle Ages, the link between geography and curse became popular. As Ephraim Isaac has written, "It is not until the Middle Ages that the curse of Canaan became attributed directly to Ham by Jewish, Muslim, and Christian writers equally."[18] This interpretation provided justification for centuries of colonization in Africa and the exportation of slaves *en masse*.

When African natives were brought as slaves to the Americas, their deities were left behind. Christian masters made use of New Testament scriptures such as the instruction of 1 Peter: "Slaves, accept the authority of your masters with all deference, not only those who are kind and gentle but also those who are harsh" (1 Pet. 2:18–25).[19] Exegesis on these passages helped to keep the newly indoctrinated slaves subservient. Therefore, when the deities of Africa died in the slaves' collective memory and slaves were forced into Christian pews, adopting Christianity became a part of their transition from Africans to African-Americans. Pre– and post–Civil War black churches emerged, and the worshipers made sense of Jesus through their worldview of life and hope in the face of suffering and injustice—a view that resonated with the Passion of Christ.

Today, depicting Christ as black is a powerful liberationist move. Just as the Isenheim Altarpiece affirms the suffering of the diseased, the black Christ affirms the suffering of blacks. *Lamentation* (fig. 3) by Harlem Renaissance painter William H. Johnson (1901–1970) is beautifully emblematic of this—what art historian Richard Powell calls a "brilliant, Afrocentric folk version of the crucifixion."[20] Painted shortly after his wife's death, Johnson's Christ feels Johnson's personal pain and the pain of black people all together. The women's dress, their gestures, and Johnson's use of bright colors create a synthesis of African, European, and African-American traditions. This Christ affirms the specific pain of a specific people. He carries their specific sorrows. The image is powerfully race-affirming. If Christ is black, then one's blackness is certainly not disapproved of by God. In a speech to African bishops, Pope John Paul II affirmed as much:

> By respecting, preserving, and fostering the particular values and richness of your people's cultural heritage, you will be in a better position to lead them to a better understanding of the mystery of Christ, which is to be lived in the noble, concrete, and daily experience of African life. . . . It is a question of bringing Christ

Fig. 3 William H. Johnson, *Lamentation*, also known as *Descent from the Cross*. 1944. Smithsonian American Art Museum, Washington, D.C., © Smithsonian American Art Museum, Washington, D.C. / Art Resource, NY.

into the very center of African life, and lifting up all African life to Christ. Thus not only is Christianity relevant to Africa, but Christ in the members of his body is himself African.[21]

Conclusion

Images of Christ throughout history are as varied as the people who worship him. These worshipers project their life experience and worldview onto the God who knows them personally. The iconographic vocabularies of the time of artistic creation provide the visual forms through which Christ is depicted. A religion's surrounding culture provides "the forms for any religious community."[22] Christ has, therefore, been inculturated as the good

news of the gospel has been spread from Roman Palestine to nations and peoples far removed from the Hellenistic context of first-century Judaism.

Notes

1. Pedro Arrupe, "Letter to the Whole Society on Inculturation," in *Studies in the International Apostolate of Jesuits* 7 (June 1978): 9, cited in Peter Schineller, *A Handbook on Inculturation* (New York: Paulist Press, 1990), 6.

2. Langdon Gilkey adopted the word "interpenetrate" to describe the give and take of religion and culture. Langdon Gilkey, "Religion and Culture: A Persistent Problem," in *The Mormon History Association's Tanner Lectures*, ed. Dean L. May and Reid L. Neilson (Urbana: University of Illinois Press, 2006), 308.

3. Thomas Tweed, *Crossing and Dwelling: A Theory of Religion* (Cambridge, Mass.: Harvard University Press, 2006), 54.

4. The Roman Catholic Tridentine Mass was celebrated almost exclusively in Latin from the publication of the Roman Missal in 1570 during the Council of Trent until the Second Vatican Council (1962–1965). See also Karl Rahner, "A Basic Theological Interpretation of the Second Vatican Council," *Theological Investigations* 20 (New York: Crossroad, 1981): 77–89.

5. All biblical references cited in this paper are from the New Revised Standard Version.

6. Langdon Gilkey, "Religion and Culture," 308, summarizing Paul Tillich, *Systematic Theology* (Chicago: University of Chicago Press, 1951), and *Dynamics of Faith* (New York: Harper and Row, 1957).

7. James B. Pritchard, ed., *Ancient Near Eastern Texts Relating to the Old Testament, Vol. 1: Anthology of Texts and Pictures* (Princeton, N.J.: Princeton University Press, 1973), 164–165, 177–178.

8. Young S. Chae, *Jesus as the Eschatological Davidic Shepherd* (Tübingen: Mohr Siebeck, 2006), 19–20.

9. Robin Jensen, *Understanding Early Christian Art* (New York: Routledge, 2000), 37–41.

10. Jensen, *Understanding Early Christian Art*, 42.

11. Jensen, *Understanding Early Christian Art*, 126–127, and Thomas F. Mathews, *The Clash of Gods: A Reinterpretation of Early Christian Art* (Princeton, N.J.: Princeton University Press, 1993), 126–127.

12. Jensen, *Understanding Early Christian Art*, 42–43.

13. *Anchor Bible Dictionary*. For more on hair in the Old and New Testaments, see Douglas R. Edwards, "Dress and Ornamentation," in *Anchor Bible Dictionary*, ed. David Noel Freedman, 6 vols. (New York: Doubleday, 1992), 2:234, 236–237.

14. It should be noted that Clement allowed for a beard though. Jensen, *Understanding Early Christian Art*, 125.

15. Jensen, *Understanding Early Christian Art*, 119, 125.

16. As quoted in Leo Steinberg, *The Sexuality of Christ in Renaissance Art and in Modern Oblivion*, 2d ed., rev. (Chicago: University of Chicago Press, 1996), 18–19.

17. Steinberg, *The Sexuality of Christ in Renaissance Art*, 21–22.

18 Ephraim Isaac, "Ham (Person)," in *Anchor Bible Dictionary*, 3:32.

19. Other New Testament passages on slavery include Colossians 3:22, Ephesians 6:5–8, 1 Timothy 6:1–2, 1 Corinthians 7:20–24, and Titus 2:9–10.

20. Richard Powell, quoted in James A. Noel, "Were You There? The Passion and the African-American Religious Imagination," in *The Passion of the Lord: African-American Reflections*, ed. James A. Noel and Matthew V. Johnson (Minneapolis: Fortress, 2005), 40. On William H. Johnson, see Steve Turner and Victoria Dailey, *William H. Johnson: Truth Be Told* (Seattle: University of Washington Press, 1998), and Richard J. Powell, *Homecoming: The Art and Life of William H. Johnson* (Washington, D.C.: National Museum of American Art, Smithsonian Institution; and New York: Rizzoli, 1991).

21. Quoted in Schineller, *Handboook on Inculturation*, 6.

22. Paul Tillich, *Systematic Theology* (Chicago: University of Chicago Press, 1951), and *Dynamics of Faith* (New York: Harper and Row, 1957), summarized in Langdon Gilkey, "Religion and Culture," 308.

Chris Coltrin obtained his undergraduate degree in history at BYU. Then, following some good counsel, he altered his trajectory slightly and obtained a Masters Degree in art history, also from BYU. He is currently pursuing a PhD at the University of Michigan under the direction of Susan Siegfried and is focused on religious art in the first half of the nineteenth century in Britain. More specifically, he is studying the religious art of John Martin and its various social, political, theological, and historical implications.

The Historicization of the Bible

in John Martin's *Adam and Eve Driven out of Paradise*, *The Deluge*, and *The Eve of the Deluge*

Chris Coltrin

THE APPARENT OPPOSITION BETWEEN SCIENCE AND RELIGION is a topic that has occupied scholarly debates in the West since at least the early Enlightenment, and it is one that continues to garner much attention in contemporary society. Perhaps the two most salient moments in the history of this debate came in the seventeenth century with Galileo and then in the nineteenth century with Darwin. The temporal moment at which I want to enter this dynamic occurs between these two touchstones, but much nearer to the latter than the former.

When Darwin published *The Origin of Species* in 1859, it was not the beginning of scientific evidences overriding the Christian conception of history, but rather the culmination of debates that had been circulating throughout the first half of the nineteenth century. The issue at the heart of these debates was the validity of scientific and religious history, particularly the historical record of the Bible. As Colin Russell has noted, "The potential for conflict was greatest where science had a historical content (as in geology or biology)."[1] Whether in debates over the scientific possibility of a worldwide flood, the geological formations of the world, or the evidence of a special creation in contrast to evolutionary theories, the clash between the

biblically described past and the scientifically revealed past formed the core of the early-nineteenth-century conflict between science and religion.

One figure who played an important role in the debate between science and religion was the British painter and printmaker John Martin (1789–1854). Martin frequently exhibited at the Royal Academy but refused to be a part of the institution because he saw its strict rules and its forced conformity as detrimental to the development of British art. While this decision had only a minor effect on his popularity during his lifetime—when Martin was "widely regarded as the greatest English artist after Turner"[2]—it did lead to his later elimination from the art historical canon.

Martin's existence outside of the art canon has limited the attention scholars have paid to him. Although Martin's integration of scientific evidences into his works has not gone unnoticed, scholars tend to portray Martin as an artist who dabbled in science but who was not an informed contributor to the nineteenth-century debate between religion and science.[3] Even those few scholars who have portrayed Martin as participating in these debates fail to postulate on how Martin used his paintings and their scientific components to engage in the discourse and what implications arise from the way Martin merges religion and science in his art.[4] In this paper, I will focus on these unexplored implications and on the way Martin's art participates in the nineteenth-century effort to historicize the Bible. I will first discuss the importance of art in the nineteenth-century debates over the historical validity of the Bible and explore the role of biblical scholars, scientists, and artists in these debates. Next I will turn to John Martin's own role in the debate, examining the kinds of visions he offers to the spectator in three specific paintings and what meanings can be generated by these representations in light of the dynamic between science and religion. Based on these visions and meanings, I will argue that in a context where the biblical past was being undermined by both scientists and artists alike, Martin created paintings and prints that both re-inscribe the reality of the biblical past and suggest harmony between recent scientific discoveries and the Christian conception of history.

The Importance of Art in the Nineteenth-Century Historical Debates

Art is important to a discussion of science and religion in the early nineteenth century because it provides a way for tracking the debate between science and religion as it occurred outside the circle of scholarly elites.

Although there is a certain degree of clarity when attempting to track this debate as it occurred in the writings of scholarly elites, that clarity dissipates when trying to ascertain how these powerful ideas were transmitted and contested in the broader social sphere. And while art is by no means the only mechanism for the transference of these ideas, it is an extremely valuable one as it is a site of cultural production that has a unique and powerful relationship to history.

The relationship between art and history emerges from the power of art to both reinforce and defy the reality of history. The ability to conceive of a time, a place, and an event removed from the reality of the present has been a chief function of art throughout history. Leon Battista Alberti wrote that "painting possesses a truly divine power in that not only does it make the absent present ... but it also represents the dead to the living."[5] Alberti also notes that the artistic presentation of historic events possesses an inherent power that can serve to reinforce the "truth" of the depicted moment. However, the relationship between art and the past is not always so unilateral; art also possesses the power to defy the reality of the depicted history. Depending on the nature of the representation, art can inscribe events as part of reality or fantasy—as history or mythology. Thus, when the actuality of a debated past is at stake—as it was in the nineteenth century with the Bible—art can be wielded as an ideological weapon.

The Role of Biblical Scholars, Scientists, and Artists in the Debate

The historical validity of the Bible was under siege from multiple directions in the early nineteenth century, with biblical scholars, scientists, and artists all playing an important role in the debate. Toward the end of the eighteenth century, scholars adopted an approach to the Bible that would, as Jonathan Sheehan has noted, transform it from a work of theology and history into a work of culture.[6] This approach, called Biblical Criticism, scrutinized the Bible using rational means, essentially treating it like any other text. And while Biblical Criticism was not solely focused on the destruction of the Bible's validity, it did allow for some scholars to speak out against the historical reality of the biblical past.

Biblical Criticism was fueled by science. New geological discoveries began to challenge aspects of biblical history, most specifically the biblical versions of the Creation and the Flood.[7] Scientists like George Buffon began to assert that the earth was not formed in a mere seven days, but rather over

a series of processes that may have taken tens of thousands or even millions of years to complete.[8] In addition, fossils that revealed extinct species challenged the notion of a perfect God creating each species independently. Scientific data was beginning to suggest that perhaps viewing the Bible as a record of history was inherently flawed.

While scientists and their discoveries were one force altering the interpretation of the past, they were by no means the only force depriving biblical history of its reality. Artists, including painters and poets, were another force that undermined the historical reality of biblical events. Painters in Britain during the Romantic period created paintings that elevated historical events to the divine and unreal. In Benjamin West's *Immortality of Nelson*, the employment of allegorical figures, the introduction of angelic beings, and the almost otherworldly setting removes the historical event from the conception of an actually lived past. In like manner, William Blake's illustrations of Milton, such as his *Raphael with Adam and Eve*, were not designed to merely recount biblical history, but to "bring it to an apotheosis."[9] By elevating a biblical event to the divine, Blake created a vision of the biblical past far removed from the sense of lived reality. Poets achieved this same effect, according to M. H. Abrams, by essentially "seculariz[ing] and naturaliz[ing] the founding myths of the Judaeo-Christian religion, internalizing Eden, the Fall and the New Jerusalem into states of the human mind."[10] Thus, rather than reinforcing the reality of the past, poets and painters in the early nineteenth century were actually distancing both biblical and strictly historical events from a sense of their actual occurrence.

The undermining of the biblical past by biblical scholars, scientists, and Romantic artists, was by no means a process that occurred without opposition. Rather, the battle over the legitimization of the Christian past through the avenues of science and reason was fought viciously on both sides during the first half of the nineteenth century. Those who opposed the undermining of the biblical past were called Natural Theologians. These Natural Theologians saw in science a confirmation of the Christian construction of history; and, for them, the mechanics of the natural world were proof of God's intelligence.

The proponents of the idea that science could support rather than undermine biblical history included not only scientists but also other artists who worked for rather than against the historicization of the Bible. In the 1820s, when the gap between artists and scientists was still rather slight, these artists were commonly viewed as types of scientists. John Constable expressed this view when, in 1836, he wrote, "Why, perhaps, should not a

painter, especially of Landscape, be considered rather as a student in any branch of Natural Philosophy, or why should not his Pictures be considered, but as his experiments, as much so as in any other branch of study."[11] Thus, according to Constable's reasoning, when artists like Martin employed scientific evidence in their paintings and prints, it was not the mere imaginings of an artist, but rather a claim from a valid scientific source.

John Martin's Role in Historicizing the Bible

As a nineteenth-century artist, John Martin played an important role in the debate between science and religion by working for the historicization of the Bible through the medium of art. Martin was clearly on the side of the Natural Theologians, and his artwork not only validated biblical history, it also transmitted and contested, in the broader social sphere, the ideas being discussed among scholarly elites. Martin could use art in this manner because, as one of the few artists who were members of the Athenaeum Club (a renowned select gathering for scientists and philosophers),[12] he was aware of the pertinent theories and arguments associated with the debate between science and religion.

However, Martin's engagement in the debate over science and religion was facilitated, not so much by his association with scientists and philosophers, as by his immense popular appeal as an artist. Martin achieved widespread fame after the exhibition of his 1821 painting *Belshazzar's Feast*. This eight-foot painting, depicting the moment when the divine hand inscribes a phrase on the wall that only Daniel could decipher, caused such excitement among the public that a barrier had to be erected to protect it from the throngs that gathered around at its exhibition. David Wilkie noted that "common observers seem very much struck with this picture; indeed, more than they are in general with any picture."[13] So great was the public demand that the exhibition run was extended three weeks. *Belshazzar's Feast* was named "picture of the year"; following his success with this painting, Martin was offered commissions from numerous patrons and businessmen.

One of these commissions, which came two years after the exhibition of *Belshazzar's Feast*, led Martin to undertake perhaps the most ambitious project of his life: a series of twenty-four mezzotints to accompany an edition of Milton's *Paradise Lost*. When the edition was issued in 1827, the reception was overwhelmingly positive. The *Literary Gazette* wrote regarding Martin's *Paradise Lost* illustrations that "there is a wildness, a grandeur, a mystery, about his designs which are indescribably fine: the painter is also a poet . . .

the sweeping elements; the chaos come again; the wonders of that heaven and hell that existed before the earth was made, are magnificently embodied. In short, we look upon these engravings to belong to the foremost order of true genius."[14] Beyond the critical praise the works garnered, they were produced in large numbers and sold for relatively inexpensive prices due to new technological developments in printmaking, specifically the steel plate mezzotint. In this way, Martin's illustrations, like *Belshazzar's Feast*, were appreciated by and made accessible to a broad audience.

Part of what Martin brought this broad audience through his artwork was an overt engagement of the scientific and religious issues under debate at this time. The works in which this engagement is most evident include Martin's illustration *Adam and Eve Driven out of Paradise*, created for *Paradise Lost*, and two later paintings of the deluge.

Adam and Eve Driven out of Paradise

The expulsion scene (fig. 1) is one of the best-known of Martin's illustrations for the 1827 version of *Paradise Lost*. In this print, Martin portrays the banished couple in the foreground and the satanic snake slithering away in the lower right corner. Adam is wrought with grief, and Eve looks back toward their former home. But rather than devoting a portion of the scene to the Edenic world being left behind, Martin focuses virtually the entire piece on the fallen world. The immense space behind Adam and Eve contains harsh mountains, an almost eternally winding river, and violently sharp lightning stemming from a turbulent sky. In this print, dominated by starkly black ink, the points of light function as visual mechanisms to control and focus the gaze of the spectator. One of those points contains the silhouettes of two animals that had only recently entered the visual culture of Britain.

Large animal bones, now identified as the remains of dinosaurs, were known of during the seventeenth and eighteenth centuries, but their full significance was not recognized until the early nineteenth century. In 1822, two accounts—one by James Parkinson and the other by Gideon Mantell—were published that revealed an entirely new and unique species of creatures.[15] Parkinson found what he called a "Megalosaurus," and Mantell discovered what he called an "Iguanadon."[16] After these initial discoveries and classifications, the discovery of dinosaurs took off with rapid speed.[17] And in 1841, Richard Owen proposed that a "new suborder of Saurian Reptiles, for which . . . [the] name of Dinosauria" be established.[18]

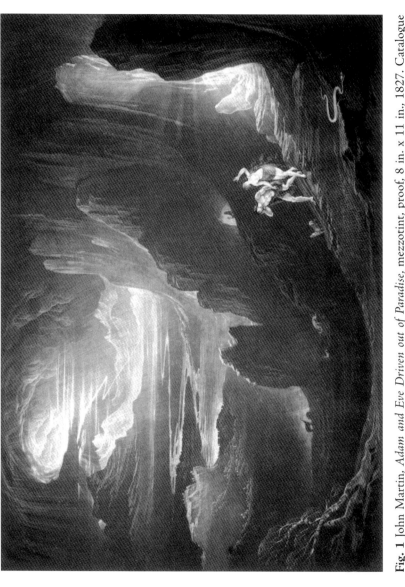

Fig. 1 John Martin, *Adam and Eve Driven out of Paradise*, mezzotint, proof, 8 in. x 11 in., 1827. Catalogue Raisonné: Bk 12, 1. 641, Museum of Fine Arts, Boston. Gift of Samuel Glaser, 69.1326. Photograph © 2008 Museum of Fine Arts, Boston.

The ancient existence of these extinct species was seen by many people as evidence against the creation described by Moses in the Old Testament, but in *Adam and Eve Driven out of Paradise*, Martin places himself firmly on the Natural Theological side of the debate. By including dinosaurs as part of the world Adam and Eve are entering upon their expulsion from the Garden of Eden, Martin asserts that there is harmony between the biblical record and scientific discoveries. This harmony is possible because Martin, while validating the biblical account of Adam and Eve, seems to defy a literal biblical interpretation of the past by implying in his prints that the earth is older than 4,000 years. The age of the earth can be seen even in Martin's prints of Adam and Eve while in the Garden of Eden, where the trees have the appearance of extreme age rather than fresh planting. In the expulsion scene, Martin likewise has Adam and Eve entering a world where animals are fully grown, implying that they existed prior to the actual expulsion. Thus, Martin's incorporation of dinosaurs and an older earth into his portrayal of the expulsion reinforces the claim of Natural Theologians that the Christian version of history is substantiated by science rather than defied by it.

The Deluge and *The Eve of the Deluge*

Martin's next engagement with the scientific and religious debates of the early nineteenth century came with his paintings *The Deluge* and *The Eve of the Deluge*. *The Deluge* (fig. 2), like *Belshazzar's Feast*, was an extremely popular painting; it was exhibited both in Britain and in the Paris Salon of 1835, where Martin was awarded a gold medal by Louis-Phillipe. In *The Deluge*, Martin once again creates a vision of immense space through the portrayal of figural groups that gradually recede into the distance, in conjunction with the mountainous forms, which, despite their violent bursting, extend the pictorial space to an extreme distance. This distance is emphasized by the diminution of the ark, which is barely noticeable, perched atop an obscure cliff miles behind and above the foreground figures. Due to this spatial gap, the meanings generated by the painting do not stem from the ark and its offer of salvation amidst calamity, but rather from the sheer violence caused by catastrophic waters rushing in and the throngs of both animals and people that wail, plead, and flee in fear.

The validity of a worldwide flood faced severe challenges from scientists in the early nineteenth century. One reason why the Flood was such a controversial topic is that, unlike the Creation, which could be explained with metaphoric "days,"[19] the Flood had been witnessed by people on the earth;

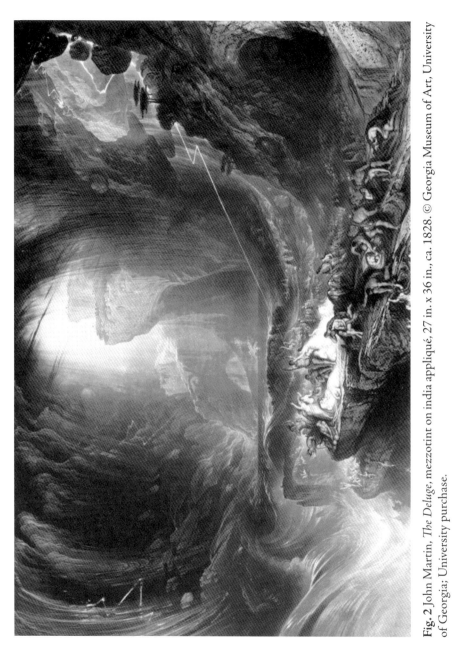

Fig. 2 John Martin, *The Deluge*, mezzotint on india appliqué, 27 in. x 36 in., ca. 1828. © Georgia Museum of Art, University of Georgia: University purchase.

therefore, the truth of the Bible as a historical account hinged on the Flood's actual occurrence.

Among those who participated in the debate about the Flood were scientists, roughly divided into two camps: catastrophists and uniformitarians. The catastrophists were proponents of the most popular geologic theory—catastrophism—which attempted to offer a scientific explanation for the Flood. Catastrophists like William Buckland and George Cuvier "saw in the rocks the evidence of a *series* of Divine Creations" at moments of great catastrophe.[20] For some of these Scriptural Geologists, the Flood was simply the most recent catastrophe among the many throughout history.

In contrast to the Scriptural Geologists stood the proponents of the uniformitarian theory. Uniformitarians, like John Fleming, argued that geological formations such as canyons and gorges would be formed by long-term forces rather than sudden inundations.[21] The implications of this theory for the Christian version of the past were serious because Uniformitarianism not only denied the significance of catastrophic floods, but it also suggested that since "the world is infinite in duration, there is no need for an original Creator."[22]

Martin was most likely aware of these ideas and theories about the possibility of a worldwide flood. Buckland's publications were widely read, and Martin would have undoubtedly been familiar with them when painting his series of paintings on the deluge. In fact, Cuvier actually visited Martin's studio at the time when Martin was working on *The Deluge* and commented on its scientific accuracy.[23] Thus it is more than mere conjecture to suppose that Martin used his paintings to consciously engage the scientific issues surrounding the account of the Flood.

In *The Deluge*, Martin engages the debate between the catastrophists and uniformitarians in three main ways. First, Martin includes in the painting an important detail that reinforces the theory of catastrophism. In the background of the painting, Martin portrays a number of animals. Perhaps most prominent are the elephants, which rear up at their impending destruction. Elephants were a key touchstone in the early nineteenth century for geologists, who had discovered elephant bones in cold climates like Britain and Siberia. Based on the evidence from this discovery, catastrophists concluded that to explain these seemingly out-of-place remains, an event as severe as a sudden worldwide flood would have had to occur to sweep these bones to such great distances. Therefore, by prominently displaying elephants in his painting, Martin alludes to the geological discoveries of the 1820s and to

the way catastrophists saw this discovery as validating the biblical account of the Flood.

In addition to including details that allude to contemporary geologic discoveries, Martin emphasizes in *The Deluge* the historical reality of the subject matter through overt references to actual mathematically calculated space. Martin noted about this painting that "relative to the scale of proportion, viz. the figures and trees, the highest mountain in the Picture will be found to be 15,000 Ft., the next in height 10,000 Ft., and the middle-ground perpendicular rock 4,000 feet."[24] Martin's attention to mathematical proportions enabled him to create accurate, deep perspective in this and other paintings. In fact, he was so famous for his precision that mathematicians from Cambridge often conversed with him about his paintings. But in *The Deluge*, Martin's employment of precise perspective did more than appeal to mathematicians; it allowed Martin to create a scene of total upheaval and catastrophe while retaining a connection to reality. Martin's use of deep and precise perspective draws the viewer into the physical space, while his attention to miniscule details and textures appeals to the viewer's tactile sense. As Martin Meisel notes, even though Martin's artistic compositions often approach the fantastic, there always remains within his scenes "a persistent kernel of bounded identity."[25]

The final way Martin engages in the debate about the historicity of the Flood is by including another important detail in his painting—one that has both astrological and scientific significance. While slightly obscured in *The Deluge*, a comet appears more prominently in another painting, *The Eve of the Deluge* (fig. 3), which was exhibited in 1841. In *The Eve of the Deluge*, the comet appears in the background with the sun and moon. This heavenly conjunction is further emphasized by the gestures of the figures in the foreground that consult prophecies and realize their fulfillment in the sky. On the one hand the comet reflects an astrological sign of the impending flood: one that was known in the nineteenth century.[26] More significantly, though, the inclusion of a comet harks back to the scientific postulation that the Flood was the result of a comet passing too closely to the earth and altering its gravitational pull. This hypothesis began circulating in the late seventeenth century and counted Newton among its adherents,[27] and these ideas were still commonly held by scientists in Martin's time. And when Cuvier visited Martin's studio and viewed *The Deluge* in 1834, he said that "when the moon and the comet come together again, their attraction would be so great that another part of the world would be deluged."[28] Martin therefore utilizes scientific theories and evidences in *The Deluge* and *The Eve of the*

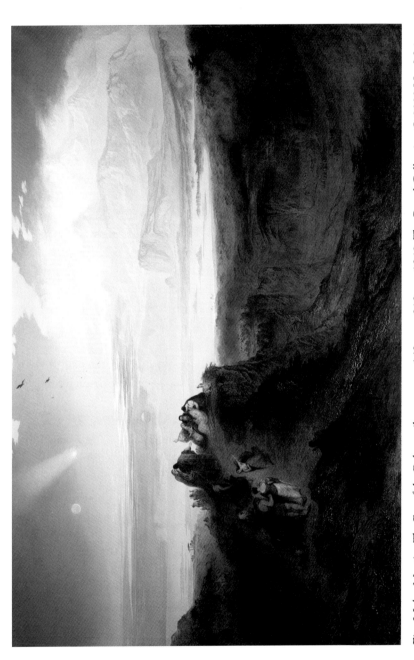

Fig. 3 John Martin, *The Eve of the Deluge*, oil on canvas, 143 cm x 218 cm, 1840. The Royal Collection © 2008 Her Majesty Queen Elizabeth II.

Deluge to once again legitimize a key event in the biblical account of history—significantly an event that science during this time was simultaneously discrediting.

In such a volatile intellectual and religious climate, Martin's inclusions of overt scientific evidences in *Adam and Eve Driven out of Paradise, The Deluge,* and *The Eve of the Deluge* are by no means hollow gestures. Through these inclusions, Martin places himself firmly on the side of the Natural Theologians and the catastrophists, and he validates the historical reality of the biblical events he portrays. The choice to not only paint biblical scenes, but to do so in a scientifically infused manner, allowed Martin to engage in the ongoing debate between science and religion during the early nineteenth century. More importantly, Martin's art demonstrates that this debate was fought not merely among scholarly elites, but in the realm of culture as well; and perhaps, if trying to ascertain the public's conception of the scientific and religious issues at hand in the early nineteenth century, widely popular art such as Martin's is a resource that deserves more attention than it has garnered to this point.

Notes

1. Colin A. Russell, "The Conflict of Science and Religion," in *Science and Religion: A Historical Introduction,* ed. Gary B. Ferngren (Baltimore: Johns Hopkins University Press, 2002), 5.

2. Francis D. Klingender, *Art and the Industrial Revolution,* ed. Arthur Elton (New York: Augustus M. Kelley Publishers, 1968), 123.

3. For example see Martin J. S. Rudwick, *Scenes from Deep Time: Early Pictorial Representations of the Prehistoric World* (Chicago: University of Chicago Press, 1992), 22–24.

4. Justine Hopkins, "Phenomena of Art and Science: The Paintings and Projects of John Martin," in *Fields of Influence: Conjunctions of Artists and Scientists, 1815–1860,* ed. James Hamilton (Birmingham, U.K.: University of Birmingham Press, 2001) 51–92; Roberta J. M. Olson and Jay M. Pasachoff, *Fire in the Sky: Comets and Meteors, the Decisive Centuries, in British Art and Science* (Cambridge, UK: Cambridge University Press, 1998); Rudwick, *Scenes from Deep Time;* Ruthven Todd, *Tracks in the Snow: Studies in English Science and Art* (London: Grey Walls, 1946).

5. Leon Battista Alberti, *On Painting and on Sculpture. The Latin Texts of* De Pictura *and* De Statua, trans. and ed. Cecil Grayson (London: Phaidon, 1972), 61.

6. Jonathan Sheehan, *The Enlightenment Bible: Translation, Scholarship, Culture* (Princeton, N.J.: Princeton University Press, 2005). Though Sheehan focuses more on the German context, he also discusses how the ideas in Germany appeared in Britain as well.

7. Vernon F. Storr, *The Development of English Theology in the Nineteenth Century, 1800–1860* (London: Longmans, Green, 1913), 181.

8. Bruce G. Trigger, *A History of Archaeological Thought* (Cambridge, UK: Cambridge University Press, 1989), 89.

9. Joseph Anthony Wittreich, *Visionary Poetics: Milton's Tradition and His Legacy* (San Marino, Calif.: Huntington Library, 1979), 34, quoted in Steven Behrendt, "*Paradise Lost*, History Painting, and Eighteenth-Century English Nationalism," *Milton Studies* 25 (1989): 155.

10. M. H. Abrams, quoted in Peter J. Kitson, "Beyond the Enlightenment: The Philosophical, Scientific and Religious Inheritance," in *A Companion to Romanticism*, ed. Duncan Wu (Cambridge, Mass.: Blackwell Publishers, 1998), 45.

11. John Constable, *John Constable, Further Documents and Correspondence*, ed. Leslie Parris, Conal Shields, and Ian Fleming-Williams (London: Tate Gallery, 1975), 20.

12. Hopkins, "Phenomena of Art and Science," 71.

13. Allan Cunningham and Peter Cunningham, *The Life of Sir David Wilkie; with His Journals, Tours, and Critical Remarks on Works of Art; and a Selection from His Correspondence*, vol. 2 (London: John Murray, 1843), 57.

14. *Literary Gazette*, April 2, 1825.

15. Gideon Algernon Mantell, *The Fossils of the South Downs; or, Illustrations of the Geology of Sussex* (London: Lupton Relfe, 1822); James Parkinson, *Outlines of Oryctology. An Introduction to the Study of Fossil Organic Remains; Especially of Those Found in the British Strata: Intended to Aid the Student in His Enquiries Respecting the Nature of Fossils, and Their Connection with the Formation of the Earth* (London: J. Compton, 1822).

16. Mantell, *Fossils of the South Downs*; Parkinson, *Outlines of Oryctology*, 298.

17. W. E. Swinton, *The Dinosaurs* (London: Alden Press, 1970), 32.

18. Owen, quoted by Davis A. Young, *The Biblical Flood: A Case Study of the Church's Response to Extrabiblical Evidence* (Grand Rapids, Mich.: W. B. Eerdmans, 1995), 123.

19. Tess Cosslett, ed., *Science and Religion in the Nineteenth Century*, Cambridge English Prose Texts (Cambridge, UK: Cambridge University Press, 1984), 4.

20. Cosslett, *Science and Religion in the Nineteenth Century*, 4.

21. David N. Livingstone, *Darwin's Forgotten Defenders: The Encounter between Evangelical Theology and Evolutionary Thought* (Grand Rapids, Mich.: W. B. Eerdmans, 1987), 14.

22. Cosslett, *Science and Religion in the Nineteenth Century*, 6.

23. "Diaries of Ralph Thomas," quoted in Mary Lucy Pendered, *John Martin, Painter: His Life and Times* (London: Hurst and Blacket, 1923), 133.

24. William Feaver, *The Art of John Martin* (Oxford: Clarendon Press, 1975), 92.

25. Martin Meisel, "The Material Sublime: John Martin, Byron, Turner, and the Theater," in *Images of Romanticism: Verbal and Visual Affinities*, ed. Karl Kroeber and William Walling (New Haven, Conn: Yale University Press, 1978), 231.

26. See a poem in *The Knickerbocker* (1833), 390.

27. Sara S. Genuth, *Comets, Popular Culture, and the Birth of Modern Cosmology* (Princeton, N.J.: Princeton University Press, 1997), 192.

28. Thomas Balston, *John Martin, 1789–1854, Illustrator and Pamphleteer* (London: Bibliographical Society, 1934), 90.

Noel A. Carmack earned a bachelor of fine arts in illustration and a master of fine arts in drawing and painting, both from Utah State University. He currently is an instructor of art at the College of Eastern Utah. He served as Preservation Librarian at Utah State University's Merrill-Cazier Library for fourteen years. Aside from his interests in book-binding and conservation, he has interests in visual art, the history of the nineteenth-century American West, and the art and cultural history of the Latter-day Saints. He has published on Mormon cultural topics in the *Journal of Mormon History*, *Dialogue*, *Utah Historical Quarterly*, and *BYU Studies*. In 2000, his BYU Studies article "Images of Christ in Latter-day Saint Visual Culture, 1900–1999," generated a thoughtful discussion on that timely topic.

"A Picturesque and Dramatic History"

George Reynolds's *Story of the Book of Mormon*

Noel A. Carmack

IF ASKED ABOUT ART FEATURING THE BOOK OF MORMON, few Latter-day Saints of today would fail to bring to mind Arnold Friberg's large, heroic characters and epic scenes. Others have a growing affection for the colorful Book of Mormon paintings by Minerva Teichert.[1] These two artists produced some of the most recognizable images to illustrate the Book of Mormon in the last century. In the second half of the twentieth century, Latter-day Saints saw a significant rise in the use of the Book of Mormon as a proselyting tool and principal selling point, contributing to the Church's rapid worldwide growth. It is not surprising, then, that in more than one hundred and seventy-five years since its publication, the Book of Mormon has inspired scores of visual images meant to bring life to the book's protagonists and geographic scenery. Many of these visuals have made a significant impact on our imaginative perceptions of Book of Mormon lands and peoples.

While Reuben Kirkham and others produced large painted canvases for his traveling panorama show from 1885 to 1886,[2] it is scarcely known that the first *published* attempt at illustrating the Book of Mormon was in 1888, with the publication of *The Story of the Book of Mormon* by George Reynolds. Reynolds, best known as the voluntary subject for the Supreme

Court test case against polygamy in 1878, showed his deep conviction for the scriptural text by popularizing the Book of Mormon narrative and providing enlivening visuals to help tell the story.[3] In the preface, Reynolds presented his prospectus to the work:

> This volume presents one unique feature, in that it is the first attempt made to illustrate the Book of Mormon; and we have pleasure in realizing that the leading illustrations are the work of home artists. To break fresh ground in such a direction is no light undertaking; the difficulties are numerous, none more so than the absence of information in the Book of Mormon of the dress and artificial surroundings of the peoples whose history it recounts. Each artist has given his own ideas of the scenes depicted, and as so much is left to the imagination, some readers will doubtless praise where others will blame; and the same effort will be the subject of the most conflicting criticism.[4]

Reynolds's intention was not only to bring an easy-to-read text of the scriptural narrative to children and young adults, but to bring together the latest in archaeology and scholarship on the pre-Columbian Americas. To historicize and authenticate the work, he provided line drawings of Aztecan charts, maps, and engravings of Mesoamerican writings and glyphs. The story itself was illustrated with dramatic narrative images. These illustrations were "reproduced from paintings and drawings specially prepared for the work by able and well known artists," including George Ottinger, William Armitage, John Held Sr., and William "Billy" C. Morris.[5]

Immediately following his release as a "prisoner for conscience' sake" in 1881, Reynolds began researching and preparing his *Complete Concordance of the Book of Mormon*, his *Dictionary of the Book of Mormon*, and his compilation, *The Story of the Book of Mormon*. In 1888, Reynolds wrote in his journal:

> During the Fall I collected my writings on Book of Mormon subjects that had appeared during the last ten years in the Juvenile Instructor, Exponant [sic], Contributor, Deseret News + Millennial Star, and adding several chapters thereto to make it a continuous narrative from Lehi to Moroni I put it into book form and agreed with Bro. Jos. H. Parry for its publication. It appeared on December 20th under the title of 'The Story of the Book of Mormon.' The agreement with myself and Bro Parry was that we were to divide equally all profits.

An edition of 5,000 was published. It was i[l]lustrated by Ottinger, Held, Armitage, Morris (of our home artists) and others.[6]

When *The Story of the Book of Mormon* appeared in December 1888, the *Millennial Star* carried a book notice that had been published in the West Yorkshire *Brighouse and Rastrick Gazette*, lauding the book's appearance as a "handsome, gorgeously and profusely illustrated and exquisitely-printed volume, fit to be placed in any parlour," a result of "profound research, deep, critical, and discriminative thought." The reviewers also referred to the book as "a picturesque and dramatic history," reminding them of the "thrilling and the pictorial style of Dean Stanley," Bishop of Norwitch and author of the popular *Sinai and Palestine in Connection with Their History* (1856).[7] Other notices placed in the *Deseret News* and *Parry's Monthly Magazine* made special mention of the illustrations and charts for the purpose of attracting the interest of young readers.[8]

Through his Book of Mormon project, Reynolds sought to reach the younger generations who had not yet formulated literary and visual imagery from the dramatic scriptural narrative. His *Story of the Book of Mormon* synthesized growing interest in the study of New World civilizations. For Latter-day Saints, it brought Promised Land characters and places to life. But it also reflected the nation's imaginative transmittal of Western myth and Old World empires on the lost civilizations of America's past.

A critical examination of the illustrations will show that *Story* artists employed imagery that was either borrowed from Bible narratives or elements that were clearly meant to show a connection with the peoples and cultures portrayed in the Bible. The use of biblical imagery was an efficient mechanism for showing readers (most specifically young people) that Book of Mormon characters were of Near Eastern origins. Since illustrative material on the Book of Mormon was virtually nonexistent, the artists had to look to the most current research on Mesoamerican archaeology and supplement it with what was then known about Israelitish customs, architecture, native costume, and so on. Naturally, they would have taken their visual cues from published imagery like that of Gustav Doré, John Martin, James Tissot, Bernhard Plockhorst, and others.[9]

The commissioned artists were known as the best from Latter-day Saint talent. The four chosen for the *Story* project were members of a small group of congenial working artists in Salt Lake City and were well prepared and experienced to do the illustrative work. Shortly after the opening of the Salt Lake Theater in 1862, George Ottinger and William "Billy" C. Morris

found employment painting stage scenery and decorations.[10] Armitage, Ottinger, and Morris were also three of the founding members of the Salt Lake Art Society, organized in October 1881.[11] Although their styles varied somewhat, the artists had known each other as friends and probably relished the idea of working together on a project of this sort. Known for his religious and historical subjects, Armitage was one of the most skillful of the group, but because of his untimely death in California in 1890, very few of his paintings are known to exist.[12] An engraver and printer, John Held Sr. was not formally trained as an artist but had several years' experience creating woodblock prints and line drawings for the *Deseret News* and *Parry's Monthly Magazine.*[13]

William Armitage's only contribution to the book, *The Glorious Appearing of Jesus to the Nephites* (fig. 1), served as the book's frontispiece. This painting appears to have been executed in the tradition of the dean of American historical painting, Benjamin West. In fact, if we compare the placement and gesture of Christ, and note the posturing of surrounding figures, we can see a striking similarity in style to that of West's in his *Christ Healing the Sick* (fig. 2). The open arms of Christ and the astonishment and resultant gesturing of the figures suggests that Armitage may well have used West's painting as his source of inspiration.

That Armitage and other *Story* artists were looking at American historical painters for their inspiration would not have been unusual. Painters such as Benjamin West, John Vanderlyn, John Singleton Copley, John Trumbull, Charles Willson Peale, and Washington Allston set the precedent for nineteenth-century Grand Manner history painting in America.[14] Often associated with the teachings of Sir Joshua Reynolds, *Grand Style* or *Grand Manner* is a term that connotes a style that "ennobles the painter's art" by depicting "some eminent instance of heroic action, or heroic suffering." History painting done in the Grand Manner ostensibly elevated viewers to a higher state by depicting ideal or noble subjects taken from classical and religious history. Grand Manner artists looked to the "authority" of masterpieces created in classical antiquity, the Renaissance, and the Baroque, studying the works of such masters as Raphael, Michelangelo, Titian, Correggio, and Poussin. Taking their inspiration from classical figures in antiquity, such as Apollo, Venus, Ariadne, and Marius, the artists sought to bring "intellectual dignity" and "excellence" to artistic renderings of historical events.[15] In this case, the *Story* artists—particularly Ottinger (fig. 3)—visually recreated events from the Book of Mormon narrative in the tradition of Grand Manner American history painters such as West, Vanderlyn and Copley.[16]

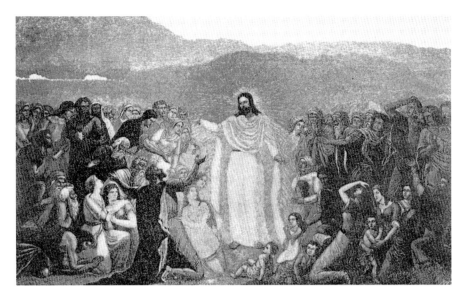

Fig. 1 William Armitage, *The Glorious Appearing of Jesus to the Nephites,* engraving. Frontispiece of *The Story of the Book of Mormon,* by George Reynolds (Salt Lake City: Joseph Hyrum Parry, 1888).

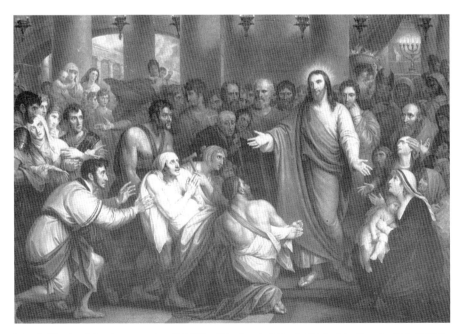

Fig. 2 Charles Heath, engraving (1822) of Benjamin West's *Christ Healing the Sick* (1811). Image reversed for comparison.

The first created image in the series, and perhaps the historical antecedent to all of the paintings in the series, George Ottinger's *Baptism of Limhi*, was a large pastoral scene showing Alma baptizing the early convert at the waters of Mormon as described in Mosiah 25:17–18. According to Ottinger, *The Baptism of Limhi* was a monumental piece, measuring seven and a half feet by five feet. It and other smaller cartoons (preliminary sketches) of Book of Mormon subjects were conceived long before *The Story of the Book of Mormon* appeared in print. In an 1872 entry to his journal, Ottinger recorded that *The Baptism of Limhi* was "the first Picture ever painted from a subject suggested by the Book of Mormon."

As encouraged as he was by the progress of the painting, he was less than hopeful about selling the piece. "I don't know of any one who will buy it," he wrote, "but our State Fair offers a gold medal for the best picture this fall and I am going to try for it."[17] A short time later, Ottinger wrote, "Two or three days more work will finish the baptism of Limhi, the largest picture I have painted so far."[18] His next mention of the painting was significant, because it shows his interest in creating more images as part of a larger series of paintings on Book of Mormon subjects:

> The Baptism of Limhi seems to give general satisfaction. I have spent some eight years gathering material for subjects suggested by the Book of Mormon. This picture is the first. I have been just twenty days putting it on canvas. Should I meet with ordinary success this winter, I will paint another subject from the same book. I have some ideas of making twelve cartoons in black and white this winter, illustrating the Book of Mormon.[19]

As he had hoped, the painting was completed in the fall and exhibited at the Territorial State Fair. The newspaper correspondent noted that Ottinger's *Baptism of Limhi* was "the largest and among the finest" in the art

exhibition. "The landscape," he wrote, "is supposed to represent a scene in the northern part of South America. The two principal figures stand out in bold relief, while the crowd of spectators on the banks of the river, witnessing the baptismal ceremony, are beautifully and tastefully grouped."[20] The image reproduced in *The Story of the Book of Mormon* (fig. 4) lacks the detail in the figures and ornament that one would expect from the large-scale piece described by Ottinger and the State Fair correspondent. This leads one to believe that the published illustration is more likely a cartoon, like one of those mentioned by Ottinger in his 1872 journal entry.

Another *Story* painting, *First Sacrifice on the Promised Land* (fig. 5), depicts Father Lehi offering sacrifice in thanks for the group's safe arrival in the New Word. Lehi is prominently shown in front of the altar with his arms stretched upward in an attitude of prayer, surrounded by his family and that of Ishmael.[21] An active volcano emits vapors in the distance while the arc of a rainbow leads our eyes back to Lehi, the central focus of the painting. The rainbow reveals that Ottinger was not only borrowing biblical imagery for a Book of Mormon narrative with little or no visual precedent but was illustrating an event that was never described in the Book of Mormon text itself (see 1 Nephi 18:23–25). By using the rainbow, he may well have been playing off of an Old Testament image with which many young readers could identify. Perhaps by using the token of the covenant between God, Noah, and the inhabitants of the earth, it would show that God's benevolent promises extend to all of the children of Abraham—including those who had crossed the great waters to arrive in the Promised Land.

Although Ottinger would make the largest contribution to Reynolds's project, he evidently didn't think it significant enough to regularly note in his journal. His observations are devoid of any further mention of *The Story of the Book of Mormon* images, other than the *Baptism of Limhi*. It is worth noting, however, that Ottinger completed other historical paintings which reflect his interest in Mesoamerican antiquities.[22] In 1887, he recorded: "January. Painted on the 'Maya Sculptor' a little but have very <u>little</u> incentive, so set it aside until I can grind up a <u>little</u> more inspiration."[23] When the *Maya Sculptor* (fig. 6) was published in the *Improvement Era* nearly twenty-three years later, Ottinger wrote,

> In some of the ruins of the old cities, especially at Copan, there are clusters of square stone pillars or obelisks varying from twelve to twenty feet high. They are elaborately sculptured, showing human figures, ornamental designs and hieroglyphic inscriptions on their

Fig. 4 George M. Ottinger, *Baptism of Limbi*, from *The Story of the Book of Mormon*, page 113. The original version of this work was a monumental painting created in 1872.

Fig. 5 George M. Ottinger, *First Sacrifice on the Promised Land,* from *The Story of the Book of Mormon,* page 53.

sides. The picture represents a Maya sculptor, elevated on his scaffolding, laboriously and patiently working out his conception of a deified king or hero, which evidently these monoliths personify.[24]

Ottinger's propensity for historical subjects would have been no surprise to the viewing public. He had been touted as one of the territory's leading artists, whose chosen pastime was the cultivation of his talent for "historical painting, a branch of the art which requires careful study as well as skill in using the brush."[25]

Considered one of Utah's most respected artists, Ottinger supported himself and his family working as Salt Lake City's fire chief, and he tried to make additional income by hand coloring photographs and selling his historical paintings to Salt Lake City patrons.[26] That he "spent some eight years gathering material" to paint Book of Mormon subjects indicates that he had been looking at the published research on the Maya and the discoveries of ancient glyphs and decorated friezes unearthed in the Yucatan. "Ah, here is a vast, almost unexplored vista, mysterious, new and picturesque!" he wrote. "Old America with all her pre-historic treasures, a store-house of material, that needed only study, time and patience to make interesting and of value; and in this direction my studies have been chiefly directed for years."[27] By the

time he and the other *Story* artists had received their commission, Ottinger would have been well acquainted with Frederick Catherwood's illustrations for John Lloyd Stephens's *Incidents of Travel in Central America, Chiapas, and Yucatán* (1841), Stephens's *Incidents of Travel in Yucatán* (1843), and Catherwood's own *Views of Ancient Monuments in Central America, Chiapas, and Yucatán* (1844).[28] He would also have undoubtedly seen William H. Prescott's *Conquest of Mexico* (1843) which was in wide circulation and contained a number of line drawings showing the elaborate stone carvings and architectural wonders of the Aztecs. Ottinger's painting *Flowers of Cola Luyona*, for example, clearly

Fig. 6 George M. Ottinger, *Maya Sculptor,* from *Improvement Era* 13 (April 1910): 498.

shows a finely executed reproduction of *The Altar of the Temple of the Sun* at Palenque, which was originally drawn by Catherwood and engraved by Archibald Dick for Stephens's *Incidents of Travel in Central America*, a complex design not only appearing as an illustration but also used for the cover of the book.[29]

During the height of Ottinger's efforts at historical painting, archaeological exploration in Mexico and the Yucatan was at a new high point. Augustus and Alice Le Plongeon were two of the earliest to excavate and photograph numerous Maya ruins in the Yucatan. Although their work was regarded as somewhat eccentric and speculative, the Le Plongeons brought the world some of the first photographic images of the Central American ruins. Contemporaneous to the work of the Le Plongeons, Désiré Charnay published his photographic record of Yucatan's pre-Columbian monuments and ruins in *Ancient Cities of the New World* (1887). The photographs of Alfred Maudslay, accompanied by the colored line drawings of his two artists, Edwin J. Lambert and Annie G. Hunter, were published in the *Proceedings of the Royal Geographical Society* in 1883 and 1886.[30]

In addition, Ottinger's cataclysmic painting *Destruction of Zarahemla* (fig. 7), taken from 3 Nephi 8:6–8, appears to have been stylistically influenced by two of the most distinguished historical painters, Nicolas Poussin and Benjamin West. The overall composition and placement of figures suggests that Ottinger drew from the widely known religious painting *Death on the Pale Horse* (fig. 8), by West. The horses, chariot, and terror-stricken figures in Ottinger's painting are similar in many ways to the visual arrangement of West's apocalyptic image. Two fallen figures in the foreground of Ottinger's rendering appear to have been inspired by West's figures of a fallen mother and children in *Pale Horse*. Furthermore, if we compare Ottinger's *Destruction* with Poussin's drawings *The Conversion of St. Paul* (fig. 9) and *The Death of Hippolytus*, we will notice even more striking visual similarities in the gesture of the horses, the chariot, darkened clouds, and fleeing figures.[31]

With this comparison in mind, we can be relatively confident that Ottinger was well familiar with both West's and Poussin's work. Ottinger shared the same interest in classicism and historical narratives that are depicted in Poussin's drawings and paintings. Traditionally, West's and Poussin's works have been linked with drama and scenery paintings, bringing life to the events being portrayed on stage.[32] Ottinger's skills and experience were created from this same tradition. If we, as spectators, visually perceive Ottinger's images as those which are created for a grand-scale drama, we can readily see the similarities of style and two-dimensional action to that

Fig. 7 George M. Ottinger, *Destruction of Zarahemla*, from *The Story of the Book of Mormon*, page 249.

Fig. 8 Benjamin West, *Death on the Pale Horse*, oil on canvas, 176 x 301 in., 1817. Courtesy of the Pennsylvania Academy of the Fine Arts, Philadelphia. Pennsylvania Academy purchase.

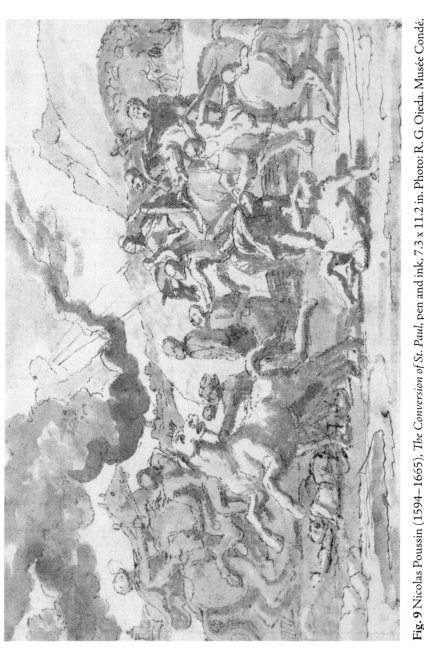

Fig. 9 Nicolas Poussin (1594–1665), *The Conversion of St. Paul*, pen and ink, 7.3 x 11.2 in. Photo: R. G. Ojeda. Musée Condé, Chantilly, France, Réunion des Musées Nationaux / Art Resource, NY.

of Poussin's. And, indeed, we see echoes of Poussin in Ottinger's background landcapes, his posturing of figures, and his placement of the activities depicted within the pictorial space, as if we are watching a drama unfold on stage.[33]

It is this theatrical arrangement in the composition of paintings that informed the art of the High Renaissance and, ultimately, the neoclassicism of the eighteenth and nineteenth centuries. Historically, the approach to composition was often characterized by the unity of a sequential narrative, with many events and places located in the same pictorial space. Or, in other examples, a historical event is depicted with its protagonists as the central focus, while supporting players act out minor scenes in the surrounding space. In its classicized form, a picture would appear as a window looking out on one scene. It would require that the background, at least, be "recognizable as one place, although it continued to be common to depict more than one moment in time in the single spacial surrounding."[34] This manner of theatrically arranging figures within a visual narrative is also thought to have been employed by American historical painters such as West, Copely, and Trumbull. Britain's own Sir Joshua Reynolds is believed to have based his ideals of Grand Style classicism in painting on the arrangement of figures on a stage. A widely read painting manual by Daniel Webb, for example, conveyed the neoclassical ideals of history painting as having their origins in drama:

> History painting is the representation of a momentary drama: We may therefore, in treating of compositions, borrow our ideas from the stage; and divide it into two parts, the scenery, and the drama. The excellence of the first consists in a pleasing disposition of the figures which comprise the action.[35]

In these compositional terms, a reverence for classicism, intellectual dignity, and noble, heroic action could best be visualized within the context of the theater. Grand Manner was a style that was founded upon theaterlike imagery.

In addition to being influenced by dramatic Grand Manner history painting, the *Story* illustrations came on the heels of other historical visualizations of pre-European New World empires.[36] Josiah Priest's widely read 1833 publication *American Antiquities* generated curiosity in the origins of Native Americans that spilled over to visual conceptions of how the native peoples might have looked and lived. The work of poets and novelists, including William Cullen Bryant and Sarah J. Hale, fed into the aura of mystery surrounding the Promised Land's vanished race.[37] Early American

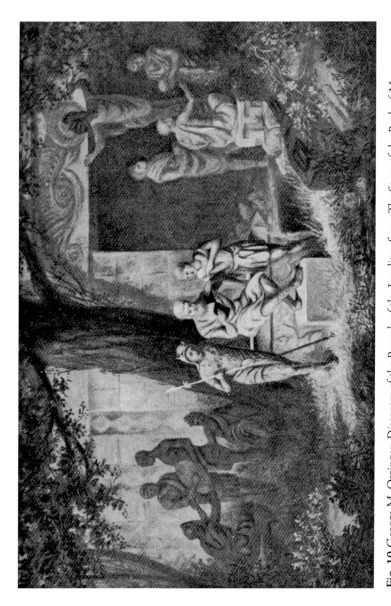

Fig. 10 George M. Ottinger, *Discovery of the Records of the Jaredites*, from *The Story of the Book of Mormon*, page 105.

Fig. 11 Frederick Catherwood, *Gateway at Labnah*, from *Views of Ancient Monuments in Central America, Chiapas, and Yucatan* (London: F. Catherwood, 1844), plate 19. Photo: L. Tom Perry Special Collections, Brigham Young University.

Fig. 12 George M. Ottinger, *Moroni Raises the "Title of Liberty*," from *The Story of the Book of Mormon*, page 185.

Fig. 13 Frederick Catherwood, *Castle at Tuloom*, from *Views of Ancient Monuments in Central America, Chiapas, and Yucatan* (London: F. Catherwood, 1844), plate 23. Photo: L. Tom Perry Special Collections, Brigham Young University.

painters and panoramists, such as John Egan, painted grand visions of the once-resourceful and warlike "Mound Builders" who lived in the Ohio and Mississippi Valleys. Speculation regarding these lost civilizations provoked the mythic theories that they were the lost tribes of Israel, that they were Vikings or Phoenician migrants, or that they were from Egypt or Atlantis. The work of Stephens and Catherwood also seemed to support the Latter-day Saint view of a new world colonized by three small groups of people descended from Israelitish tribes.[38]

Although the *Story* illustrations do not approach Friberg's skill for capturing the heroism of Book of Mormon characters or the naturalistic manner in which he visualized them, they convey the "nineteenth-century Mormons' connection between specific archaeological sites and events described in the Book of Mormon."[39] For example, a toppling Mayan monument in *Destruction of Zarahemla* suggests a correlation between Copan or Quiriqua and Zarahemla and might indicate that Ottinger was aware of Church writings to that effect.[40] The scene depicted in Ottinger's illustration *Discovery of the Records of the Jaredites* (fig. 10) also appears to owe much to Catherwood's lithographs of ancient ruins in Central America. The painting shows the discovery of Jaredite records and ruins as described in Mosiah 21:26–27, and is laid out as though it is another act in a stage performance in which figures are placed in front of an elaborate backdrop—a situation with which Ottinger, as a theatrical scene painter, would have been intimately familiar. The principal figures are dressed in Roman frocks and are central to a larger dramatic narrative within the picture plane—yet another indication that Ottinger was following the traditional classicism of the history painters who had preceded him. The minor figures are inspecting the elaborately carved structure and fallen stone carvings. The painted scene shows reliance on Catherwood's sketches of his own team making similar discoveries of overgrown ruins in the Yucatan (fig. 11).[41]

Another Ottinger illustration in the *Story* series, *Moroni Raises the "Title of Liberty"* (fig. 12), shows three principal figures at the top of the steps of a Maya temple. One upright figure, Moroni, raises his hands high as he holds the Title of Liberty as described in Alma 46:12–24. A multitude of onlookers crowds the lower steps, waving pieces of their own garments in token of the covenant they made with God, as further described in the scriptural passage. If we compare this image to Ottinger's *Aztec Maiden*, we will see that Ottinger was well aware of the Temple of Inscriptions at Palenque and similar ruins at Tulum in Mexico (fig. 13). The Roman military garb worn

by the figures in this scene, again, indicates that Ottinger was following the nineteenth-century neoclassical tradition. Indeed, the scene is one of theatrical staging, with centrally placed protagonists in costume that suggests a highly ordered, civilized society—a mythologized pre-Columbian empire.

The principal subjects of John Held's *Vision of Nephi* (fig. 14), depicting 1 Nephi 11:20, are also shown wearing Romanesque robes; the Madonna and child appear in a visionary cloud overhead, reminiscent of the angelic apparitions which are characteristic of religious paintings of the Italian

Fig. 14 John Held Sr., *Vision of Nephi,* from *The Story of the Book of Mormon,* page 39.

Baroque period. Again, as with the other artists enlisted in this project, Held was turning to familiar religious imagery. Envisioning the virgin birth would naturally cause one to borrow what other artists had done during religious periods preoccupied with the immaculate status of the mother of Christ.

Held's illustration *Prophets Preaching to the Jaredites* (fig. 15), as described in Ether 11:1–2, shows what appears to be a prophet dressed in priestly robes, addressing a group of congregants. The architecture in the image is an ambulatory and radiating chapel with an odd combination of unstuccoed

Fig. 15 John Held Sr., *Prophets Preaching to the Jaredites*, from *The Story of the Book of Mormon*, page 463.

Gothic-style vaults and columns with capitals bearing Persian motifs. Curiously, what appears to be a pedestal font can be seen at the front of worshipers, suggesting the ritual element of baptism.

While the handling of figures is quite primitive in Held's paintings, he is not unwilling to render complex, action-filled scenes that are rarely seen even in modern visual depictions of Book of Mormon narratives. In what was perhaps his strongest, most skillful piece in the series, Held conveys high drama in his woodblock print *The Martyrdoms at Ammonihah* (fig. 16). This compelling image shows the believers and their scriptures being consumed by fire as described in Alma 14:8–14. The victims are depicted burning at the stake, while the guards throw their sacred scriptures into the fire with them. Held's catastrophic image *Deliverance of Alma and Amulek* (fig. 17) shows the two missionaries breaking their shackles, while pillars and walls crumble down upon their captors (see Alma 14:26–29). Although inelegantly conveyed, these illustrations are visually progressive and reveal more than meets the eye. The dynamism in these images is another indication that Held and the other artists were drawing inspiration from the interactive movement of figures in other historical paintings of the time.

Held's illustration entitled *Appearance of Christ to the Brother of Jared* (fig. 18) shows the interplay between man and deity, also revealing the LDS belief in an ante-mortal Christ who, although appearing in spirit, had a form and visage. Ironically, the figure of Christ is distinguished with a halo, a mystical Christian symbol which is normally excluded from modern Latter-day Saint religious imagery. Nevertheless, the painting is true to the Book of Mormon incident supporting the passage that "Jesus showed himself unto this man in the spirit, even after the manner and in the likeness of the same body even as he showed himself unto the Nephites" (Ether 3:6–28).

By comparison, Held's illustration *The Three Nephites and Wild Beasts* (fig. 19; see 3 Nephi 28:22) is somewhat static but reminiscent of other known biblical illustrations showing Daniel in the lion's den (Dan. 1:8; 6:7–16) or Shadrach, Meshach, and Abednego in the Assyrian king's fiery furnace (Daniel 1:6–15; 3:16–30). In like manner, the three Nephite characters face ferocious lions without fear, standing in a shaft of light piercing a darkened dungeon. The theme and casting of these characters in a recognizable visual scene supports the notion that the *Story* artists were drawing upon biblical narratives that would render the Book of Mormon event comfortably familiar to the young, impressionable reader.

William Morris (fig. 20), whose strength was in the decorative arts, did not have the artistic background to visualize these narratives in a naturalistic

Fig. 16 John Held Sr., *The Martyrdoms at Ammonihah*, from *The Story of the Book of Mormon*, page 157.

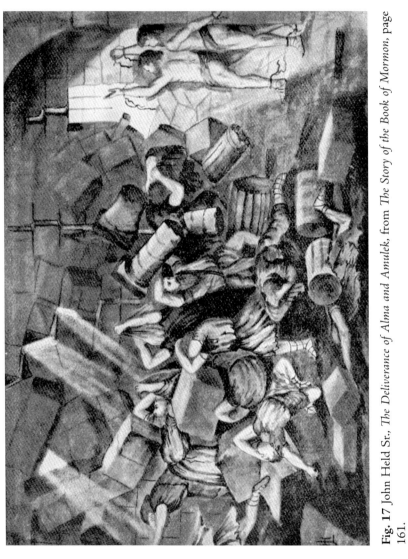

Fig. 17 John Held Sr., *The Deliverance of Alma and Amulek*, from *The Story of the Book of Mormon*, page 161.

Fig. 18 John Held Sr., *Appearance of Christ to the Brother of Jared*, from *The Story of the Book of Mormon*, page 455.

Fig. 19 John Held Sr., *The Three Nephites and Wild Beasts*, from *The Story of the Book of Mormon*, page 293.

way. His dark, nocturnal-like paintings are naive but show his capacity to illustrate a scene with brooding drama. The stark Baroque lighting of his subjects resembles the gaslight illumination of actors on a stage. His contributions to the *Story* project, *Teancum Slays Amalickiah* (fig. 21, see Alma 51:33–34) and *Ether Finishing His Record* (fig. 22, see Ether 15:33), are viscerally painted in darker values, coarsely heightened in areas with contrasting lighter color. Indeed, Morris's characters are like phantoms who participate in the narrative under a moonlit sky, recalling the Neapolitan Baroque qualities of Salvator Rosa and Monsù Desiderio. He may have also been attempting to emulate the biblical visionary paintings of English Romanticist John Martin. Unfortunately, Morris's accidental death of gas

Fig. 21 William Morris, *Teancum Slays Amalickiah*, from *The Story of the Book of Mormon*, page 195.

Fig. 22 William Morris, *Ether Finishing His Record,* from *The Story of the Book of Mormon,* page 467.

asphyxiation in January 1889 halted any further development of his artistic training at the New York Academy.[42] He died not knowing that *Story* would become popular.

As it turned out, *The Story of the Book of Mormon* was a successful seller. Reynolds recorded in his journal that "by the end of the year about 3,000

copies of "The Story of the Book of Mormon ^were^ ~~was~~ sold, and the greater part of the expenses being paid it began to yield a profit."[43] Subsequent editions also proved popular. The Church's General Board of Education recommended the use of *The Story of the Book of Mormon* in Church academies and schools as a text. Despite its impressive sales, Hyrum Parry did not continue publishing the book, relinquishing his undivided one-half interest in the copyright, plates, illustrations and unsold copies of *Story* to George Reynolds for the second 1898 edition and other subsequent editions.[44]

In a memo addressed to Church educators, Reynolds promoted the sale of the book as a text for use in Church schools. Except for a slight change in the weight of the paper, very little changed in the second edition. "Two or three ugly pictures have been left out in the second edition, and a slight condensation made in the letter press," Reynolds conceded.[45] The two illustrations, *Teancum Slays Amalickiah* and *Prophets Preaching to the Jaredites*, were dropped from this edition, presumably because they were considered poorly rendered and did not have the desired level of naturalism. By comparison, the other reproductions in the second edition were clearer and bore a better tonal quality than the first.

Its widespread use in Church lessons indicates that *Story of the Book of Mormon* was a useful tool for teaching in the Church Primary and Sunday School organizations. Reynolds, a member of the General Board of the Deseret Sunday School Union, undoubtedly lobbied for more Book of Mormon visuals to be used in religious teaching. A call for more Book of Mormon art in the *Deseret News* in March 1890 included a list of desired images.[46]

The importance of historical accuracy could not be overestimated. Teaching children with meaningful visual aids would require that participating artists research their subjects and only include elements that conveyed the sense of proper culture and antiquity. The call for artwork stipulated the need for this integrity by stating, "The Union desires that the artists maintain, as far as possible, the unities of time, place, dress, etc., that the pictures may not be misleading to the children, even in their minor details. The characters therein (except the angels) are all Israelites of the sixth century before Christ, and the localities are Palestine, Arabia and Chili [Chile]."[47]

This desire for utility in teaching was no less important for the Union's Book of Mormon Chart series as it was for Reynolds in his *Story* project. For example, Ottinger created for the Book of Mormon Chart series a new version of *First Sacrifice on the Promised Land* (see fig. 5) and named it *Arrival*

in the New World (fig. 23). This vertical version was visually composed in the same manner as the first, but without the bow in the clouds. The removal of the rainbow and the placement of the letters "L" for Lehi and "N" for Nephi

Fig. 23 George Ottinger, *Arrival in the New World*, ca. 1890. © Intellectual Reserve, Inc. Courtesy Museum of Church History and Art, Salt Lake City. It appeared in *Juvenile Instructor* 26 (August 1, 1891).

on the clothing of the two main protagonists shown in the scene helped to distinguish the main characters and avoid potential confusion with the biblical flood story. Such distinguishing marks would make the painting more didactically useful in the classroom.[48] In an apparent de-emphasis of mystical symbolism, Ottinger also painted a version of Nephi's vision of Mary and the Christ child (fig. 24), without the recognizably Baroque Madonna hovering above the Book of Mormon prophet and his angelic guide, as was rendered by Held in his version of the scene (see fig. 14).

By fall 1891, a sufficient number of artists had responded to the call that the list of desired pictures had been filled. "We had our own artists procure premium oil paintings of the important events in the early life of Nephi, etc., which formed the basis of the Book of Mormon charts, which we expect will be ready for sale about February, 1892. We have ordered 5,000 sets of twelve pictures each, and they will be a great aid in teaching the children of Zion the truth and beauty of the Book of Mormon," proclaimed the *Deseret Weekly*.[49] The first of these illustrative teaching aids were then published in the *Juvenile Instructor* during the second half of the 1891 subscription year. Although none of the images bear attribution, it appears that the Union used several of Ottinger's paintings and may well have adopted several more of Armitage's Book of Mormon illustrations which were painted before his untimely death in 1890. Ottinger's *Baptism of Limhi* and his *Arrival in the New World* were both included in this second series of Book of Mormon visuals.[50] Other images in the Book of Mormon Chart series bear the primitive stylistic qualities of Latter-day Saint artist C. C. A. Christiansen.[51]

Of the thirteen paintings published in *The Story of the Book of Mormon*, Ottinger's illustrations appear to be the most well-informed and deftly executed. If we can confirm their attribution, we will undoubtedly find that Ottinger also contributed most of the images in the Deseret Sunday School Union's Book of Mormon Chart series.[52] His images were

Fig. 24 Artist uncertain, probably George Ottinger, *Nephi's Vision*, from *Juvenile Instructor* (1891).

evidently popular enough to be used well into the twentieth century. Several of Ottinger's *Story* paintings were reproduced in a romanticized Book of Mormon novel, *Cities of the Sun*, written by Elizabeth Rachel Cannon some twenty-two years later.[53] Five of Ottinger's illustrations were included in Genet Bingham Dee's *A Voice from the Dust*, which was published as a handsome update to what Reynolds had started with *The Story of the Book of Mormon* more than fifty years earlier.[54]

The illustrations created for *The Story of the Book of Mormon* may not have been sterling specimens of narrative fine art by today's critical standards of excellence. But the visual impact they may have left on young readers of the Book of Mormon is immeasurable. If we dismiss them as simplistic nineteenth-century primitives or naive art, then we fail to recognize their significance as character-building visuals. Artists who illustrated for *The Story of the Book of Mormon* had accomplished something of lasting value. They carried forth in the minds of young people the official visual representation of Book of Mormon characters, places, and narrative events. For at least one generation—perhaps longer—these images were the first to be associated with the Book of Mormon text and the stories contained therein.

NOTES

1. On Friberg's Book of Mormon images, see Vern Swanson, "The Book of Mormon Art of Arnold Friberg, Painter of Scripture," *Journal of Book of Mormon Studies* 10, no. 1 (2001): 26–35. For Teichert's work, see John W. Welch and Doris R. Dant, *The Book of Mormon Paintings of Minerva Teichert* (Salt Lake City: BYU Studies and Bookcraft, 1997).

2. "Notice," *Utah Journal*, January 9, 1886, 3, and "Reuben Kirkham," *Deseret News*, April 28, 1886, 1. A biography of Kirkham is currently in preparation by Donna Poulton and Vern Swanson.

3. For more on George Reynolds (1842–1909), see Andrew Jenson, *Latter-day Saint Biographical Encyclopedia*, 4 vols. (Salt Lake City: Reprint, Western Epics, 1971), 1:206, and Bruce A. Van Orden, *Prisoner for Conscience' Sake: The Life of George Reynolds* (Salt Lake City: Deseret Book, 1992).

4. George Reynolds, *The Story of the Book of Mormon* (Salt Lake City: Joseph Hyrum Parry, 1888), "Preface," iv.

5. "A New Book," *Deseret Evening News*, October 30, 1888, 3; see also Reynolds, *The Story of the Book of Mormon*, "Preface."

6. George Reynolds, Journal, 1888, 78, MS 3347, LDS Church Archives, Historical Department, Salt Lake City, Utah.

7. "The Story of the Book of Mormon," *Latter-day Saints' Millennial Star* 51 (August 5, 1889): 492–493. Rev. Arthur Stanley (1815–1881) was Regius Professor of Ecclesiastical History and Canon of Christ Church, Oxford and later Dean of Westminster

from 1864 to 1881. He is known for his trip to Egypt and Palestine and the best-selling account of his observations, *Sinai and Palestine in Connection with Their History* (1856).

8. "From the Press," *Deseret News*, December 9, 1888, 13, and "New Home Publication," *Parry's Monthly Magazine* 5 (February 1889): 195.

9. That *Story* artists would strive to visually convey a close association with biblical stories, peoples, and cultures may be seen as curious, given that some critics of the Book of Mormon in the 1880s accused Joseph Smith of plagiarizing the Bible. See, for example, M. T. Lamb, *The Golden Bible, or, The Book of Mormon: Is It from God?* (New York: Ward and Drummond, 1886). Perhaps *Story* art plays into that criticism, but the concern for historical and cultural authenticity in visualizing the Book of Mormon reflected the same concerns shown by nineteenth-century Bible illustrators. See Ljubica D. Popovich, "Popular American Biblical Imagery: Sources and Manifestations," in *The Bible and Popular Culture in America*, ed. Allene Stuart Phy (Philadelphia, Penn.: Fortress Press, 1985), 193–233, esp. 208, and Paul Gutjahr, "American Protestant Bible Illustration from Copper Plates to Computers," in *The Visual Culture of American Religions*, ed. David Morgan and Sally M. Promey (Berkeley: University of California Press, 2001), 267–285, esp. 276.

 This same concern for historical authenticity was just as important for youth picture study in Church Sunday Schools, visualizations of the Bible, and the depiction of the Book of Mormon in motion pictures. See J. Leo Fairbanks, "Picture Study in the Sunday Schools," *Juvenile Instructor* 48, no. 1 (January 1913): 3–5; Edwin F. Parry, "Moving Pictures as Helps to Bible Study," *Juvenile Instructor* 48, no. 9 (September 1913): 584–588; and "Book of Mormon in Picture Play," *Deseret News*, December 20, 1913, 122.

10. "Art and Artists in Utah," *Tullidge's Quarterly Magazine* 1 (January 1881): 213–220.

11. "The Fine Arts," *Deseret News*, October 26, 1881, 609.

12. See "Christ and Mary," *Salt Lake Daily Tribune*, December 20, 1881, 4. For biographical information on William Joseph Armitage (1817–1890), see Robert S. Olpin, William C. Seifrit, and Vern G. Swanson, *Artists of Utah* (Salt Lake City: Gibbs Smith, 1999), 8, s.v. "Armitage, William Joseph."

13. For biographical information on John Held Sr. (1862–1936), see Olpin, Seifrit, and Swanson, *Artists of Utah*, 127, s.v. "Held, John, Sr." For examples of Held's illustrative work and woodcuts, see *Parry's Monthly Magazine*, vol. 6 (1890) and *Utah Monthly Magazine*, vols. 7–9 (1891–1892).

14. See Ann Uhry Abrams, *The Valiant Hero: Benjamin West and Grand-Style History Painting* (Washington, D.C.: Smithsonian Institution Press, 1985); and Wayne Craven, "The Grand Manner in Early Nineteenth-Century American Painting: Borrowings from Antiquity, the Renaissance, and the Baroque," *American Art Journal* 11, no. 2 (April 1979): 4–43.

15. Abrams, *The Valiant Hero*, 9, and Craven, "The Grand Manner," 6–9.

16. It is worthy of note that in mid-June of 1874, Ottinger was visiting San Francisco, where he saw Vanderlyn's *Marius amid the Ruins of Carthage* (1807) up close at the de Young Museum while it was being prepared for restoration. See George M. Ottinger, Journal, June 12, 1874, 207, copy of original, MS 123, Special Collections, Marriott Library, University of Utah. On the importance of this painting, see Craven, "The Grand Manner in Early Nineteenth-Century American Painting," 15–19.

17. George M. Ottinger, Journal, 1872, 197–98.

18. George M. Ottinger, Journal, 1872, 200.

19. George M. Ottinger, Journal, 1872, 201.

20. "Territorial State Fair," *Deseret News*, October 9, 1872, 4. See also, Heber G. Richards, "George M. Ottinger, Pioneer Artist of Utah: A Brief of His Personal Journal," *Western Humanities Review* 3, no. 3 (July 1949): 209–218.

21. The orant or *orans* posture, a gesture of prayer with uplifted hands, was used by officiating priests in the early Christian church. A form of this prayer gesture was used in ancient times and later in this dispensation, after the Church was restored. See, for example, Exodus 9:29; 1 Kings 8:22; D&C 88:120, 132, 135; and 109:9, 19. For more on the *orans* posture, see Clark D. Lamberton, "The Development of Christian Symbolism as Illustrated in Roman Catacomb Painting," *American Journal of Archaeology* 15, no. 4 (Oct.–Dec., 1911): 507–522; Walter Lowrie, *Art in the Early Church*, 2d ed. rev. (New York: Harper Torchbook, 1965), 44–49; and Hugh Nibley, "Early Christian Prayer Circles," *BYU Studies* 19 (Fall 1978): 41–78.

22. For a thorough list of works mentioned in his journal, see Richards, "George M. Ottinger, Pioneer Artist of Utah," 216–217.

23. George M. Ottinger, Journal, 1887, 269.

24. George M. Ottinger, "The Maya Sculptor," *Improvement Era* 13 (April 1910): 498–499.

25. "Cultivation of the Fine Arts," *Parry's Monthly Magazine* 5 (November 1888): 76–77; quote from 77. See also "Art Notes," *Deseret News*, November 3, 1886, 1.

26. For more on George M. Ottinger (1833–1917), see Richards, "George M. Ottinger, Pioneer Artist of Utah"; Olpin, Seifrit, and Swanson, *Artists of Utah*, 185–189; Madeline B. Stern, "A Rocky Mountain Bookstore, Savage and Ottinger of Utah," *BYU Studies* 9, no. 2 (1969): 144–154; and Richard G. Oman, "Outward Bound: A Painting of Religious Faith," *BYU Studies* 37, no. 1 (1997–98): 75–81.

27. "Ottinger," *Tullidge's Quarterly Magazine* 1 (January 1881): 219. For more on Ottinger's artistic activities, see sources cited in notes 19 and 24.

28. For more on Stephens and Catherwood, see Victor Wolfgang von Hagen, *Maya Explorer: John Lloyd Stephens and the Lost Cities of Central America and Yucatán* (Norman: University of Oklahoma Press, 1947); von Hagen's *Frederick Catherwood, Archt.* (New York: Oxford University Press, 1950); and C. W. Ceram, *Gods, Graves, and Scholars: The Story of Archaeology* (New York: Alfred A. Knopf, 1962), 337–356. See also Evans R. Tripp, *Romancing the Maya: Mexican Antiquity in the American Imagination, 1820–1915* (Austin: University of Texas, 2004). It should be noted that Joseph Smith and early Church members were well aware of Stephens's *Incidents of Travel in Yucatan*. In fact, it was once owned by Joseph Smith as part of his personal library. See "Zarahemla," *Times and Seasons* 3 (October 1, 1842): 927–928, and Kenneth W. Godfrey, "A Note on the Nauvoo Library and Literary Institute," *BYU Studies* 14, no. 3 (1974): 386–389.

29. See von Hagen, *Frederick Catherwood*, page 73 and figure 11, following page 144.

30. See Lawrence Gustave Desmond and Phyllis Mauch Messenger, *A Dream of Maya: Augustus and Alice Le Plongeon in Nineteenth-Century Yucatan* (Albuquerque: University of New Mexico Press, 1988); Ian Graham, *Alfred Maudslay and the Maya: A Biography*

(University of Oklahoma Press, 2002); the contributions of Lambert and Hunter are discussed on 221–223.

31. See Anthony Blunt, *The Drawings of Poussin* (New Haven and London: Yale University Press, 1979), 68–69.

32. For more on Poussin's method of arranging small wax figures and scenery on a miniature stage, see Anthony Blunt, *Nicolas Poussin*, Bollingen Series 35, no. 7 (Washington, D. C.: Bollingen Foundation; Pantheon Books, 1967), 242–247; and Blunt, *Drawings of Poussin*, 95–99.

33. See Blunt, *Nicolas Poussin*, 40–50.

34. Barbara Carlisle, "Pageants and Painting: The Theatrical Context of High Renaissance Style," *The Centennial Review* 24, no. 4 (Fall 1980): 459–473; quote from 463. For a more thorough study on landscape in nineteenth-century scene painting, see Nancy Hazelton, "'Green to the very door': Painted Landscape on the Nineteenth-Century Stage," *Theatre History Studies* 22 (June 2002): 115–136.

35. Quoted in Abrams, *The Valiant Hero*, 123.

36. See Angela Miller, "'The Soil of an Unknown America': New World Lost Empires and the Debate over Cultural Origins," *American Art* 8, no. 3/4 (Summer–Autumn 1994): 8–27.

37. Miller, "The Soil of an Unknown America," es 11–16 and 21–23.

38. Tripp, *Romancing the Maya*, 88–102, esp. 99–102; Josiah Priest, *American Antiquities, and Discoveries in the West . . .* (Albany: Hoffman and White, 1833); Robert Silverberg, *The Mound Builders of Ancient America* (New York: New York Graphic Society, 1968). See also Curtis Dahl, "Mound-Builders, Mormons, and William Cullen Bryant," *New England Quarterly* 34, no. 2 (June 1961): 178–190.

39. Tripp, *Romancing the Maya*, 94.

40. See "Zarahemla," *Times and Seasons* 3 (October 1, 1842): 927–928. Interestingly, the writer (presumably editor John Taylor) stated: "We are not agoing to declare positively that the ruins of Quiriqua are those of Zarahemla, but when the land and the stones, and the books tell the story so plain, we are of the opinion, that it would require more proof than the Jews could bring to prove the disciples stole the body of Jesus from the tomb, to prove that the ruins of the city in question, are not one of those referred to in the Book of Mormon" (927).

41. Ottinger's reliance on archaeological discoveries, as introduced to the West by Stephens, Catherwood, Prescott, and others, is not unlike that of other artists who relied on the latest archaeological knowledge for historical paintings depicting New World events. See, for example, William H. Truettner, "Storming the Teocalli—Again: Or, Further Thoughts on Reading History Paintings," *American Art* 9, no. 3 (Autumn 1995): 56–95.

42. For more information on William C. Morris (?–1889), see Olpin, Seifrit, and Swanson, *Artists of Utah*, 179, s.v. "Morris, William 'Billy' Charles." See also "To Sue the Deputy Coroner," *New York Times*, January 8, 1889, 5; "A Gentle Spirit Gone," *Deseret Weekly* January 12, 1889, 19, and "W. C. Morris' Funeral," *Deseret Weekly*, January 19, 1889, 28.

43. Reynolds, Journal, 1889, 81.

44. See signed copyright transferral receipts and *Circular of the Story of the Book of Mormon* in Reynolds papers, MS 1342, Box 2, folder 10, Special Collections, Marriott Library, University of Utah.

45. George Reynolds, "Memo. Regarding Books written by Geo. Reynolds," George Reynolds Papers, MSS 1342, Box 2, folder 10, Special Collections. Marriott Library, University of Utah.

46. "To the Artists of Utah," *Deseret Weekly*, March 8, 1890, 23.

47. "To the Artists of Utah," *Deseret Weekly*, March 8, 1890, 23.

48. A close examination of Ottinger's Book of Mormon chart image "The Peacemakers" shows the labeling of Nephi ("N") in the same manner.

49. "Sunday School Union," *Deseret Weekly*, October 17, 1891, 3.

50. Reproductions of these visuals are still preserved in the LDS Museum of Church History and Art. See also "Lehi Preaching to the Jews," *Juvenile Instructor* 26 (April 15, 1891): 234; "Lehi and His Family in the Wilderness," *Juvenile Instructor* 26 (May 1, 1891): 283; "Nephi and Zoram with the Records," *Juvenile Instructor* 26 (May 15, 1891): 298; "The Peacemakers," *Juvenile Instructor* 26 (June 1, 1891): 349; "Nephi's Vision," *Juvenile Instructor* 26 (June 15, 1891): 375; "Lehi Finding the Liahona," *Juvenile Instructor* 26 (July 1, 1891): 408; "The Building of the Ship," *Juvenile Instructor* 26 (July 15, 1891): 438; "Lehi Offering Sacrifice," *Juvenile Instructor* 26 (August 1, 1891): 476; "Lehi Blessing His Posterity," *Juvenile Instructor* 26 (August 15, 1891): 503; "Nephites Seeking a New Home," *Juvenile Instructor* 26 (September 1, 1891): 537; "The Building of the Temple," *Juvenile Instructor* 26 (September 15, 1891): 575; "Nephi Making the Plates," *Juvenile Instructor* 26 (October 1, 1891): cover.

51. A number of Book of Mormon charts have been attributed to C. C. A. Christiansen in the records of the LDS Museum of Church History and Art.

52. An advertisement poster dated October 1, 1897, lists dates, quotes the cost of the "Book of Mormon Picture Charts," and evidences the fact that the picture charts were issued in two parts. See Accession # LDS 93-109-1, LDS Museum of Church History and Art, Salt Lake City, Utah. Thanks to Carrie Snow for alerting me to this source.

53. Elizabeth Rachel Cannon, *The Cities of the Sun: Stories of Ancient America Founded on Historical Incidents in the Book of Mormon* (Salt Lake City: Deseret News, 1910). Several of Ottinger's paintings were retitled but are clearly from *The Story of the Book of Mormon* series. His work in this volume included: "Alma Baptizing in the Waters of Mormon" (22); "Moroni Raises the Standard of Liberty" (60); "Amalickiah Sent the Corpse of Her Husband to the Lamanite Queen" [not from series] (75); "Amickiah Sacked the Coast Cities and Put Hirza to the Sword" [Destruction of Zarahemla] (78); "Alla Deriding the Idols" [not from series] 82; and "The Cliff Dwellers' Daughter" [not from series] (108).

54. See Genet Bingham Dee, *A Voice from the Dust: A Sacred History of Ancient Americans, The Book of Mormon* (Salt Lake City: Deseret News Press for Genet Bingham Dee, 1939). Ottinger's paintings in this volume included: "Nephi's Vision of the Virgin and the Son of God," (88); "Out into the Wilderness," (64); "Making the Plates of Nephi," (129); "Lehi's Parting Blessing," (140); and "Offering Sacrifice as a Token of Gratitude," (271).

Bryant Davis, a student of history and art history at Brigham Young University, has been a part of the Museum of Art since its inception. As a docent, Bryant has given tours to countless patrons. As a curatorial assistant, Bryant worked in the development of the exhibition *Nostalgia and Technology*. Bryant's areas of emphasis are ancient history and twentieth-century American history.

Tracing the Artistic and Literary Transformation of Judas Iscariot

Bryant Davis

THROUGHOUT THE CHRISTIAN ERA, artists have taken upon themselves the responsibility of giving a face to the name associated with ultimate betrayal and deception—Judas Iscariot. The portrayal of Judas, the most controversial apostle, evolved as Christian understanding and scholarship developed. From the medieval period onward, artists and writers transformed Judas from a fallen disciple into a visual symbol of greed, evil, and betrayal. Later artists portrayed Judas in a way that questioned the traditional Christian methodology. This article reflects upon Judas Iscariot in the cycle of Christian art, paying particular attention to symbolism and iconography, the radical myths surrounding Judas, and the Christian fascination with Judas as the villain, as well as the portrayal of Judas in the Bible and in the recently translated Gospel of Judas.

Judas the Fallen Disciple

In the earliest days of Christianity, scholars and artists rarely treated Judas differently than they treated Christ's other apostles. In fact, modern scholars are quick to point out that the story of Judas's treachery and defection was largely ignored in early Christian writings. Even the four Gospels

contain very little information about Judas, focusing not on Judas's motives or intentions, but rather the act of betrayal itself. For instance, the Gospels reveal that after Judas received the sop from Christ at the last supper and "Satan entered into him," Judas then "went his way, and communed with the chief priests and captains, how he might betray [Jesus] unto them" (Luke 22:4–5). "Judas then, having received a band of men and officers from the chief priests and Pharisees, cometh thither with lanterns and torches and weapons" (John 18:3). Judas then "drew near unto Jesus to kiss him" (Luke 22:47), to which Jesus responded, "Judas, betrayest thou the Son of man with a kiss?" The only account that references Judas's reaction to the events surrounding the arrest of Christ is found in Matthew: upon seeing that Jesus was condemned, Judas "repented himself, and brought again the thirty pieces of silver to the chief priests and elders" (Matt. 27:3). Even there, the biblical account says nothing of Judas's motives or purpose. Perhaps this lack of information about Judas's role led scholars and artists to explore possible explanations for Judas's true character and behavior, altering the common perception of Judas from traitorous disciple to vile monster.

Judas the Villain

Literature in the Early Christian period had a significant impact on the representation of Judas. While the early Christian church was developing its system of beliefs and doctrine, apocryphal writings and folklore in particular helped to change Judas from fallen disciple to evil traitor. For example, the Coptic Gospel of Bartholomew, an apocryphal text ascribed to the fifth century, created a narrative around Judas not contained in canonized scripture. The Gospel of Bartholomew excluded Judas from distributing the bread in the miracle of the loaves because he was not worthy to approach Jesus.[1] This treatment created a prominent contrast between Judas and the other disciples, foreshadowing Judas's treachery.

Other writings were much more overt, fueling the powerful conception of Judas as a man born a demonized traitor—a persona Judas would wear for centuries to come. Searching for understanding, medieval scholars and theologians created a character type out of Judas. For example, the apocryphal Arabic Gospel of the Saviour's Infancy, dating to the sixth century, contains an entertaining rendition of Judas's childhood, underscoring his evilness and possession from an early age. The colorful text declares that Judas was often "seized" by Satan and that he "used to bite all who came near him; and if he

found no one near him, he used to bite his own hands and other limbs."[2] When Judas's mother took him to Lady Mary and her son Jesus,

> the demoniac Judas came up, and sat down at Jesus's right hand; then, being attacked by Satan in the same manner as usual, he wished to bite the Lord Jesus, but was not able; nevertheless he struck Jesus on the right side, whereupon He began to weep. And immediately Satan went forth out of that boy, fleeing like a mad dog. And this boy who struck Jesus, and out of whom Satan went forth in the shape of a dog, was Judas Iscariot, who betrayed him to the Jews; and that same side on which Judas struck Him, the Jews transfixed with a lance.[3]

Medieval writers were not constrained in their interpretations of Judas, even attributing his treachery to his wife's persuasion to "betray Jesus and to accept blood-money" for his deed.[4] In the thirteenth-century Ballad of Judas, Judas commits incest with his sister and, through gambling, "he loses thirty pieces of silver belonging to Jesus, with which he was supposed to buy the materials for the Eucharist for the Last Supper. In order to replace the lost money, Judas in desperation agrees to betray Jesus to the Jews for this sum."[5]

Drama also played a part in the development of Judas at this time. The Passion Plays, which emerged in the thirteenth and fourteenth centuries in Europe, helped to perpetuate the negative stereotype of Judas by depicting him as the ultimate antagonist. These plays depicted the Passion of Christ—his trial, suffering, and death—and reduced Judas to a recognizable character type. Through the Passion Plays, Judas left the pages of the Bible to become a three-dimensional character with the ability to teach mass audiences by example. Morality plays, or allegories based on the choice between good and evil, also portrayed Judas as an identifiable type, distinguishing his character by red hair and a red beard, a long nose and chin, and Jewish clothing.[6] Author Hyam Maccoby theorizes that perhaps "redness, as the colour of blood, was reserved for those taking the leading murderous parts—Judas for his acceptance of blood-money and his association with the Field of Blood."[7] Along with Judas, other figures to be identified by red hair in the Passion Plays were Herod and Satan.[8]

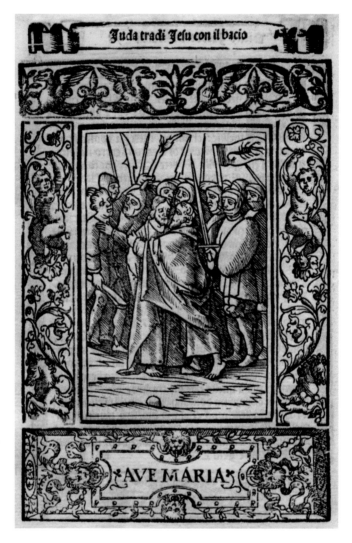

Fig. 1 Woodcut, "Judas betrays Jesus with the evil kiss of the traitor," leaf 99, 4 in. x 6 in., from Father Alberto da Castellano, *Rosario della gloriosa vergine Maria* (Venice, 1521), in possession of Bryant Davis.

The Development of Judas through Symbols

In addition to literature, representations of Judas developed in artwork and other visual imagery. During a time when Christian images and productions were meant to elicit an emotional response from the viewer, the Judas symbol was particularly effective in visually transmitting a strong warning to the Christian layman: do not do as Judas did. Trying to communicate with their illiterate and unlearned flocks, church theologians and artists followed "the adage that devotion could be aroused 'more by what is seen than by what is heard.'"[9] Thus, the representation of Judas began to blend both psychological and visual symbolism, creating propaganda for the church, which seemed to believe that it was better to demonize Judas the betrayer than to correctly portray Judas the disciple.

Artists began to amass a collection of signs and emblems to characterize Judas, to make him instantly recognizable to viewers, and to visually represent his evil characteristics. Three common symbols, the scorpion, the torch, and the rope, became popular because the Gospels mentioned them in association with Judas.

The scorpion, already a symbol of evil, was an ideal symbol for Judas "because of the treachery of its bite."[10] The scorpion often appeared on the flags and shields held by the soldiers who assisted in the Crucifixion of Christ, for example in this 1521 woodcut (fig. 1) printed in a rosary book.[11] This use of the scorpion represented Judas's important role in the crucifixion.

The torch was also used to symbolize the betrayal, particularly because John describes Judas's use of torches just before his betrayal of Christ: "Judas then, having received a band of men and officers from the chief priests and Pharisees, cometh thither with lanterns and torches and weapons" (John 18:3). This symbol is evident in Denis van Alsloot's *The Arrest of Christ*, in which faceless soldiers carry blazing torches against the blackened sky.

The rope symbol referenced the Passion and related to Judas both historically and through traditional belief. According to John 18:12–13, "Then the band and the captain and officers of the Jews took Jesus, and bound him, and led him away." John is the only Evangelist to reveal that "Jesus was bound on this occasion, but Matthew and Mark mention that He was bound when taken to Pilate the next morning. According to tradition, it was with a rope that Judas hanged himself after the betrayal, in desperate repentance for his awful deed."[12] When each of the Apostles is represented with a shield, Judas's shield frequently has a rope and thirty pieces of silver.

In addition to the scorpion, torch, and rope, artists created other symbols to represent Judas in a particular way. Giotto, for instance, depicted

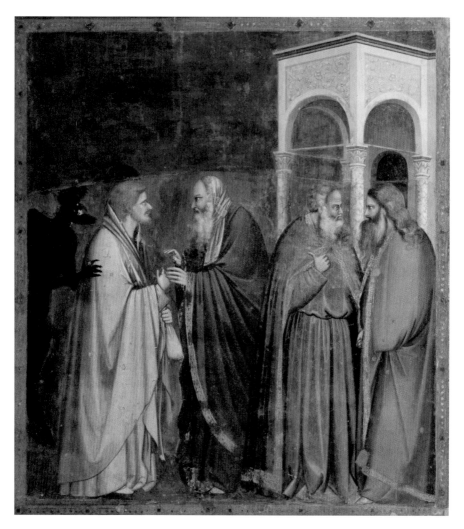

Fig. 2 Giotto di Bondone, *Judas Receiving Payment for His Betrayal*, circa 1305. Scrovegni Chapel (Arena Chapel), Padua, Italy, © Alinari / Art Resource, NY.

Judas clearly in his famed Arena Chapel frescoes (fig. 2). These frescoes, painted in the early fourteenth century, depict Judas similarly in many different scenes by repeating clearly identifiable symbols. One very important scene illustrates the first event in Judas's act of betrayal, that of making the agreement to betray Christ in exchange for thirty pieces of silver. In this painting, Giotto portrays the devil himself influencing Judas, coaxing him towards the chief priests as he accepts the bag of silver. This image incorporates two of the most repeated symbols associated with Judas—the money bag and yellow clothing.

Iconographically, the thirty pieces of silver are normally represented by Judas's bag of money, a symbol that became the antithesis of the Savior's teachings. Judas's association with greed became a strong counterbalance to the Christian teaching of humility, restraint, and meekness. Jesus emphasized building treasures in heaven, not on earth, and used earthly riches as a parable to symbolize that which is subject to corruption and decay. He also taught that it is impossible to serve both God and riches, which placed a heightened responsibility on Judas, who was the treasurer for the disciples. Ironically, by selling Christ for thirty pieces of silver, Judas betrayed his Savior for the material riches of the world, and the mere association with money became a defining symbol for Judas's treachery. As early as the fifth century, Christian theologian Jerome wrote, "No matter how you interpret it, [Iscariot] means money and price."[13] In the thirteenth-century *Lignum vitae*, Bonaventura writes that Judas

> was so filled with the poison of deceit that he would betray his Master and Lord; he burned so intensely with the fire of greed that he would sell for money the All-Good God, and accept for Christ's priceless Blood the price of a cheap reward; he was so ungrateful that he would pursue to death the One who had entrusted the common purse to him, and he elevated him to the dignity of the Apostleship.[14]

The impurity and immorality associated with greed is also reflected in another symbol Giotto prominently attributed to Judas—the color yellow. In traditional Christian painting, Judas is often depicted wearing a yellow cloak. In fact, medieval Passion Plays specified that Judas be clothed in yellow.[15] Interestingly, the color yellow has two symbolic meanings in Christian iconography: golden yellow is used to represent divinity, like the golden rays of the sun, a hue worn by both St. Joseph and St. Peter. In contrast, dingy or contaminated yellow "is sometimes used to suggest infernal light, degradation, jealousy, treason, and deceit."[16] Accordingly, "in the Middle Ages heretics were obliged to wear yellow" and "in periods of plague, yellow crosses were used to identify contagious areas."[17] Yellow was also a color highly associated with Judaism, as Jews were often required to wear at least one specific item of yellow clothing.[18] Not confined to the medieval era nor to Jewish symbolism, the use of yellow continued to be a derogatory symbol in Europe for hundreds of years: "In certain regions of France and Italy it was customary to daub the doors of the homes of felons in yellow."[19] Thus, the yellow robe of Judas identified Judas with the Jews and marked him as a felon.[20] In

the twentieth century, the Nazis revived the yellow badge to distinguish not felons but Jews, reviving the Jewish iconography associated with Judas.

Judas's Artistic Placement: A Contrast to Christ and the Apostles

Although objects were important symbols in the transformation of Judas, no symbol came close to holding the meaning of the figure of Judas himself. The way that artists represented the figure of Judas—his posture, outward appearance, or position in relation to Christ or the other apostles—added significantly to Judas's evil intentions or character. Usually, Judas is depicted on the opposite side of the table from Christ, as in Andrea del Castagno's *Last Supper* of 1447, which visually separates and alienates him from the rest of the apostles; or he is portrayed bounding up from the table, giving visual description to Christ's words in Luke 2:21, "But, behold, the hand of him that betrayeth me is with me on the table."

Judas's presence in Giotto's Passion cycle culminates in perhaps the most famous scene of the Arena Chapel frescos—the *Arrest of Christ*. In this highly charged image, Giotto mirrors the profile of Judas against that of Jesus, in the climatic moment of the kiss, when Jesus responds movingly, "Judas, betrayest thou the Son of man with a kiss?" (Luke 22:47). The kiss scene becomes a defining moment for Judas—the act of ultimate betrayal. Bart Ehrman suggests that the kiss may have been seen as a reference to Proverbs 21:6: "Well meant are the wounds a friend inflicts, but profuse are the kisses of an enemy." Or perhaps, as Ehrman writes, "the betrayal by a kiss was meant to refer to 2 Samuel 20:9–10, where one of the soldiers of King David, Joab, meets another of his own men, Amasa, who had been delinquent in carrying out David's orders. Joab is said to have grabbed Amasa by the beard with his right hand to kiss him, while with the left hand he drove a sword into his belly."[21]

Giovanni Pisano, a contemporary of Giotto, incorporated a similar depiction of Judas in the famed Pulpit in the Pisa Cathedral dating to 1302. In *The Kiss of Judas*, Pisano portrayed Judas reaching up towards Jesus' body as he places his hand on Jesus' chest. Giovanni's "over-the-shoulder" device creates a contrast between Judas's slender, twisting body and the robust figure of Jesus as he reaches out in apparent surprise. Jules Lubbock eloquently describes the visual distinction between the erect figure of Jesus and

Judas's sinuous, snake-like, perhaps even hunchbacked body insinuating itself in a half-stooping bow into his master's presence

and favour, his right hand on Jesus' breast seeming to stroke him, paw him, caress him or even claw him in an embrace so ambiguous, so full of duplicity as to be the very essence of what we mean when we call someone a 'Judas.'[22]

The hunchback device was also used by Pierto Lorenzetti in the *Capture of Christ* of 1320. In this image, Judas swoops over menacingly, his body significantly lower than the noble Jesus. Judas again places his hand on Jesus' chest, who recoils slightly, as if in surprise.

Judas the Monster

As artists contributed to a developing iconography, the snakelike appearance of Judas fueled the creation of the Judas character as the ultimate symbol of treachery. Reflecting this shift, Judas began to take upon an extreme, almost animalistic quality as if to reflect the influence of the devil. For example, Northern Renaissance master Hans Holbein the Younger depicted Judas with exaggerated, disproportionate features. In the *Last Supper* (1524), Judas is seated on the opposite side of the table, turning away from Jesus as he rests his hand on his chin in dark contemplation. In this scene, Judas's features—his red hair, beaklike nose, and gnarled mouth—are so extreme, he appears grotesque and monstrous.

Even more shocking is Flemish painter Joos van Cleve's *Last Supper* (fig. 3). In this image, Judas barely appears human as he clutches his bag of money as if guarding it from the other disciples. Leaving little to the imagination, van Cleve shaped Judas's face into a distorted caricature, with his beaklike nose, rubbery lips, and pointed red beard. Beastlike, Judas cranes his neck to peer at the other disciples, a hint of red gleaming from his fierce eye. Indeed, it appears almost as if Judas is actually decomposing before our eyes—the bones of his face jut through his dark, blotchy flesh; wrinkles slash across his furrowed skull; he hunches toward the table as if struggling to hold his body upright. The artist even used Judas's clothing itself to depict his divided nature—that of being both disciple and traitor. Rather than the typical yellow cloak, Judas wears a dingy, grayish cloak half illuminated, presumably by Christ on his right, and half in deep shadow. It is almost as if the color yellow—with its other connotations of purity and light—is unsuitable to clothe Judas, whose garments are drained of all color.

The exaggerated features of van Cleve's Judas may reflect a more complex level of symbolism—one recorded in Judas's physical features. The study of physiognomy, which emerged as early as the third century BC, resurfaced in

Fig. 3 Joos van Cleve, Last Supper, predella from *Altarpiece of the Lamentation of Christ*, wood, 45 x 206 cm., circa 1530. Musée du Louvre, Paris, France. Photo © Erich Lessing / Art Resource, NY.

medieval art, focusing on the idea that the condition of the soul is reflected in the appearance of the body.[23] Thus, "a person's character may be determined by observing" such physical signs as skin, hair and eye color; facial expressions; gestures; and body proportions.[24] Debra Hassig notes that these ancient concepts were later incorporated into medieval theological art— holy persons, like Christ and Mary, are depicted with "virtuous" attributes, such as "well-proportioned bodies, serene expressions, elegant gestures, fair skin, smooth hair, and smooth complexions," whereas theologically evil figures are depicted with "ill-proportioned bodies, contorted postures, and ugly facial features which might include bulging or crossed eyes; large, pointy, or bulbous noses; mouths with fleshy lips; pointy or missing teeth; grotesque expressions; ruddy or dark skin; and facial blemishes."[25] Clearly, van Cleve's depiction of Judas is a culmination of medieval and even ancient symbolism demarking evil and treachery. With one glance at the image, the viewer is immediately able to identify Judas.

Judas the Strong Man

Yet a paradox exists within the development of the Judas cycle. Although the majority of artists depict Judas as a monster, several images in the medieval era and in baroque Europe create a normal image of the man Judas, adding to the complexity of the Judas image. For example, Ugolino di Nerio's *Arrest and Betrayal* (1325) contains a very youthful, clean-shaven, and handsome depiction of Judas, whose hair and skin is the exact same as that of Jesus himself. Although Judas does wear yellow, it is obscured by a red toga, which fuses with the red drapery worn by Jesus. Similarly, in Durer's *Betrayal of Christ* of 1508, Judas's body does not twist snakelike over to Jesus, but instead, appears strong, robust and powerful. Jesus looks directly at Judas rather than turning away or stepping back in surprise.

A host of Last Supper images dating to the fifteenth and sixteenth centuries depict Judas among the twelve disciples without noticeably setting him apart. For example, in Mannerist painter Jacapo Bassano's *Last Supper*, Judas sits at one end of the table, mirroring the disciple on the opposite end in both dress and gesture. Similarly, French baroque painter Philippe de Champaigne gave Judas a very prominent position in his *Last Supper* (fig. 4). One of the lightest figures in the composition, Judas looks more like a Republican Roman than a betrayer, his right hand placed confidently on his hip as he leans into the table, his features more like those of Jesus himself than a tormented devil.

Fig. 4 Philippe de Champaigne, *Last Supper*, circa 1648. Musée du Louvre, Paris, France. Photo © Erich Lessing / Art Resource, NY.

But few artists dared to explore the rich psychology and turbulent emotion of Judas's betrayal the way Caravaggio did in his *Betrayal of Christ*. Using his classic naturalistic baroque style, Caravaggio was not satisfied with the stock character type of Judas the betrayer; instead, he focused on a moment of great psychological intensity. Caravaggio painted Judas the man, not Judas the beast. It is as if the viewer is being urged to empathize with Judas, who looks directly at Jesus's heartrending expression. Rembrandt took the portrayal of Judas one step further in his *Judas Returning the Thirty Pieces of Silver*, which depicts Judas begging the priests to accept the silver strewn out at their feet as he laments his plight.

These images present a stark contrast to the accepted iconography that had been developing for over a millennia. But why? What were artists like Caravaggio and Rembrandt trying to capture with their works? Did they see something different in the tale of Judas, something obscured by the traditional doctrine? Were artists finally questioning the motives of Judas in an attempt to address the unanswered questions that continue to plague Christians as to why Judas, one of Christ's chosen disciples, would actually betray his Savior and Lord?

Exploring Interpretations of Judas's Motives

There are several possible interpretations of Judas's betrayal: First, that Judas succumbed to temptation, fulfilling King David's prophesy regarding the betrayal in Psalms 41:9, "Yea, mine own familiar friend, in whom I trusted, which did eat of my bread, hath lifted up his heel against me"; second, that Judas acted with the Lord's knowledge, his act of greed and possible possession actually fulfilling the Lord's mission, as the Lord himself told Judas before the betrayal, "That thou doest, do quickly" (John 13:27); or third, that Judas was working under the direction of the Lord himself to fulfill his messianic duty.

The last interpretation is proposed by the Gospel of Judas, an ancient Gnostic text written around AD 150–200, discovered in 1978, and published in 2006 by National Geographic. It proposes an idea so radical that its proponents were branded as heretics, and the idea was hidden and ignored for centuries. In the Gospel of Judas, Jesus confides in Judas, speaking with him privately and apart from the other disciples. When Judas asked Jesus about his own fate, Jesus replies, "You will become the thirteenth, and you will be cursed by the other generations—and you will come to rule over them. In the last days they will curse your ascent to the holy [generation]."[26]

Jesus later tells Judas, "You will exceed all of them. For you will sacrifice the man that clothes me." The authors state that in this passage, "Judas is instructed by Jesus to help him by sacrificing the fleshly body ('the man') that clothes or bears the true spiritual self of Jesus. The death of Jesus, with the assistance of Judas, is taken to be the liberation of the spiritual person within."[27]

The conclusion of the gospel—Judas's betrayal—is contained in only a few lines: The high priests approached Judas "and said to him, 'What are you doing here? You are Jesus' disciple.' Judas answered them as they wished. And he received some money and handed him over to them."[28] The authors of the annotated text point out that the title The Gospel of Judas is not "The Gospel According to Judas," stating, "It is possible that the title means to suggest that this is the gospel, or good news, about Judas and the place of Judas in the tradition. What he accomplished, the text concludes, is not bad news but good news for Judas and for all who would come after Judas—and Jesus."[29] The newly discovered Gospel of Judas adds another layer of possibility and complexity to our understanding of who Judas was.

Conclusion

As a literary and artistic symbol, Judas has functioned as a character in a Christian drama often more concerned with the events surrounding the death of the Savior than with his glorious life and resurrection. Due to the unverifiable nature of Judas's personal life, we may never understand Judas's true character and motives—whether Judas was prompted by greed and the thirst for power, whether he fell under the influence of evil, or whether he acted of his own accord. Even though this review of the visual depictions of Judas has been necessarily brief, we have seen that artists and scholars have presented Judas in such varied roles as the fallen disciple, the twisted villain, the strong and handsome player, and even, in the Gospel of Judas, a misunderstood hero. Examining his portrayal in Christian art and literature gives us a window into both the theology and iconography that has motivated the many faces of Judas.

NOTES

1. Hyam Maccoby, *Judas Iscariot and the Myth of Jewish Evil* (New York: Free Press, 1992), 91.
2. Maccoby, *Judas Iscariot*, 90.

3. Maccoby, *Judas Iscariot*, 90.

4. Maccoby, *Judas Iscariot*, 91.

5. Maccoby, *Judas Iscariot*, 107.

6. Maccoby, *Judas Iscariot*, 109.

7. Maccoby, *Judas Iscariot*, 109.

8. Maccoby, *Judas Iscariot*, 109.

9. Janet Robson, "Judas and the Franciscans: Perfidy Pictured in Lorenzetti's Passion Cycle at Assisi," *Art Bulletin* 86, no. 1 (March 2004): 31.

10. George Wells Ferguson, *Signs and Symbols in Christian Art* (New York: Oxford University Press, 1959), 10.

11. Another example is a fifteenth-century illustrated manuscript showing a scorpion inscribed on a banner held by a horseman present at the Crucifixion. Folio 189v, Manuscript 1089, Hours, Morgan Library, New York. See also Ferguson, *Signs and Symbols*, 10.

12. Ferguson, *Signs and Symbols*, 111.

13. Robson, "Judas and the Franciscans," 40.

14. Robson, "Judas and the Franciscans," 40.

15. On the Lucerne Play of 1588, see Andreas Petzold, "Of the Significance of Color: The Iconography of Color in Romanesque and Early Gothic Book Illustrations," in *Image and Belief: Studies in Celebration of the Eightieth Anniversary of the Index of Christian Art*, ed. Colum Hourihane (Princeton: Princeton University in association with Princeton University Press, 1999), 133.

16. Ferguson, *Signs and Symbols*, 92.

17. Ferguson, *Signs and Symbols*, 92.

18. Petzold, "Of the Significance of Color," 133.

19. Petzold, "Of the Significance of Color," 133.

20. Petzold, "Of the Significance of Color," 133.

21. Bart D. Ehrman, *The Lost Gospel of Judas Iscariot: A New Look at Betrayer and Betrayed* (Oxford: Oxford University Press, 2006), 27.

22. Jules Lubbock, *Storytelling in Christian Art from Giotto to Donatello* (New Haven, Conn.: Yale University Press, 2006), 124.

23. Debra Hassig, "The Iconography of Rejection: Jews and Other Monstrous Races," in Hourihane, *Image and Belief*, 28.

24. Hassig, "Iconography of Rejection," 28.

25. Hassig, "Iconography of Rejection," 32.

26. Rodolphe Kasser, Marvin Meyer, and Gregor Wurst, eds. *The Gospel of Judas* (Washington D.C.: National Geographic, 2006), 32–33.

27. Kasser, Meyer, and Wurst, *Gospel of Judas*, 43 n 137.

28. Kasser, Meyer, and Wurst, *Gospel of Judas*, 45.

29. Kasser, Meyer, and Wurst, *Gospel of Judas*, 45 n. 151.

Joseph Ostenson is a PhD student in the Psychology department at Brigham Young University, specializing in Theory and Philosophy. His present research involves reconceptualizing the field of marital therapy using a postmodern approach to the underlying assumptions of professional and popular views of the marital relationship. His interest in art and art history is not secondary to his work in psychology; in fact, he finds art history more interesting and more wholesome. He is married to Bethany and they have three children.

Caravaggio and Christ
The Humanity of a God

Joseph Ostenson

Images of Christ often dwell on his divinity. While this is perhaps the most important aspect of Christ's being, it is not the only aspect. Christ was also human. In this paper, I will discuss a baroque artist—Michelangelo Merisi da Caravaggio—whose interest in conveying the humanity of Jesus Christ is made particularly clear through his work *The Calling of Saint Matthew*. I begin by introducing the reader to several elements which expressed the divine in medieval and early Renaissance portrayals of Christ. I juxtapose these elements with opposing elements found in Caravaggio's representations of Christ. Throughout the paper, I will cite several biblical passages for the purpose of emphasizing the themes represented by all forms of iconography presented in this paper. In doing so, I hope to give a clear contrast to the humanistic emphasis of Caravaggio's work in comparison to the more divine emphasis of other artists immediately previous to his time.

Divinity of Christ

One of the most familiar medieval symbols of divinities is the halo. The halo represents a number of things associated with righteousness. It represents a glow of sanctity that surrounds the head or personage of a saintly

individual;[1] it represents a crown above the head of a saintly individual, symbolic of kingship and rule; it also represents the grace that emanates from the soul of such an individual. Halos were particularly popular among medieval artists such as Giotto and Cimabue. Christ is therefore almost always portrayed with a halo in medieval paintings. Such is the case in Giotto's *Madonna Enthroned with Child, Angels, and Saints* (fig. 1): in this painting, the Christ child is merely an infant, and yet even in his infancy he exudes grace. The large halo surrounding his head is evidence of the glory with which he came into the world and the righteous life that he will live. In Cimabue's *Crucifix* there is again a large halo that surrounds the head of Christ, this time as he is dying on the cross. The halo in this painting represents Christ's power over death.

Christ's power over life and death has been a focus of Christianity since its inception. This theme was constantly emphasized by the Apostle Paul, as it is in Titus 3:4–7:

> But after that the kindness and love of God our Saviour toward man appeared, Not by works of righteousness which we have done, but according to his mercy he saved us, by the washing of regeneration, and renewing of the Holy Ghost; Which he shed on us abundantly through Jesus Christ our Saviour; That being justified by his grace, we should be made heirs according to the hope of eternal life.

Since the halo represents the grace of goodness and of God, it was often used around saints and Deity as a sign that, through these individuals, grace might be obtained. When it appears around the head of the Son of God, we are reminded of the energy and grace that he successfully achieved through living a life of service and of sacrifice, and we are encouraged to supplicate our Savior for a measure of that grace.

In Rogier van der Weyden's polyptych on the Beaune altarpiece, entitled *The Last Judgment*, the viewer is witness to the great love Paul talks about in his letter to the Ephesians: "But God, who is rich in mercy, for his great love wherewith he loved us, Even when we were dead in sins, hath quickened us together with Christ . . . And hath raised us up together, and made us sit together in heavenly places in Christ Jesus" (Ephesians 2:4–6). His love is symbolized by the lily, which extends from the right ear of the Lord. In this image, Christ comes in glory—again, a halo surrounds his head—and he extends that glory both to the saints immediate to him and to many of those rising from the earth below. Christ is considered the fountain of grace, so his halo is also distinct from the halos of the others in this image.

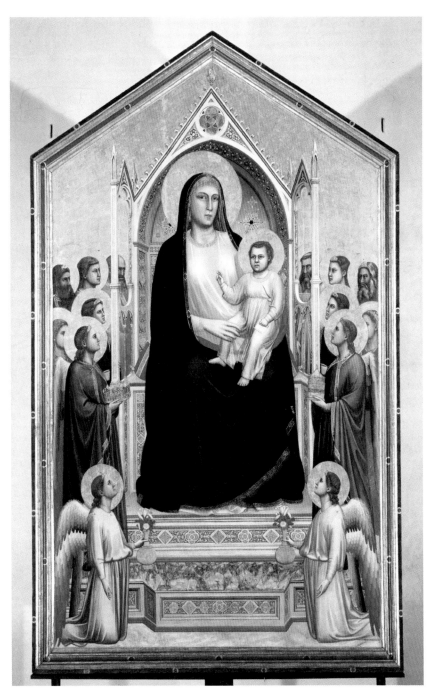

Fig. 1 Giotto di Bondone, *Ognissanti Madonna: Madonna Enthroned with Child, Angels, and Saints*, tempera on wood, 128 x 80 in., 1306–1310. Uffizi, Florence, Italy. © Scala / Art Resource, NY.

In van der Weyden's *Last Judgment*, Christ also is the prominent character. Not only is his figure in the center panel of this polyptych, but he stands above everyone, he is surrounded by fiery clouds and by light, he sits upon a rainbow, and he is clothed in red robes of glory. This prominence is another medieval element that helps to focus our attention on his divinity. For example, in Giotto's *Lamentation*, Christ is no longer in the center of the painting; however, the entire scene seems to lean into the figure of Christ in the lower left-hand corner. Those who mourn his death literally lean their bodies into Christ's striated figure, the angels above do the same, and even nature gives our attention a pull as it literally draws the line of sight toward the deceased Jesus Christ. We cannot help but focus our attention on the Lord.

All medieval Christians had good reason to focus their attention on Christ, for as Jesus said: "I am the way, the truth, and the life: no man cometh unto the Father, but by me" (John 14:16). If we again consider Giotto's *Madonna Enthroned with Child, Angels, and Saints*, we notice another example of this focus. Here the Savior is once again in the center of the painting, but he is also larger than life, disproportionate to the other figures beside him and his holy mother. Notice again the words of John: "Then spake Jesus again unto them, saying, I am the light of the world: he that followeth me shall not walk in darkness, but shall have the light of life" (John 8:12). During the middle ages and the early Renaissance, Christ was almost always the prominent figure in Christian iconography, which helped viewers to focus their attention and their worship on him and on his divinity.

The role of Christ's divinity is a little different in Michelangelo's version of *The Last Judgment*, painted on the altar wall of the Sistine Chapel. In this painting, Christ is the Judge, in all his splendor, glory, and greatness—and in all his anger and jealousy. The divine here is manifest through the terror of the Last Judgment of mankind, after the Second Coming of Christ. The action of Christ's hands is reminiscent of the second epistle of Peter, where he states:

> The Lord knoweth how to . . . reserve the unjust unto the day of judgment to be punished: But chiefly them that walk after the flesh in the lust of uncleanness, and despise government. Presumptuous are they, selfwilled . . . made to be taken and destroyed . . . and shall utterly perish. (2 Peter 2:9–10, 12)

We should fear the judgment of Christ, for he sits on his throne high in the heavens and in the Last Day the unrighteous shall feel the wrath of his heavy hand. The divine Christ was not only full of grace, light and truth; he was

also full of wrath for the wicked, a theme which Michelangelo represents well in his *Last Judgment*.

The above paintings are just a sample of how Christ's divinity was portrayed in Christian iconography leading up to Caravaggio's day: light, grace, truth, a figure worthy of worship, a figure worthy of fear. But Christ was not just divine; he was also born into this world fully human. A passage in 2 Corinthians alludes to the reason why: "For ye know the grace of our Lord Jesus Christ, that, though he was rich, yet for your sakes he became poor, that ye through his poverty might be rich" (2 Corinthians 8:9). It was his humanity that gave us the means whereby we might be exalted.

Humanity of Christ

One way Caravaggio presented the humanity of Christ was through an innovative style that became associated with the word *baroque*. The word *baroque* has origins in two medieval Latin words. The first, *barrocco*, with two 'r's, means "misshapen pearl." Glorifying the ugly and mundane was a very popular theme both in baroque art and baroque literature. The second medieval Latin word is *barocco*, with just one 'r'. This word is roughly defined as "something belonging to the ordinary person."[2] Taken together, these two meanings, "misshapen pearl" and "belonging to the ordinary," apply rather appropriately to Caravaggio's work. He incorporates these two elements in what was called "deliberate realism."

Though Caravaggio still focused on individuals, he went further than the humanists immediately previous to his time by rejecting the idealism wherein individuals were often portrayed. He preferred nature as his best—and only—teacher. For Caravaggio, art imitated life. In fact, it was Caravaggio's habit to employ passers-by in the street as models for his paintings.[3] It should come as no surprise, then, that in his religious works, humanity was often considered more important than divinity.[4] Caravaggio approached the divine through the so-called "physical" senses, much like the newborn empiricists of his day, though not necessarily in the naturalist sense. It was an approach to mysticism grounded in the physical—the real—realm.[5]

Take, for example, Caravaggio's *The Conversion of Saint Paul* (fig. 2). In this painting, Paul lies at the foot of a horse, blinded by the light that has stopped him on the road to Damascus. But the divine, which is represented by the light, is not explicit; instead, it enters as an unseen force—a mysterious light from above—which paints the scene with stark contrasts of light and dark. The light and dark contrast is called tenebrism, one of Caravaggio's

Fig. 2 Caravaggio (Michelangelo Merisi da), *The Conversion of Saint Paul*. Coll. Odescalchi Balbi di Piovera, Rome, Italy. © Scala / Art Resource, NY.

baroque innovations. Tenebrism was meant to emphasize different elements in Caravaggio's paintings and strongly contributes to the meaning of the work.[6] In this particular work, the viewer is not to focus as much on the arm of heaven extended to convert, but rather on the man, Paul, who lies on the ground, struggling with blindness.

Caravaggio extends his deliberate realism to the figure of Christ. In *Ecce Homo*, Caravaggio shows Christ as he is mocked by men. Christ's eyes are downcast, and he does not look out toward the viewer; instead, it is Pilate that stares forth from the frame. Christ stands before the viewer, not as a god, but as a mortal facing his death: "He is despised and rejected of men; a man of sorrows, and acquainted with grief" (Isaiah 53:3).

In *Flagellation of Christ*, Christ is beaten and torn by his accusers. Again, he does not look up toward the viewer; nor can he, it seems. In fact, his position is awkwardly dramatic, an element of baroque associated with the "misshapen pearl." It is painful for the viewer to imagine standing as Christ is standing, let alone to imagine being whipped. "And when they had platted a crown of thorns, they put it upon his head, and a reed in his right hand: and they bowed the knee before him, and mocked him, saying, Hail, King of the Jews! And they spit upon him, and took the reed, and smote him on the head" (Matthew 27:29–30).

Christ's body is limp in death in *The Entombment*. His body is not the body of a God, but the body of a deceased mortal: his mouth hangs open; his arm falls lifeless; his body is heavy in the arms of those who carry him. And it seems there is nothing preventing him from falling out of the painting. *The Entombment* was placed above the altar, where Christ's "body" would be lain each Mass during the Eucharist. Yet even when associated with the symbolism of transubstantiation, it is not a divine being that is laid before us, but a mortal. "And when Jesus had cried with a loud voice, he said, Father, into thy hands I commend my spirit: and having said thus, he gave up the ghost . . . and [Joseph of Arimathea] took [Christ's body] down, and wrapped it in linen, and laid it in a sepulchre that was hewn in stone" (Luke 23:46, 53).

In *The Incredulity of Saint Thomas*, a Christ of flesh stands before the viewer. He is not an exalted being, whose throne is in the ethereal realm, beyond the reach of humanity, but a being of flesh, such that Thomas might "reach hither [his] hand, and thrust it into [Christ's] side" (John 20:27).

But the piece which recalls many of the themes already discussed—as well as a couple of very unique features—is Caravaggio's *The Calling of Saint Matthew*. In this painting, Caravaggio takes the ethereal and mystic and—

true to the baroque style—uses his deliberate realism to bring the scene and, consequently, the Savior, to the simple man.

The Calling of Saint Matthew

In *The Calling of Saint Matthew* (fig. 3), there are certain elements which convey the divinity of Christ. For instance, using tenebrism, Caravaggio enshrouds the actors in a darkness which is pierced by a light emanating from above the head of Jesus Christ. There also exists a halo—something we do not see in the works cited above—directly over his head. But the piercing light and nearly invisible halo are all that point us to Christ's divinity. The rest of the painting seems to be directing attention to the humanity of Christ. This aspect can be seen more especially when it is contrasted with the divine elements of the medieval and Renaissance depictions mentioned previously.

First, the halo above the head of Christ is much thinner than a typical medieval halo. It lies in a position which makes it rather faint; its color and shape are almost imperceptible. Contrast this with the fullness of Giotto's halo over the infant Jesus in Giotto's *Madonna Enthroned with Child, Angels, and Saints*. Christ also loses his prominence in *The Calling of Saint Matthew*. His human successor, Peter, almost blocks our view of Christ entirely. And finally, notice the arm of Christ: it does not retain the same terrifying glory that Michelangelo's Christ does in the *Last Judgment*. In fact, the action displayed by his hand in *The Calling of Saint Matthew* is not terrifying at all. Instead, it seems to recall another of Michelangelo's hands: that of Adam, in *The Creation of Adam*, on the ceiling of the Sistine Chapel. In *The Creation of Adam*, Adam's lifeless hand is receiving life from the hand of God; in *The Calling of Saint Matthew*, Christ is being represented as the second Adam,[7] receiving life from the characters in this scene. We are reminded of the theme from 2 Corinthians quoted earlier: "Yet for your sakes he became poor, that ye through his poverty might be rich." His humanity was for our sakes.

Other baroque elements evident in this piece give the viewer a chance to participate in this scene. For instance, the dress of the actors is contemporaneous with Caravaggio's time. This costuming would have been inviting to the viewer, who would not have felt so detached from the artwork. There is also an empty spot at the table, left empty for the viewer, who is invited to participate in the scene by joining the other players at the table. To stand before *The Calling of Saint Matthew* is not necessarily to think of an exalted

Fig. 3 Caravaggio (Michelangelo Merisi da), *The Calling of Saint Matthew*. Contarini Chapel, San Luigi dei Francesi, Rome, Italy. © Scala / Art Resource, NY.

Christ who sits on his throne in heaven. It is to see him standing just to the right of where we sit, calling all viewers to his ministry, though they be mortal.

Caravaggio's Invitation

And what is Caravaggio inviting us personally to do? Perhaps he is inviting us to consider another side of the divine Savior with whom we are so familiar: One who condescended in birth: "And she brought forth her firstborn son, and wrapped him in swaddling clothes, and laid him in a manger; because there was no room for them in the inn" (Luke 2:7). One who faced some of our same trials: "Then was Jesus led up of the Spirit into the wilderness to be tempted of the devil" (Matthew 4:1). And one who suffered pains at the hands of men: "The men that held Jesus mocked him, and smote him.

And when they had blindfolded him, they struck him on the face" (Luke 22:63–64).

On one hand, there is the divinity of Christ. Attending church during Caravaggio's time, one would often see naves and altars filled with the images which exude the divine distinction so characteristic of Renaissance art. Contemporaries of Caravaggio were all too familiar with this divinity, so when they looked upon Caravaggio's images, it is possible that they found themselves looking upon a God who was more than just divine, a God who was made poor so that he might show us how to be rich.

We, too, are familiar with the divine in Christ. We know of his great sacrifice made to save mankind. We know of his perfect love for all. And yet at times, it seems as if the world rejects the divine love as merely an ideal which no mortal can ever achieve, an ideal beyond our reach in this world, one to be reached only in the next. So to engage with Caravaggio's *Calling of Saint Matthew* is to be introduced to a Christ who is not only a glorious god, but also a contemporary companion. He was a god who condescended to be born as a human, to live as a human, to be reviled and persecuted as a human, to be hated as a human, and to die as a human. If we acknowledge the humanity of Christ, so evident in scripture and made visual in Caravaggio's paintings, we cannot help but feel as though Christ were one of us—as if he were a mortal with whom we can walk. And if a mortal lived the ideal that Christ's life was, subject to the same death as all other mortals, we might be more inclined to take his teachings seriously.

I cannot speak for Caravaggio's contemporaries, but I can speak for myself. When I look upon *The Calling of Saint Matthew*, I see a mortal standing before me, a mortal who lived as I live and died as I, too, will die. And though he is now elevated to a throne in the heavens, his words during his mortality still echo in my ear: "A new commandment I give unto you, That ye love one another; as I have loved you" (John 13:34). "Whosoever shall lose his life for my sake and the gospel's, the same shall save it" (Mark 8:35). "Love your enemies, bless them that curse you, do good to them that hate you, and pray for them which despitefully use you, and persecute you" (Matthew 5:44). As a mortal hearing these words from the mouth of another mortal, I am more fully persuaded that I can follow them.

NOTES

1. James Hall, *Illustrated Dictionary of Symbols in Eastern and Western Art* (London: John Murray, 1994), 102.

2. James Lees-Milne, *Baroque in Italy* (New York: Macmillan, 1960), 56.

3. Lees-Milne, *Baroque in Italy*, 96.

4. Patrick Hunt, *Caravaggio* (London: Haus Publishing, 2004), 15.

5. Lees-Milne, *Baroque in Italy*, 97.

6. Helen Gardner, *Gardner's Art through the Ages* (Fort Worth, Tx.: Harcourt College, 2001), 702.

7. Gardner, *Gardner's Art through the Ages*, 702.

Ashlee Whitaker graduated with honors from Brigham Young University in 2005 and received her MA in art history in 2008. Her graduate research focused on aspects of eighteenth-century English landscape gardens. Ashlee's scholarly interests afforded her the opportunity to conduct on-site research in archives and gardens throughout England in 2006 and 2007. Her current research interest, building on her graduate thesis, examines the English tradition of ornamental dairies in eighteenth-century gardens in relation to contemporary dialogues about femininity. Ashlee completed an internship with the Smithsonian Institute in Washington D.C. and now works for the Springville Museum of Art in Springville, Utah.

Hallowed Garden, Sacred Space

The Garden Park at Hagley

Ashlee Whitaker

In December 1788, poet Anthony Pasquin recorded his impressions of the garden park at Hagley Hall, England, as he likened himself to a Crusader participating in a sacred journey. He wrote:

> Each mount, each dale, each tree,
> Are sacred all, as Israel's ark, to me:
> Impell'd by Love and Hope I rove around,
> Yet dread to violate the classic ground . . .
> To lay their trembling hands on Jesu's tomb.[1]

The reverential tone with which he traversed the garden is clear, comparing it to a spiritual pilgrimage to worship at the tomb of Christ. Pasquin's impassioned response to the garden compels one to inquire what about the garden evoked such feelings of veneration and zeal.

Hagley Park was infused with sacred allusions that reflected the religious interests of its creator, Lord George Lyttelton. Hagley's expression of the sacred was unique among eighteenth-century English gardens. However, the iconographical significance of Hagley Park has been overlooked by contemporary garden scholars because of the dilapidated state of the current garden and the eclectic nature of its garden features, which at first glance

Fig. 1 Hagley Hall, park, and the church. Photo by Ashlee Whitaker.

indicate no single decorative or thematic program. Yet when Hagley Park is viewed in light of the symbolic nature of eighteenth-century gardens, an understanding of George Lyttelton's religious preoccupations, writings, and valued personal relationships as well as the Christian and Classical motifs within the garden, Hagley emerges as an artistic manifestation, a picture of George Lyttelton's unique piety.

The Art of Landscape Gardens

Hagley Park (fig. 1) was a product of England's golden age of gardening, the eighteenth century. The natural terrain of country estates was transformed into an art form laden with symbolism and expression. The fashion for landscape gardening was inspired by classical Roman poetry and Arcadian landscape paintings of the seventeenth century. Gardening was considered a sister art to painting itself. As one published connoisseur wrote, "There is at least as much room for exercising the great arts of design and composition in laying out a garden as in executing a good painting."[2] However, landscape gardens of the mid-eighteenth century transcended the simple mimesis of painting.

These garden parks were conceived as discursive sites of expression. Emblems such as architectural structures, statues, and benches were strategically placed throughout the garden to create sites and views that inspired contemplation on various themes. Each emblem could connote multiple meanings, depending on the viewer's understanding of cultural and biographical factors encoded in the site, making the garden experience unique to each viewer. As nuanced expression was encouraged in emblematic parks, the landed gentlemen who fashioned these gardens often inserted elements of their own tastes and ideologies. Thus, mid-century gardens were intentionally layered with aesthetic, philosophical, and theological motifs that reflected the men who created them.[3]

George Lyttelton, the Creator

Hagley Park reveals the piety and religious enthusiasm of George Lyttelton's life. One contemporary described Lyttelton as "an enthusiast both in religion and politics," a term which connoted an ill-favored, visionary passion for religious pursuits.[4] Typical of his aristocratic station, he supported the Anglican Church (the Church of England), especially in matters of politics, and was a vocal opponent of the Catholic Stuart Royalists, who were attempting to reclaim the monarchy.[5] However, Lyttelton was deeply

opposed to the practices of the Anglican clergy and found deep spiritual kinship among Christian philosophers and prominent Dissident clergymen. Ultimately, Lyttelton practiced a highly personal form of worship, which he called his "primitive Christianity."[6] He strictly adhered to the doctrines taught in Christ's day and celebrated Christian piety wherever it was found. On his deathbed, Lyttelton stated, "I have made [Christianity] the rule of my life, and the ground of my future hopes. I have erred and sinned, but have repented, and never indulged any vicious habit."[7]

Lyttelton's religious zeal was distinctive among his gentlemen peers.[8] His devotion was widely known through his political activities and also through his published writings, most notably his *Observations on the Conversion of the Apostle Paul*, published in 1748. This influential treatise challenged the rational view of religious analysis so prevalent in Enlightenment England and asserted the divine origins of Christianity. In response to the wide acclaim and criticism which his writing sparked, Lyttelton wrote, "My only hope in publishing it was, that it might bring some people to think a little more deeply and candidly . . . upon a matter of so great importance. . . . It is of some consequence . . . to show that one is not afraid of that ridicule which deters many from owning their Faith, though they are fully convinced of the truth of it."[9] This unabashed devotion to Christianity pervaded every aspect of Lyttelton's life and permeated his garden at Hagley, creating a space of reverential spirituality.

The Garden: Structures of Piety

When examined in relation to Lyttelton's biography, religious activities, and poetic writings, the features of his garden become symbols of the sacred. Lyttelton used both overt and nuanced signifiers to create a space saturated with spiritual overtones as he began creating his emblematic garden in the 1740s. His garden was influenced by those of prominent friends and family, such as the garden at Stowe and Alexander Pope's garden at Twickenham, both sites laden with personal expression and biographical import.[10] Hagley Park was praised by eighteenth-century tourists for the refined taste and elegance of the park, its breathtaking views, and its notable garden features.[11]

The church (fig. 2) was located at the beginning of the garden walk, close to the manor house, and affirmed Lyttelton's religious stance. It was often the first feature visited by tourists at Hagley. One visitor wrote of the church, "It was erected in the remote past, long ere the surrounding pleasure-grounds had any existence; but it has now come to be as thoroughly enclosed

Fig. 2 The church at Hagley, located at the start of the garden walk. Photo by Ashlee Whitaker.

in them as the urns and obelisks of the rising ground above, and forms as picturesque an object as any urn or obelisk among them all."[12] The parish church had existed on the site since late Saxon times but was renovated and

expanded in Gothic style by George Lyttelton in 1752. The renovation in Gothic style was practical and significant, as the Gothic mode was considered the classical English style, used in Anglican churches during the eighteenth century to emphasize the Church's indigenous heritage.[13]

Lyttelton's deliberate placement of his manor house, constructed during the 1750s, close to the church can be seen as a very pointed assertion of the ascendancy of the Anglican Church. The manor house was built in a decade of intense religious debate between the political camps of Hanoverian Protestants and Catholic Stuart Royalists. During this time of political uncertainty, the security of English Protestantism was threatened more than once.[14] Lyttelton's alignment of home and church emphasize his vocal support of the Protestant monarchy and the Anglican Church as the state religion. Recent scholarship has identified at least ten other prominent estates that in the same decade constructed their homes adjacent to Anglican churches, as at Hagley, and asserts them as pointed statements of the same pro-Anglican political tastes to which Lyttelton adhered.[15]

The Garden: Monuments of Spirituality

In addition to the structures throughout his garden, Lyttelton erected monuments to represent spiritual motifs. Numerous travel accounts mention a picturesque well, called Jacob's Well. Lyttelton's incorporation of the Jacob's Well within his garden was rare in eighteenth-century England. Such a singular Christian motif is not documented in other garden parks of this status and scale, a unique feature in an era where copying between gardens was rampant.

Lyttelton's well is described as resembling Poussin's painting of Christ and the Samaritan woman, the story found in the Gospel of John where Christ alludes to himself as the Living Water.[16] The metaphor of Christ as water was prevalent in religious discourse of the time. In a hymn written by a clergyman and close friend of Lyttelton in 1732, Christ invites:

> Ho, ev'ry thirsty Soul,
> Approach the sacred Spring;
> Drink, and your fainting Spirits chear;
> Renew the Draught, and sing.
> Let all, that will, approach;
> The Water freely take;
> Free from my op'ning heart it flows
> Your raging thirst to slake.[17]

This feature was intended to evoke similar associations in the mind of the visitor and was particularly telling as the well was located near a stream that flowed throughout the garden. The present well (fig. 3) was rebuilt during the nineteenth century but still bears the inscription "O Ye Wells, Bless Ye the Lord," a line from a Sanctus Dei, confirming the religious import of the well even into the Victorian era.[18]

A wooded area further along the garden walk, called the Hermitage, was also replete with religious symbolism. Eighteenth-century accounts of this hallowed haunt mention one particular bench decorated with inlaid crosses of beads and shells, as well as a small fountain called the Hermit's Fountain.[19] These obvious Christian symbols augmented the transcendent implications of the Hermitage itself as a place of seclusion, away from the world and closer to God. Thomas Parnell's widely acclaimed poem "The Hermit," published in 1722, describes the pious devotion of the hermit: "Remote from Man, with God he pass'd the Day, Pray'r all his Bus'ness, all his Pleasure Praise."[20] By the 1740s, the theme of the hermit was popular in literature, and hermitages became popular garden conceits. They were considered sites of sacred meditation and communion. Lyttelton included lines from John Milton's poem "Il Penseroso" in the Hermitage. In the poem,

Fig. 3 The well in Hagley Park. Photo by Ashlee Whitaker.

the hermit rejoices that "at last" he has reached the weary age that allows him to leave this impious world and enter into a more "peaceful Hermitage," an abiding rest from the trivialities and pains of the world.[21]

The Garden: Memorials of Immortality

The sense of the spiritual in the garden was furthered by several memorials which Lyttelton placed within his park, commemorating the loss of beloved family members and friends, most notably his young wife Lucy, who died in 1747.[22] Their memories were incorporated into the garden as he erected memorials to celebrate and immortalize their lives. The memorial to Lucy, located inside the church in

Fig. 4 Memorial to Lucy Lyttelton, inside the church at Hagley. Photo by Ashlee Whitaker.

the garden, is a statue of the Roman god of marriage, Hymen, weeping next to an urn that bears a portrait of Lucy (fig. 4). The severe impact of Lucy's death is evident in Lyttelton's personal and published writings and affected the conception and reception of his garden as a consecrated commemorative space.

Following Lucy's death, Lyttelton composed a monody, a Grecian form of elegy, to her memory. His elegy was published and received with approval and sympathy from many, including the critic Thomas Gray.[23] Throughout the poem, Lyttelton laments the loss of his wife by associating her with aspects of the garden park, as in the following lines:

> To your sequester'd dales . . .
> From an admiring world she chose to fly;
> With nature there retir'd and nature's God
> The silent paths of wisdom trod,
> And banish'd every passion from her breast
> But those, the gentlest and best.[24]

Not only do these lines imply Lucy's fondness for the garden park, they praise her virtue and further imply her deep spiritual connection with the

garden as a realm separate from the world, a haven for spiritual renewal and sanctification.

The publication of *Monody* heightened popular awareness of Lyttelton's grief as well as the association of Lucy Lyttelton with the park at Hagley. This is evident in a verse penned on a bench by a visitor in 1748, which reads:

> Ye pendant groves, that seem to hang the head,
> As if to mourn, with him, your mistress dead,
> Exalt your heads and smile, for henceforth ye
> Shall grow immortal in her monody.[25]

For those familiar with the poem, Hagley Park evoked memories of Lyttelton's poetic tribute and immortalized Lucy's presence within her sanctified garden space, imbuing the park with a hallowed sense of memorial. This elegiac reverence was heightened by other memorials within the garden.

As visitors embarked upon the garden path, they encountered other structures that held very personal meaning for Lord Lyttelton and had strong religious implications. Lyttelton commemorated his close friendship with James Thomson (one of the most celebrated pastoral poets of the age) by erecting a semi-octagonal temple. The temple was built within a grove of trees that the poet particularly admired and had praised in his popular poetry book *The Seasons*.[26] Lyttelton's inscription in Latin consecrated the site to the "immortal genius" of the great poet.[27]

Lyttelton also raised a Doric portico, of which only a sketch remains, and a memorial urn in honor of Alexander Pope, a close friend and "a frequent visitor at Hagley."[28] Like Thomson's monument, the memorials to Pope were also placed in a locale known to be Pope's favorite in the garden park. Thus, both memorial sites evoked the personalities and moods of the two great poets.

These memorials held very personal religious signification for Lyttelton that furthered their sense of immortality. Following the deaths of his wife, his father, and James Thomson, Lyttelton expressed:

> It often occurs to my mind that the death of our friends is one of the most powerful . . . means made use of by Providence to detach our affections and hopes from this world, and convince us that we have here *no enduring city, but are to look for a better.* . . . If we were never to meet again, to what purpose has nature implanted in us such strong, such bitter, such lasting regrets at this separation; these

affections are not in vain, they are not fixed upon what is no more; they are intimations and notices of a life to come, and are designed to carry our views, our wishes, I could almost say our passions, on to that life.[29]

George Lyttelton saw death as a force that focused mankind's sights on eternity. He associated his profound sense of loss with the assurance of future reunion. For him, the memorials were reminders of the promised immortality of the soul and his firm conviction in an anticipated reunion.

Classical Motifs of the Sacred

Throughout Hagley Park, Lyttelton incorporated numerous garden features which referenced Christian themes to invoke a sense of the sacred. Yet Lord Lyttelton also drew upon classical and pagan themes to create a hallowed space of reverence. Classical architecture often implied a sense of honor or import at a certain site, and connoted a sense of immortality tied to the immortal legacy of antiquity. These classical temples (fig. 5), though connected with pagan tradition, were then capable of invoking a sacred presence within the garden. In 1712, Joseph Addison explained the connection

Fig. 5 Classical temple at Hagley Park. Photo by Ashlee Whitaker.

between classical temples and the sacred when he wrote: "Not only that they might, by the Magnificence of the Building, invite the Deity to reside within it, but that such stupendous Works might, at the same time, open the Mind to vast Conceptions, and fit it to converse with the Divinity of the Place."[30]

Thus, the commemorative tone invoked by the memorials to Pope and Thomson acquired more sacred implications because of their style. These structures invoked a holy presence, whether the spirit of the immortal bards themselves or a superior divinity who governed the unknown realm of the immortals. One garden visitor described his fear of treading amiss within the area that was "hallowed" by the memory of the great bards.[31] Another visitor, upon viewing the memorials, wrote: "Here live the reverend sages of mankind. . . . The laurel'd offspring of immortal Rome Live here, and with their presence guard the dome!"[32] The memorials to the immortal geniuses of Pope and Thomson became sites of the sacred within the garden.

The reverential overtones of the park also influenced the reception of many of the Classical statues and structures within the garden. Like many English landscape parks of the era, Hagley Park contained overt symbols of pagan belief and tradition. While such inclusions seem incongruous with the Christian elements of the garden and Lyttelton's own faith, Lyttelton felt no incongruity in placing statues of Venus and Apollo, classical urns, and Roman texts in his garden. Eighteenth-century England was captivated by classical Rome and considered themselves the inheritors of the immortal classical tradition, the offspring of the ancients. The language of antiquity, with its motifs and symbols, became the language of the eighteenth century.[33] The appropriation of pagan themes and imagery was more a reflection of Lyttelton's erudition, social status, and familiarity with and love of classical literature and themes than a rejection of Christianity or orthodox religion.[34]

An example of this classical influence is found in the Cascade Vale. The cascades were a series of natural waterworks and pools, enclosed in a thick canopy of trees, described by one visitor as forming "a Gothick arch."[35] Lyttelton crowned the top of the vista with a classical-style Roman rotunda with a Palladian bridge at the bottom, marked by a Doric portico. Tourist descriptions almost universally describe this spot as an Elysium, a hallowed spot, enchanted and graced by the Muses or some other divine presence, usually of classical derivation. Among the streams and cascades, Lyttelton placed a statue of Venus, the goddess associated with abundance and nature. The statue was placed amid the water such that it appeared to one visitor "as coming up out of a fountain" and to another "as if newly risen from the

foam."[36] Lyttelton's Venus implied the classical trope of the birth of the goddess Venus, which signified ideas of birth, regeneration and resurrection, placing within the idyllic woods a Christian theme as well as a classic one.

Hallowed Space of Reverence

Lyttelton's distinctive fusion of Christian and classical motifs within the landscape park created an idyllic haven removed from the world, a paradise where it was possible to experience the sacred, even the divine. Upon a bench called "Milton's Seat," Lyttelton inscribed the following lines from Milton's epic "Paradise Lost":

> These are thy glorious works, Parent of good,
> Almighty! thine, this universal frame,
> Thus wond'rous fair; thyself how wond'rous then!
> Unspeakable, who sit'st above these heavens,
> To us invisible, or dimly seen
> In these thy lowest works; yet these declare
> Thy goodness beyond thought, and power divine.[37]

Lyttelton's use of this renowned verse praising nature and its benevolent Creator conveyed his belief that nature itself was testament of the divine and connected Hagley's natural beauty to the primordial Garden of Eden, a sanctified site infused with the presence of God. Other seats, secluded within the dense foliage of the park, cite poetry by the Roman poet Horace that speaks of obtaining idyllic rest and repose within the shade of trees near cascading streams that invited a "balmy sleep."[38] In this environment of memorial and the sacred, such lines connoted a transcendent rest, an eternal and lasting peace.

Whether compared with the Elysium of the ancient gods or the paradise of God, Hagley Park was Lyttelton's own Eden. His fashionable landscape became a site in which he could express his spirituality and beliefs, his hopes and losses, all of which were tied to his Christian faith and concept of the divine. To those who understood, the journey through his garden was a spiritually edifying and instructive pilgrimage. As James Thomson confirmed in the following verse written at Hagley:

> The love of Nature works
> And warms the bosom; till at last . . .
> We feel the present Deity, and taste the Joy of God.

Thomson then acknowledges this shared vision of the garden's creator himself, so evident at Hagley, when he adds:

These are the sacred feelings of thy heart,
O Lyttelton, the friend![39]

The memorial inclusions in the garden, the Christian signs and even the connotations of the antique sacred, combined with the distinctive religiosity of its creator, Lord Lyttelton, transformed Hagley into a hallowed space where nature and emblem fused to create a personal portrait of one man's faith.

Notes

1. Anthony Pasquin, *Poems, by Anthony Pasquin*, 2 vols. (London, 1789), 1:144.

2. Thomas Martyn, *The English Connoisseur: Containing an Account of Whatever Is Curious in Painting, Sculpture, &c. in the Palaces and Seats of the Nobility and Principal Gentry of England, Both in Town and Country*, 2 vols. (London, 1766), v.

3. John Dixon Hunt, "Gardening, Poetry and Pope," *Art Quarterly* 37 (1974): 2.

4. Rose Mary Davis, *The Good Lord Lyttelton: A Study in Eighteenth Century Politics and Culture* (Bethlehem, Pa.: Times Publishing, 1939), 164.

5. Many of Lyttelton's parliamentary speeches reflect his firm opposition of the Tory cause. One notable document is Lyttelton's *Letter to the Tories*, published in London in 1747.

6. Davis, *Good Lord Lyttelton*, 157.

7. Rebecca Warner, ed., *Original Letters, from R. Baxter, M. Prior, Lord Bolingbroke, A. Pope, Dr. Cheyne, Dr. Hartley, Dr. S. Johnson, Mrs. Montague, W. Gilpin, J. Newton, George Lord Lyttleton, C. Buchanan, etc., etc.* (Bath, UK: Richard Cruttwell, 1817), 278.

8. Davis, *Good Lord Lyttelton*, 153, 164.

9. Davis, *Good Lord Lyttelton*, 152.

10. Davis, *Good Lord Lyttelton*, 165, 179. Lyttelton was a frequent visitor at Stowe, the seat of his uncle, Lord Cobham, as well as Twickenham. Alexander Pope also visited Hagley Park several times prior to his death in 1744.

11. Eighteenth-century accounts of Hagley Park that extol the various garden scenes can be found by the following garden visitors: James Thomson, Horace Walpole, Dr. Richard Pococke, Arthur Young, William Mason, John Parnell, Joseph Heely, Thomas Whatley, Anthony Pasquin, and Thomas Martyn. John Adams also visited Hagley Park during his tour as ambassador to England in 1786. There is also a nineteenth-century account written by Hugh Miller that has an extensive inventory of the park.

12. Hugh Miller, *First Impressions of England and Its People* (Boston: Gould and Lincoln, 1851), 138.

13. Michael McCarthy, *The Origins of the Gothic Revival* (New Haven, Conn.: Yale University Press, 1987), 16.

14. Michael Charlesworth, "Sacred Landscapes: Signs of Religion in Eighteenth-Century Gardens," *Journal of Garden History* 13, no. 2 (1993): 62.

15. Charlesworth, "Sacred Landscapes," 65.

16. Davis, *Good Lord Lyttelton*, 176.

17. Philip Doddridge, *Hymns Founded on Various Texts in the Holy Scriptures. By the Late Reverend P. Doddridge* (London: Job Orton, 1766), 312.

18. Michael Cousins, interviewed by Ashlee Whitaker, Hagley Park, July 20, 2006.

19. Richard Pococke, *Dr. Pococke's Journey into England from Dublin*, The Royal Historical Society Publications, ed. James Joel Cartwright, vol. 44 (New York: Johnson Reprint Corporation, 1965), 224.

20. David R. Coffin, *The English Garden: Meditation and Memorial* (Princeton: Princeton University Press, 1994), 91.

21. Thomas Maurice, *Hagley. A Descriptive Poem* (Oxford, 1776), 10. This passage is referenced in most travel accounts of Hagley.

22. Martyn, *English Connoisseur*, 63.

23. Davis, *Good Lord Lyttelton*, 135.

24. George Lyttelton, *Poems by George Lyttelton* (London, 1800), 22.

25. Davis, *Good Lord Lyttelton*, 138. The lines are now assumed to be written by Joseph Wharton.

26. Davis, *Good Lord Lyttelton*, 173.

27. Joseph Heely, *A Description of Hagley, Envil and the Leasowes, Wherein All the Latin Inscriptions Are Translated, and Every Particular Beauty Described* (Birmingham, 1775), 111.

28. Miller, *First Impressions of England*, 131.

29. Davis, *Good Lord Lyttelton*, 140.

30. Joseph Addison, *The Spectator*, no. 415 (June 16, 1712), 555.

31. Pasquin, *Poems*, 1:144.

32. Maurice, *Hagley*, 17.

33. Peter Gay, *The Enlightenment: An Interpretation: The Rise of Modern Paganism* (New York: Alfred A. Knopf, 1966), 41–42.

34. Gay, *Enlightenment*, 39.

35. Pococke, *Dr. Pococke's Journey*, 226.

36. Pococke, *Dr. Pococke's Journey*, 227; Heely, *Description of Hagley*, 69.

37. Maurice, *Hagley*, 10–11.

38. Heely, *Description of Hagley*, 55.

39. Lines from James Thomson's *The Seasons* (1744), quoted in Miller, *First Impressions of England*, 120.

Rita R. Wright is Museum Educator over Academic Programs at the Brigham Young University Museum of Art. She has an undergraduate degree in theatre and film and a masters degree in humanities from BYU, where she taught history of civilization courses for seven years. She is a doctoral candidate at the University of Utah in European history with ancient and art history minors. She was named Museum Educator of the Year in Utah for 2003–2004 and continues to serve on the Statewide Arts Partnership (SWAP) and other professional committees. In her previous position as K–12 Educator she was responsible for education packets and public school tours and activities at the museum. She is currently working with students and faculty to promote campus collaboration and student involvement at the Museum of Art. Her research interests emphasize learning models and the visitor experience in museum galleries.

Pious Pagans

Redressing the Religious Image
through Victorian Ritualism

Rita R. Wright

> At the mere sound of the magical words "Golden Bough" the scales fell—
> we heard and understood.
>
> Jane Ellen Harrison, *Reminiscences of a Student's Life*, 1925[1]

Prolegomenon,[2] or Preface

Like Jane Ellen Harrison, a late-nineteenth-century classical scholar, I remember the first time I heard the magical words *The Golden Bough*. It was here at Brigham Young University campus, over thirty years ago, in an upper division theatre history course taught by Dr. Harold I. Hansen, one of the original founders and directors of the Hill Cumorah Pageant. He told us students that Sir James Frazer's monumental tome, *The Golden Bough* (1890), which associated religious myths, primarily classical, with more primitive and savage forms of ritual reenactment, held much of importance for any understanding of the history of the arts. I believe Professor Hansen's claims caught us by surprise. Ours is a highly conservative and religious campus,[3] and I'm sure we questioned the propriety of this study of pagan

rites within that context. But like the Victorians Frazer addressed with his book, we were soon fascinated by ancient ritual. Something about the sublime paradox of revulsion and attraction embedded in the topic engaged our youthful curiosities. When I learned that another faculty member on campus, Dr. Hugh Nibley, was connecting ritual dances and theatre to ancient temples, articulating their significance for our LDS religious culture, the scales began to fall just as they had for Jane Harrison. Still, I wondered at the notion that these pagan rituals held such relevance for the study and production of Christian art.

Since that time I have learned that Frazer was not always correct nor was he the only one studying ancient religious practices. But I have also learned that his elite and well-educated Victorian audience was indeed familiar with ritual in its varied forms. It seems Victorians were as fascinated by ancient ritual as I was. They studied it, depicted it, and frequently reenacted it. Artists painted enormous works celebrating both Christian and pagan rites. Musicians and dancers revived the antique Morris dances. Theosophical practitioners engaged in discourse and reenactment of Egyptian and other Near Eastern initiation ceremonies. Like so many other curiosities gathered from a vastly expanding empire, the rituals of ancient peoples, oddly enough, intrigued some of the most sophisticated members of an increasingly secularized society.[4] Sometimes in bursts of piety in redressing Protestant iconoclasm and sometimes in an effort to discredit the originality of Christianity, scholars and artists were using religious images to inform, influence, and even occasionally displace other ideologies, as David Morgan suggests, "[by putting] images to use in constructing the social realities that shape the lives of human beings."[5] This emphasis on ancient ritual practice in the nineteenth century was frequently, and sometimes pejoratively, referred to as "ritualism."

Ritualism

"Ritualism: [f. RITUAL a. and n. + -ISM. Cf. F. ritualisme.] 1. The study, practice, or system of ritual observances; esp. excessive observance or practice of ritual."[6]

Two waves of ritualism surged through Victorian culture—one at the beginning of the period in the late 1830s developing as part of an Anglo-Catholic revival, the other resulting from the study of ancient pagan culture by classicists, archaeologists, and anthropologists in the latter half of the nineteenth century. The rise of ritualist movements with their focus

on religious practice, rather than the predominant Protestant emphasis on creed or belief as in Luther's *fides sola* (faith alone), indicates an intricate confluence of social, intellectual, and religious ideologies of the period that are reflected in the production of religious images and in theories about reception of images, including other sacred phenomena, that continue to impact our arts, beliefs, and meanings in the twenty-first century. My purpose in this presentation is to suggest that careful consideration of Victorian sacred images reveals

1) shifting perceptions about and tolerance for alternative religious practices during the period,

2) some continuity in what can be termed a "ritual aesthetic,"

3) how the use of ritual images from antiquity functioned at that time to advance understanding of the relationship between religion and art, and

4) how late-nineteenth-century ritualism changed our theoretical perspective on the sacred viewing experience.

The Catholic "Other"

The first wave of ritualism emerged as the topic of Catholic emancipation and toleration surfaced in political and social arenas during debates on British legislative reforms. A group of academic fellows at Oxford headed by the young John Henry Newman (best known to most of us for his hymn text "Lead Kindly Light") mounted a defense *against* Catholic toleration for fear of the impact the Catholic vote would have on university appointments, which required confession of allegiance to the Church of England.[7] As Newman and his colleagues studied ancient precedents in a search for anti-Catholic evidence in support of maintaining strict Anglican control of university academic and legal programs, they began to admire much about pre-Reformation Catholicism. Eventually some members of the group began promoting restoration of liturgical practices as contained in the rituals or liturgical manuals of former days and advocated the visual and performative characteristics of those practices.[8]

The first images we will consider are works of the Pre-Raphaelite Brotherhood, which had been strongly influenced by the Catholic revival and John Henry Newman's Oxford Movement. The poet Christina Rossetti, sister of artist Dante Gabriel Rossetti and his occasional model, was one of the movement's strongest female proponents,[9] and many of the other artists of the circle had been touched by the movement's effects as well. It will be noted that many of the early Pre-Raphaelite works depict Catholic subject

matter or traditional Catholic symbolism and iconology, much of which had been discouraged due to Protestant doctrinal belief and academic strictures. Dante Gabriel referred to himself as an "art Catholic," and his first two major oil paintings *The Girlhood of Mary Virgin* (1848–1849) and *"Ecce Ancilla Domini!" (The Annunciation)* (1850) underscore that declaration.[10] Both take for their subject matter the life of the Virgin Mary and employ a host of iconographic staples from medieval and early Renaissance art.

The Girlhood of Mary Virgin (fig. 1) depicts a scene from the daily life of the Virgin's family—a simple scene, yet replete with numerous biblical typological symbols. The Virgin and her mother, Saint Anne, sit embroidering Mary's lineage on a red cloth while her father, Joachim, tends a grapevine in the background, symbolic of the wine of the Eucharist. The Holy Spirit, in the form of a dove, rests on one of the arbor supports, watching. A red-winged angel supports a pitcher of lilies, symbolizing the Virgin's purity, on a stack of books which reference the law of Moses, which would soon be overthrown and which is depicted in colors representing a host of medieval virtues: temperance, fortitude, faith, hope, and charity. In a nod to the Oxford influence, these colors also refer to those of High Church ecclesiastical vestments and altar decorations promoted by Ecclesiologists and Tractarians.[11] Pre-Raphaelites William Holman Hunt and John Everett Millais also depicted similar Catholic-inspired scenes in works such as Hunt's *The Shadow of Death* (1869–1873), anticipating Jesus' crucifixion as a young carpenter stretches in his shop, his shadow cast against the walls where nails and other implements of the Passion seem to pierce the shadow. Millais's *Christ in the House of His Parents* (1849–1850) depicts the Child Jesus, Mary, John the Baptist, and other members of the household engaged in everyday activities in a carpenter shop—a seemingly ordinary domestic scene filled with traditional Christian iconography representing the Holy Spirit, crucifixion, and baptismal cup.

Evangelical reactions to the Catholic revival, however, created tensions within the Christian community and eventually opened the floodgates to alternative interpretations and practices of religion. Owen Chadwick assessed the expanding options:

> Political and economic reform went hand in hand with religious reform and from the moment that European opinion decided for toleration, it decided for an eventual free market in opinion. . . . Once concede equality to a distinctive group, you could not confine it to that group. You could not confine it to Protestants; nor, later,

Fig. 1 Dante Gabriel Rossetti, *The Girlhood of Mary Virgin*, oil on canvas, 83.2 x 65.4 cm, 1848–1849. Tate Gallery, London, © Tate, London / Art Resource, NY.

to Christians nor, at last, to believers in God. A free market in some opinions became a free market in all opinions.[12]

What began early in the century as toleration of Catholics and their liturgical practices evolved by the end of the century into a much broader acceptance of other religious practices and values.

The Pagan "Other"

With the influx of ethnographic data from throughout the British empire and the application of scientific methodologies to the study of religion following the mid-century embrace of archaeology and anthropology, scholars and artists challenged previous paradigms of religion and sacred art. This toleration and pluralism of religious belief and behavior marked the Victorian era as a major proponent of diverse and expansive attitudes about spirituality and religious experience—Christian, pagan, Eastern, and aboriginal, each constituent being promoted for its unique contribution to the more basic human spiritual experience. Classicist Jane Harrison's full quote, mentioned at the beginning of this essay, conveys the mood of the period:

> We Hellenists were, in truth, at that time a "people who sat in darkness," but we were soon to see a great light, two great lights—archaeology, anthropology. Classics were turning in their long sleep. Old men began to see visions, young men to dream dreams. I had just left Cambridge when Schliemann began to dig at Troy. Among my own contemporaries was J. G. Frazer, who was soon to light the dark wood of savage superstition with a gleam from *The Golden Bough*. The happy title of that book . . . made it arrest the attention of scholars. They saw in comparative anthropology a serious subject actually capable of elucidating a Greek or Latin text. Tylor had written and spoken; Robertson Smith, exiled for heresy, had seen the Star in the East; in vain; classical deaf-adders stopped our ears and closed our eyes; but at the mere sound of the magical words "Golden Bough" the scales fell—we heard and understood. Then Arthur Evans set sail for his new Atlantis and telegraphed news of the Minotaur from his own labyrinth; perforce we saw this was a serious matter, it affected the "Homeric Question."[13]

Academic paintings reflecting these shifts of toleration for other religious traditions increased in the latter half of the century. The shift from depictions of the Catholic "other" of the Oxford Movement and the Pre-Raphaelite Brotherhood to depictions of the pagan "other" can be observed in a series of images, over several decades, created by Frederic Leighton, the late-Victorian president of the Royal Academy of Art in London, whom one newspaper journalist referred to as the "High Priest of the Cult of Beauty." It is interesting to note the term "Brotherhood" was chosen for the Catholic revivalists (including the German religious painters, the Nazarenes) while

the terms "high priest" and "cult" were used for the classical Olympian painters, signifying the shift from Catholic terminology to pagan descriptors as awareness and acceptance of other values emerged.

Leighton's first work exhibited at the Royal Academy of Art in London (1855) was an imagined scene of a Catholic liturgical procession introducing a new work of art, *Cimabue's Celebrated Madonna Is Carried in Procession through the Streets of Florence* (fig. 2). The subject and style of the painting was inspired by his days as a young student in Italy. Leighton frequently wrote home about the impact of pre-Protestant art and architecture and expressed delight in Catholic style.[14] The attention to historical detail and iconographic types reflects the same characteristics of the Catholic revival which had influenced the Pre-Raphaelites. Later, however, as a member of the Royal Academy, his preferences shifted toward pagan processions and themes. One of his largest and most impressive works, *The Daphnephoria* (fig. 3) depicts a pagan festival in honor of Apollo with a priest, musicians, and celebrants parading in front of adoring crowds. The processional format and attention to ritual accoutrements is similar to those depicted in *Cimabue's Celebrated Madonna*, but the subject and tone are overtly non-Christian. A similar scene of a ritual ancient Greek ritual procession, Francis David Millet's *Thesmophoria* (1894–1897), can be seen in the BYU Museum of Art.

Continuity in the ritual aesthetic

Although the subject matter in many later Victorian paintings changed from Christian to pagan ritual scenes and processions, the general characteristics of the Catholic "ritualist" aesthetic remained surprisingly consistent. Artists appropriated the sculptural and iconic hard line, the vibrant Italo-Byzantine coloration, and the bold use of gold leaf from highly symbolic Christian works for their non-Christian subjects. As Joseph Leo Koerner suggests in *The Reformation of the Image*, a formal and aesthetic continuity may clearly "represent a re-formation of the sacred images [the iconoclasts had] replaced. Specifically, they renew an image that, from the start, displayed its object by negating it."[15] The extreme iconoclasm of the anti-religionists of the Enlightenment and the anti-Catholics of the Protestant Reformation actually may have prompted an iconophilia for symbol, form, color, and emotion by its very rejection.

A specific example of strong aesthetic continuity is that of the gilded halo that carries over from Catholic revival to the later neoclassical works

Fig. 2 Frederic Leighton, *Cimabue's Celebrated Madonna Is Carried in Procession through the Streets of Florence*, oil on canvas, 222 x 521 cm, 1853–1855. National Gallery, London, The Royal Collection © 2008 Her Majesty Queen Elizabeth II.

of academic painters. It also appears in works reflecting contemporary Victorian social themes. Both Christian Madonnas and pagan priestesses share the dramatic golden halo. An alarming work of a contemporary abandoned "Madonna" and her illegitimate child by Ford Madox Brown, *"Take Your Son, Sir!"* (1857), incorporates the traditional halo as an Arnolfini-like mirror reflecting the fleeing seducer. Thomas Cooper Gotch's critique on the innocence of childhood in the Victorian era, *The Child Enthroned* (1894), uses a similar halo encircling the child's head. Even a painting of the decadent *Heliogabalus, the High Priest of the Sun* (1866), in which painter Simeon Solomon celebrates the Roman emperor who instituted the worship of Baal, shares the same rich style, his head framed in a halo of gold.

The early Christian aesthetic sensibility permeates works across social and conceptual boundaries.

The Evidence of Image: Uses of Ancient Ritual Depictions

We have seen that paintings of the period reflected the growing acceptance and depiction of non-Christian ritual themes and continuity in the Catholic ritual aesthetic in classical or pagan-inspired works, but how does late-nineteenth-century ritualism change our theoretical perspective on the sacred viewing experience? I believe an important key lies with the later ritualist group, the Cambridge Ritualists, which coalesced around Jane Ellen Harrison. Harrison was a colleague of Sir James Frazer at Cambridge and

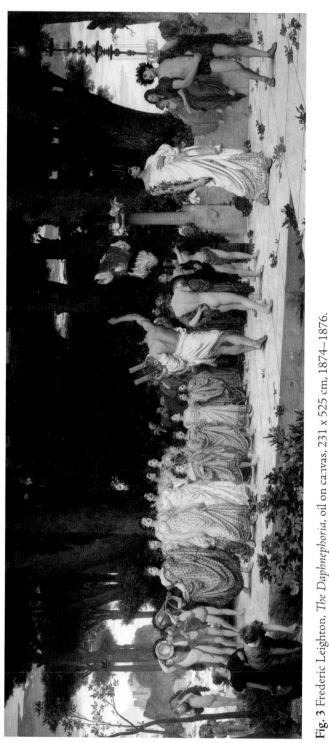

Fig. 3 Frederic Leighton, *The Daphnephoria*, oil on canvas, 231 x 525 cm, 1874–1876. Lady Lever Gallery, Port Sunlight, United Kingdom, © National Museums, Liverpool.

was fascinated by his comparative myth-narratives of the Priest of Nemi in *The Golden Bough*. Harrison was familiar with Frazer's thesis that myth, the creedal narrative of religious behavior, developed concurrently with ritual, the gestural and performative aspects of religion, but rejected that thesis in favor of a theory proposed by biblical scholar William Robertson Smith in his book *Lecture on the Religion of the Semites* (1889). In this seminal work, Robertson Smith asserts the primacy of ritual over myth; the ritual act came first, the myth developed to explain the ritual. Robertson Smith had warned his contemporaries against "the modern habit . . . to look at religion from the side of belief rather than of practice."[16] He continued:

> the antique religions had for the most part no creed; they consisted entirely of institutions and practices. . . . So far as myths consist of explanations of ritual their value is altogether secondary, and it may be affirmed with confidence that in almost every case *the myth was derived from the ritual, and not the ritual from the myth.*[17]

Based on Robertson Smith's concept of the primacy of ritual action over myth-narrative, the ritualism of classical scholar Jane Ellen Harrison and her Cambridge colleagues focused on primitive *behaviors* and endowed an academic legitimacy to explorations of "pagan" mysteries and rites.[18]

Harrison was one of the first women to graduate from Cambridge and spent her next few years studying the Greek vases at the British Museum and exploring archaeological sites for evidence of ancient Greek culture. She had always felt inadequate at traditional textual analysis and felt it was more important to search for meaning than to "parse a phrase."[19] With a passionate willingness to consider material "texts" (almost unheard of at the time because of the strict emphasis on literary analysis and philology in the classical curriculum), she published profusely in art and classical journals on Greek art and wrote several books describing the rituals depicted on the Greek vases.

Initially Harrison's lectures at the British Museum complied with general classical discourse on harmony, order, and what she called "Ideality" in the manner of Johannes Winckelmann, the eighteenth-century "father of art history and archaeology." Eventually, however, the "darker shapes she saw moving behind the images" led her to explore the "primitive side" of preclassical religion—what she considered to be the actual historical and psychological context for the works.[20] Once while regarding the image of a siren on a funerary vase, she lamented, "It is hard for us, with our Christian associations, deepened to a gloomier austerity by Puritan training, to

feel with the Greeks about death and funeral ceremonies; but if we wish to understand them at all we must cultivate this historical sympathy."[21] Her anti-Protestant bias became increasingly evident. She wanted to use pagan images to propose a nobler and less restricting kind of spiritual existence for her contemporaries.

In 1913 the Home University Library published Harrison's *Ancient Art and Ritual.* The book is a summation of her ideas about the role of art and its origins in ritual, and gives her recommendations for its practical benefit to society and individuals. Harrison states, "Art and ritual, it is quite true, have diverged to-day; but the title of this book is chosen advisedly. Its object is to show that these two divergent developments have a common root, and that neither can be understood without the other."[22] Emboldened by her studies of the past, Harrison declared, "It is at the outset one and the same impulse that sends a man to church and to the theatre."[23] In the ancient world (and by the transferred association between past and present, the modern world), art was not the proverbial "handmaiden to religion"; art *was* religion.[24]

In her theoretical construct of *dromenon,* "a thing done," promoting action over creedal confession, Harrison argues:

> The Greek word for a *rite* as already noted is *dromenon,* "a thing done"—and the word is full of instruction. The Greek had realized that to perform a rite you must *do* something, that is, you must not only feel something but express it in action, or, to put it psychologically, you must not only receive an impulse, you must react to it . . . [so] that rites among the primitive Greeks were *things done,* mimetic dances and the like.[25]

Similar to John Henry Newman's advocacy for renewal of liturgical practice, Harrison's ritual-based perspective that ancient religion was not simply a declaration of creed and belief but was grounded in *action* prompted her readers to consider the value of the total religious experience. And if the impulse initiating that action is the same as that which "sends a man . . . to the theatre," then Harrison has described a relationship whereby "art and ritual are near relations."[26] In Harrison's assessment there is also

> no division at first between actors and spectators; all are actors, all are doing the thing done, dancing the dance danced. . . . No one at this early stage thinks of building a *theatre,* a spectator place. It is in the common act, the common or collective emotion, that ritual starts. This must never be forgotten. . . .

The spectators are a new and different element . . . in the old days all or nearly all were worshippers acting, now many, indeed most, are spectators, watching . . . not doing.[27]

Harrison's writings reflect the confluence of artistic and religious ideas that we have already seen emerging in late Victorian culture. They also anticipate concepts and styles developing in the modernism of the early twentieth century. Significant creative individuals such as Virginia Woolf, T.S. Eliot, Isadora Duncan, and James Joyce adopted her theories in their modernist literature and performances.[28] Note that her *Ancient Art and Ritual*, with its emphasis on the individual artistic experience, was written nearly twenty years before John Dewey's seminal *Art as Experience*.[29]

Through equating art and ritual, then detaching it from ritual to be enacted for its own performative, social, and psychological benefits, Harrison secularized the "sacred" behaviors previously attached to traditional religion for strictly artistic purposes. Through articulating the phenomenon of ancient sacred experience and advocating the behaviors of the "pious pagans" depicted in ancient religious vase art and in contemporary Victorian paintings, Harrison's ritualism provided a gateway to the study of the "sacred gaze" across cultures and in manifold artistic media. Acceptance of "other" religious practice as a valued experience encouraged Victorians to adopt an expanding pluralist view about other religions in general. Ritualist interest in sacred images, albeit pagan ones, in essence helped to redress the Protestant and Enlightenment iconoclasm that had prevailed throughout the earliest decades of the nineteenth century and in turn promoted further study of the Christian ritual experience.

Like the members of the Oxford Movement, the Cambridge Ritualists discovered an exuberance in the communal worship of ancient cultures that they longed to see expressed in their own time. They recognized that literary text alone does not capture the religious experience of ancient peoples, Christian or pagan. Both ritualist groups dared to disembark from the security of traditional scholarship in their disciplines to examine the value of alternative religious practices and propose their redress in contemporary culture. This early exploration of the total phenomenon of sacred experience by Newman in the early, and Harrison in the late, nineteenth century anticipates the theories David Morgan develops in his work *The Sacred Gaze* and continues to enrich and inform our study of sacred images. In her preface to *Ancient Art and Ritual*, Harrison states her intent to show the "intimate connection which . . . exists between ritual and art. This connection has, I

believe, an important bearing on questions vital to-day, as, for example, the question of the place of art in our modern civilization, its relation to and its difference from religion and morality; in a word, on the whole enquiry as to what the nature of art is and how it can help or hinder spiritual life." As both ritualist constituencies of the Victorian era examined the total religious experience, creedal and performative, they established ideas about the relationship between art and religion that continue to instruct us in our efforts to make meaning along the borders of our experience where art and religion collide.

Notes

1. Jane Ellen Harrison, *Reminiscences of a Student's Life* (London: Hogarth Press, 1926), 83.

2. In the spirit of Harrison's writings and title of one of her books *Prolegomena to the Study of Greek Religion*, I use the word *prolegomenon* in its usage as an explanatory *preface* to a work.

3. Brigham Young University, in Provo, Utah, is funded by The Church of Jesus Christ of Latter-day Saints.

4. Alex Owen, *The Place of Enchantment: British Occultism and the Culture of the Modern* (Chicago: University of Chicago Press, 2004), 8.

5. David Morgan, *The Sacred Gaze: Religious Visual Culture in Theory and Practice* (Berkeley: University of California Press, 2005), 31, 68.

6. Oxford English Dictionary Online, at http://dictionary.oed.com.

7. Students and faculty members at Oxford and Cambridge, both institutions of the Church of England, were required to subscribe to the "Thirty Nine Articles" of the Anglican Church, a doctrinal statement agreed upon in 1571. See C. Brad Faught, *The Oxford Movement: A Thematic History of the Tractarians and Their Times* (University Park: Pennsylvania State University Press, 2003), 17–19.

8. David Newsome, *The Victorian World Picture: Perceptions and Introspections in an Age of Change* (London: John Murray, 1997), 219.

9. Faught, *The Oxford Movement*, 110–113.

10. Alicia Craig Faxon, *Dante Gabriel Rossetti* (New York: Abbeville, 1989), 34.

11. Faxon, *Dante Gabriel Rossetti*, 54. The Ecclesiologists studied and promoted the Gothic style in art and architecture; "Tractarians" is another name for the leaders of the Oxford movement, who published a series of "tracts" disseminating their arguments.

12. Owen Chadwick, *The Secularization of the European Mind in the Nineteenth Century* (New York: Cambridge University Press, 1975), 1.

13. Harrison, *Reminiscences*, 82–83.

14. Mrs. Russell Barrington, *The Life, Letters and Work of Frederic Leighton*, 2 vols. (London: George Allen, Ruskin House, 1906), 1:73.

15. Joseph Leo Koerner, *The Reformation of the Image* (Chicago: University of Chicago, 2004), 13.

16. William Robertson Smith, "Lectures on the Religion of the Semites, Lecture One," in *The Myth and Ritual Theory: An Anthology*, ed. Robert A. Segal (Oxford: Blackwell, 1998), 28–29.

17. Robertson Smith, "Lectures on the Religion of the Semites, Lecture One," 28–29, italics added.

18. In fact, the definition of the word "ritual" itself underwent descriptive and relevant changes during the period. In the first edition of the *Encyclopaedia Britannica* (1771) until the seventh one (1852), the word ritual referred to "a book directing the order and manner to be observed in celebrating religious ceremonies." But by the eleventh edition (1910), the term had undergone a noteworthy change according to its entry author R. R. Marett. The entry stated that "the term ritual, as meaning the prescribed routine, is also extended to observances not strictly religious in character." Originally, it indicated a text, primarily a Catholic liturgical text, which was the contextualization of the charges of "ritualism" aimed at John Henry Newman in the early Victorian period, but throughout the rest of the century it took on new meaning as a word describing symbolic behaviors with sociological and psychological functions. See Talal Asad, *Genealogies of Religion: Discipline and Reasons of Power in Christianity and Islam* (Baltimore: Johns Hopkins University Press, 1993), chapter 2, "Toward a Genealogy of the Concept of Ritual"; and Barbara Boudewijnse, "British Roots of the Concept of Ritual," in *Religion in the Making: The Emergence of the Sciences of Religion*, ed. Arie L. Molendijk and Peter Pels (Leiden: Brill, 1998).

19. Harrison, *Reminiscences*, 58.

20. See Thomas W. Africa, "Aunt Glegg among the Dons, or Taking Jane Harrison at Her Word," *The Cambridge Ritualists Reconsidered*, ed. William Calder III (Atlanta: Scholars Press, 1991), 23.

21. Jane Ellen Harrison, *Myths of the Odyssey in Art and Literature* (London: Rivingtons, 1882), 159.

22. Jane Ellen Harrison, *Ancient Art and Ritual* (London: Oxford University Press, 1948), 9.

23. Harrison, *Ancient Art and Ritual*, 9–10.

24. Harrison, *Reminiscences*, 84.

25. Harrison, *Ancient Art and Ritual*, 35.

26. Harrison, *Ancient Art and Ritual*, 35.

27. Harrison, *Ancient Art and Ritual*, 126–127.

28. This was also, however, at the same time that BYU scholar Hugh Nibley was quoting Harrison and her ritualist colleagues for his own purposes—writing on ancient temple rites. See for example Hugh Nibley: *The Ancient State* (Salt Lake City: Deseret Book, and Provo, Utah: Foundation for Ancient Research and Mormon Studies, 1991), 102.

29. Dewey's *Art as Experience* was first published in 1934.

Elliott Wise is originally from San Diego, California. In the spring of 2009 he will receive a master's degree in art history from BYU, and he then plans to pursue a doctoral degree. He focuses his studies on devotional art, usually dealing with late Gothic and early Renaissance painting. He has done research on miracle-working images of the Virgin Mary in the Naples region of Italy and is currently writing a thesis on a fifteenth-century altarpiece by the Flemish master Robert Campin.

The Black Madonna of Częstochowa

Resistance and Redemption in Communist Poland

Elliott Wise

Since her installation at the Polish monastery of Jasna Góra in 1382, the Black Madonna of Częstochowa (fig. 1) has drawn millions of pilgrims to her shrine, seeking miracles and strength in times of political and personal trial. Precious votive offerings, left in gratitude for the Madonna's protection and intervention, obscure most of the painting with gold and jewels. Normally, little more than the hands and faces of the Christ Child and his mother are visible. The Virgin's countenance, scarred by iconoclasts and blackened from centuries of candle smoke, gazes at her devotees from beneath a towering crown. As the Polish nation emerged from the brutality of World War II into the grip of an atheist, communist regime, pious Poles took refuge at Jasna Góra, seeking the Black Madonna's protection. In the ensuing battle between church and state, the cardinal-primate, the first Polish pope, and millions of faithful Catholics used Our Lady of Częstochowa as a symbol of resistance and nationalism. As "Queen of Poland," the Black Madonna pitted the monarchal authority of the Catholic Church against the communist government, and as "mother of the Polish people," the icon co-suffered with the struggling nation and offered hope for freedom, redemption, and a political resurrection.

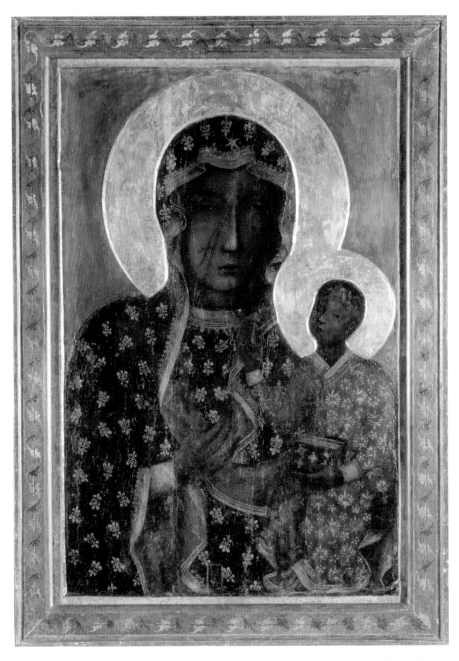

Fig. 1 Our Lady of Częstochowa (Black Madonna). Jasna Góra Monastery, Częstochowa, Poland. Photo by Nicolas Sapieha / Art Resource, NY.

The Black Madonna's regal associations originated with the first prior of Jasna Góra, who arrived in Poland from Hungary in the late fourteenth century, bringing with him popular middle-European devotion to Mary as "Queen of Heaven." Beginning in the fourteenth century, Poland was ruled by a commonwealth government that balanced power between an elected king, an aristocratic senate, and a democratic chamber of envoys. But the Vasa dynasty (1587–1668) was an unusual departure into "confessional absolutism," with dictatorial kings denouncing heresy and demanding loyalty to the Catholic Church.[1] The icon's political power expanded significantly under the reign of the Vasa family: Ladislaus IV, who reigned as king of Poland from 1632 to 1648, presented two crowns to the Black Madonna image. A few years later, after Jasna Góra's famous defense against the Swedes, King John Casimir consecrated his entire kingdom to the Black Madonna's protection. From then on, the image received the title "Queen of Poland."

When these two autocratic kings surrendered their vast realms at the Virgin's feet, they established a tradition for the Black Madonna's unconditional political power. A 1682 painting on the back of the image adds other secular kingdoms to the Black Madonna's sphere of authority: it depicts Empress Pulcheria, Constantine the Great, and King Ludwig of Hungary all venerating the icon. Through succeeding centuries of turmoil, invasion, and insecurity, Polish Catholics maintained a deep, personal loyalty to the Black Madonna as the most constant and legitimate ruler for their nation.[2]

In addition to ascribing her monarchal associations, Polish Catholics also looked to the Black Madonna as their mother.[3] Catholic theology teaches that when the dying Christ entrusted his mother to the care of Saint John by declaring, "Behold thy mother" (John 19:27), the Virgin Mary also became the "mother" for all of humanity. Through her "Seven Sorrows" at Golgotha, she shared in the redemptive suffering of her son and learned empathy for mankind. Poles applied this doctrine specifically to their nation. From the "Calvary" of Jasna Góra, the Virgin of Częstochowa co-suffered the atrocities committed against her Polish children.[4] In a solemn oath of consecration to the motherly Black Madonna, Polish clerics proclaimed, "With gratitude in our hearts we recall her maternal protection in years gone by and we are confident that thanks to her alone the faith in Poland was preserved."[5] Combining politics with their filial relationship to the Black Madonna, faithful Poles prayed, "Virgin Mother, mother of the Church, queen of Poland and Our Lady of Częstochowa, you are given to us, as our strength in defense of the Polish nation!"[6]

In much the same way that Christians cast their burdens on the "Lamb of God," pilgrims to Jasna Góra leave emblems of their suffering as gifts for the Black Madonna. Votive offerings of silver hands and hearts, along with wooden crutches, hang thickly from the monastery walls, while heirloom jewels and crosses decorate the ornate "robes" that normally clothe the image. These precious offerings represent earnest petitions and heartfelt gratitude from the Black Madonna's suffering children. Other, grimmer gifts attest to the violent trials heaped upon the mother of Poland and her children. Pope John Paul II's sash, stained with his blood after an assassination attempt, lies on the altar in front of the image. Gifts from World War II concentration camp victims, such as a rosary made from bread and a crown of thorns fashioned from barbed wire, recall the atrocities of Ravensbrük and Dachau.

The Black Madonna of Częstochowa became a nationalistic symbol of resistance through a long-standing legacy of protecting the Polish people from heretics and invaders.[7] The most famous of these miraculous defenses occurred in 1657 when a scanty band of monks and knights defended the Black Madonna's shrine against Swedish cannonballs and saved the nation from Protestant oppression.[8] The seventeenth-century writings of Father Augustine Kordecki compared the Virgin's power to hold back the "floods of opposition" to Noah's ark and also to the temple of Jerusalem, which sheltered the persecuted Maccabees.[9] A sign of hope to the downtrodden, the icon continued to intervene in the politics of the twentieth century when, in 1920, the "miracle on the Vistula" preserved Warsaw from domination by the Bolsheviks.[10] During his 1979 visit to his homeland, Pope John Paul II recalled the dark days of 1936 when political dissenters would seek refuge behind the protecting walls of the Jasna Góra monastery.[11]

Resisting Communism

With her ongoing status as a national symbol of resistance, it is not surprising that the Black Madonna of Jasna Góra became a central figure in the fight against communism. After the Yalta agreement of 1945, communism deluged Poland and the monastery of Jasna Góra naturally became the fortress headquarters for the Church's fight against tyranny.[12] Cardinal-primate Stefan Wyszyński, head of the Polish Catholic Church, became the de facto leader of the communist opposition and used the Black Madonna as a symbol for the "program of his work in the Church."[13] He incorporated her image into his official seal, endorsing his signature with the authority of her face. Following a lengthy stay in prison, the cardinal initiated pilgrimages to Jasna

Góra, where the printing of illegal, anti-government material infuriated the state, inciting them to denounce the Black Madonna's shrine as a "factory of delusions."[14] The political associations with the image and its monastery became dangerous enough that the government banned Pope John Paul II from presiding at the 600th anniversary of the founding of Jasna Góra in 1982.

During the years of communism, the Poles spoke out against the state's policies through a more extreme type of votive offering to the Black Madonna. After the government had held Cardinal Wyszyński in prison for many months, a staunch group of his supporters, known as "The Eight," began protesting from Jasna Góra. One woman, despite forcible opposition from the secret police, willfully imprisoned herself behind the monastery walls, vowing to remain a hostage to the Queen of Poland until the state released the cardinal-primate.[15] Even after Cardinal Wyszyński's liberation, a member of "The Eight" always remained at Jasna Góra to pray for Poland's freedom from communism. These "votive imprisonments" hearken back to seventeenth-century literature under the Vasas. John Chomętowski's *The Chains of St. Mary* urged the faithful to become "eternal servant[s] and slave[s]" to the Virgin.[16] Polish clerics capitalized on this tradition, encouraging "filial slavery" to the Queen of Poland and loyalty to the cardinal-primate.[17]

The state searched for opportunities to censure Cardinal Wyszyński and the "opposition capital" he had established at Jasna Góra by building a new road through Częstochowa that would interfere with pilgrimage routes to the shrine. Outraged, Catholics fought back with a demonstration of fasting and incessant bell ringing from the local parishes. When the state refused to allow Pope Paul VI to officiate at the 1966 millennial celebration of Christianity in Poland, angry protestors carried copies of the Black Madonna of Częstochowa in procession, stirring onlookers into an emotional frenzy.[18]

The Polish clergy, as well as Pope John Paul II, frequently used Jasna Góra and the image of the Black Madonna as a podium to counsel and critique the oppressive policies of the state.[19] On her feast day, Poland's religious leaders delivered sermons from the shrine defending labor strikes and condemning the government's severe martial law. While Cardinal Wyszyński languished in prison for opposing the atheist regime, Poland's bishops opened a novena service at Jasna Góra, celebrating a thousand years of Christianity in Poland. In a politically charged prayer, they implored the Black Madonna to "guard [Poland's children] from godlessness and moral degradation."[20] During his visit to Jasna Góra shortly after his election, Pope John Paul II entrusted the future of his beleaguered nation to its people,

urging them to imitate Our Lady of Częstochowa by "be[ing] watchful" over their land and its politics.[21] Then, in a statement subtly condemning the socialist state, the pope explained that the heart of the Black Virgin was "necessary to the world, which tends to express everything through cold calculations and purely material ends."[22]

The government's opposition to the Black Madonna and her shrine went beyond mere irritation at the monastery's libelous printing press and critical sermons. As the socialist state tried to establish a utopian, communal society for the common worker, it must have been disconcerting to see the proletariat masses rallying around the queenly image of the Black Madonna, covered in regal gold and jewels. While the government attempted to regulate the finances and labor of the Polish people, the Black Madonna continued to attract pilgrims who dedicated to her not only their labor, but votive emblems of their hands, legs, and hearts.[23] As anonymous crowds carried her image in processions of protest, the sense of a personalized, united outcry so unnerved the government that on one occasion the state confiscated a copy of the icon, escorted it back to Jasna Góra, and posted guards to keep it from leaving the monastery again.[24]

The face of the Queen of Poland undermined the power of the socialist state by propagandizing a competitive "government" of monarchy and spiritual nationalism. In his address from Jasna Góra, Pope John Paul II challenged the secular version of politics and nationalism that the socialist government had imposed on Poland: "If we want to know how [our] history is interpreted by the heart of the Poles, we must . . . come hear the echo of the life of the whole nation in the heart of its Mother and Queen."[25] With the Black Madonna established as the "true sovereign" of Poland, the Church preempted the communist state by becoming the Queen's only legitimate regent. The Church had intervened in politics many times during Poland's turbulent history. In periods of abdication or instability, the cardinal-primate served as interrex, a temporary king ruling the nation until another acceptable government could be established.[26] Even when not directly in control, the Polish Catholic Church had long stood for human rights, forcing kings to safeguard the civil liberties of their people with a vow at the tomb of St. Stanisław, an eleventh-century bishop who was axed to death for defending his countrymen against a tyrannical ruler.[27] These oaths were so integral to their history of legislating freedom that the Poles could legitimately refuse to obey a monarch who abused the oath of St. Stanisław. Even under "confessional absolutism," the totalitarian Vasa kings still staunchly protected the rights of the Polish peasantry.

The atheist regime, however, shunned this spiritual tradition of government and trampled on the liberties that centuries of kings had vowed to protect. In reaction, the Church, inspired by the Black Madonna, condemned the new government. Cardinal Wyszyński seemed to follow the footsteps of former cardinal-primates by assuming some of the roles of interrex. In so doing, he warned the state that Polish Catholics regarded the communist regime as no more than an interregnum, a transitional period between one acceptable government and the next. The state, already uneasy with Cardinal Wyszyński's propaganda literature and sermons, became irate when the cardinal-primate took governmental responsibilities upon himself, issuing a formal statement in behalf of the nation of Poland that pardoned all German Catholics for the abuses of World War II.[28] Significantly, during this same time Pope Paul VI compared the Polish Church to the nation's first Christian ruler, Mieszko I, who pledged the allegiance of his country to Christianity. [29] At the height of the Church's millennial festivities in 1966, Cardinal Wyszyński reenacted the vows of King John Casimir as he led thousands of Poles in vowing "the act of total servitude to the Mother of God for the freedom of the Church in Poland and throughout the world."[30]

Redemptive Suffering

Comparing their sad history to the Passion of Christ, Poland persevered through political domination with a messianic endurance.[31] The highly controversial letter of 1965 pardoning German Catholics illuminated the redemptive suffering of Poland. In an effort to resolve centuries of hostility between the two nations, the Polish Episcopate enumerated their grievances against Germany, especially the atrocities of World War II, and then promptly "offered [them] forgiveness like Christ on the cross offered forgiveness."[32] Perhaps they referenced the dark wounds of the co-suffering Virgin of Częstochowa when they wrote, "We hope that time, the great healer, will slowly close up our spiritual wounds."[33] Catholic leaders believed that Poland's World War II massacres and death camps had mystically atoned for the sins of the German perpetrators. Pope John Paul II extended this messianic assertion to the political trials facing a socialist Poland during a public mass in Warsaw's Victory Square. The pontiff referenced Christ's parable regarding the seeds that must first die before they can be fruitful. Then he compared the sufferings of ordinary Poles—from their deaths at war to the drudgery of their everyday work—to seeds "in the hands of the Mother of God—at the foot of the cross on Calvary."[34] With a huge, wooden cross

set up behind him and a large portrait of the Black Madonna at its base, the allusion made Poland's suffering a preparatory step towards the new growth and flowering of political independence. In his sermon at a 1910 coronation ceremony for the image, Father Szlagowski had compared the Virgin's tiara to Poland's allegorical crown of thorns.[35] World War II poetry continued the imagery, describing visions of the Madonna appearing to soldiers in the battle trenches with "clotted blood on her feet"—allusions to the stigmata wounds of her son.[36]

Surrounded by racks of glittering votive offerings and literally dressed in the emblems of her suffering people, the Black Madonna's image merges together the voices of millions of faithful Poles. The heavy offerings seem to weigh on the sad countenance of the Virgin of Częstochowa, paralleling the crushing load of the world's sin and pain endured by her son. Although initially evoking a sense of opulence and grandeur, the Virgin's jewel-encrusted treasures compare more aptly with the "clotted blood" and thorny tiara that she endures alongside the afflicted.

Scars of Redemption

The prominent gashes on the Madonna of Częstochowa's cheek further express the Virgin's redemptive suffering during all of Poland's trials, including the communist years of the twentieth century. Although scholars disagree on the origins of the scars, one hypothesis suggests that they may be scratches created by robbers hastily ripping jewels off the icon.[37] This makes an interesting corollary with the idea of votive offerings as emblems of suffering. More traditional theories claim that these marks came from an iconoclastic attack on the image in the fifteenth century, although scholar Robert Maniura also notes that the scars were once painted red and could have been part of the original composition. He postulates that they may imitate an old mourning custom in which medieval women tore at their faces to express sorrow.[38] Turn-of-the-century Polish drama echoes Maniura's hypothesis. In a scene from Lucjan Rydel's *The Polish Bethlehem*, a grief-stricken Mary kneels in prayer for her Polish children, declaring before heaven that she is "torn into dust."[39] Whether or not the gashes are original to the image, they definitely became integral to the pathos of the icon. One source even asserts that the Virgin of Jasna Góra miraculously absorbed the wounds into her image, preventing later restorers from painting over them.[40] The pain on her face resonates with the suffering pilgrims flocking to her shrine.[41] Just

as Christ heals and saves mankind by virtue of his Passion, so the Black Madonna's suffering enables her to heal the diseased and save the guilty.

One historian, documenting the riots during the time iconoclasts supposedly defaced the Black Madonna, writes that the perpetrators mocked Christian images, saying, "If you are God or one of his saints, save yourself and we will believe in you."[42] This obvious reference to the bystanders who ridiculed the crucified Christ emphasizes the literal connection between the scars inflicted by iconoclasts and the wounds of the Passion. Just as the resurrected Christ's stigmata became symbols for his triumph over death, the scars of the Black Madonna anticipate Poland's triumph over political oppression. They condemn the socialist state, which persecutes the Church like modern iconoclasts. In a larger sense, the scars on the Black Madonna's face endow her with the authority to save Poland from communism and heal the nation from oppression.

The Black Madonna and the Resurrection of Poland

In honor of Poland's Christian millennium, the diocese of Worcester, Massachusetts, compiled a history of miracle stories attributed to the Black Madonna. Many of these legends center on the theme of resurrection. In most of them, grieving mothers and fathers have lost a child. The stories grimly stress the utter hopelessness of their plight with gory details—the bluish-purple faces of suffocated infants, the deathly pallor of dead children, or the distorted bodies of little ones who died in excruciating pain.[43] Refusing to give up hope, the parents turn to the Black Madonna who once mourned over the corpse of her own son.[44] The compassionate Virgin rewards their faith by bringing the child back to life.

Applied to twentieth-century politics, these miracle stories anticipate Poland's ultimate redemption, when the nation, having imitated the death of Christ in the same hopelessly gory details of the Worcester legends, prepares to also share in his resurrection.[45] A political movement known as Messianism mystically looked forward to "the day when justice, liberty, and love would rule the whole world."[46] This platform seemed to draw on the Black Madonna's liturgy, which equates the Queen of Poland's throne on the "Bright Mountain" of Jasna Góra with the Holy City on Mount Zion and the apocalyptic reign of Christ.[47] In this view, the Virgin of Częstochowa represents the despised "daughter of Zion," patiently hearing the pleas of pilgrims who flock to "the spiritual capital" of their nation and pray for Poland's millennial day of glory and political power.[48] Pope John Paul II elaborated on

the Virgin's place in this progression from suffering into joyful resurrection when he entrusted to the Black Madonna the world's "sorrow and suffering and finally the hope and expectation of [the] final period of the twentieth century of the Christian era."[49] Just as the rosary moves the believer from "sorrowful mysteries" into "glorious" ones, so the Black Madonna can move a nation nearly dead in the throes of atheism into a glorious resurrection from the tomb. As the pope promised his countrymen in a final speech before returning to the Vatican, "The faith of Poland . . . contains a message of optimism and hope: 'Christ . . . having been raised from the dead will never die again.'"[50]

Through all the violent years of Poland's history and especially during the harsh regime of communism, the image of the Black Madonna of Częstochowa inspired political resistance and redemptive hope as the authoritative Queen of Poland. Her wounded face, surrounded with glittering votive offerings, commiserated with the suffering nation during its political Calvary and promised that one day Poland would be "resurrected." The icon's defining role in the twentieth-century battle against communism adds another chapter to its long history as the fearful enemy of the heretic and the reassuring strength of the faithful.

Notes

1. Richard Butterwick, "Introduction," in *The Polish-Lithuanian Monarchy in European Context, c. 1500–1795*, ed. Richard Butterwick (New York: Palgrave, 2001), 12.

2. Marian Załęcki, *Theology of a Marian Shrine: Our Lady of Częstochowa*, vol. 8 of *Marian Library Studies*, ed. Theodore Koehler (Dayton, Ohio: University of Dayton, 1976), 190. The Poles' devotion to the Black Madonna as their only legitimate ruler gained especial prominence between the late eighteenth century and the aftermath of World War I during which Poland was divided in three and governed by Russia, Austria, and Prussia. Papal coronations in 1717 and 1910 validated the Poles' acceptance of the Black Madonna as their legitimate Queen.

3. Załęcki, *Theology of a Marian Shrine*, 181.

4. J. S. Orvis, "Partitioned Poland, 1795–1914," in *Poland* (Los Angeles, 1945), 59, as cited in Załęcki, *Theology of a Marian Shrine*, 176, 200.

5. Załęcki, *Theology of a Marian Shrine*, 154.

6. Załęcki, *Theology of a Marian Shrine*, 154.

7. See Kate Wagle, "Vernacular of the Sacred: Laminae Ex Voto in Southern Italy," *Metalsmith* 18 (Spring 1998): 28–36. Wagle identifies the significance of many types of votive offerings in southern Italian religious culture. Her discussion of laminae ex votos shaped like body parts has particular relevance to

the Black Madonna of Częstochowa. She emphasizes the significance of these offerings as personal gifts of the worshiper's own body.

8. Norman Davies, *God's Playground: A History of Poland, vol. 2, 1795 to the Present* (Oxford: Clarendon, 1981), 224.

9. In this same vein, the icon's power saved the village of Glewice from a hopeless onslaught of Lutherans in 1917. *The Glories of Częstochowa and Jasna Góra: Millennium Edition Commemorating the Thousandth Anniversary of Poland's Conversion to Christianity* (Diocese of Worcester, Mass.: Our Lady of Częstochowa Foundation, [1966]), 42–43.

10. Augustine Kordecki, *Noua Gigantomachia, contra Sacram Imaginem Deimarae Virginis a Sancto Luca depictam . . . Per Suecos & alios Haereticos excitata* (Cracoviae, 1655), 155, 161, 150–151, as cited in Załęcki, *Theology of a Marian Shrine*, 124–125. Father Kordecki described the story of the Swedes invading Jasna Góra as a "deluge," with the Black Madonna's miraculous intervention paralleling the "ark of Noah" that preserved humanity from the biblical "deluge."

11. Bogdan Szajkowski, *Next to God . . . Poland: Politics and Religion in Contemporary Poland* (London: Frances Printer, 1983), 2; P. Kennedy, "Jasna Góra— Spiritual Capital of Poland—Help of the Half-Defeated," *Immaculate* 17 (April 1966): 20.

12. Pope John Paul II, *Return to Poland: The Collected Speeches of John Paul II* (New York: Collins, 1979), 110.

13. Kennedy, "Jasna Góra," 15.

14. Andrzej Micewski, *Cardinal Wyszyński: A Biography* (San Diego: Harcourt Brace Jovanovich Publishers, 1984), 32.

15. Micewski, *Cardinal Wyszyński*, 188. The state imprisoned Cardinal Wyszyński because the primate refused to allow the government any authority in nominating bishops.

16. Maria Okońska locked herself in the monastery in 1956.

17. John Chomętowski, *Pętko Maryjej abo sposób oddawania się B. Pannie Maryi za sługę I niewolnika* [The Chains of St. Mary, of the Way to Serve Blessed Virgin Mary as Servant and Slave], trans. F. St. Fenicki in *Mariae mancipium* in Zbigniew Bania and Stanisław Kobielus, *Jasna Góra* (Warsaw: Instytut Wydawniczy Pax, 1985), 23.

18. Załęcki, *Theology of a Marian Shrine*, 153.

19. Ronald C. Monticone, *The Catholic Church in Communist Poland: Forty Years of Church-State Relations* (New York: Colombia University Press, 1986), 43–45.

20. Kennedy, "Jasna Góra," 15.

21. Micewski, *Cardinal Wyszyński*, 158.

22. John Paul II, *Return to Poland*, 95–97.

23. John Paul II, *Return to Poland*, 106.

24. This has an interesting parallel to the communist confiscation of Russia's nationalistic Vladimir icon of the Mother of God. For decades, the image was only occasionally displayed in museums.

25. John Paul II, *Return to Poland*, 55. An excellent example of the nationalistic associations with the Queen of Poland comes from a sermon at the Virgin's 1910 coronation ceremony: "High above the cherubim and seraphim . . . stands the queen of angels adorned with the Polish royal insignia . . . appear[ing] in [the] national colors . . . [with] the white Polish eagle, the symbol of Poland." A. Szlagowski, *Witaj Królowo*, kazanie wypowiedziane w kaplicy na Jasnej Górze podczas Koronacji Cudownego Obrazu Matki Bożej Częstochowskiej w Uroczystość Świętej Trójcy dnia 22 Maja 1910 roku (Warszawa, 1910), as cited in Załęcki, *Theology of a Marian Shrine*, 131. Several years later, Pope Pius XI cemented the patriotic associations of the image when he allowed a feast for the Black Madonna on May 3, the holiday honoring the Polish constitution.

26. Some of the most famous occasions when the cardinal-primate served as inter-rex include the aftermath of the 1668 abdication of King John Casimir and the early-eighteenth-century period of succession controversies. See Mariusz Markiewicz, "The Functioning of the Monarchy during the Reigns of the Electors of Saxony, 1697–1763," in Butterwick, *Polish-Lithuanian Monarchy*, 177–178; Robert I. Frost, "Obsequious Disrespect: the Problem of Royal Power in the Polish-Lithuanian Commonwealth under the Vasas, 1587–1668," in Butterwick, *Polish-Lithuanian Monarchy*, 151.

27. Monticone, *Catholic Church in Communist Poland*, 2.

28. See Pope Paul VI, the Apostolic Letter "Mille exactos," December 17, 1965, AAS, LXVI (1966), 205–210, in Załęcki, *Theology of a Marian Shrine*, 152.

29. As an example of the anger resulting from the cardinal's formal pardon, the Polish newspaper *Życie Warszawy*, "Who authorized the bishops to speak out on issues of foreign policy . . . without prior consultation and coordination with the Polish government?" Adam Michnik, *The Church and the Left* (Chicago: University of Chicago Press, 1993), 90.

30. John Paul II, *Return to Poland*, 55.

31. Orvis, in Załęcki, *Theology of a Marian Shrine*, 200.

32. *Listy Pasterskie Episkopatu Polski* [Pastoral Letters of the Polish Episcopate] (Paris: Editions du Dialogue, [1975]), 435–437, in Michnik, *The Church and the Left*, 89–92.

33. *Listy Pasterskie Episkopatu Polski*, 829–836, in Załęcki, *Theology of a Marian Shrine*, 187.

34. John Paul II, *Return to Poland*, 29.

35. Szlagowski, in Załęcki, *Theology of a Marian Shrine*, 131.

36. Anonymous poet, in Załęcki, *Theology of a Marian Shrine*, 199. It is interesting to note that some have claimed that the darkness of the Black Madonna's skin indicates that she, like Christ, has been wounded for sins. Załęcki, *Theology of a Marian Shrine*, 176. Others compare her scarred countenance to the face of Christ as "man of sorrows." Załęcki, *Theology of a Marian Shrine*, 171.

37. W. Kurpik, "Podłoże obrazu Matki Bożej Jasnogórskiej jako niepisane źródło do dziejów wizerunku," *Jasnogórski ołtarz Królowej Polski. Studium teologiczno-historyczne oraz dokumentacja ovientów zabytkowych i prac konserwatorskich*, ed. J. Golonka (Częstochowa, 1991), 100, in Robert Maniura, *Pilgrimages to Images*

in the Fifteenth Century: The Origins of the Cult of Our Lady of Częstochowa (Woodbridge, UK: Boydell Press, 2004), 77.

38. Maniura, *Pilgrimages to Images*, 79, 129–130.

39. L. Rydel, *Polskie Betleem*, Cf. *Matka Boska . . .* , II, 144, as cited in Załęcki, *Theology of a Marian Shrine*, 196.

40. Maniura, *Pilgrimages to Images*, 44; Załęcki, *Theology of a Marian Shrine*, 172.

41. Maniura, *Pilgrimages to Images*, 129.

42. Lawrence of Březová, *De gestis et variis accidentibus regni Boemiae*, Fontes Rerum Bohemicarum, 5 (Prague, 1893), 411, as cited in Maniura, *Pilgrimages to Images*, 74–75.

43. *Glories of Częstochowa and Jasna Góra*, 81–83, 88–89, 98–99, 138.

44. *Glories of Częstochowa and Jasna Góra*, 98–99. The iconography of the Black Madonna of Częstochowa simultaneously empathizes with the despondent parents and holds out the promise of resurrection to them. Even with Christ as a healthy infant in her arms, the Virgin's mournful face foresees his coming death. Załęcki, *Theology of a Marian Shrine*, 175. Yet, at the same time, the exalted Queen bears witness of the joyful outcome of his resurrection.

45. Orvis, as cited in Załęcki, *Theology of a Marian Shrine*, 200.

46. Orvis, as cited in Załęcki, *Theology of a Marian Shrine*, 200.

47. Załęcki, *Theology of a Marian Shrine*, 176–177.

48. Załęcki, *Theology of a Marian Shrine*, 178–181; John Paul II, *Return to Poland*, 106.

49. John Paul II, *Return to Poland*, 57.

50. John Paul II, *Return to Poland*, 186. The theme of most of the pope's sermons during his first official visit to Poland complemented this transition between suffering and hope, with many of his homilies juxtaposing the cross and the resurrection.

Before joining the Salt Lake Art Center staff—currently Curator of Exhibitions, formerly Curator of Education—Jay Heuman worked at the Nora Eccles Harrison Museum of Art, Utah State University, Logan, Utah; and the Joslyn Art Museum, Omaha, Nebraska. Mr. Heuman earned a Bachelor of Visual Arts and MA in Art History from York University, Toronto, Ontario. His research interests include art as documentation, memory, and/or revisionism; visual art by marginalized populations; iconology of abstract art; conceptual/performance art; and cross-disciplinary approaches to art education. In addition to his duties at the Salt Lake Art Center, Mr. Heuman currently serves on the editorial review board of *Art Education*, the National Art Education Association's monthly publication.

The Crucifixion

Modern Latter-day Saint and Jewish Depictions

Jay Heuman

Catholicism and Catholic iconography are fixated on the events of the Passion[1] to reinforce the arousal of compassion but also as a reminder of the debt to God for sacrificing Jesus on the cross to cleanse the sins of humanity. But in truth, this fixation on the Crucifixion originates with Constantine. As James Carroll, a journalist and former Catholic priest, has written: "Before Constantine, the cross lacked religious and symbolic significance." In truth, the Roman catacombs—site of early Christian worship—reveal many symbols such as palm branches, the dove, the peacock, the bird of paradise, the sacred fish, and the monogram of Jesus. But in 312 CE, Constantine's vision at Milvian Bridge of a cross in the sky with the accompanying prophesy *In Hoc Signo Vinces* ("In This Sign, Conquer")—and his subsequent conversion to Christianity—assured the cross, the Crucifixion, and the Passion prime symbolic importance.[2] And the Nicene Creed, finalized at the Council of Constantinople in 381 CE, according to Carroll, "put the crucifixion at the center of faith and the death of Jesus at the heart of redemption."[3]

Thomas Aquinas, the thirteenth-century theologian, explained the need for ecclesiastical artworks:

> [There is] a threefold reason for the institution of images in the Church: first, for the instruction of the unlettered, who might

learn from them as if from books; second, so that the mystery of the Incarnation and the examples of the saints might remain more firmly in our memory by being daily represented to our eyes; and third, to excite the emotions which are more effectively aroused by things seen than by things heard.[4]

As an example of exciting the emotions, *De meditatione passionis Christi per septem diei horas libellus*, an influential thirteenth-century Latin work by Pseudo-Bene, gives instructions for what a viewer should bear in mind while looking at depictions of the Passion: "What then would you do if you were to see these things? Would you not throw yourself on our Lord and say: 'Do not, oh do not do such harm to my God. Here I am, do it to me, and don't inflict such injuries on him.' And then you would bend down and embrace your Lord and master and sustain the blows yourself."[5] As the Catholic hierarchy grew to understand the popularity of creative representations of biblical events, they found at their command not only a powerful means of reaching the deepest emotions of parishioners, but also the means of raising funds. This was part *pro gloria Dei* ("For the Glory of God") and part *invenies staterem illum sumens* ("You will find a *stater* [shekel]; take it and give it to them").[6]

Depictions of the Crucifixion, a subject dominated by Catholic artists over the centuries, vary stylistically; yet the overall look remains unvarying. From early Christian carvings to modern Catholic paintings, we see predominantly a Caucasian Jesus with long hair, wearing a loincloth; arms outstretched horizontally, hands nailed to the cross; legs hanging vertically, sometimes with a slight curve left or right; and nails through the top of his feet.[7]

Carl Heinrich Bloch produced a series of twenty-three paintings of the life of Jesus for the King's Praying Chamber in the Chapel of Frederiksborg Castle in Hillerød, Denmark. Despite the artist not being a Latter-day Saint, this series holds much appeal for those of the LDS faith partly due to the efforts of Doyle L. Green, the managing editor of *Improvement Era* magazine from 1950 to 1970. Between 1956 and 1958, serialized readings on the life of Christ were printed and illustrated with Bloch's artworks. Later, Deseret Book compiled the series in a volume entitled *He That Liveth*.[8] Additionally, reproductions of Bloch's paintings have been printed in numerous other LDS publications and hang in LDS facilities.[9]

In Bloch's *The Crucifixion* (1870), we see a traditional depiction of the subject. Jesus' lifeless body hangs on the cross, bathed in the radiance of evening light. The Virgin Mary (in blue and white) and Mary Magdalene (in blue and red) lie faint at the base of the cross. I believe John the Evangelist broods, seated on a stone to the right; to the left, Joseph of Arimathea leans over the Virgin Mary, checking on her well-being. Nicodemus and attendants arrive with two ladders to remove Jesus' body from the cross, fine linen in which to wrap the body, and myrrh and aloes to sprinkle over the body.

Let us focus for a moment on the actual details of Jesus and his position on the cross. To inspire deeper worship, to emphasize the physical suffering of Jesus, to protect his modesty, and to create an aesthetically pleasing composition, and without any modern archaeological and scientific evidence, Bloch repeated age-old errors identified over the years by numerous scholars. What we know is this:

Jesus may not have had nails driven through the palms of his hands, nor through the tops of his feet. Based on skeletal remains of Jehohanan—a man crucified sometime between 7 CE, the time of the census revolt, and 66 CE, the beginning of the war against Rome—Richard Lloyd Anderson (Professor Emeritus of Ancient Scripture and senior research fellow at the Joseph Fielding Smith Institute for Latter-day Saint History at Brigham Young University) reports nails may have been driven into the forearm between the radius and ulna, and through the heel bones.[10] Further, Joe Zias (Senior Curator of Archaeology/Anthropology for the Israel Antiquities Authority from 1972 to 1997) reports few crucifixions involved nails through the forearm, as rope sufficed to secure the upper body, though the Jehohanan find implies nails were used at the heel.[11] Several scholars have argued crucifixion was a bloodless form of death.[12]

Jesus would not have worn a loincloth—nor would any other person condemned to crucifixion have been offered such a covering for modesty. According to Zias, crucifixion was intended to humiliate the condemned and to terrorize those who witnessed the physical and psychological agony.[13]

Jesus would not have had long hair. According to Lawrence Schiffman (Ethel and Irvin A. Edelman Professor in Hebrew and Judaic Studies, New York University), the Jews ridiculed Greek and Roman men who often had long hair.[14]

Jesus was not Caucasian, but Semitic. His face would have been rounded and Mediterranean, not elongated and Nordic; his skin, an olive complexion; his eyes, dark; his hair, black or brown—not blond or auburn.[15]

Having forwarded these facts, I shall now progress to different depictions of the Crucifixion—or its abbreviated form, the Crucifix—by three artists who were or are members of The Church of Jesus Christ of Latter-day Saints and two artists who were Jewish. I categorize all these artists as "modern," whether born in the late nineteenth or mid-twentieth century. "Modern" as a stylistic category embraces those who explore abstractions—whether individual or shared—that transcend reality, as contrasted to realists who confine themselves to representations of that which is visible to all. My intention is to demonstrate that modern depictions are not more accurate than previous depictions but have shifted from the concrete to the abstract, from idealized to idea.

First, however, a few thoughts about why LDS and Jewish artists chose to—or not to—depict the Crucifixion, as we are aware it is not a popular subject in either faith. The LDS faith emphasizes the Atonement and the Resurrection, and deemphasizes the Crucifixion. The Atonement, especially the episode in the Garden of Gethsemane, represents Jesus' willingness to save all humanity by accepting upon himself all their sins. The Resurrection, Jesus rising from the dead three days after the Crucifixion, is the symbolic proof that humanity is cleansed of sin and can move forward toward salvation, dedicated to God the Father, Jesus the Son, and the Holy Spirit. This is described better by Orson Scott Card, noted LDS novelist:

> I don't believe that the manner of Jesus' death had anything to do with either the atonement or the resurrection. That's why we Mormons don't use the symbol of the cross on our churches—to us, crucifixion was merely the method that the Romans used to execute those of whom they wanted to make a public example. Had the death been by lethal injection, the effect on our salvation would have been the same.[16]

Jewish artists have avoided the Crucifixion because, quite simply, Jesus is rejected as the Messiah; however, some rabbis have regarded Jesus as a significant reflection of Jewish life in Roman-occupied Judea. Rabbi Emil G. Hirsh, editor of the late-nineteenth-century Jewish journal *Reform Advocate*, wrote in 1894: "The thorny crown; who wears it? ... The lash, who felt it? ... We bore a cross, the weight of which was a thousand-fold heavier than that which Jesus carried to the place of his execution."[17] And Rabbi Irving Greenberg, an orthodox rabbi and Harvard Ph.D., has written more recently, "Out of defensiveness, the rabbis confused a failed messiah (which is what Jesus was) and a false messiah. A false messiah is one who has the wrong values...

. A failed messiah is one who has the right values, upholds the covenant, but who did not attain the final goal."[18] After all, there were many Jewish leaders and sects competing for power during Jesus' time, but the Pharisees—the Temple sect—dominated. For the Jews, the Romans were one in a long line of groups who oppressed Jews because of Christian theology. Regardless of denomination, Christian theology has typically been a bugbear for Jews, leading only to negative consequences: theft of property to expulsion, blood libels to massacres, and attempted genocide.

Trevor Southey. Returning to the goal—modern LDS and Jewish depictions of the Crucifixion—my starting point is an artist who has modernized Carl Bloch, embracing a style that merges the classical ideal of the Renaissance with the depiction of the so-called Nordic Jesus. Trevor Southey, born in Rhodesia and raised in South Africa, converted to the LDS faith and moved to Utah, where he earned two degrees at Brigham Young University (BFA 1967; MFA 1969) and taught art at BYU (1969–1977), before leaving the LDS faith. In the years since, Southey has continued to pursue art-making with frequent inclusion of religious subjects. In his *Crucifixion* we see that art has re-embraced—after the Modernist abandonment of recognizable subjects—the use of the human figure to express psychological concerns. All the same, this is not hard-edged photorealism; rather, the figure is roughed in, not depicted in minute detail, hovering on an ambiguous ground—no foreground, middle ground, or background—and filling the entire picture plane to leave no room for other figures who complete the narrative. This is comparable to preparatory sketches by Michelangelo, unintended as discrete artworks; however, these sketches are the essence of the physical masses he carved and painted. Of note is Southey's palette of soft blues, burgundy, and violet. This is as abstract as Southey gets, saying, "I look at abstract works by other artists with some admiration and some envy. But, the narrative and the rendering of things is something that is so deep in my bones it would be a form of betrayal."[19]

Working also in three dimensions, we see Southey's *Crucified*, a bronze standing 44 inches high, with a 23-inch arm span and 20-inch deep base. The sleek figure of Jesus is nailed to the cross yet hovers as if weightless—without visible sign of strain on the hands or arms—and with an ecstatic facial expression. Dave Gagon, writing about Southey's work in general, describes how Southey's "core work explores the human condition in the tradition of beauty established in Italy by Renaissance masters and continuing on until the turn of the century with Rodin."[20]

Frank McEntire. Continuing to move away from the concrete and toward increased abstraction are two artists, one LDS and one Jewish, who appropriated the Crucifix to their own ends. Frank McEntire—artist, art critic, independent curator, and former Executive Director of the Utah Arts Council—scours flea markets and antique shops for knickknacks of all kinds, quite literally hoarding them in his studio for the moment of inspiration. His often surprising juxtapositions and arrangements can be profoundly delightful and can convey deep meaning. Of his many artworks that incorporate crucifixes, three in particular are metaphoric and poetic reminders of the meaning of Jesus' sacrifice. In *Cricket Cage Crucifix*, he uses a cricket cage, introduced in China to keep crickets for good luck, possibly to symbolize Jesus held captive by the Romans, and his immortal spirit trapped in a mortal body. In *Passage*, McEntire affixes a crucifix to the edge of a door fragment between two knobs, as if commuting from here to there, life/death to Resurrection, body to spirit, Earth to Heaven. In *Ascension*, a white porcelain crucifix is atop a delicate wrought metal stand, as if the pure spirit of Jesus is floating upward from the earthly bounds into the limitless Heaven above. This art is, quite literally, the salvation of the Crucifix—from the humble flea market to the hallowed art space.

Marc Chagall. Rather than striving for salvation of the Crucifix, Marc Chagall placed the crucified Jesus in the context of the anti-Jewish pogroms he witnessed as a child in Vitebsk, Russia, and the mass deportation and attempted genocide of Jews during the Holocaust of World War II he witnessed as an adult. Other eastern European Jewish artists, including Samuel Hirszenberg and Maurycy Minkowski, depicted with harsh realism the loss and despair in daily life. Hirszenberg's *The Black Banner* depicts a funeral procession for a rabbinic leader, but the mourning was also for a way of life that was constantly under threat by anti-Jewish governments and an oft-violent mob mentality.[21] And in Minkowski's *After the Pogrom*, a group of mothers and their children sit in the foreground as others, in the background, leave town with what they can carry. Men are nearly absent, especially young men, as many were killed in pogroms and the rest were often conscripted into the Czar's army.[22]

Chagall, on the other hand, adopted the Crucifix—in *Calvary* (fig. 1) and numerous later artworks—for two purposes: first, as an injunction against primarily Christian anti-Jewish hatred; second, as a reclamation of Jesus as the Jew he was from birth to death. We can see Chagall incorporating the Crucifix in numerous other contexts: in *The Falling Angel* (1923–1947) Jesus' loincloth is a *talit*, a Jewish prayer shawl. *The Crucified* (1944) was a

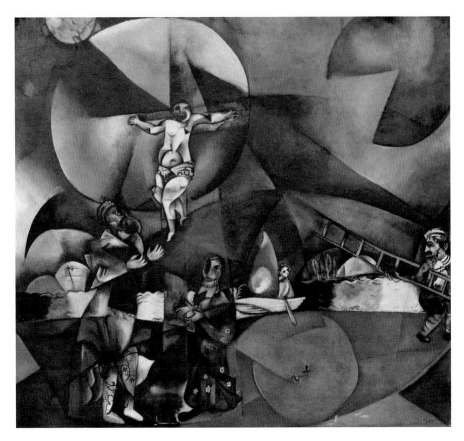

Fig. 1 Marc Chagall, *Calvary*, oil on canvas, 69 in. x. 76 in., 1912. Acquired through the Lilllie P. Bliss Bequest. The Museum of Modern Art, New York, NY. © The Museum of Modern Art/ Licensed by SCALA / Art Resource, NY.

response to mass deportations of Jews via transit camps to concentration and death camps. *White Crucifixion* (1938) was painted immediately following Kristallnacht, an anti-Jewish pogrom in Germany instigated by Nazi anti-Jewish laws. *Exodus* (1952–1966) was a response to the "remnants" of the Jewish population of Europe, rescued from concentration and death camps and housed in displaced persons camps for lack of homes to which to return. Chagall used the Crucifix also in *Resistance* (1937–1948), *Resurrection* (1937–1952), *The Martyr* (1940), *Der Krieg* (1943), *Yellow Crucifixion* (1943), *Crucifixion* (1960), and *Job* (1975).

A quotation from well-known artist Ben Shan, born in Lithuania and immigrated to the United States, expresses a feeling similar to Chagall's, though in reference to the injustice of the 1931–1932 trial of Italian anarchists Sacco and Vanzetti: "Ever since I could remember, I'd wished I'd been

lucky enough to be alive at a great time—when something big was going on, like the Crucifixion. And suddenly I realized I was. Here I was living through another crucifixion. Here was something to paint!"[23] For Chagall, the Jews of Europe were crucified time and again.

Ron Richmond. At last, we reach two artists who move one step further away from representation and toward the metaphysical. LDS painter Ron Richmond, a graduate of BYU's art program (BFA 1987, MFA 1992) and currently a BYU art professor, painted a series entitled *Sacrifice* that probes the mystery of the death of Jesus by crucifixion, the ultimate sacrifice by God the Father of his Son. In *Sacrifice No. 3*, a sacrificial precinct demarcated by four pillars has a centralized altar draped in red cloth. Red is symbolic of love and anger, of the Passion and martyrdom, and of the Pentecost—fifty days after the Resurrection of Jesus when the Holy Spirit descended upon the Apostles who were still in hiding, imbuing them with the knowledge of foreign tongues and compelling them to go out into the world to preach the gospel.

In *Sacrifice No. 4* (fig. 2), we see a purple cloth with gold trim. Purple, a color of royalty because of its rarity in the ancient world, was also a symbol of power and often represents God. Purple also symbolizes repentance and sorrow, and is often worn in the weeks leading up to Easter to represent mourning for the crucified Jesus. Gold, the color of the sun and divine radiance, is symbolic of the revealed truth of the resurrected Jesus.

Sacrifice No. 15, *Sacrifice No. 16*, and *Sacrifice No. 17* offer unique perspectives of the altar and the cloths, symbolic of sins and the sacrifice that leads to salvation. *Sacrifice No. 17* was included at the Sixth International Art Competition, organized by the Museum of Church History and Art in Salt Lake City, and Richmond cites two verses—one from the book of Isaiah and one from the book of Alma—that provide context. Isaiah 1:18: "Though your sins be as scarlet, they shall be as white as snow; though they be red like crimson, they shall be as wool." And Alma 5:21: "There can be no man saved except his garments are washed white; yes, his garments must be purified until they are cleansed from all stain, though the blood of him of whom it has been spoken by our fathers, who should come to redeem his people from their sins." And yet, despite the metaphysical goal, Richmond does not push into complete abstraction.

Barnett Newman. A second artist striving for the metaphysical, who pushed further into abstraction than most before him, was the Jewish artist Barnett Newman, who painted *Stations of the Cross* between 1958 and 1966. The title of the series refers to the meditative and iconographic program

Fig. 2 Ron Richmond, *Sacrifice No. 4*, oil on board, 36 in. x 53 in., 1999. © Ron Richmond.

of fourteen incidents that occurred to Jesus during his walk along the Via Dolorosa, carrying the cross. In accordance with Catholic iconographic tradition, Newman's series is composed of fourteen paintings. However, while Catholic custom is to depict each station as a figural composition to serve as a reminder of the narrative recorded in the Gospels, Newman provides abstraction, the stark contrast of black and white. On grounds of raw canvas, black "zips" bisect the canvas and planes compress the space. According to Harold Rosenberg, these zips "can be conceived as a crucifix against the sky, but without the arms, that is to say, without the specifics of history or mythology, without anthropomorphism, absolutely abstract."[24]

Lawrence Alloway, curator at the Guggenheim Museum, granted Newman his first solo exhibition, titled *Stations of the Cross: Lema Sabachthani*, which opened April 20, 1966. The exhibition was well attended. Some critics, including John Canaday and Dore Ashton, expressed negative reactions to the purported symbolism and significance of these paintings; other critics, like Nicholas Calas, wrote favorable reviews: "Barnett Newman identifies himself with the agony of a compassionate man who was crucified, not with the transfiguration of a mortal being."[25]

To defend the exhibition and the depiction—or antidepiction—of the subject, Newman agreed to a public conversation with Thomas Hess on May 1, 1966. He explained, "But when I call them *The Stations of the Cross* I'm saying that these paintings mean something beyond their formal

extremes. . . . What I'm saying is that my painting is physical and what I'm saying also is that my painting is metaphysical. What I'm also saying is that my life is physical and that my life is also metaphysical."[26] Also in May 1966, Newman wrote about his series, then on exhibition, for *ARTnews:* "I wished no monuments, no cathedrals. I wanted human scale for the human cry. . . . I wanted to hold the emotion, not waste it in picturesque ecstasies."[27]

The series is not a concrete, literal reference to the Passion of Christ; rather, it is intended as a metaphorical reference to the suffering of Jesus, the historical man—not the messianic Christ. We know this in two ways. First, all but one of Newman's references to the crucified man, including in his exhibition statement in the catalogue, are to the historical figure of Jesus—not the messianic persona identified by the Greek or Latin words for messiah (Gk. *Christós*; Lat. *Christi*).[28] Second, Newman's reference points for subtitle and symbolism are two Jewish sources—not the Gospels: Newman indicated during the public conversation with Thomas Hess that the main title, *Stations of the Cross*, was chosen so broader audiences would understand his intended allusion, even though he did not believe in the divinity of Jesus. The subtitle, however, is less familiar: *Lema Sabachthani.* This is Aramaic for "Why hast thou forsaken me," Jesus' final statement while on the cross, recorded in the Gospels of Matthew (27:46) and Mark (15:34); however, the origin of the phrase is Psalm 22 of the Hebrew Bible.[29] No doubt, this parallel was drawn by early Christian theologians to emphasize that the Israelite King David, credited as author of Psalm 22, was supposedly an ancestor of Jesus of Nazareth. In fact, Newman explained his choice of title:

> I could have called the Stations "The Twenty-second Psalm," but that would not have made the point I want to make as well, although the Twenty-second Psalm, the psalmist does ask, "God, why has thou forsaken me?," and there are some of the same elements—the pierced hands, and the throwing of dice for the clothes, and all that. [But if the title were "The Twenty-second Psalm"], I would be making a painting illustrating a poetic expression. . . . Also, since there is a tradition of Stations, as a painter I felt I could make that point more viable within that framework. Otherwise, I could have made one painting and called it "The Twenty-second Psalm."[30]

Ultimately, for Barnett Newman, the story of Jesus' persecution and death signifies the existential search for self. In the Jewish community, this existential search was precipitated by the attempted genocide of the Jewish people

by Adolf Hitler and Nazi Germany's war machine; by anger at and confusion about a God perceived to be distanced, uninvolved, and apathetic; and by an upsurge of synagogue construction and congregation formation that followed World War II. Nevertheless, an ecumenical spirit—especially influenced by Madame Blavatsky's Theosophy, Rudolf Steiner's Anthroposophy, and Christianization as a defense against Communism—had informed much of America's and Western Europe's modernist manifestation of the visual arts, typified by the following assertion from Theodore Adorno: "Works of art are supposed to grasp the universal within the particular, the universal being the hidden principle of coherence of empirical life. They must not cover up the dominant universality of the bureaucratized world by a false emphasis on particularity."[31]

Newman was once quoted, "They say that I have advanced abstract painting to its extreme, when it is obvious to me that I have made only a new beginning."[32] And so, the Crucifixion has inspired new creation in new contexts. The LDS faith—founded by merging Christian roots with Joseph Smith's new revelations—stresses the Atonement and Resurrection of Jesus, but allows for momentary reflection upon the mechanism of his death. In Chagall's and Newman's artworks, Jesus is reborn as a symbol of Judaism; a man oppressed throughout history, but always revived.

NOTES

1. The Passion, from the Latin for "sufferings," refers to the events leading to the death of Jesus (in corporeal form), often including: entry into Jerusalem, washing the feet of the disciples, the Last Supper, the agony in the Garden of Gethsemane, the kiss of Judas and the arrest, trial before the high priest (Caiaphas), Peter's three denials, appearing before the Roman governor (Pilate), scourging (or the flagellation), crowning with thorns and the mocking of Christ, carrying the cross, the Crucifixion, the deposition (or descent from the cross), the Pietà, the lamentation, and the entombment.

2. James Carroll, *Constantine's Sword: The Church and the Jews, a History* (Boston: Houghton Mifflin, 2001), 171–175.

3. Carroll, *Constantine's Sword*, 191.

4. Thomas Aquinas, *Commentarium super libros sententiarum: Commentum in librum III*, dist. 9, art. 2, qu. 2, in David Freedberg, trans., *The Power of Images: Studies in the History and Theory of Response* (Chicago: University of Chicago Press, 1989), 62.

5. For this text, part of the Short Office of the Cross that was first popularized in the thirteenth century, see *Patrologiae Cursus*, series *Latina*, vol. 94, cols. 561–568. Also see James H. Marrow, *Passion Iconography in Northern European Art of the Late Middle Ages and Early Renaissance*, Ars Neerlandica, vol. 1 (Kortrijk, Belgium: Van Ghemmert, 1979), 12.

6. The phrase *pro gloria Dei*, often used to defend the emphasis on visual representations in Catholicism, originates in the Gospel of John (11:4): *Audiens autem Iesus dixit eis infirmitas haec non est ad mortem sed pro gloria Dei ut glorificetur Filius Dei per eam.* (And Jesus hearing it, said to them: This sickness is not unto death, but for the glory of God: that the Son of God may be glorified by it.)

 Invenies staterem illum sumens references the Gospel of Matthew (17:26): *ut autem non scandalizemus eos, vade ad mare, et mitte hamum: et eum piscem, qui primus ascenderit, tolle: et aperto ore eius, invenies staterem: illum sumens, da eis pro me et te.* (But that we may not scandalize them, go to the sea (of Galilee), and cast in a hook: and that fish which shall first come up, take: and when thou hast opened its mouth, thou shalt find a stater [or shekel]: take that, and give it to them for me and thee.)

7. For just few examples demonstrating consistent use of this image throughout ages and styles, see:

 Crucifixion of Jesus and Death of Judas (British Museum, London), Early Christian ivory relief, c. 420–430 CE;

 Sancta Sanctorum Icon (Vatican Museums), Palestinian painted wood panel, c. sixth century CE;

 Nicola Pisano, *Crucifixion* (Pisa Cathedral), carved marble, 1302–1311;

 Giotto di Bondone, *Crucifixion* (Scrovegni Chapel, Padua), buon fresco, c. 1305;

 Andrea del Castagno, *Crucifixion and Saints* (Ospedale Santa Maria Nuova, Florence), fresco, 1440–1441;

 Raphael Sanzio, *The Crucifixion* (National Gallery of Art, London), oil on panel, c. 1503;

 Mathias Grünewald, *Christ on the Cross* (Eisenheim Altarpiece, Colmar), oil on panel, c. 1515–1520;

 Rembrandt van Rijn, *Christ on the Cross* (Parish Church, Le Mas d'Agenais), oil on canvas and wood, 1631;

 Paul Gauguin, *The Yellow Christ* (Albright-Knox Art Gallery, Buffalo, N.Y.), oil on canvas, 1889;

 George Rouault, *The Crucifixion* (Philadelphia Museum of Art), oil and gouache on paper, c. 1918;

 Salvador Dali, *Crucifixion (Hybercubic Body)* (Metropolitan Museum of Art, New York), oil on canvas, 1954.

8. Doyle L. Green, *He That Liveth* (Salt Lake City: Deseret Book, 1958).

9. "Carl Bloch's Art Has Church Connections," *Utah County Journal*, March 21, 2001.

10. Richard Lloyd Anderson, "Discovery: The Ancient Practice of Crucifixion," Neal A. Maxwell Institute for Religious Scholarship, Brigham Young University, Provo, Utah, available at http://maxwellinstitute.byu.edu/display.php?table=transcripts&id=107.

11. Joe Zias, "Crucifixion in Antiquity: The Anthropological Evidence," available at http://www.joezias.com/CrucifixionAntiquity.html.

12. Martin Hengel, *Crucifixion in the Ancient World and the Folly of the Message of the Cross* (Philadelphia: Fortress Press, 1977), 31, citing both E. Brandenburger, "Kreuz," in *Theological Dictionary of the New Testament II*, 10 vols. (Grand Rapids, Mich.: Eerdmans, 1967), 1:826; and Joachim Jeremias, *The Eucharistic Words of Jesus* (New York: Charles Scribner's Sons, 1966), 223. See also sketches of Jehohanan crucifixion by V. Tzaferis, by Joe Zias, and in the Alexamenos Graffito.

13. Joe Zias, quoted in Megan Goldin, "Jesus Scholars Find Faults in Gibson's 'Passion,'" on MSNBC.com (February 25, 2004), and at www.reuters.com/newsArticle.jhtml;type=

enterntainmentNews&StoryID=4424778.

14. Lawrence Schiffman, quoted in Goldin, "Jesus Scholars Find Faults in Gibson's 'Passion.'"

15. See Jim Caviezel from "The Passion of the Christ" (2004); painting by Armenian artist Pasquale Ariel Agemian (1935), based on the Shroud of Turin; and reconstruction based on work by Richard Neave, retired medical artist from University of Manchester, England.

16. Orson Scott Card, "The Passion of the Christ—Three Reviews and a Letter," *Ornery American*, February 29, 2004, http://www.ornery.org/essays/warwatch/2004-02-29-1.html. [The review first appeared in print in the *Rhinoceros Times*, Greensboro, N.C.; and was included in several other web sites such as meridianmagazine.com.]

17. Emil G. Hirsh, *The Doctrine of Jesus* (Bloch and Newman, 1894), 28, quoted in Stephen Prothero, "Is America's Jesus Good for the Jews?" in the 2005 Swig Lecture, sponsored by the Swig Judaic Studies Program, University of San Francisco, September 22, 2005.

18. Irving Greenberg, "The Relationship of Judaism to Christianity: Toward a New Organic Model," *Quarterly Review* 4 (Winter 1984): 13.

19. Quoted in Shawn Dallas Stradley, "Eyes on Trevor Southey," *15 Bytes* (July 2005): 1, 4.

20. Dave Gagon [of the *Deseret News*], excerpt from his review of Trevor Southey's book *Reconciliation*, http://www.trevorsouthey.com/book.html.

21. Jewish Museum, New York, oil on canvas, 1905.

22. Jewish Museum, New York, oil on canvas, c. 1910.

23. Quoted in "Show Marks 75th Year of Sacco and Vanzetti Trial," *Yale Bulletin and Calendar*, October 11, 2002, available at www.yale.edu/opa/arc-ybc/v31.n6/story10.html.

24. Harold Rosenberg, *Barnett Newman: Broken Obelisk and Other Sculptures* (Seattle: University of Washington Press, 1971), 15.

25. Nicolas Calas, "Subject Matter in the Work of Barnett Newman," *Arts Magazine* 42 (November 1967): 39.

26. "A Conversation: Barnett Newman and Thomas B. Hess," in John P. O'Neill, ed., *Barnett Newman: Selected Writings and Interviews* (New York: Alfred A. Knopf, 1990), 280.

27. Barnett Newman, statement in *ARTnews* 65 (May 1966): 26–27, 57. He also wrote his series was not fourteen "anecdotes" or "sentimental illustrations"; rather, they were fourteen discrete artworks which "form a complete statement of a single subject." Also see "The Fourteen Stations of the Cross, 1958–1966" in O'Neill, *Barnett Newman*, 190.

28. Barnett Newman, "Statement," in Lawrence Alloway, *Barnett Newman: Stations of the Cross, Lema Sabachthani* (New York: Solomon R. Guggenheim Foundation, 1966), 9. The only occasion upon which Newman referred to the "Passion of Christ"—using the messianic title—was in the interview "Unanswerable Questions," *Newsweek*, May 9, 1966, 100, quoted in O'Neill, *Barnett Newman*, 187–188.

29. There are additional parallels between Psalm 22 and the narrative of the Crucifixion. The psalmist was laughed at and scorned (Psalm 22:7) as Jesus was mocked by the Roman soldiers, made to wear a crown of thorns and carry a scepter, and scorned as King of the Jews—the words painted on a panel hung atop the cross upon which Jesus was crucified. As the psalmist declares his God from the time in his mother's womb (Psalm 22:10), so Jesus is considered the Son of God the Father, carried in the womb of

the Virgin Mary. As the psalmist describes the distribution of his garments based on the casting of lots (Psalm 22:18), so are the Roman soldiers described as casting lots for Jesus' clothes. As the psalmist promises to declare God's name, offer praise and worship, through fear and awe (Psalm 22:22–23), thus is Jesus described throughout the four Gospels of the New Testament. As the psalmist foresees the coming of the Messiah (Psalm 22:28), so did early Christian theologians use Psalm 22 as the prophecy of Jesus' birth, life, and death as the Messiah, the Christ.

30. O'Neill, *Barnett Newman*, 284. Additionally, Newman told an interviewer from *Newsweek* magazine: "I tried to make the title a metaphor that describes my feeling when I did the paintings. It's not literal, but a cue. In my work, each station was a meaningful stage in my own—the artist's—life. It is an expression of how I worked. I was a pilgrim as I painted." Newman, "Unanswerable Questions," *Newsweek*, 100, quoted in O'Neill, *Barnett Newman*, 187–88. This recalls a similar statement by Newman included in "Remarks at Artists' Sessions at Studio 35," in O'Neill, *Barnett Newman*, 240.

31. Theodor W. Adorno, *Aesthetic Theory*, trans. C. Lenhardt, ed. Gretel Adorno and Rolf Tiedemann (London: Routledge, 1984), 124.

32. Barnett Newman, "From *The New American Painting*," in O'Neill, *Barnett Newman*, 180.

Matthew O. Richardson is Professor of Church History and has been a faculty member at Brigham Young University since 1996. He teaches Doctrine and Covenants, The Living Prophets, and LDS Marriage and Family Relations. Richardson served as Associate Dean of Religious Education from 2002 to 2006. He is the recipient of the Robert J. Matthews Teaching award, the Professor of Integrity award, and Brigham Young University's Circle of Honor Award, and he held the Religious Education Teaching of Excellence fellowship for four years. Richardson taught with the Church Educational System and then taught as an instructor in Religious Education at Brigham Young University while completing his graduate degree. Richardson received a doctoral degree in Education Leadership from Brigham Young University, a M.Ed. in Educational Leadership and Curriculum from BYU, and a B.A. in Communications also from BYU. He is a member of the Golden Key Honor Society. Dr. Richardson is married to the former Lisa Jackson of Seattle, Washington, and they are the parents of four children.

Bertel Thorvaldsen's *Christus*

A Latter-day Saint Icon of Christian Evidence

Matthew O. Richardson

IN THE 1950S, THE TEMPLE SQUARE PRESIDENCY (Richard L. Evans, Marion D. Hanks, and Robert McKay) were assigned to find ways to improve missionary work at Temple Square. In 1954, while consulting with Church architect George Cannon Young, who had been working on the idea since the mid-1940s, they began designing a new visitors' center for Temple Square, which they called the Bureau of Information. In 1955, the First Presidency approved the project.[1]

In addition to building a new visitors' center, the Temple Square presidency reworked the guided tours on Temple Square to facilitate a more orderly and informative experience for visitors. The presidency organized significant sites on Temple Square into numbered "stations" where visitors heard short presentations on LDS history and theology. According to George Cannon Young, it was in a planning meeting when Elder Richard L. Evans, Temple Square President and member of the Quorum of the Twelve Apostles, commented, "You know, the world thinks we're not Christians . . . because they see no evidence of Christ on this square. They hear the words, but see no evidence."[2] In response to Elder Evans's comment, President Hanks expressed the need for a "representation" of the Savior that would leave little doubt that Mormons were Christians. The representation, in

his estimation, should be something that would "make an impact upon the world—one that would be world-known and be received without creating controversy."[3] As the group discussed possible images that would meet their criteria, Elder Hanks suggested using a marble copy of Bertel Thorvaldsen's *Christus*.[4] Brother Young was also familiar with the statue. In their proposal to the First Presidency, the group agreed that they would place the statue of Christ on the southeast side of the square "in line with the east spires."[5]

On June 7, 1957, Presidents Evans, Hanks, and McKay and Brother Young joined Wendell Mendenhall, chair of the Church Building Committee, to meet with the First Presidency and present their proposed changes for Temple Square. While the group looked at the map, or "scheme," as Brother Young called it, and discussed the proposed tour sites, the Temple Square presidency paused at the station where they hoped to place a statue of Christ. Even though they felt certain that a heroic-sized statue of Christ should be placed on Temple Square, they were nervous about how the First Presidency might react to such a proposal. After all, statues of Christ had never been a part of traditional LDS worship. Their obvious pause in the presentation caused President David O. McKay to ask, "What is this?" as he looked at the station in question on the map. Before anyone else could answer, President Stephen L Richards, first counselor in the First Presidency, said, "Here is a place for the *Christus!*"[6] The Temple Square presidency were both surprised and delighted by President Richards's comment.

Like Marion D. Hanks and George Cannon Young, Stephen L Richards had previously seen Bertel Thorvaldsen's *Christus*. As part of his 1950 apostolic assignments, President Richards visited missions in Europe, Scandinavia, Britain, and the Middle East.[7] On September 2, 1950, in Copenhagen, President Richards and his wife, Irene Smith Merrill Richards, visited the Church of Our Lady, the home of the original statue. In a letter home, Sister Richards commented, "The statuary of Thorvaldsen's *Christus* and the Twelve Apostles is of course famous and awe-inspiring."[8] While President and Sister Richards wrote no other letters from Denmark, upon their arrival home they described their experience in the Church of Our Lady. According to their son, Philip Richards, they had had an "awe-inspiring experience" while they were in the Danish cathedral. While there, they had gazed at the *Christus* and "the idea was planted" in his father's mind that a copy of this statue needed to be on Temple Square.[9]

While this 1950 experience with the *Christus* was inspirational for President Richards, he had probably already seen a *Christus* in California at Forest Lawn Cemetery, which displayed three *Christus* replicas. In fact,

President Richards commented on having seen a *Christus* statue at Forest Lawn in a 1957 letter to his friend Hubert Eaton, owner of Forest Lawn Cemeteries.[10]

Although President Richards reported that the desire to obtain a copy of the *Christus* was "planted" while in Denmark, apparently he was not in a hurry to purchase a statue. He continued, however, to mull over the idea of eventually obtaining one. LaRue Sneff, who became Stephen L Richards's secretary in 1954, remembered that President Richards expressed a desire to purchase the statue with his own funds and give it to the Church as a gift, hoping that it might be his "legacy" to the Church.[11] Meanwhile, the Temple Square discussions and proposals were all converging to eventually nudge his dream into reality.

Temple Square President Richard L. Evans agreed with President Richards that Thorvaldsen's *Christus* was a good representation of the Savior to use on Temple Square and proposed that the statue be reproduced. Apparently Presidents McKay and Richards had already discussed the *Christus* prior to meeting with the Temple Square presidency, because President McKay turned to him and asked, "Don't you have access to acquire a statue through your association with Hubert Eaton and Forest Lawn?"[12] Stephen L Richards contacted Hubert Eaton the very next day and commissioned the project.

With very little discussion, the two presidencies agreed on an image of Christ to present strong visual evidence linking the Church to Christ publicly. Such an agreement is fascinating because there were so many images of Christ available at the time. Perhaps this decision should not be surprising, however, since Thorvaldsen's *Christus* had made such a distinctive impression upon so many of the group long before their Temple Square involvement. When it came time to choose an image of Christ that fit their specified criteria, apparently they unanimously chose Thorvaldsen's *Christus*. Their confidence in using the *Christus* as their Christian evidence does cause one to contemplate how Thorvaldsen conceived the visual image of Christ in creating his *Christus*.

Bertel Thorvaldsen's *Christus*

In 1820, forty-nine-year-old Bertel Thorvaldsen, a renowned Danish sculptor, returned from Denmark to his studio in Rome with a new commission for a freestanding marble statue of Christ. This statue was to be enshrined in the Church of Our Lady in Copenhagen. Thorvaldsen rarely made notes

detailing his work, so he never really identified specific sources of inspiration for his *Christus*. It would be reasonable, however, to assume that Thorvaldsen was influenced by the art he viewed, studied, sculpted (either copied, created, or both), and owned. Thus, rather than being influenced by a single tradition or culture, Thorvaldsen's visual conception of Christ was most likely influenced by multiple artists, styles, traditions, and images.

Thorvaldsen embraced neoclassical styling and was considered one of Europe's most sought-after and well-known sculptors by 1822. Neoclassical sculpture emulated the classic Greco-Roman forms but avoided dramatic, ornamental, twisting poses and colored marble that were popular during the Baroque period. Instead, neoclassicism embraced noble and idealized forms and was usually expressed in white marble. Thorvaldsen was exposed to sculpture from classical antiquity, since he copied many well-known Greek figures such as the Greek Shepherd and Apollos during his early formative years. It is interesting to note that these particular figures greatly influenced conceptions of Christ during the early Christian periods.

Thorvaldsen also collected classical Greek figures for his private collection. One of these was of Asclepius, the Greek god of healing. This figure may have directly influenced Thorvaldsen's portrayal of Christ in the *Christus*.[13] Asclepius stood with his weight placed upon his back leg and wore a mantle over his left shoulder leaving the right portion of his chest exposed—similar to the *Christus*. In considering the Greek influence on his work, Thorvaldsen reportedly said, "I certainly know that when I have passed away, they will say about my Christian figures that they are Greek and that is correct, inasmuch as without the lessons from the Greeks you cannot work in a proper and comprehensible way."[14]

It may be argued that Thorvaldsen's Danish heritage contributed more to his conception of the image of Christ than has otherwise been thought. Contrary to what most would assume, the early Danish images of Christ were not the "Nordic Jesus" images that portrayed Jesus as a stereotypical Dane—light-skinned, blue eyes, light-colored hair, etc. In truth, the Christian images of early Denmark embraced a Byzantine flair more than they reflected the appearance of the locals. According to legend, in AD 988 in Constantinople, the Varangians, or guards of the Byzantine Emperor Basil II, were actually Scandinavians. It is believed that they brought the culture and influence of the eastern empire with them upon their return sometime after AD 1200. Thus, the early images of Christ in Denmark are thought to have both western and eastern influence. Images of a young and beardless Christ that were used in the early church were supplanted with the Byzantine form

that conceived of a Christ with his hair parted in the middle, a bifurcated beard, and a slender, long, and straight nose.

It is thought that these Byzantine images of Christ were actually conceived according to the Mandylion tradition, which became an early icon of Christ. The Mandylion tradition stems from a legend that the ailing King Abgar of Edessa (Ufra, Turkey) sent a messenger to ask Jesus to come heal him. Jesus instead sent a cloth that he had pressed against his face and which retained his features. This cloth, first called the Image of Edessa, later was known as the Mandylion.[15] In 944, the cloth was brought to Constantinople, then disappeared around 1247, leading some to believe that the Shroud of Turin is actually the Mandylion. Regardless of the authenticity of the tradition, the similarities of these Byzantine facial images of Christ and the *Christus* are strong and distinctive.

Thorvaldsen was also influenced by the artists of the Italian High Renaissance, whom he studied and admired. He was particularly fond of Raphael, and as an avid collector of art, Thorvaldsen owned an etching of Raphael's *Christ Presenting the Keys to Peter* in his private collection. This painting depicts a bare-chested Christ with his robe draped across his left shoulder and resembles Thorvaldsen's *Christus*. In addition to the masters, Thorvaldsen's contemporaries likely influenced his work as well. Vincenzo Camuccini (1773–1844) and Peter Von Cornelius (1783–1867), for example, are two artists whose paintings and sculptures have striking commonalties with Thorvaldsen's *Christus*. While Thorvaldsen was teaching at the Academy of Saint Luke in Rome, he became acquainted with Camuccini and his 1805 *St. Thomas the Doubter*, which presents Christ in a similar posture: weight on his rear foot, lance mark on the right side, and robe draped from the left shoulder. Finally, Peter von Cornelius's 1813–1816 painting *The Five Wise and the Five Foolish Virgins* has striking similarities with Thorvaldsen's *Christus*. This painting, on loan from Cornelius, actually hung in Thorvaldsen's Rome apartment for years prior to Thorvaldsen creating the *Christus*.[16]

In 1821, Thorvaldsen turned over his sketch model of the *Christus* to Pietro Tenerani (1789–1869), Italian sculptor and student of Thorvaldsen, to model the *Christus*. The *Christus* made its debut in Copenhagen as a plaster cast at the consecration of the Church of Our Lady on June 7, 1829. The final marble carving of the *Christus* was shipped from Italy in May 1833 and arrived in Copenhagen six months later. It was then moved into the Church of Our Lady in November 1833 and finally mounted in May 1839.

Thorvaldsen's *Christus* become popular during the nineteenth century. Before the final copy of the *Christus* was even mounted, copies were already being made for other locations. In 1833, for example, Thorvaldsen had the statue copied in reduced size for the Cathedral of Krakow on Wavel Hill in Poland (mounted in 1835). After Thorvaldsen's death in 1844, the statue continued to be copied and displayed in Europe and throughout the world. The first known American copy was installed in the Johns Hopkins Hospital in Baltimore, Maryland, in the autumn of 1896.[17] Mass fabrication of the statue was also done in porcelain, plaster, and wax, making it impossible to number the replicas and copies of the *Christus* made since its first casting in 1822. Although the statue's popularity began to wane during the twentieth century, it was already established as a "world-known" image of Christ and was well received without notable controversy.

The *Christus* for the Latter-day Saints

With the decision to use Thorvaldsen's *Christus* as the Christian evidence the Church was seeking, Stephen L Richards contacted his long-time associate and friend, Hubert Eaton of Forest Lawn Cemetery in California on July 8, 1957, and inquired about obtaining a suitable copy of Thorvaldsen's *Christus*. After some deliberation and planning, President Richards contacted Eaton again on April 22, 1958, to order a full-size copy of Thorvaldsen's *Christus*.[18] Since the *Christus* statue is not copyrighted,[19] Eaton was free to find a suitable sculptor without restrictive stipulations. While vacationing in Italy, Eaton commissioned Rebechi Aldo & Gualtiero, a marble studio in Pietrasanta, Italy, to carve the *Christus* out of white, statuary marble from the pits in Carrara, Italy.[20]

Rebechi Aldo & Gualtiero finished carving the statue in January 1959 and began preparing to ship it to the United States. After completing an assignment in Europe, Stephen L Richards became gravely ill and on May 13, 1959, he died. Two days later, his *Christus* left Florence, bound for San Francisco. Sadly, President Richards never saw the statue that was his legacy to the Church. The *Christus* arrived in San Francisco in early June and reached Salt Lake City before the end of the month. The copy measures 11 feet ¼ inch and weighs close to twelve thousand pounds (fig. 1).[21]

With the statue now in the possession of the Church, some people were concerned that a heroic-sized statue of Christ was not a traditional part of Mormon worship. The Church had previously commissioned statuary such as the This Is the Place Monument (1947), the Temple Square statues

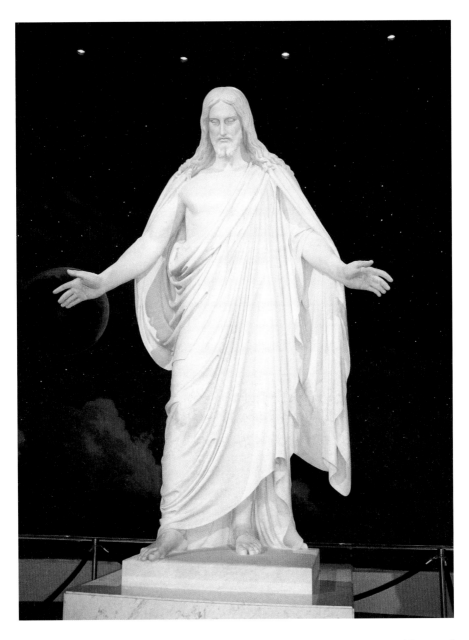

Fig. 1 *Christus*, Temple Square, Salt Lake City. The original statue was created by Bertel Thorvaldsen from 1821 to 1833. This copy was created by Rebechi Aldo & Gualtiero studio in 1959. Photograph courtesy Natalie Rose Ross.

of Joseph and Hyrum Smith (1910), and the Brigham Young Memorial (1893), but the Church has always taken a careful position regarding statuary (especially of Jesus Christ) in places of worship. Some feared that those seeing the statue might worship the statue itself, genuflecting to the marble and not paying homage to the Savior.[22] While this concern was legitimate, it seems to have been short-lived.

Despite initial worries about the statue and worship, by 1959 it was apparent that the *Christus* was a dominant part of the early designs for the new Bureau of Information (now called the North Visitors' Center). In fact, Richard Marshall, a special consultant to the Church exhibits and displays at the time, recalls that the center was literally designed around the *Christus* as the "cynosure" of the structure.[23]

While the visitors' center was under construction, the First Presidency determined that the Church would be involved with the 1964–65 New York World's Fair.[24] It was decided to build a temporary pavilion, and once again the *Christus* played a predominant role in the design of the pavilion. A heroic-sized statue would communicate that Latter-day Saints were Christians, immediately and with visual clarity. The Church Information Service Committee (CIS) recommended that the *Christus* statue in Salt Lake be sent to the World's Fair, since the visitors' center was not yet complete. However, when Brother Marshall began to make arrangements in early 1963 to ship the *Christus* to New York, he found that he could actually commission another statue in Italy and ship it to New York for the same price as sending the Richards statue from Salt Lake City to New York.[25] As a result, Brother Marshall contacted Forest Lawn Cemetery and arranged to commission another copy from Rebechi Aldo & Gualtiero.[26] The second *Christus*, cut from the same casting as the Richards *Christus* and hence its exact duplicate, was finished in January 1964. It arrived in New York in March and was placed in the pavilion shortly afterward.[27] Meanwhile, the first *Christus* remained crated in the visitors' center rotunda in Salt Lake City.

In New York, the overwhelmingly positive responses to the Mormon pavilion were quite unexpected. Because of these positive responses and visitors' requests for more information, missionary efforts were impacted for years to come, public attitudes were changed, and the Church felt encouraged to approach missionary work and displays differently.[28] The statue's success also decisively removed worries that a statue of Christ might be seen as too great a departure from traditional Mormon worship. Rather, the New York World's Fair sparked new confidence for the Church to continue its

planned exhibitions for the new North Visitors' Center on Temple Square and future public exhibitions and displays.

Following the New York World's Fair, the second copy of the *Christus* was moved to the visitors' center adjacent to the Los Angeles Temple. Encouraged by the positive experience in New York, the Church announced in 1969 that it would participate in the World Exposition to be held in Osaka, Japan.[29] Again Thorvaldsen's *Christus* would serve as a visual announcement that the Latter-day Saints were indeed Christians. Since both statues of the *Christus* were on permanent display in Salt Lake City and Los Angeles, Richard Marshall commissioned a third statue, this time negotiating directly with Rebechi Aldo & Gualtiero on the commission.[30] In the early stages of development, the design committee contemplated several different sizes of the *Christus* statue to be used in Japan, settling on one that was 9 feet 6 inches tall and weighed ten to eleven thousand pounds.[31] In early 1970, the *Christus* was shipped from Florence, Italy, directly to Osaka, Japan, and was placed in the pavilion in preparation for the opening of the Expo on March 15, 1970. After the Expo closed on September 13, 1970, the third *Christus* statue was stored in a warehouse in either Osaka or Kobe for the next six years.[32] Finally, in March 1977, the statue was shipped to New Zealand to be displayed in the visitors' center in Hamilton on Temple Hill.[33]

The success of the *Christus* statues in confirming the Church's Christianity encouraged its use in the Church's larger visitors' centers as well, while its success at the visitors' centers in Salt Lake City, Los Angeles, and Hamilton, New Zealand, impacted the future course of exhibits in the Church. Between 1979 and 1988, the Church commissioned four more statues for visitors' centers in Laie, Hawaii (1979), Mesa, Arizona (1981), Mexico City (1983), and Washington, D.C. (1988).

Two years after the Washington, D.C., statue was put in position, the *Church News* reported that a "miniature statue of the *Christus*" would appear in the newly enlarged visitors' center in Nauvoo, Illinois.[34] Clearly, the Church was still interested in using the image of the *Christus* in its displays because the image fit comfortably with the Church's objectives. In addition, the statue had achieved a familiar association with the Church through the fairs and visitors' centers. Rather than create a smaller marble statue, the Church Department of Missionary Exhibits and Displays sought a way to produce the statue more economically. As a result, a new artist was used to replicate Thorvaldsen's work as well as a new medium.

In September 1990, Stacey Goodliff, Department of Missionary Exhibits and Displays, contacted 3-D Art, a fiberglass company in Kearns, Utah,

and commissioned the next generation of statues. Owner LaVar Wallgren asked J. Dell Morris, an art instructor at the University of Utah, and Dee Jay Bawden, one of Morris's former students, to work on the project.[35] They produced an eight-foot clay model of Thorvaldsen's *Christus* from which they created a fiberglass mold. The fiberglass statue created from the mold was then sprayed with a marble coating. This process took only thirty working days and weighed only 250–300 pounds.[36] This innovation set the standard for the Church's *Christus* statues from then on. Fiberglass versions of the *Christus* are located at the visitors centers' in Nauvoo (1990), Oakland (1992), St. George (1993), Palmyra/Hill Cumorah (1995), the Icelandic Immigration Museum in Reykjavik (2000), Independence, Missouri (2006), and Idaho Falls (2007). Another fiberglass copy known as the "Traveling *Christus*" was first used at the San Diego temple open house in 1992 and has since been on display at temple open houses throughout the world. Literally millions of people have viewed the "Traveling *Christus*" alone.

Conclusion

Using the image of Thorvaldsen's *Christus* to imprint the Church's position of Christianity fit well for the Church; furthermore, the *Christus* has become increasingly identified with the Church. In addition to the statues in visitors' centers, the *Christus* has been seen by countless individuals in the Church's media productions, advertisements, pamphlets, open houses, videos, and magazines and on two official Church websites (www.lds.org and www.mormon.org). It is not surprising then that so many identify the image of the *Christus* with the Latter-day Saints. For example, when Reverend Thomas A. Baima, an ecumenical officer for the Catholic Church's Archdiocese of Chicago, saw a foam board cutout of the *Christus* at the Parliament of World Religions in Chicago, he commented: "I immediately identified the exhibit as being from The Church of Jesus Christ of Latter-day Saints."[37] Thus, for Latter-day Saints and non–Latter-day Saints alike, the *Christus* has become a familiar representation of The Church of Jesus Christ of Latter-day Saints—an icon of sorts. It is ironic that what some have considered "a veritable emblem of the Protestant faith"[38] has, in many ways, become to many an icon of The Church of Jesus Christ of Latter-day Saints. While it is impressive that the Temple Square presidency had the foresight to realize the need for visual evidence that the Latter-day Saints are indeed Christians, it is even more impressive that the image they chose has continued to fulfill their expectations so well for nearly fifty years.

Notes

1. George Cannon Young said that he approached Marvin O. Ashton, then first counselor in the Presiding Bishopric (1938–1946), and suggested remodeling the existing Bureau of Information (dedicated 1902). After some study, it was decided that the building was not worth preserving and should be replaced. On March 3, 1955, Presidents Evans, Hanks, and McKay and Brother Young presented their proposal to the First Presidency, who approved it on April 7, 1954, and appropriated a budget of $1.5 million on June 22. See George Cannon Young, Oral History, interview by Paul Anderson, 1973, transcript, 9, James Moyle Oral History Program, Church Archives, The Church of Jesus Christ of Latter-day Saints, Salt Lake City; George Cannon Young, Appointment Books, 1954, Special Collections, J. Willard Marriott Library, University of Utah, Salt Lake City. The appointment books contain figures, notes, and dates that confirm these events.

2. Young, Oral History, 9.

3. Marion D. Hanks, interview, March 15, 2000, notes in author's possession.

4. Hanks said that he had seen Thorvaldsen's *Christus* earlier, possibly in Copenhagen, and had been impressed by it. Hanks, interview. George Cannon Young had seen one of the Forest Lawn *Christus* copies prior to this meeting. George Cannon Young, Biography, January 17, 1980, transcript, 7A-6, Special Collections, Marriott Library.

5. This site was sometimes referred to as station #7 on the proposed tour layout and is located between the temple and the South Visitors' Center. Young, Biography, 7A-5.

6. Young, Biography, 7A-6; Marion D. Hanks, interview; and Young, Oral History, 9.

7. Philip L. Richards, interview, March 15, 2000, notes in author's possession; see also Philip L. Richards, "Christus," *Ensign* 22 (January 1992): 79; Philip L. Richards, "An Inspiration to So Many People," *Church News*, published by *Deseret News*, June 13, 1992, 7. In addition, a travel itinerary of this trip in 1950 and letters to family members with details of this trip are found in the Stephen L Richards Collection, L. Tom Perry Special Collections, Harold B. Lee Library, Brigham Young University, Provo, Utah. See also W. Dee Halverson, *Stephen L Richards, 1879–1959* (Salt Lake City: Heritage Press, 1994), 144.

8. Irene Smith Merrill Richards, letter to her children, September 2, 1950. Her letters were bound in a family-produced volume, *Dear Children*, copy in possession of Philip L. Richards.

9. Philip L. Richards, interview.

10. In 1925, Forest Lawn Cemetery had acquired a small marble replica of the *Christus*. A full-size marble copy arrived in 1946. In 1947 a small (3 feet 2 inches), yellow replica was added. Margaret Burton (Forest Lawn Cemetery Museum Curator), interview by telephone, March 17, 2000, notes in author's possession.

11. LaRue Sneff, interview, April 2000, notes in author's possession.

12. Hanks, interview. Richard L. Evans, Memo to Stephen L Richards, June 7, 1957, Stephen L Richards Papers, also confirms that the location of the *Christus* was "settled in meeting" and gives the statue's height as 11 feet 3 inches.

13. Thorvaldsen's private collection included several copies of *Asclepius*. Torben Melander, "Antik Skuptur—restaureret, kopiieret og burtfort," in *Kunst og Live I Thorvaldsens Rom* (Copenhagen: Thorvaldsen Museum, 1992).

14. Anne-Mette Gravgaard and Eva Henschen, *On the Statue of Christ by Thorvaldsen* (Copenhagen: Thorvaldsen Museum, 1997), 25.

15. Mandylion, meaning "little handkerchief." The Mandylion was also known as *Akheiropoietos*, "not made by human hands."

16. Dyveke Helsted, Eva Henschen, and Bjarne Jornaes, *Thorvaldsen* (Copenhagen: Thorvaldsen); Gravgaard and Henschen, *On the Statue of Christ*, 43–44.

17. The Johns Hopkins statue, often called *Christus Consolator* or *The Divine Healer*, was commissioned by local businessman William Wallace Spence for $5,360 in 1889. Executing the statue—10 feet 6 inches tall and weighing six tons—took seven years. Randi Henderson and Richard Marek, *Here Is My Hope: A Book of Healing and Prayer: Inspirational Stories from the Johns Hopkins Hospital* (New York: Doubleday, 2001), 2–3.

18. Thorvaldsen's original Christus is 345 cm. According to Forest Lawn's records, the statue that Elder Richards ordered was to be a precise copy of the original—measuring 135 inches, or 11 feet 3 inches. Burton, interview.

19. Although there has been some concern regarding the replication of the *Christus* and possible copyright violation, Thorvaldsen's Museum in Copenhagen confirms that "there isn't any copyright concerning the statue of Christ, except an unwritten obligation to respect the common rules of ethics." Gitte Smed (Assistant, Thorvaldsens Museum), e-mail, March 19, 2002.

20. The specifications appear in a contract sent to President Richards from Rebechi Aldo & Gualtiero studios on August 12, 1958, Richards Papers. This price of $10,000 also included commissions, shipping, customs, etc. Young, Oral History, 11. According to Forest Lawn's curator, the total cost of the statue itself would have cost no more than $9,000. Burton, interview. Because President Richards's personal donation is considered private, the records documenting the actual cost are not made public.

21. Measured by author, March 2000.

22. Florence Jacobsen, interview, March 13, 2000; Richard J. Marshall, interview, St. George, Utah, March 21, 2000, notes in author's possession; Young, Oral History, 9.

23. Richard Marshall, interview, May 23, 2000.

24. Irene E. Staples, 1976, Church Archives; Brent L. Top, "Legacy of the Mormon Pavilion," *Ensign* 19 (October 1989): 22–28.

25. According to George Cannon Young, he would not let anyone get near the crate without President David O. McKay's personal permission. He also said that just removing the rotunda roof, the glass, or both would equal the cost of a new statue. Young, Oral History, 11; Young, Biography, 7A-10.

26. Although Forest Lawn arranged the commission, Brother Marshall oversaw the project, even visiting Rebechi Aldo & Gualtiero studios in Italy to evaluate progress. Marshall, interview, March 21, 2000.

27. Young, Oral History, 11; Marshall, interview, March 21, 2000.

28. Top, "Legacy of the Mormon Pavilion," 28.

29. The Church also participated in the San Antonio Hemisfair (1969) and a smaller exposition in Montreal, Canada (1967). These exhibits were smaller and less costly than the New York and Japan pavilions. While it is certain that the *Christus* statue was not used in either, it is unknown whether a photograph or cutout of the *Christus* was used in one or both.

30. Marshall, interview, March 21, 2000; Richard Marshall, interview, May 22, 2000.

31. Building Division, Minutes, March 27, 1969, Church Archives.

32. While the exact location is uncertain, Suzuki, interview, April 7, 2000, and Cheiko Okazaki, interview, Salt Lake City, April 2000, notes in author's possession, both felt that the statue was stored in either Kobe or Osaka. The length of time is suggested by Elder Mark E. Petersen, Memo, March 8, 1976, Historical Sites File, s.v. "Christus," Church Archives: "I do know of one other copy which was made for the world fair in Japan. It is still in Japan." Historical Sites File, s.v. "Christus Statue," Church Archives.

33. Albert Zobell, Church Historical Librarian, a statement by Zobell not directed to anyone, to be placed in sites file, March 9, 1976, Historical Sites File, bears a handwritten note by an unidentified writer: "Now in New Zealand, Mar. 1977- Exhibits." Glen Rudd, emeritus member of the Second Quorum of Seventy, found notes in a "day book" indicating that the statue arrived in New Zealand in 1977 when he was Zone Director of Welfare Program in the Pacific.

34. Dell Van Orden, "Nauvoo," Church News, June 16, 1990, 3.

35. LaVar Wallgren, interview, Kearns, Utah, June 2, 2000, notes in author's possession. Dee Jay Bawden was inspired by the Christus in Salt Lake City as a teenager and felt impressed to prepare himself for sculpting images of the Savior in his future. Dee Jay Bawden, interview, February 28, 2007, notes in author's possession.

36. The statue was delivered to Nauvoo by October 6, 1990. Wallgren, interview, June 2, 2000. It is estimated the cost of the fiberglass Christus is one-eighth of a marble statue of comparable size. LaVar Wallgren, interview, Kearns, Utah, January 8, 2003, notes in author's possession.

37. Gerry Avant, "Parliament of World's Religions," Church News, September 11, 1993, 3.

38. Gravgaard and Henschen, On the Statue of Christ, 55.

Pat Debenham earned a masters degree at UCLA and has been an artist and educator for more than thirty years. He is Professor of Contemporary Dance and Music Theatre at Brigham Young University, a Certified Laban/Bartenieff Movement Analyst, a master teacher for the Utah Arts Council, and was codirector of Contemporary DanceWorks—a semi-professional modern dance company in Utah for fifteen years. His choreography, workshops, presentations, and published papers demonstrate how Laban principles can be woven into and through dance curriculums that focus on teaching, performing, composition, and research. He has presented nationally and internationally on a variety of subjects and he has published in *BYU Studies* ("The Seduction of Our Gifts"), *Research in Dance Education*, *The Journal of the Utah Academy*, the *NAHE Interdisciplinary Journal*, *Contact Quarterly*, and most recently *The Journal of Dance Education*. Recently his wife Kathie, their three dancing daughters, two grandchildren, and three sons-in-law produced a lively and artistically satisfying concert entitled "Debenham Dance." It was a grand event.

Reading the Body of Christ in Art, Theatre, Film, and Dance

Pat Debenham

IN THE PAST TWENTY-FIVE YEARS, LATTER-DAY SAINT artists have produced an unprecedented amount of faith-based art, resulting in an abundance of images that can be purchased in LDS bookstores; music produced by vocalists, instrumentalists, lyrists, and composers; stage plays and films that have been produced by both the Church and commercial enterprises; and dances choreographed by LDS dancers. For many members of The Church of Jesus Christ of Latter-day Saints, art is an expression of faith. Woven into the fabric of their works are concepts and doctrines that celebrate the grand themes of the Restoration.

I delight in this explosion of faith-based art. However, as I reflected on this phenomenon, I realized that although paintings, films, and pageants are replete with representations of Christ, I have never seen a dance in which Christ was either an actual or an implied figure.[1] As a dancer and choreographer in the LDS community for more than thirty years, I began to wonder if there were some unspoken rule that made it inappropriate to depict Christ as an active, physical being who experiences himself and the world with weight, strength, and an expressive, dynamic range. Is it sacrilegious to portray Christ as moving, perhaps even dancing? Is this limitation a personal, cultural, or doctrinal phenomenon?

I have long felt that in most representations I encounter, Christ is portrayed as static, stiff, and, perhaps worse, passive. More often than not, my response to what I see is a recognition that an image may be beautifully rendered and may richly illuminate a story of the Savior's expansive ministry, but may still feel hollow and passionless, with Christ almost floating on the page. Perhaps the artists who create these images are consciously portraying him as being "in the world but not of the world." It may be too that these artists are attempting to portray the humble Christ, the meek Christ, the caring Christ, and the teaching, inviting Christ. As important and essential as such qualities are, as rendered they often lack vitality. As a mover and a dancer, someone who enters the world and understands it through concrete, physical experiences, I long for images where I can participate in a painting or production and kinesthetically feel his impact. I long to know, in a sensate way, that he lived.

This paper explores how Christ is represented in the visual and performing arts. The major portion of the paper focuses on visual images in which the physical body of Christ is used to illuminate eternal truths of the gospel. I explore how doctrinal and cultural mandates about the body affect the images we create, display, and accept. I also discuss how our cultural and personal aesthetics determine the kinds of depictions of Christ that are produced. I then examine existing images of Christ with more physical awareness in order to understand them in a more kinesthetically compelling way. Most importantly, this paper is a call to action, a call to reconsider the way we perceive ourselves as creators and consumers of art.

The Nature of the Body and an Active Christ

In profound and unacknowledged ways, the attitudes we have about the body shape our ideas about how Christ ought to be represented physically in the arts, specifically in theatre and dance, where the body is the primary expressive instrument. I believe that the major concern many members of the Church have with depicting a dancing Christ is due to a misdirected understanding about the eternal nature of the body and its relationship with the spirit. All children of God are patterned after an eternal image, organized in the similitude of our Father in attribute and structure. Although we glory in many aspects of this eternal similitude, we do not fully understand the eternal implications of having a physical tabernacle.

We live in a world, both within and without the Church, that associates the body, the instrument of my art, with the Fall of Adam and Eve; our

passions and our carnal natures doom us to a fleshy, earthly existence. At some level, we distrust our bodies, blaming them for our sins and our short-comings. They are awkward and clumsy; they decay. Consequently, we think they are a less heavenly, less celebratory aspect of our existence.

Knowing what we do about our own telestial physical natures, we may not wish to see a physical, human, dancing Christ because we feel it might diminish him in some way. Dancing is an art of passion. In dance, the body makes visible, through discipline and sweat, our powerful, sensual, gendered selves; to portray a dancing Christ might imply that he is susceptible to his passions and vulnerable to the bonds of carnality. Dance makes visible the eternal principle of opposition in all things, a principle that we may fully comprehend only in the eternities.

But why is a moving Christ less than divine? He who organized matter, who moves both heaven and earth, is an active agent in the universe. As he created worlds without end, did he sit straight-backed on a throne, in some far-off realm, pointing at the universe to affect change? On the contrary, I envision a Christ who interacted in a co-creative, accommodating way with the elements, similar to how I create a "world" of my own in performance and choreography, as unsophisticated as my method may be compared with his. When Christ was on the earth, did he not bend down, lean forward, and cradle a foot in his hand as he washed and anointed it? As I consider the events of his life, I envision both an earthly and a heavenly Christ who manifests his presence not only spirit to spirit but *body to body* by showing us, through his touch, how we ought to lift, support, and work for the good of each other. [2]

Body and Spirit in Opposition or in Union

Culturally, there are subtle but pervasive concerns about the body that cause members of the Church to lose sight of the doctrine and destiny of the soul. In spite of revealed latter-day truths about the body,[3] we still unconsciously reinforce a Cartesian sensibility that the body and the spirit are at odds with one another, polar opposites on a continuum that vertically stretches between earth and heaven, the spirit being more connected to God than the telestial body is.

We know that body and spirit will be inseparably linked in our post-mortal existence, but we sometimes view the body as a temporary inconvenience that will be less problematic in the hereafter. We believe our spirit ascends to heaven only when the body is made subservient, suggesting that

the body needs to be trained, not the spirit. This belief subjugates the body to the spirit and negatively affects our understanding of the body. This view is particularly troubling as it plays out in art.

But this view is merely a cultural perception, not a doctrinal truth. While members of the Church may accept this take on the relationship of the body to the spirit, many Church leaders confirm that "it is not the physical body that we are struggling with; it is the spirit we must bring into subjection."[4] Rather than being a force that drags us down to sin, the body actually liberates the spirit. "The union of the body and spirit is something that is wonderful, joyous and great. . . . The body open[s] up great horizons for all of us."[5] As a dancer, I instinctively understand this principle.

Conceptually, body and spirit are no more hierarchal than justice and mercy. To fully understand the spirit and its place in the eternal plan, it must be understood in relation to the body. Stephen E. Robinson, professor of ancient scripture at BYU, clarifies the coeternal nature of the spirit and the body when he explains:

> For Latter-day Saints there is no ultimate incompatibility between spirit and matter or between the spiritual and the physical realms. In LDS theology, the physical elements are coeternal with God. The idea that physical matter is transitory, corrupt, or incompatible with spiritual or eternal life is rejected.[6]

Rick Jepson reinforces the point Professor Robinson brings to the fore, highlighting a doctrinal truth that sets the Church apart from almost all major belief systems:

> I believe physical events *are* spiritual. Our doctrine suggests as much: "There is no such thing as immaterial matter. All spirit is matter" (D&C 131:7). All of our "spiritual" experiences have physical components. And if our spiritual experiences are all physical, it follows that the reverse is also true—our physical lives are intimately connected to our spiritual lives.[7]

For me, this idea affirms the material and the eternal nature of both my body and my spirit and allows me to consider them jointly, holistically. Viewing them in any other way causes trouble; when the body is pitted against the spirit, it is the body—my dancing body—that loses.

The LDS doctrines of earthly corporality and eternal embodiment weave together the human and the divine. Jesus Christ has only one nature, in which the divine is perfectly united with the human.[8] His incarnation, or

"enfleshment," is not at odds with his divinity, and neither is ours. Before we are able to accept a Christ incarnate in the arts, we must first begin to accept our own physicality as essential to our divine destiny.

Personal and Cultural Conditions That Shape Our Representations of Christ

Along with the previously mentioned issues about the body, a number of personal and cultural conditions shape the way we create and perceive images of Christ. Examining these conditions provides insight into why specific types of representations dominate the visual landscape and why we do not often see images of a physically sensate Christ.

Acceptable images of Christ are culturally constructed. The normative, acceptable LDS image of Christ is presented by the Church and reinforced by the community collective. It often reflects the "face" of the community; we "have a Christ that looks like us because we want to see our face in him."[9] The image has changed over time; recently we have adopted a northern European- or Scandinavian-looking Christ,[10] but the images of Christ that I grew up with were far less tidy than the trimmed Christ we see now. Our current culture prefers the meek, longsuffering, comforting, reverent Christ—often resulting in images that are unassertive and disconnected.

Our understanding of the scriptures and our personal spiritual experiences affect what images we respond to. If our experiences have been dynamic, quiet, joyous, comforting, or peaceful, our expected image of Christ would embody those qualities. However, if our experience has been strong and specific, perhaps no image will adequately represent it. Is there an image that represents Christ as "the Lion of the tribe of Juda" (Rev. 5:5) or the powerful "Wonderful, Counsellor, The mighty God, The everlasting Father" (Isa. 9:6)? Sterling Van Wagenen, director of two of *The Work and the Glory* films, has no representations of Christ in his home because he feels any visual representation pales in comparison with the personal connection he has with Christ.[11]

Personal need fashions our image of Christ. If I need a Christ that is a caring older brother, I may respond to representations of Christ embracing those in the picture. If I need forgiveness, I might look for a compassionate, yielding Christ who will absolve me from my transgressions. If I am seeking truth, perhaps my Christ is a teacher who imparts the doctrines of the gospel to small groups of followers.

What we want to see most of all in Christ is who we are. The images we respond to most strongly are a reflection of what we personally value physically, emotionally, spiritually, and intellectually. For instance, because I respond kinesthetically to the motional components of any work of art, I want to see a moving, dynamically engaged Christ. Because I believe that life is a process, I want to see Christ in the process of his ministry. As another example, when asked what kind of Christ he wanted to see depicted, visual artist Chris Young responded without hesitation, "A virile Christ, of course!" Anyone who knows Chris will understand his response. He not only values the chiseled, athletic form he would like to see—he *is* that form.[12]

These personal and cultural conditions combine in various ways to shape what images of Christ are acceptable and widely distributed. Visual artist James C. Christensen suggests that, at some level, there is a "generic icon" that artists need to honor if they wish to have their images of Christ be accepted (or even recognized).[13] Although a shift to more dynamic images of Christ is already happening in the visual arts, these individual and cultural conditions must undergo a major change for a similar shift to occur in theatre, film, and dance.

Comprehending Art, Life, and the Spiritual Kinesthetically

Regardless of cultural or personal acceptance, any successful work of art is grounded in physical sensation. Even when the intent of a work is abstract, the work arises from tangible experiences. The elements of artistic communication—dance, harmony, word, and form—take their impetus from movement, the messenger between our inner and outer worlds. Lisa Ullmann, a protégé of Rudolf von Laban, made this clear when she wrote, "Man's drive to create is a movement force."[14] In other words, we create and respond to art from a physical place.

We bring physical biases and sensitivities to all our experiences, from social interactions to encounters with works of art. Our somatic experiences form the terra firma from which we ascribe meaning to an image, especially when the body is the vehicle of the message. The stance of the body is a significant indicator of character and through it we "read" the values and attributes of an individual and a culture. By attending to the posture, the shape, and the weight of bodies, and their relationship one to another, we begin to see the meaning imbedded in the movement.

Making Interpretive Kinesthetic Responses— A Shared Physical Language

As we move into the next section of the paper, put aside acculturated preferences for visual processing and consider the world viscerally, kinesthetically, phenomenologically. To do this you will have to reconnect with the part of yourself that trusts physical sensation as a way of knowing. You will have to "feel" your way beyond your immediate visual response to the form, color, light, and surface content of an image. I'm asking that you invest in the physical sensations the work offers you and kinesthetically read the "fleshed out" emotional and spiritual content inherent in the image.

To demonstrate how our shared physical language conveys meaning, I'd like you to consider a few examples. With these examples, I'm not suggesting that there is a universal correlation between every action and its associated meaning, but there are general cultural interpretations that we can make. It is important to recognize that when "reading" any situation or image, context determines meaning. Michael Neff and Eugene Fiume explain that a person's stance relative to an object or another person could be read as a demonstration of interest or possible disdain. A contracted pose with a sunken chest has a possible sad or negative connotation. A torso that leans away might be an indication of repulsion, toward could be attraction.[15] Delsarte, an internationally recognized movement teacher who practiced in the late nineteenth century, suggests that "the elbow approaches the body by reason of humility, and moves outward, away from the body, to express pride, arrogance, assertion of will."[16] If Delsarte's interpretation reflects a cultural perception, we can understand why artists depict a Christ whose limbs are close to his body rather than reaching and stretching out into space.

When we are able to identify the extent to which the physical expresses meaning, and specifically how spiritual qualities can be understood through the physical, perhaps the body and dance will be perceived without suspicion as legitimate territory where the united soul of man can express the hope of the eternities.

Reading the Body of Christ

In the context of all we have discussed to this point, we will now begin to consider images of the Savior. We first examine the physical language of popular images hung in LDS places of worship, used in publications, and purchased by the Saints, paintings I feel are passive, static images of Christ.

Then we will examine images of Christ in which he is dynamically engaged in the world.[17]

As I describe these paintings, consider your response to the way Christ is physically portrayed. Experience the paintings from the inside out, not from the outside in. Allow your body to be the lens through which you experience the image, and notice what impressions come to you physically rather than visually.

Without pointing to any specific paintings, I would like to consider the following types of paintings and the meaning their physical language conveys to me. Many of them are beautifully rendered and tell the story of the Savior with skill and narrative detail, yet in spite of this they leave me wanting. As I describe them, recall similar images that you have seen.

Often Christ is portrayed in a passive fashion. He is soft and retiring. In these images, weight releases down and back into his lower body; his chest sinks and retreats. Often his head tilts slightly, suggesting humility. When I assume this posture, I feel apologetic, lacking the energy to move—never mind lead others. I read this posture as lack of strength, a lack of visible, committed intention.

There are also static, staged images of Christ. In many of these paintings, his spine is straight, rather rodlike. He may be gesturing with the limbs of his upper body, but I feel as though his arms are in a fixed relationship with his spine. In these paintings if he were to rotate side to side or bend forward, his arms, torso, head and neck would move as one unit, maintaining their relationship, like the animated figures in a Disney diorama. When I see someone who has a fixed position or orientation, I perceive their attitudes to be as unbending and unyielding as their posture. They see the future as fixed and predetermined, and I question if they are capable of accommodation and compassion. This doesn't coincide with my understanding of the mission of Christ either as judge or mediator.

One thing I find interesting about the static, staged images is that in almost all cases, from the waist down the body seems inert. Although the upper body connects us to the world beyond ourselves, the lower body allows us to move in order to make those connections. I long for a visual image of Christ that is directional, in motion, and ready to take me with him.

Focus and proximity in passive and static representations of Christ are problematic for me as well. In these paintings, Christ's focus is often everywhere and nowhere. I often feel he has a remote stare that removes him from the present situation. Problems with proximity are often apparent in narratives of healing. Christ often stands, with his torso erect, several feet

away from the person to be healed, his arms extend toward him. Instead of kneeling to meet the person on the ground and leaning toward him with yielding, confirming, healing hands, Christ seems removed by distance. Compositionally this space in the painting may let the viewer see all aspects of the visual image, but the relationship established between the Healer and the healed is distant and removed.

Many variations of the resurrected Christ are static and staged. This Christ often appears in a wall-like shape that stresses both a vertical and a horizontal direction, creating a plane of presentation rather than a plane of communication. I see this plane as a barrier, a lack of access rather than an invitation to connect. In these paintings Christ's head is erect, and he looks out, beyond the figures in the painting, almost beyond the viewer. Sometimes his head is tilted down, and we can't tell if his focus is inward or outward. He is flat, both arms outstretched. He is stiffly planted on two feet in a stance that says, "Come to me. See me. Feel the wounds in my hands." Consider the feelingful, emotional, and spiritual implications of this Christ who invites and yet, at the same time, erects a barrier.

In static, classic depictions of Christ, the Savior either sits or stands and, like the resurrected Christ, gestures with his arms. But his arms are just there, without a significant connection to the center of his body. His gestures seem to point the way for us to follow, but pointing is not leading; it is only directing, much like a disaffected bobby directing traffic from his post on the streets of London. The image of a leader contains a spatial intent and a shaping that conveys a directional intent that these images lack.

Often, even when Christ is central to a painting, I feel he is not actually present in the work. Though visually present in the narrative of the story, his body lacks a connection to the ground, leaving me unsettled. Whether he is sitting, standing, or kneeling, whether he is healing through touch or connecting through an embrace, he seems to be perched, his body mass hovering, as if to say, "I am here only momentarily."

I hope, even without visuals, you get a physical and mental image of how these paintings portray Christ. I don't know how you respond to the physical scenarios that I have just presented, how it felt to have tried them on in your own body, but they leave me wanting. Yet these are, for the most part, the preferred images of the LDS community.

Fig. 1 Walter Rane, *Alma Arise*, oil, 56 in. x 50 in., 2000. Museum of Church History and Art. © by Intellectual Reserve, Inc.

A Crack in the Cultural Landscape

Walter Rane, who has recently had several of his kinesthetically rich paintings purchased by the Church, is changing the cultural landscape. He shared with me the following story about one of his paintings that was being considered for purchase by the Church Acquisitions Committee.[18] Although the painting is not of Christ, I believe this story exemplifies just how deeply embedded our cultural, institutional, and personal values are in the art we create and display. It indicates that a cultural shift, at least in the visual arts, is already in motion.

Rane created a painting of the angel appearing to Alma the Younger and the sons of Mosiah entitled *Alma Arise* (fig. 1). The painting captures the genuine power of the moment, with men being thrown to the ground in an injunction to repent. The heavenly messenger is diagonally and dramatically posed above the men. He is off balance, spine slightly twisted, legs in action behind him in the air. His whole body tilts forward into the horizontal plane, advancing toward the unsuspecting men. His arrival caught them by surprise, and several have been thrown to the ground in fear and panic. With an outstretched arm that is clearly connected to his back, the angel looks directly at Alma with purpose and strength. We know this angel has something important to say and these men need to listen.

Alma Arise was displayed in the Church's International Art Competition, but when the Church Acquisitions Committee first considered purchasing it for the Church, the committee rejected it. The painting was deemed inappropriate because "angels don't act like that. . . . Angels are supposed to be dignified. They are supposed to stand balanced on both feet."[19] However, after eight months, the committee's initial consideration was reversed, and the painting is now hanging in the Conference Center in Salt Lake City.

Rane, who looks to Michelangelo and Caravaggio as "mentors," begins his paintings by first considering the dynamic arrangements of the figures. Though he refers to the arrangements of the persons in his paintings as poses, they are far from static or lifeless. His ideas are best portrayed through compositions that involve the human form in motion. He captures the action of the event with a feeling of movement and dynamic direction, the way we experience life.[20] When I consider and experience his work, I am spiritually and emotionally touched because I am *physically* moved first, almost without knowing it.

For Rane, paintings are not meant to be "snapshots of an event." They are meant to express gospel principles, using the human form "to express [a] testimony plus whatever gospel principle is trying to be conveyed through

the story."[21] Rane knows the power of physical language. Even in paintings that are quiet in nature, he portrays human forms as grounded in the physical reality of the moment, not as staged, static representations. Rane uses posture, shape, weight, and proximity in his paintings to create kinetically charged scenarios in which we begin to see the meaning embedded in the movement.

With the static images of Christ juxtaposed with the kinetically charged scene of *Alma Arise* in your mind, consider now some paintings of Christ in which the physical language is kinesthetically rich and fulfilling. These images, like their static counterparts, are finely crafted and tell a narrative story, but they also reveal the artists' intent in a way that is "fleshed out." These examples move beyond passive, static forms, beyond the visual richness of the work to communicate with the physical as well as the visual, subtly inviting us to respond sensately.

Unlike in the static images we considered before, Christ is an actual physical presence in these paintings. For me there are three general indicators of physical presence: (1) a shared kinesphere or reach space, (2) a spine and torso that shape themselves in response to the environment, and (3) a grounded connection and an awareness of weight. When Christ is present in a painting, both spiritually and physically, according to these criteria, we are affected. Through viewing his presence, we establish a relationship with him. I believe that's the purpose of faith-based art—to establish and reinforce our relationships with Christ.

As you consider the next images, track both your physical and emotional responses and see what they mean to you.[22] I love Liz Lemon Swindle's *Seeking the One*. In it, Christ is going somewhere with purpose; his eyes seem to take in the world with directness. Connected to the ground through his feet, his lower body propels him through the space, indicating that he is a man of action. He tilts slightly to the side, showing he has a natural cross-lateral gait, which makes him appear to be a three-dimensional person. Christ's upper body is comfortably attentive to the world, and the ease of his posture makes me want to walk with him, converse with him, know him.

I empathize with Christ's sense of touch in Simon Dewey's *In Humility*. I feel as though he could be cradling my foot. There is a shared sense of kinesphere, or reach space, in this painting. Christ is not just *in* the space with this person—he *inhabits* the space as well. We feel the curve of Christ's spine as he moves toward the feet of this person. His spine is not stiff and distanced. The enclosing of his shoulders, the roundness of his shape, and his forward attention all bring our focus to the foot of the person being

Fig. 2 Walter Rane, *These Twelve Jesus Sent Forth*, oil, 42 in. x 60 in., 2000. Museum of Church History and Art. © by Intellectual Reserve, Inc.

attended to, not to Christ himself. With a cloth in his right hand, he gently caresses the foot, accommodating to the curve of the arch. His left hand truly supports the weight of the foot by cradling the arch, letting it yield into his hand. Through this proxy, I feel Christ also accepts me, all parts of me, including my weary, dusty feet.

In *These Twelve Jesus Sent Forth* (fig. 2), Walter Rane captures the essence of the everyday, preaching Christ. This depiction is far more appealing, inviting, and human than the pontificating Christ who sits in a wall-like shape, arm upraised, as the center of attention on a rock, followers surrounding him. Through Rane's Christ, I see not only him but his vision of the future. He and his apostles are in an intimate space. He gestures with directional intent. He sees beyond the immediate physical space, and with arm reaching and torso leaning forward, he invites his apostles to participate in his vision of the future. Even his shoulder and scapula support his arm as it extends into space from his back. His focus is direct and clear. The weight and feel of his foot on the rock as he leans forward with intent shows commitment; he is here in the painting with us, his presence confirming the reality of things to come.

Fig. 3 Harry Anderson, *Not My Will But Thine Be Done*, acrylic on fiberboard, 22in. x 29 in., purchased 1961. © Pacific Press Publishing.

Of the many renditions of Christ's experience in Gethsemane, I respond most fully to Harry Anderson's *Not My Will But Thine Be Done* (fig. 3). This painting shows a clear spatial direction and orientation. I feel a tension in Christ's body. His arms are held a foot or so away from his torso and seem to pull inward as if to say, "Please, please not this." The pleading and the torment of the moment are registered in the rotation of his legs against his pelvis. There is also a counter twist in his torso. The weight—the yielding into the ground of his whole body—confirms his presence in the moment. The reaching head, neck and sternum pull to heaven, asking for mercy. And yet, his weight conveys that he is accepting and ready to do his Father's will. Reaching heavenward yet yielding to the earth, he is connected to both. Anderson has captured Christ *in the process* of accepting his role as Savior. This is not a staged event. He captures the majesty of the moment and hints, through the spiraling body parts, of the agony that is to come. Christ's outside form reveals his inner struggle.

In *One by One*, Walter Rane offers us a resurrected Christ that is different than the wall-like Christs already mentioned. His Christ leans forward, embracing with soft, rounded shoulders the woman in front of him. He lets her into his personal space to closely examine the wounds of his hands rather than distancing himself in a trophy-like fashion. His extended arm appears to be pulling her closer in a comforting embrace saying, "It's all right; I have done this for you." By implication, this embrace includes the rest of us.

Simon Dewey's *He Lives* presents the resurrected Christ coming out of the tomb in a way I find kinesthetically satisfying. Though wall-like, this Christ exits the tomb with strength and magnitude that match the event. Rather than being flat and two-dimensional, he moves into three-dimensional space, his torso and spine suggesting action. He is grounded, yet, as would be appropriate to the moment, there is a directional pull forward and up, an active sternum in recognition that his mortal journey has been completed, that he is risen. We, as viewers, are reminded that we, too, will rise again.

A Picture of Christ in Motion

In the October 2006 general conference, Elder Jeffery R. Holland offered a compelling and emotional picture of a physically present Christ. The scriptural passages that he wove together made it clear to me that Christ needed a sensitively attuned physical body in order to accomplish his divinely appointed spiritual mission. Elder Holland stated,

To all of you who think you are lost or without hope, or who think you have done too much that was too wrong for too long, to every one of you who worry that you are stranded somewhere on the wintry plains of life and have wrecked your handcart in the process, this conference calls out Jehovah's unrelenting refrain, "[My] hand is stretched out still." "I shall lengthen out mine arm unto them," He said, "[and even if they] deny me; nevertheless, I will be merciful unto them, . . . if they will repent and come unto me; for mine arm is lengthened out all the day long, saith the Lord God of Hosts." His mercy endureth forever, and His hand is stretched out still. His is the pure love of Christ, the charity that never faileth, that compassion which endures even when all other strength disappears.[23]

These words describe a kinetically dynamic Christ who physically comforts and soothes souls. It is my hope that through the skillful use of a physical language in all the arts we can create kinetic images of Christ that are as compelling as Elder Holland's. To do so we will have to move beyond convention, beyond the generic icon, and envision Christ as he might envision himself. To this end I offer the following.

Expanded Representations of the Savior—A Call to Action

The phrase "I am that I am" as spoken to Moses in the Old Testament has great significance.[24] In Exodus 3, God has just asked Moses to lead the Israelites out of bondage. In order to assure the Israelites that God himself made this request, Moses asks by what name has he been sent to do this. "And God said unto Moses, I AM THAT I AM: and he said, Thus shalt thou say unto the children of Israel, I AM hath sent me unto you" (Ex. 3:14). Literally, "I am" is the name by which God wanted himself to be identified.

"I am," as it appears in the King James Version of the Bible, does not fully represent the intent of the original archaic Hebrew phrase, which is *ehyeh aser ehyeh* or *Yahweh*. *Yahweh* is derived from the verb "to be" and actually means "He is." In this instance, the name by which God identifies himself "is not merely an act of identification;" it reveals to us the inherent properties of Deity.[25] The phrase has other readily accepted interpretations that are significant in considering what images of Christ are appropriate. They are "I am who I am," "I am what I will be," "I cause to be whatever comes into being," and "the self-existent one."[26]

Ultimately what Jehovah, or Christ, is saying is, "I will not be defined or confined. I will be who I will be!"[27] God himself, just by his very name,

refuses to be confined. This significant point reinforces that we are culturally, not doctrinally, limited to certain kinds of representations of Christ. As his name suggests, the face of Christ, the body of Christ, the manifestation of Christ is always changing. If we have eyes to see, we will be able to see the incarnate Christ in and through *all* things, even in the faces—and dare I say the bodies—of our brothers and sisters as they create and perform works of art.

We understand the scriptural admonition to treat others as we would treat Christ and that if we turn away from one of our spiritual brothers or sisters, with whom we share not only a spiritual heritage but also a material bond that reaches back to matter unorganized, we turn away from him. We might, however, extend this principle to the creative offerings of our fellow saints—that which is created by his children is created by him, and we should treat their creations as we would treat his. I now have to consider the following questions: Can I recognize and accept the face of Christ in sincere artistic offerings of others? Am I able to see in their body of work the body of Christ? Do I view their Herculean task of taking matter unorganized and shaping it through the sweat of their brow as a manifestation of Christ's creative work? To do so I would need to be equally open to seeing him in a Del Parson painting, in a dance of colleague Caroline Prohosky, and in the initial attempt of a student in my dance composition class who earnestly places his or her work on my altar of judgment.

In the creative act, each bears witness, or testimony, as Eric Samuelsen says, of the world and of Christ, and we ought to look upon that offering with compassion.[28] There are obviously issues of refinement, craft, form, skill, and clarity of intent that can be questioned in any representation, but the medium, the messenger, and the artistic offering itself ought not to be rejected because it is not the accepted, cultural norm. If we reflect on the phrases "I am that I am" and "I will be who I will be," we realize that neither the Creator nor the creation can be confined.

Conclusion

I began this journey wanting to understand why I have never seen a dancing Christ onstage. At this juncture of my investigation, I do not have a clear-cut answer. It is a complicated and multilayered issue. I don't know that we will ever see a dancing Christ on stage, but when we see Christ dance, it will be magnificent. I don't think we are sufficiently prepared, personally or culturally, to experience the immediacy and the impact of a lively, three-

Fig. 4 Walter Rane, *Jehovah Creates the Earth*, cil, 67 in. x 44 in., 2000. Museum of Church History and Art. © by Intellectual Reserve, Inc.

dimensional Christ. The image of a dancing Christ deviates too far from the culturally acceptable Jesus that most of us can imagine. At some level, at least in concert dance, it appears that it is difficult for us to celebrate, in multifaceted ways our own incarnateness, much less his.

As a person who experiences life from and through my body, I hope this view of dance will change, but I do not think it will soon. Dance, as a corporeal art, is still suspect. For that shift to happen, we will have to see dance as something more than entertainment. When we see it as worship, as a spiritual practice that integrates body and spirit, when we consider it equal to music in appropriateness and ability to express sacred principles in sacrament meeting, perhaps then we will see a dancing Christ. In the meantime, I must rejoice in small victories like full theatrical productions in the Conference Center, the revival of dance festivals, and spots featuring dance during the Tabernacle Choir's Christmas concert.

There will always be need for an institutional image of Jesus, one for universal consumption. That Jesus will reflect our understanding of certain aspects of his character. If, however, God ultimately is not to be confined, each of us can and should find appropriate media and forms to share our perception of him with others. I take courage from Walter Rane and others who venture into the unexplored territory where a dynamic inner spiritual life is outwardly revealed in an active and animate manner. From him I have learned that you just have to go about doing good work and when the time is right, when the work is right, a shift will happen.

In his painting of Christ creating the universe, *Jehovah Creates the Earth* (fig. 4), Rane presents a glorious scene with a fully realized, three-dimensional Christ creating heavens and earth, reaching out with the full intention of his entire being, not just pointing and gesturing but stirring and embracing the elements, inviting the unformed universe to join in a dance that cannot be comprehended from the perspective of earthly time and space. This metaphoric dance is around us continually. Through gesture and movement, we affirm the life, the action, and the motion of a universe that began eons ago.

The question of a dancing Christ no longer haunts me as it did before I began this exploration. However, the journey to find an answer has expanded in ways that I could not have expected, increasing my desire to directly infuse gospel themes into my own work. For much of my artistic life I have hesitated to make dances that are based on scriptural stories (in part because my work is not generally narrative in nature). I have also been reluctant to directly address gospel themes in my work because physical metaphors that communicate specific, abstract spiritual truths are somewhat elusive. I also

have a fear, or a concern, that I don't have the skill to express my spiritual understandings in a sophisticated way. To create a work that literally, figuratively, or metaphorically addresses spiritual truths without sentimentality is a difficult task and takes a skilled and spiritually sensitive artist. Had I attempted this task earlier in my artistic life, my work would have been hesitant and faulty.

Possibly the time is now ripe for me, my colleagues, and my students to move forward with faith. I feel many of them already are. This is an invitation to all artists to go and do—do your art, live your life, and be bold! This is an invitation to all dancers to kinetically reveal truth, to illuminate spiritually potent concepts though the physical body. In return, I'd like to share publicly my commitment to be more courageous and explicitly infuse the substance of the gospel into my artistic work.

"Men are, that they might have joy" (2 Ne. 2:25), and men were placed on earth to receive physical bodies. These doctrines are inseparably connected. We, as a culture, must find a way to embrace what has been revealed and then celebrate it in *all* its manifestations. We must not limit ourselves, God, or the work we can do on his behalf by censoring ourselves through fear and cultural constraints. He has provided everything that we need to accomplish what is required; now we must be bold, going forward with faith.

I realize now that I *have* seen the body of Christ onstage and just have not recognized it. Though I have not seen a dancing Christ, his reality has been witnessed through the bodies of my brothers and sisters. They have been him incarnate as he was God incarnate. The individual onstage reveals truth as Christ reveals truth and light to us. When I listen, when I see, and when I feel, the dancers become the oracle and the incarnation of the Word, just as the Word was made flesh and became the oracle for the Father.

NOTES

1. In this paper, dance is delimited to the traditional concert forms of dance, modern dance, and ballet, with the possible inclusion of music theatre.

2. Consider that the Holy Ghost, our major link between heaven and earth, communicates through physical sensations—such as a burning in the bosom—as well as to our minds. We know Christ through this visceral witness. When in art and performance Christ is rendered as disconnected from the physical realm, he is essentially eviscerated and the Holy Ghost cannot witness to the audience who he is. Rodger Sorensen, conversation with author, October 2007.

3. See Doctrine and Covenants 45:17; 88:15; 93:33–35; 1 Corinthians 3:16–17; 6:19–20.

4. Hartman Rector, Jr., "Repentence Makes Us Free," *Improvement Era* 73 (December 1970): 76. Others have reiterated this message: Marion D. Hanks, "Follow the King," BYU devotional address, March 11, 1986, at http://speeches.byu.edu; Melvin J. Ballard, "Three Degrees of Glory" (address given in Ogden Tabernacle, Ogden, Utah, September 22, 1922).

5. Eric Samuelsen, interview by author, Provo, Utah, October 2006.

6. Stephen E. Robinson, "Doctrine: LDS Doctrine Compared with Other Christian Doctrines," in *Encyclopedia of Mormonism*, ed. Daniel H. Ludlow, 4 vols. (New York: Macmillan, 1992), 1:400.

7. Rick Jepson, "Godwrestling: Physicality, Conflict, and Redemption in Mormon Doctrine," *Sunstone* (November 2005): 19.

8. See John 1:14; Colossians 2:9.

9. Samuelsen, interview.

10. Richard Neitzel Holzapfel, "'That's How I Imagine He Looks': The Perspective of a Professor of Religion," *BYU Studies* 39, no. 3 (2000): 95. See also other articles on representing Christ in LDS artwork in that issue of *BYU Studies*.

11. Sterling Van Wagenen, interview by author, Provo, Utah, October 2006.

12. Chris Young, interview by author, Provo, Utah, October 2006.

13. James C. Christensen, "That's Not *My* Jesus: An Artist's Personal Perspective on Images of Christ," *BYU Studies* 39, no. 3 (2000): 10.

14. Lisa Ullmann, "The Value I See in Laban's Ideas," *New Era in Home and School* 40, no. 5 (1959).

15. Michael Neff and Eugene Fiume, "Methods for Exploring Expressive Stance," preprint submitted to Elsevier Science, March 25, 2005, 2–5.

16. Neff and Fiume, "Expressive Stance," 5, citing Ted Shawn, *Every Little Movement*.

17. For the purposes of this paper, reading the body of Christ is limited to the visual arts, largely because the images discussed are familiar, can be shared in print, and are easily referenced. The same issues and concepts discussed in regard to visual images apply as well to theatre, dance, or film.

18. Walter Rane, telephone interview by author, Oct. 2007.

19. Rane, interview.

20. Rane, interview.

21. Rane, interview.

22. All images referred to in the article can be found online.

23. Jeffery R. Holland, "Prophets in the Land Again," *Ensign* 36 (November 2006): 106–107.

24. "Of all the definitions of God, none is so well put as the biblical statement 'I am that I am' in Exodus chapter three." David Godman, "I Am—The First Name of God," citing *Talks with Sri Ramana Maharshi*, talk no. 106, http://davidgodman.org/rteach/fnofgod1.shtml (accessed January 16, 2007).

25. Godman, "I am."

26. Godman, "I am"; The Church of Yahweh, "God Is Not God's Name," http://www.yhwh.com/YHWH/Yhwh.htm (accessed January 16, 2007). See also His Covenant Ministries, "YHWH True Name of our Creator," http://www.hiscovenantministries.org/yhwh.htm; Ivan Maddox, "Is 'I Am' God's Name?" http://evans-experientialism.

freewebspace.com/jesus_name.htm; Laura Olshansky, "I Am That I Am," http://www.realization.org/page/doc0/doc0042.htm (accessed January 16, 2007).

27. Robert Millet, phone conversation with author, October 2006.

28. Samuelsen, interview.

Professor C. Jay Fox is the Nan Osmond Grass Professor of English at BYU. He is a former writing consultant with Shipley Associates, and with private clients. Administrative assignments have included department chair, chair of the Communication and Language Arts Division, dean, and academic vice president, all at BYU Hawaii. At BYU–Provo he has served as the director of the Center for the Study of Christian Values in Literature and editor of *Literature and Belief,* and chair of the English Department. This article grows out of research for literature and film classes. His *Arthur Symons, Critic among Critics: An Annotated Bibliography* with Robert Means and Carol Stern of Northwestern University, appeared in 2007, published by ELT Press at the University of North Carolina at Greensboro.

Images of the Character of Jesus in Film

Divinely Human or Humanly Divine?

C. *Jay Fox*

FILMMAKERS FROM THE SILENT ERA TO THE PRESENT DAY have struggled with the same quandary in depicting Jesus in film: to what extent can this character be portrayed with human qualities with which we can identify while still preserving his role as a condescended, divine being? After viewing and researching some forty films of the more than two hundred that are listed as depicting Christ in the Internet Movie Database (imdb.com), I agree with Barnes Tatum that "the problem of the cinematic Jesus encompasses at least four dimensions: the artistic, the literary, the historical, and the theological."[1]

One of the earliest attempts to tell the story of Jesus artistically as both a historical figure and a miracle worker based on text from the Gospels is director Sidney Olcott's 1912 film *From the Manger to the Cross.* In depicting the miracle of turning the water into wine, actor Robert Henderson-Bland is shown mingling with the wedding guests, then raising his arm in a kind of victory gesture. Then, in order to signal to the viewer that something miraculous has occurred, Jesus' face goes from a natural image to one illuminated by a flash of light. Early on, filmmakers such as Olcott were cautious about how to depict Jesus. Peter Malone reminds us that "British censors" recommended "that it was not appropriate for the figure of Jesus [in *From*

Fig. 1 The Tableau Jesus
Howard Gaye as Jesus, in *Intolerance* (1916), directed by D. W. Griffith.

the Manger to the Cross] to be seen fully on screen; suggestion of his presence (back of the head, shoulder, etc.) would be sufficient."[2]

 Intolerance (1916) does something similar with the wedding miracle, although D. W. Griffith's Jesus, played by Howard Gaye, is less animated than the earlier Henderson-Bland portrayal. In fact, I have termed the image in *Intolerance* the "tableau Jesus" (fig. 1) because Christ appears so motionless and lifeless. Even at the wedding feast, he seems afraid to move. He sits with the guests and then as the water-into-wine miracle occurs, the sign of the cross is superimposed over the image of Christ (fig. 2). When I first saw the film many years ago, I thought I had a bad print, but then I realized that Griffith, like his predecessor Olcott, wanted to make sure that we knew that this was no mere human being that had done this act and that something miraculous had occurred.

 Of course, the presentation of Jesus in film entails more than just the static image, or, in the case of the Griffith film, the oxymoronic static motion picture. In their *Divine Images: A History of Jesus on the Screen*, Roy Kinnard and Tim Davis observe, "The once-solemn, stoic, and (lifelessly) reverent

Fig. 2 The Sign of the Cross
Howard Gaye as Jesus, in *Intolerance* (1916), directed by D. W. Griffith.

portrayal of an all-divine Christ, which audiences demanded and these films provided have, by virtual necessity, been replaced by more realistic and introspective productions which, for better or worse, explore Jesus, the man who also happened to be God."[3] An example of the introspective blending of the divine and the human is the 1999 miniseries *Jesus*, in which Jeremy Sisto has the title role. In this portrayal of the wedding miracle, Jesus is depicted as growing into a sense of his divine calling, encouraged by his mother. (In fact, Mary is such a catalyst in the miniseries that I believe this is one of the reasons that Pope John Paul II wrote a letter of congratulation, which appears in the special features on the DVD, on the "evangelization commitment which characterizes" the film.[4])

Just before the wedding scene, Mary has reminded a somewhat doubtful Jesus that the Magi would not have come at the time of his birth if his life had not been divinely ordained. Jesus sees a blanket Mary has been making as a wedding gift for Jesus' relative Benjamin and enthusiastically tells Mary he wants to attend the wedding with her and then promptly invites two of his disciples to accompany them. Once at the wedding feast, Jesus, without reticence, joins in the dancing (fig. 3) and then talks and jokes with

Fig. 3 Jesus Dancing at the Marriage in Cana
Jeremy Sisto as Jesus, in *Jesus* (1999), directed by Roger Young.

his disciples, but then at the prompting of his mother performs the miracle of turning the water into wine (fig. 4).

This portrayal of Jesus and our response to it evokes David Morgan's concept of the "Sacred Gaze":

> *Sacred gaze* is a term that designates the particular configuration of ideas, attitudes, and customs that informs a religious act of seeing as it occurs within a given cultural and historical setting. A sacred gaze is the manner in which a way of seeing invests an image, a viewer, or an act of viewing with spiritual significance. The study of religious visual culture is therefore the study of images, but also the practices and habits that rely on images as well as the attitudes and preconceptions that inform vision as a cultural act.[5]

Jesus is clearly portrayed "with spiritual significance" as the Christ in this miniseries, one who performs the major miracles clear through to the Resurrection and Ascension, but is this recreational, joking Jesus too human an image for some viewers in Latter-day Saint culture? Some of my students

Fig. 4 Jesus Turning Water into Wine
Jeremy Sisto as Jesus, in *Jesus* (1999), directed by Roger Young.

are a little uncomfortable with this portrayal—they seem to prefer the tab-leau Jesus who speaks only scripture.

In the prologue to his novel *The Last Temptation of Christ*, Nikos Kazantzakis gives us a justification for seeing the human element in an otherwise divine being:

> Christ passed through all the stages which the man who struggles passes through. That is why his suffering is so familiar to us; that is why we share it, and why his final victory seems to us so much our own future victory. That part of Christ's nature which was profoundly human helps us to understand him and love him and to pursue his Passion as though it were our own. If he had not within him this warm human element, he would never be able to touch our hearts with such assurance and tenderness; he would not be able to become a model for our lives. We struggle, we see him struggle also, and we find strength. We see that we are not all alone in the world: he is fighting at our side.[6]

Fig. 5 The Cosmic Landscape
Jeffrey Hunter as Jesus, in *King of Kings* (1961), directed by Nicholas Ray.

Often the human struggle that Kazantzakis speaks of is placed in a setting to give the story a bigger-than-life look, what I call the "cosmic setting" of films about Jesus. The cosmic setting places Jesus' earthly temptations in a grand landscape, thus suggesting that the stakes have been raised in the outcome (fig. 5). Nicholas Ray attempted a cosmic setting in the 1961 *King of Kings* with a young Jeffrey Hunter in the lead (fig. 6). Here Jesus goes into the desert to be tempted of the devil in a vast mountainous region, but a voice-over for Satan and an unrealistic image of the kingdoms of this world make it difficult for us to identify with the reality of temptation (fig. 7). I remember at the time that viewers referred to the film as the " I-was-a-teen-age-Jesus" movie because Hunter appealed to a young age group. Additionally, viewers complained that Hunter had been sanitized because his armpits

Fig. 6 Jesus in the Wilderness
Jeffrey Hunter as Jesus, in *King of Kings* (1961), directed by Nicholas Ray.

Fig. 7 The Kingdoms of This World
King of Kings (1961), directed by Nicholas Ray.

were shaved for the crucifixion scene. (There is little doubt what Mel Gibson would think of that nicety.)

In the 1965 *The Greatest Story Ever Told*, George Stevens chose the expanses of Glen Canyon (before the lake filled it) and Canyonlands National Park and environs in Utah for the film's setting (fig. 8). In the novel on which the film is based, Fulton Oursler described the setting as a "gigantesque waterless region . . . an inchoate place like a piece of creation begun but not finished; abandoned by all except fanatics and madmen . . . a mountainous expanse of stone ravines, blistering hills, and beds of crumbling shale . . . a lonely, scorched, and gloomy place."[7] In this setting, Max von Sydow, the actor playing Jesus, climbs to a ledge on a mountain on his own in the dark of the sub-lunar, fallible world, and he is tempted by the Satanic "Dark Hermit" played by Donald Pleasence (fig. 9). Pleasence is roasting

Fig. 8 Another Cosmic Landscape
The Greatest Story Ever Told (1965), directed by George Stevens.

Fig. 9 Jesus Being Tempted by the Dark Hermit
Max von Sydow as Jesus, *right*, and Donald Pleasence as the Dark Hermit (Satan), in *The Greatest Story Ever Told* (1965), directed by George Stevens.

Fig. 10 Jesus' Triumph over Temptation
Max von Sydow as Jesus, in *The Greatest Story Ever Told* (1965), directed by George Stevens.

Fig. 11 Jesus Played by a Nonprofessional
Enrique Irazoqui as Jesus, in *Il Vangelo secondo Matteo* (1964; *The Gospel according to St. Matthew*, 1966), directed by Pier Paolo Pasolini.

Fig. 12 Satan in Human Form
Uncredited actor as Satan, in *Il Vangelo secondo Matteo* (1964; *The Gospel according to St., Matthew*, 1966), directed by Pier Paolo Pasolini.

meat over an open fire and tempts Jesus to take some. Each of the temptations is presented in a very human, natural, and believable way, and Jesus responds accordingly. Once he has passed all the tests, the morning light floods Jesus, and he continues his climb and views the vast expanse of the canyons surrounding him. The image is one of enlightened triumph (fig. 10).

Although on not so grand a scale, Pasolini in *The Gospel according to St. Matthew* (1966) depicts Satan as a man in a vast cosmic landscape who walks the earth and comes to tempt Jesus (figs. 11 and 12). Pasolini shot this

Fig. 13 Landscape in *Jesus Christ Superstar*
(1973), directed by Norman Jewison.

Fig. 14 "Mary, what more can I say or do to help you understand?"
Yvonne Elliman as Mary Magdalene and Ted Neeley as Jesus, in *Jesus Christ Superstar*
(1973), directed by Norman Jewison.

black and white film in a neo-realistic style and emphasized the common
humanity of the characters by choosing non-professionals to play the roles.
The English voices dubbed over the Italian soundtrack are so mundane,

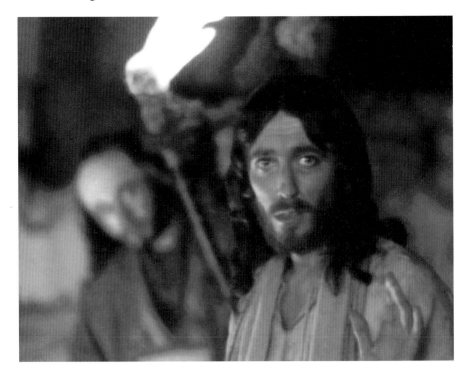

Fig. 15 Jesus as Bibliotherapist
Robert Powell as Jesus, in *Jesus of Nazareth* (1977), directed by Franco Zeffirelli.

however, delivered as if they are being perfunctorily read, that some of the visual images are undercut by the poor audio performance.

Even Norman Jewison's 1973 adaptation of *Jesus Christ Superstar* from the Webber musical employs a cosmic landscape (fig. 13) in Israel. In this setting, Jesus' followers sing "Could We Start Again, Please?" when they feel that things are going wrong after Jesus is apprehended and brought to trial. Mary Magdalene is framed with Jesus holding his hands out as if he is saying, "What more can I say or do to help you understand?" (fig. 14). This image represents for me all those attempts by Jesus to help his disciples recognize and understand his ultimate mission, the full extent of which they did not comprehend until after his death.[8]

More profound, although not in a cosmic landscape, is Franco Zeffirelli's masterful made-for-television *Jesus of Nazareth* (1977), a film Jim D'Arc, Brigham Young University film archivist, tells me the LDS Church tried to buy out of admiration for its accomplishments. The director's and writer's intention in this film was, according to Lloyd Baugh, summarizing Zeffirelli, to present a Jesus who was "not too human, nor too divine;"[9] consequently, Zeffirelli omits some of the miracles, although he still clearly sees Jesus as the divine Messiah. He wanted a balance between a "too divine . . . too-high Christology" and a "too human (a too-low Christology)."[10]

The images in this film that impress me are in the sequence in which Zeffirelli depicts Jesus healing a crippled man after inviting himself to eat with "publicans and sinners" in the house of Matthew. Christ is depicted as the masterful bibliotherapist who can unite the objecting Peter and the Publican Matthew by recounting to both sinners and disciples the entire story of the Prodigal Son (fig. 15). Even though Zeffirelli was criticized for staging the telling of the parable in this setting, he "felt that the conflict between Peter and Matthew should come to a head in the house of a sinner." It was there, Zeffirelli explained to his critics, "that Jesus broke through to the hearts of the people with his story of love and forgiveness, which convinced not only Matthew but the somewhat aggressive Peter—and all of this occurs in a house that his followers were convinced would contaminate and defile them all, including the Master."[11] As Jesus relates the parable, the camera joins him as a narrator to show us for whom various parts of the story are intended. The coda comes as Peter, softened by Jesus' words, enters the house of sinners, crosses the liminal space created by the Savior, and actually touches Matthew, who stands to greet him, the very man that Peter thought earlier would defile him (fig. 16).

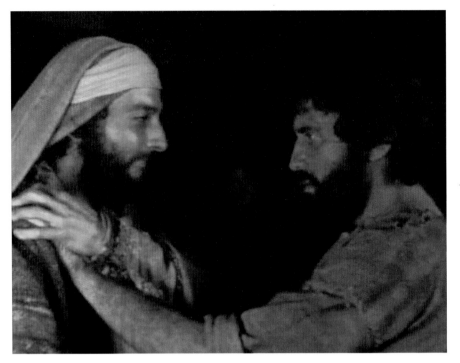

Fig. 16 Matthew and Peter Reconciled
Keith Washington as Matthew, *left*, and James Farentino as Peter, in *Jesus of Nazareth* (1977), directed by Franco Zeffirelli.

An interesting side note is that if you read Joseph Smith's interpretation of the Prodigal Son story, Zeffirelli's interpretation is very close to Joseph Smith's.[12] Here again is the interactive Jesus who represents his Heavenly Father but who is always in human society. The edifying presentation in the Prodigal Son scenes are to me what Ezra Pound called the symbolic image: "An image is that which presents an intellectual and emotional complex in an instant of time." He believed that such images give us "that sense of sudden liberation; that sense of freedom from time limits and space limits; that sense of sudden growth, which we experience in the presence of the greatest works of art." In what amounts to a kind of reverse hyperbole, he concludes: "It is better to present one image in a lifetime than to produce voluminous works."[13]

Contrast the image in a work like *Jesus* or *Jesus of Nazareth* with that of the image of the battered Christ in Mel Gibson's 2004 *The Passion of the Christ*. Except for the redemptive flashbacks which help us see the living, active Christ, we are presented with a battered image that for some viewers

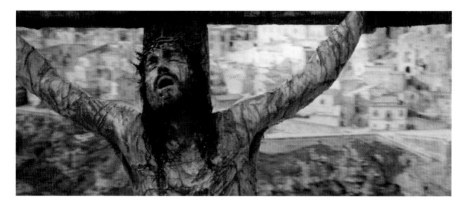

Fig. 17 The Battered Christ
James Caviezel as Jesus, in *The Passion of the Christ* (2004), directed by Mel Gibson.

becomes monotonous, resembling a waxen crucifix similar to those often seen in European churches (fig. 17). David Morgan elucidates the effect of this image on the sacred gaze:

> Mel Gibson's widely viewed film *The Passion of the Christ* (2004) uses a rather similar likeness of Jesus but subverts his prettiness with outlandish violence and the graphic portrayal of suffering. The film seems to thrive on displaying the bloody abuse of the attractive Jesus, thereby subordinating devout viewers to a merciless demolition of the gaze they bring to the film. This violation is quite intentional. In an interview Gibson stated that he "didn't want to see Jesus looking really pretty. I wanted to mess up one of his eyes, destroy it." His

Fig. 18 The Violation of Jesus' Eye
James Caviezel as Jesus, in *The Passion of the Christ* (2004), directed by Mel Gibson.

Fig. 19 Satan as a Condoning Witness
Rosalinda Celentano, *center*, as Satan, in *The Passion of the Christ* (2004), directed by Mel Gibson.

determination to destroy Jesus' eye seems emblematic, as if he intended to assault the very means of vision. By violating the eye, Gibson eradicates the view of Jesus as pretty and effeminate, as well as the

Fig. 20 Jesus Mending a Child's Toy
H. B. Warner as Jesus, in *The King of Kings* (1927), directed by Cecil B. DeMille.

Fig. 21 Jesus as Divinely Human
H. B. Warner as Jesus, in *The King of Kings* (1927), directed by Cecil B. DeMille.

theology, piety, politics, and lifestyle that he may believe correspond to that prettiness and effeminacy. Gibson wants to destroy an entire way of seeing and install in its place a manly Jesus who is his father's son, one who by virtue of extreme iconoclasm has been purged of rival ways of seeing. The film plunges viewers into a protracted agony in order to wrench from them the devotional gaze.[14] (fig. 18)

At least Gibson softens the human culpability in the flogging by placing Satan as a condoning witness next to the High Priest (fig. 19). (Or perhaps their juxtaposition is ambivalent.)

Let me conclude with the filmmaker that I see as the fountainhead of depicting an image of Jesus as human and divine. This portrayal is remarkable for the second decade of the twentieth century. Jesus is clearly the miracle worker in Cecil B. DeMille's 1927 *King of Kings*, the Master Healer of both body and soul. Although this film is from the silent era, there is no tableau Jesus here. The divine Jesus has earlier miraculously healed the leg of a boy named Mark and now lovingly engages the little children that his disciples have tried to send away by mending a broken leg of a child's doll,

ironically that of a toy Roman soldier (fig. 20). This depiction of the divinely human Jesus who is also humanly divine has never been surpassed (fig. 21).

NOTES

1. W. Barnes Tatum, *Jesus at the Movies: A Guide to the First Hundred Years* (Santa Rosa, Calif.: Polebridge, 1997), 6.

2. Peter Malone, "Jesus on Our Screens," *New Image of Religious Film*, ed. John R. May (Kansas City, Mo.: Sheed and Ward, 1997).

3. Roy Kinnard, and Tim Davis, *Divine Images: A History of Jesus on the Screen* (New York: Citadel, 1992), 14.

4. "Special Features: Letter from the Pope," *Jesus*, Dir. Roger Young, Perf. Jeremy Sisto, DVD, Trimark Home Video, 1999.

5. David Morgan, *The Sacred Gaze: Religious Visual Culture in Theory and Practice* (Berkeley: University of California Press, 2005), 3.

6. Nikos Kazantzakis, "Prologue," in *The Last Temptation of Christ*, trans. P. A. Bien (New York: Simon and Schuster, 1960), 2–3.

7. Fulton Oursler, *The Greatest Story Ever Told* (New York: Doubleday, 1989), 94.

8. Although this film received considerable criticism from various religious groups, what would you guess the MPAA rating to be? Would you believe a "G"?

9. Lloyd Baugh, *Imaging the Divine: Jesus and Christ-Figures in Film* (Kansas City, Mo.: Sheed and Ward, 1997), 73.

10. Baugh, *Imaging the Divine*, 74.

11. Franco Zeffirelli, *Jesus: A Spiritual Diary*, trans. Willis J. Egan (San Francisco: Harper and Row, 1984), viii.

12. See C. Jay Fox, "From Lana Turner to Mikhail Baryshnikov and Beyond: The Prodigal Son Story in Text and Film," in *Colloquium: Essays in Literature and Belief*, ed. Richard H. Cracroft, Jane D. Brady, and Linda Hunter Adams (Provo, Utah: BYU Center for the Study of Christian Values in Literature, 2001), 167–178.

13. Ezra Pound, "A Retrospect," *Modern Poetics*, ed. James Scully (New York: McGraw Hill, 1965), 32.

14. Morgan, *The Sacred Gaze*, 5.

Bren Jackson is a junior at Brigham Young University majoring in art history. Currently she is employed in the education department at BYU Museum of Art. In the future she hopes to study museum education in a graduate program and work with children. Aside from school, Bren loves reading, cooking, singing, and hiking.

Brian Kershisnik

Relationships within *Nativity*

Bren Jackson

IN *NATIVITY* (FIG. 1), BRIAN KERSHISNIK EXPLORES a traditional theme in a very personal manner. In the ultimate act of subjectivity, Kershisnik's own experiences become the inspiration for his interpretation of the Holy Family. *Nativity* shows his desire to represent relationships between men, women, and children. The mystical fellowship of sisterhood that Kershisnik has observed, particularly among his wife and her sisters, is played out in his portrayal of Mary and the midwives in *Nativity*. His own experiences with the bewilderment, confusion, and occasional exclusion of fatherhood leak into his portrayal of Joseph. Kershisnik's representation of the human qualities of Mary and Joseph in *Nativity* serve as a reminder that ordinary people have the potential to become holy.

Within any nativity scene is the theme of the Madonna and Child. This popular subject exemplifies the ideal mother and child relationship, and it is something that a majority of viewers can relate to. I imagine that any mother who has held a newborn baby in her arms shares the tender feelings Mary had for baby Jesus. Kershisnik makes a fascinating comparison: A pregnant woman, Kershisnik says, is the most beautiful thing in the universe; "that pregnancy is beautiful because they [women] are Mary."[1] As a Latter-day Saint, the artist seems to recognize the divine calling of motherhood. His

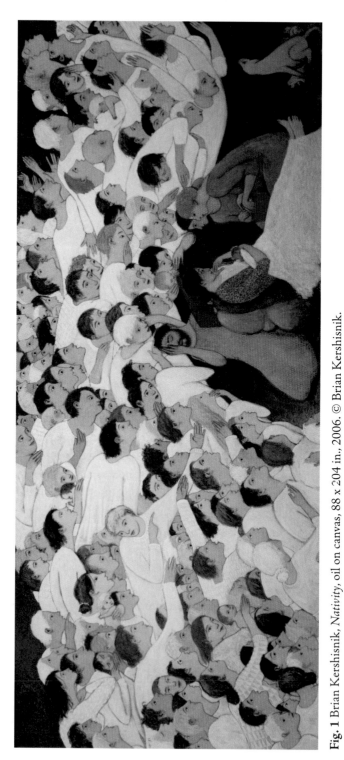

Fig. 1 Brian Kershisnik, *Nativity*, oil on canvas, 88 x 204 in., 2006. © Brian Kershisnik.

paintings of women and children inspire a sort of sacred intrigue. The mothers in his works hold their children with confidence and peace. They act fearlessly upon intuition and bear an intelligence of things seemingly foreign to men. They find comfort in relationships with and in company of other women.

In *Nativity*, Kershisnik conspicuously includes two women at Mary's side. These noncanonical midwives have assisted with the Savior's birth, and their hands are still bloodied.[2] Mary's close relationship with these women is emphasized as they lean nearer to see the new baby. Mary and the midwives embody Kershisnik's understanding of and fascination with sisterhood. He explains:

> I grew up in a family with only brothers and married a woman from a family with only sisters. My brothers are now scattered across the country, but I live among all of my sisters-in-law and am fascinated (a polite adjective that describes my feelings only partially) by their interactions. My paintings of sisters are not portraits of the sisters I know (except occasionally and accidentally). Rather, they are paintings about the connections women seem to have, connections that may or may not include sharing the same parents. All women, it seems, are sisters, but some more than others.[3]

Joseph plays the role of supporter, while Mary is involved in Christ and her relationship with the midwives. Although included in the overall event, Joseph is physically separated from the circle of women. The backrest behind Mary creates a barrier between them. While Joseph undoubtedly played a large role in the Savior's life, it cannot be ignored that Mary and her child experienced a truly unique relationship.

As a father himself, Kershisnik may have experienced Joseph's feeling of exclusion at the birth of his own son, Noah. This emotion can also be seen in Kershisnik's other paintings. In *Little Father* (2002),[4] an abnormally small father figure stands perched on the armrest of the chair where his wife sits to nurse their new baby. Although he is supportive, there seems to be little he can contribute to the situation. This is mother and child bonding time, and nothing can replace it. Like Mary, the mother in *Little Father* is absorbed in nursing. As she nurses, she contemplates her child and his future. The father stands a bit awkwardly, ready to do whatever may be needed. But at this moment, his presence is sufficient.

"It is a sociological fact that women need women," Marjorie Hinckley states. "We need deep and satisfying and loyal friendships with each other."[5]

This crucial relationship is reiterated in several of Kershisnik's paintings. *Ten Women with Infants* (1997) is a particularly beautiful depiction of this camaraderie. Here, women gather on a grassy hill to play with their children and talk. The social nature of the activity is emphasized and the gathering serves as an opportunity to share maternal joys. Each woman, even if not engaged in conversation, thrives on the occasion. In *Slivers* (2004) women gather again, this time to share their problems, however small they may be. Like sisters, the women in *Mother and Child with Companions* (2003) share in the joy of the central mother. Whether or not the three women are sisters from the same parents is irrelevant. The care and love they show for the child seems equivalent to that of the mother. Her baby is their baby; they are one in purpose. Perhaps the midwives in Kershisnik's nativity recognize the significance of their newborn King as the Savior of all men. In a theological sense, Christ is quite literally God and Savior of each individual who beholds him. The care and attention the midwives impart to Christ reflect their personal devotion and admiration.

In Catholicism, Mary is often referred to as the Queen of Heaven. It is interesting to note the light emanating from all three women in *Mother and Child with Companions*. The painted gold background of this work is reminiscent of the background in Byzantine mosaics, symbolizing divinity. The tesserae-like pattern behind the women's heads curves to form faint halos. For Kershisnik, motherhood is worthy of a halo. As Jacquelyn Mitchard describes motherhood, "To have created and received a person is to be drawn aloft, like an angel or a mythic queen."[6] Knowledge of this divine calling seems evident in women's calmness and confidence in other paintings by Kershisnik.

Mother and Child on Wheels (fig. 2) may exemplify the surety of women—their intuition and their confidence—that Kershisnik finds so intriguing. A mother stands upright on some rudimentary form of a skateboard. With no steering device, no brakes, and no seatbelt, she clutches her child and smiles. She seems to be on a ride that she has no control of, but she is at perfect peace. Similarly, *Woman with Infant Flying* (1995) shows a woman on a journey, yet this time she is floating. She is not drifting aimlessly, but presses forward with a purpose. She knows exactly where she is going and how she is going to get there. The logical mind knows that flying challenges all sense and reason, yet the confidence of this woman dispels any doubt that flying is possible. Likewise, Mary was asked to accept the insurmountable task of being the mother of the Son of God. When the angel Gabriel appeared to Mary, she simply replied, "How shall this be, seeing I know not

a man?" (Luke 1:34). The angel told her that she would conceive a child through the Holy Ghost. Though this was illogical to the human mind, Mary submitted to the will of God. She questioned no further and put her trust in God.[7] Despite the physical exhaustion of Kershisnik's Mary, she realizes the magnitude of her task and remains calm and confident that God will never leave her. She acts according to the angel's promise "For with God nothing shall be impossible" (Luke 1:37).

Returning to *Nativity* (fig. 3), we see Joseph's face on the opposite side of Mary's backrest providing a stark contrast to Mary's serenity. He is overwhelmed by the miraculous event and places his hand on his face in sheer awe as if he is thinking, "What is

Fig. 2 Brian Kershisnik, *Mother and Child on Wheels*, acrylic on panel, 30 in. x. 24 in., 2002. © Brian Kershisnik.

happening?" This reaction is not a lack of faith, but rather an acceptance of something he cannot fully understand. In this sense, Joseph represents Kershisnik's experience with women. Kershisnik paints about not knowing women. As Kershisnik describes it, "Having grown up in a family of brothers, I painted my wife's sisters . . . [as] foreign, exotic, alien—an idea seen from outside."[8]

In many paintings Kershisnik plays upon the idea that women are filled with a sort of holy intuition and intelligence. *Giving Directions* (2005) may be one of the most obvious (and humorous) examples of Kershisnik's faith in maternal intuition. The woman in the foreground simply gives direction to the men behind her. Without flinching or second-guessing her instructions, they heed almost mindlessly as if to say, "Of course she is right!" This ironic play on stereotypical men who will not ask for directions is a statement of the artist's meekness. Like Joseph, the men in this painting do not call attention to themselves but humbly accept a woman's guidance. What Kershisnik sees as the wise simplicity of women is further emphasized in

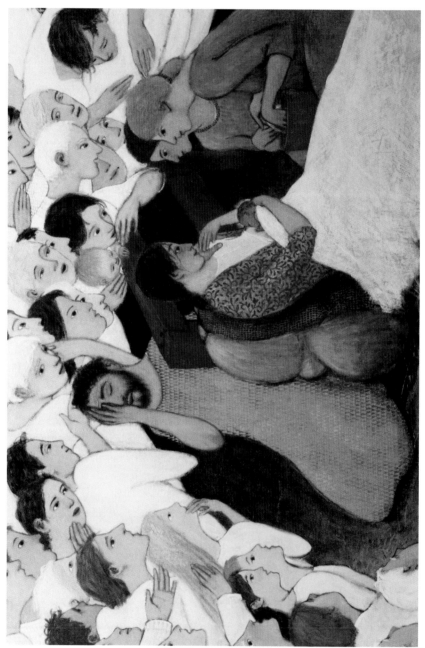

Fig. 3 Brian Kershisnik, detail from *Nativity*. © Brian Kershisnik.

Would You Just Walk (2003). The man in this painting seems to be complicating life by performing his gymnastics, yet the woman appreciates his humor and lets him know this through a small smile. In Nativity, Mary and Joseph repeat this subtlety in their own relationship. Mary, who is herself overwhelmed and has clearly just given birth, places her hand on Joseph's hand as a sign of love and comfort to him. Although Joseph is in a stupor at the miraculous event, he places a hand on her shoulder as if to let her know that he knows this is right. These very human and naturalistic elements of Nativity remind the viewer that Mary and Joseph were indeed human and that through obedience we, too, can become holy.

Professor of art history Mark Magleby draws attention to Kershisnik's Disheveled Saint (fig. 4) as an example of our potential to be holy vessels of the Lord and, literally, instruments in his hand.[9] He writes:

> The writer depicted in Disheveled Saint could be any of us; it is important to Kershisnik that his saint be a bit scruffy, adorned in a T-shirt. The authors of Genesis and Revelation were not required to be well kempt; nor, indeed, were they required to be good writers: they were required only to be worthy vessels for the Spirit of the Lord.[10]

Like the Disheveled Saint, the angels at the nativity are mortals that became holy though Christ. They recognized their potential for goodness and acted upon it. And unlike the beloved angels of artists such as Fra Angelico or Giotto, these angels are individuals with distinct personalities and reactions to the event (fig. 5). Each viewer is invited to consider his or her own reaction. Would I join the angelic chorus in praise, shed a tear in quiet joy, stare in pure awe, or, as one angel does, pat Joseph on the head? The veil between mortality and immortality appears to be thin.

As Mary and Joseph demonstrate, we mortals have the potential to become closer to God. Lovers in the Space Between Trees (2000) is a glorious example of this knowledge. The couple stands alone among bare trees. They are simple and honest, yet the iconic gold halo hovers over each head as a symbol of potential divinity. Their commitment to each other is confirmed with a kiss. Kershisnik's Mary and Joseph share the very human moment of witnessing a birth as concourses of angels sing praises at the sacred event. The commitment of the couple's relationship is signified not through a kiss but by Joseph's hand on Mary's shoulder and her hand on his. The personas of Mary and Joseph are based on the artist's understanding, or desire for understanding, of these fascinating human relationships.

Fig. 4 Brian Kershisnik, *Disheveled Saint*, oil on paper, 7 in. x 6¾ in., 2001. © Brian Kershisnik.

Fig. 5 Brian Kershisnik, detail from *Nativity.* © Brian Kershisnik.

Despite the differences between men and women, Kershisnik recognizes their dependence on one another in order to become holy, for it is within our nature to be holy—to fly. As Kershisnik describes it, "Flight is such a universal part of our dreaming and fancy that I have to suspect it is rooted in our origins or destiny."[11] Several Kershisnik paintings of people practicing flying may allude to our time on earth to prepare to be angels like those hovering over the newborn Christ. When we awkwardly crash to the ground, as we often might, *Halo Repair* (2005) reminds us that we are not quite ready to fly. In this particular painting, an angel replaces the halo on a mother. Her children watch intently, as they will someday have to go through the same process. Thus, becoming like the angels in *Nativity*, despite our follies, is not out of reach.

Kershisnik's *Nativity* and several other paintings personify relationships as he understands them. His understanding of women—their mystical sisterhood, maternal intuition, unwavering faith, and potential divinity—is found in his depiction of Mary. Joseph's character stems from the simple awe and holy confusion Kershisnik may have experienced as a witness to the birth of his own children. The inclusion of these very human qualities within a sacred event reminds the viewer of his or her divine potential to one day become holy and literally fly as an angel.

Notes

1. Brian Kershisnik, interview by the author, May 25, 2006, Kanosh, Utah.

2. Kershisnik draws upon the Proto-Renaissance/Renaissance art tradition by including midwives in the nativity. The midwives were often depicted cleaning the newborn baby.

3. Leslie Norris and Mark Magleby, *Kershisnik: Painting from Life* (Madison, Wis.: Guild Publishing, 2002), 82.

4. Art of Brian Kershisnik that is not reproduced in this printing may be viewed at http://www.kershisnik.com, in the archives file.

5. Quoted in Bonnie D. Parkin, "Oh, How We Need Each Other!" *Liahona* 28 (March 2004): 26.

6. Jacquelyn Mitchard, "Holy Difficulty in the Paintings of Brian Kershisnik," in Norris and Magleby, *Kershisnik: Painting from Life*, 10.

7. It is interesting to note that upon her visit with Gabriel, Mary ran to her cousin Elisabeth. She confided in her dear friend and cousin, a woman, before anyone else.

8. Mark Magleby, "Willing Suspension: The Paintings of Brian Kershisnik," in Norris and Magleby, *Kershisnik: Painting from Life*, 44.

9. See Mosiah 27:36: "And thus they were instruments in the hands of God in bringing many to the knowledge of the truth, yea, to the knowledge of their Redeemer."

10. Magleby, "Willing Suspension," 29.

11. Brian Kershisnik, "Portfolio: The Artist's Voice," in Norris and Magleby, *Kershisnik: Painting from Life*, 73.

Phillip A. Snyder received his doctorate at the University of North Carolina-Chapel Hill, and he is now an Associate Professor and Graduate Coordinator of the English Department at Brigham Young University. He was most recently the coordinator of the American Studies program at BYU. He teaches and publishes about the American West and twentieth-century literature, and he has served on a faculty advisory committee for the re-hanging of the Museum of Art's American collection.

Delys W. Snyder teaches on the part-time faculty of both the English Department and the Linguistics and English Language Department at BYU. She teaches writing in the arts and humanities, technical writing, history of the English Language, and many other courses. Her B.A. and M.A. are in English, and her Ph.D. is in Instructional Psychology and Technology.

Christian Iconography in Latter-day Saint Domestic Space

Brian Kershisnik's *Standing with Jesus on the Grass*

Phillip A. Snyder and Delys W. Snyder

> Even the most perfect reproduction of a work of art is lacking in one element: its presence in time and space, its unique existence at the place where it happens to be.... The authenticity of a thing is the essence of all that is transmissible from its beginning, ranging from its substantive duration to its testimony to the history which it has experienced.... That which withers in the age of mechanical reproduction is the aura of the work of art.[1]
>
> Walter Benjamin

REPRESENTATIONS OF JESUS CHRIST ARE UBIQUITOUS in Latter-day Saint culture. We see them everywhere—in hallways of Church buildings and temples; throughout visitor centers; in the offices of bishops, stake presidents, and others; on the pages of the official Church magazines; in scriptures; throughout lesson manuals; on calendars; and as posters, prints, and bookmarks on display at Deseret Book stores and other such retailers. In fact, the only places where they seem to be absent are in the most sacred ordinance rooms of the temple and in the chapel proper, suggesting perhaps that there is no need for such representations of Christ in these places. Further, in connection with its emphasis on the family, The Church of Jesus Christ of Latter-day Saints especially encourages its members to purchase and display religious artwork in their homes and makes these items readily

available at moderate prices in its distribution centers and through its website. The artwork's presence in an LDS home serves primarily two functions: (1) to call family members to religious remembrance and (2) to bear witness of the family's religiosity. The demand for religious artwork has brought about an industry that creates and mass produces and markets reproductions in a variety of venues, readily available for purchase.

While there is an obvious benefit to having reproductions so readily available—getting art into the hands of more families—many people want to personalize the selection and display of their reproductions of religious artwork to minimize the art's cultural ubiquity and to mediate, in Walter Benjamin's terms, the loss of authenticity and unique artistic aura. We propose to explore this goal by discussing the domestic framing and ordering of a 1988 painting by LDS artist Brian Kershisnik entitled *Standing with Jesus on the Grass*, which we own and which, to our knowledge, has not been copied. We then want to discuss our (re)framing and (re)ordering of the painting within our own domestic sphere among the other religious artworks we display, some original and some reproductions. This dual (re)framing and (re)ordering mitigates against the ubiquitous force of LDS Christian iconography and renders the context(s) of our artwork unique. However, this movement from the ubiquitous toward the unique may also reinscribe an elitist class privilege which would seem antithetical to the function of Christian iconography within LDS culture—that is, to represent a relationship open and available to everyone—so we want to conclude with a cautionary note on over-privileging the artistic aura.

Remembrance and Witness

Because nothing is more central to LDS theology than the remembrance of Jesus Christ, particularly with regard to the Church's saving ordinances such as baptism and the sacrament, representations of the Savior function as covenant reminders. Like many of the Protestants who disclaim image worship, as described in the "Domestic Devotion and Ritual" chapter of David Morgan's book *Visual Piety*,[2] Latter-day Saints are careful not to stray into the Catholic realm of iconography with their representations of Jesus. Unlike some of Morgan's respondents, however, Latter-day Saints tend not to create domestic pseudoshrines or central sites of family devotion—not to respond "to the image as if it were more than an image"[3]—because of this idolatry anxiety. Nevertheless, some representations of the Savior pervasive in LDS culture imply a certain verisimilitude in their near photographic

painting style. The mimetic authority of these "realistic" representations of the Savior, perhaps even implying a definitive depiction of him, is undercut by the multiplicity of artistic renditions of Jesus Christ, both in portraiture and in illustration of his life and ministry. Thus, no one version of the Savior dominates LDS culture as, according to Morgan's study, Warner Sallman's *Head of Christ* seems to dominate Protestant culture.

There are, however, particular representations of the Savior which tend to be especially popular. Reproductions of Albert Bertel Thorvaldsen's statue the *Christus* abound, as Matthew O. Richardson discusses elsewhere in this collection, as do reproductions of Del Parson's *The Lord Jesus Christ*, Harry Anderson's *The Second Coming*, and others. One reason for this ubiquity may be that when the Church holds the copyright and reproduction rights to particular artworks, they are made readily available to the public at very moderate prices. This availability means that within the LDS culture certain artworks proliferate, occupying various sacred sites both public and private, so that a particular artwork can become a token of the memories associated with individual experiences within these various sites. For example, as a ubiquitous, officially approved LDS representation of the Savior, the *Christus* may be invested with memories of someone's first Temple Square visit, of someone else's participation in a moving Sunday School lesson on the resurrection featuring a miniature *Christus* as a visual aid, of a couple's temple sealing because they received a miniature as a wedding gift, of someone's regular browsing of LDS.org, and so forth—almost as if the *Christus* were a Rowlingesque portkey with the power to transport one elsewhere. Its presence becomes a call to personal, as well as religious, remembrance. This personal religious remembrance evoked by the *Christus* can also encompass multiple sites and represent many experiences within an individual life.

Representations of Jesus Christ displayed in LDS homes also bear witness to family members and to other Latter-day Saints of the family's piety. Sometimes these displays of Christian iconography have special witnessing significance within individual families. One LDS family, for instance, suffered serious domestic turmoil because the father decided to reject the Church and to forbid any religious observance in the home, placing him in direct conflict with the feelings of the other family members. After he finally moved out, one of the children suggested they place portraits of Jesus Christ throughout the home to signify the subsequent change in their domestic atmosphere. Undoubtedly this Christian iconography also bore witness to him whenever he returned—to pick up the children for a visit, for instance—

that his family opposed his agnosticism and that, now free from his domination, they were determined to express their faith in tangible ways.

Depictions of the Savior in LDS homes also function in important witnessing ways to those of other beliefs in a reverse but parallel manner to Morgan's Protestant respondents who "go out of their way to display images of Jesus in the home, with the intention of 'witnessing' to Catholic or Jewish or Mormon visitors."[4] Morgan quotes one woman respondent, for instance, who reports hanging Sallman's *Head of Christ* in the hallway near the front door and explains, "As we live in a strong Mormon community, it gives me an opportunity to witness to them and any others who often knock on our door with the Book of Mormon or their *Watchtower* in hand."[5] In light of evangelical insistence that Latter-day Saints cannot be Christian, the witness function of Christian iconography in LDS domestic space takes on equally important status. For example, a couple of our acquaintance reports being very conscious of their decision to place portraits of the Savior around the house so that their relatives who are not members of the Church could see for themselves the centrality of the Savior in the LDS Church. Another couple, the wife a convert, reports that they continually had the "are Mormons Christian?" discussion with her mother during the early years of their marriage. What put this debate to rest was when the wife finally said, "Mom, you've been in our home and seen the pictures of the Savior that we've hung on the walls. Does it look to you like we're not Christians?" The mother was compelled to admit that her LDS daughter and family were, indeed, Christians.

Dual Domestic Contexts

The dominant image of Christ that we have in our home is *Standing with Jesus on the Grass* (fig. 1), painted by Brian Kershisnik at the end of his undergraduate studies in art at BYU and included in his last show before he went on to graduate school. Delys played piano for the show's opening and later arranged to purchase the painting along with another painting we call *Baptism*, a charcoal drawing entitled *Annunciation*, and a pair of woodcut prints, one depicting Adam and Eve and the other depicting Moses raising the serpent in the wilderness. In those days Brian mounted and framed his own artwork, thus involving himself intimately not only in the creation of his art but also in its presentation. By allowing his customers to make payments over time, he seems to have nourished the possibility of his artwork hanging in people's homes. We have visited with Brian and his wife,

Fig. 1 Brian Kershisnik, *Standing with Jesus on the Grass*, oil on paper, 19 in. x 15 in., 1988. Collection of Phillip and Delys Snyder. Photo by William S. Dant.

Suzanne, in Kanosh, Utah, and have had a tour of Brian's studio and the space where Suzanne operates a children's theater company. Our experiences with the artist and his family affect our family's interpretations of the paintings. *Standing with Jesus on the Grass*, along with the other artwork, then, has for us a particularly personal domestic frame: First, the painting *Standing with Jesus on the Grass* itself seems to depict a very personal, contemporary domestic scene, even though it is outdoors; and second, the painting is part of our own domestic space as it hangs in our family room.

Standing with Jesus on the Grass features four main ordering elements: (1) the central figure of the Savior in profile, (2) the couple in the lower right, (3) the title written beneath the feet of the Christ figure and moving left to right toward the couple, and (4) the background. The Christ figure is clearly the resurrected Jesus, clothed in white with white hair and beard and just a suggestion of the nail mark on his left foot. His half-turned posture, with his left foot pointing forward and his right foot and head turned to his right, does not suggest a triumphant Second Coming to the world but, rather, a more personal, individual appearance that is, perhaps, just coming to an end as the Savior begins to move away. The couple, figures that tend to reoccur in Brian's work as emblematic of Brian and his wife, Suzanne, representing male and female in marriage, are touching each other and are turned toward the Savior figure with only the back of the male figure's head visible and the left side of the female figure's face visible in profile. In the aftermath of their encounter with the resurrected Christ, both are in attitudes of reverence with the female figure's head bowed and her eyes cast downward. By depicting the postrevelatory moment, Brian seems to be suggesting that the actual face-to-face encounter with Deity might be too sacred for representation or too private for observers outside the experience to behold. The Savior's moving on also suggests that what matters most might be what happens after the personal witness, which is always circumscribed by the invitation to "Come, follow me," so the moment of the painting is that liminal time between personal invitation and individual action. Further, the placement of the couple mirrors the position that observers of the painting would occupy, underscoring the couple's vicarious representational status and suggesting that they are standing in for us.

Brian's placing of the painting's title within the painting itself underscores the significance of the title's interpretive framing power in directing our interaction with the painting. "Standing" is a gerund, a verbal which functions as a noun, so gerunds embody both the action of a verb and the substance of a noun. In addition, gerunds suggest a perpetual presence of

continuous, yet arrested, action, so the "standing" in Brian's title implies substantial present action. Further, a number of definition variations of the verb "stand" apply here, from "taking up and maintaining a position" to "performing a duty"—all of which are amplified by scriptural references such as the following (emphasis added in these verses):

> And Moses said unto the people, Fear ye not, *stand* still, and see the salvation of the Lord. (Ex. 14:13)
>
> For I know that my redeemer liveth, and that he shall *stand* at the latter day upon the earth. (Job 19:25)
>
> And his feet shall *stand* in that day upon the mount of Olives. (Zech. 14:4)
>
> Watch ye therefore, and pray always, that ye may be accounted worthy to escape all these things that shall come to pass, and to *stand* before the Son of man. (Luke 21:36)
>
> For the great day of his wrath is come; and who shall be able to *stand*? (Rev. 6:17)
>
> But my disciples shall *stand* in holy places, and shall not be moved. (D&C 45:32)
>
> Yea, blessed are they whose feet *stand* upon the land of Zion, who have obeyed my gospel. (D&C 59:3)

In these verses, "standing" is always associated with the revelation of God's power and judgment, particularly as in the presence of Christ's very person, and denotes individual worthiness in surviving such an encounter with Deity. The wicked cannot abide the presence of the sacred. Obviously, Brian's couple survives, at least partly because this is not a final judgment sort of encounter. His use of the preposition "with" in the title—especially as opposed to other viable options such as "before"—underscores the benign nature of this encounter and implies a cooperative, almost leveling stance with regard to the couple and the Savior. Further, the prepositional phrase "on the grass" reaffirms this leveling implication and, in emphasizing the tangible, ordinary nature of the terrestrial world, also suggests that Christ's visit to the couple is literally "down to earth." The green hilly background alludes to a more personal and private version of Mount Zion or the Mount of Olives, one which embodies reverence without the apocalyptic fear of judgment. The cloudy heavens occupy only the top fourth of the painting so that, while Christ's head is connected to heaven, most of his body, especially his feet, is connected to the grass-covered ground. Thus, the Christ figure

Fig. 2 Brian Kershisnik artwork displayed in the home of Phillip and Delys Snyder. Left, top: *Untitled* (Adam and Eve), lithograph, 1988. Left, bottom: *Untitled* (Moses Raising the Serpent), lithograph, 1988. Center: *Untitled*, oil on paper, 19 in. x 15 in., 1988. Right: *Standing with Jesus on the Grass*, oil on paper, 19 in. x 15 in. Collection of Phillip and Delys Snyder. Photo by William S. Dant.

here mediates between heaven and earth in a largely domestic, rather than global, scene.

In our family room, the most central and well-used room in our house, we have framed and ordered *Standing with Jesus on the Grass* within another domestic context (fig. 2). Our reframing and reordering of the painting occurs within three interrelated spheres: (1) its relationship to the other Kershisnik artworks displayed with it, (2) its relationship to other objects in the room, and (3) its relationship to our personal aesthetic theory of inspiring LDS art. The painting is naturally paired with an untitled painting of identical size and mounting, picturing a man, a boy, and two small figures all dressed in white clothing. The father figure—another iteration of Brian's recurring autobiographical male figure—faces the Christ figure in *Standing with Jesus on the Grass* in a relation that makes it seem as if the father is looking up slightly toward the Savior. His reverent, contemplative countenance links the baptism implied in the painting to the figure in whose name that ordinance will be done and also provides an object for the gaze of the Savior in the other painting. The contemporary setting and recurring human figures of both paintings link them further.

The pair of woodcuts (both untitled) picturing Adam and Eve and Moses raising the serpent, hanging on the same wall, also connect to the

Christ figure, especially as they work with each other and with the untitled image of baptism. The gaze of the couple in Adam and Eve, like that of the couple in *Standing with Jesus on the Grass*, is downward, in this case toward the figure of Moses raising the serpent, the typological representation of Christ, as if they know to whom they should look for salvation once they are cast out of the garden. In fact, the two couples frame our Kershisnik tableau, with Adam and Eve on the upper left and the contemporary couple on the lower right, and they also span the distance between the creation and the contemporary world, one being the first couple and the other being the most recent. The Old Testament woodcuts represent key prefiguring episodes of the coming of Jesus Christ, Adam and Eve representing the Fall and the necessity of a Savior and Moses raising the serpent representing the saving promise of the Savior. Moses, like the father figure in the baptism painting, in turn, looks toward the Christ figure in *Standing with Jesus on the Grass*, and, perhaps most importantly, Moses must look through the ordinance of baptism to get to the Savior.

We strategically placed the Kershisnik Old Testament woodcuts just above our modest television to remind our family that we live in a fallen world and that we should not perish in a televised wilderness because we are too distracted to look up and behold our salvation in Moses's serpent. *Standing with Jesus on the Grass* hangs on the opposite end of the wall, just above our gas-powered replica of an old-fashioned wood stove, to suggest a connection between the Savior and an earthly source of light and heat. A cabinet divides the wall in half and stands directly opposite the dining room/kitchen area, representing domesticity and bread-of-life nourishment in that it features a flour bin and originally functioned as a breadmaking station. If one sits down on the couch, other displays of religious iconography are clearly visible: Kershisnik's *Annunciation* on one side and a *Christus* tableau on the other, featuring, in addition to the miniature statue, an antique sacrament cup; a miniature of the Nauvoo Temple; the Book of Mormon, the Doctrine and Covenants, and the hymnal; and a photograph of President Gordon B. Hinckley.

All these religious artworks and their arrangements reflect our personal preferences for impressionistic rather than realistic art and for the unique rather than the ubiquitous. We prefer representations that embody more the *idea* of their referents over definitive mimetic representation of iconic religious figures. We have tried to arrange these pieces in an imaginative, personal way that teaches our family.

Ethical Implications

While Walter Benjamin claims that unique artwork brings a particular aura to religious iconography not present in ubiquitous reproductions, he also argues against such privileging of the unique artistic aura and actually looks forward to what may follow from the "withering" of the aura in the "age of mechanical reproduction,"[6] an age that would make reproductions of unique artwork available to the public: "The technique of reproduction detaches the reproduced object from the domain of tradition. By making many reproductions it substitutes a plurality of copies for a unique existence. And in permitting the reproduction to meet the beholder or listener in his own particular situation, it reactivates the object reproduced."[7]

Here Benjamin suggests that the work of art is actually reactivated, not diminished, through the multiplicity of its reproductions. According to Benjamin, the aura functions in a tradition that controls the context of how we relate to a work of art. Reproduction, however, undermines this singular context and provides a multiplicity of contexts, laying the foundation for a great democratization in the world of art.

We see this democratization at work, for example, throughout Morgan's *Visual Piety*, in which he reproduces a multiplicity of contexts in which Sallman's *Head of Christ* figures prominently, none of which can make any claim of being definitive. This dispersal of the artistic aura connected with Sallman's particular representation of the Savior further demonstrates the productive ways in which the ubiquitous can be valued over the unique. We see the same phenomenon with the *Christus* in LDS culture. Reproduction multiplies the contextual possibilities for Christian iconography almost infinitely. This wide availability of canonized representations of the Savior may be the aesthetic equivalent of making reasonably priced scriptures readily available.

While we have certainly enjoyed having an original artwork in our home, we also see the value in its reproduction. Thus we have presented it in this volume as a first step in its "reactivation" within a plurality of cultural contexts, domestic and otherwise, and hope our readers will enjoy the painting and the paper in a context of their choice.

Notes

1. Walter Benjamin, "The Work of Art in the Age of Mechanical Reproduction," in *The Continental Aesthetics Reader*, ed. Clive Cazeaux (London: Routledge, 2000), 324.

2. For example, see David Morgan, *Visual Piety: A History and Theory of Popular Religious Images* (Berkeley: University of California Press, 1998), 157.

3. Morgan, *Visual Piety*, 157.

4. Morgan, *Visual Piety*, 153.

5. Morgan, *Visual Piety*, 163.

6. Benjamin, "Work of Art," 324.

7. Benjamin, "Work of Art," 325.

Val Brinkerhoff is Associate Professor of Photography in the Visual Arts Department at Brigham Young University, where he teaches a variety of courses ranging from digital imaging to portraiture. Besides teaching, Val is a regular contributor to a variety of photography magazines, produces large print work for exhibition, and has published four books. He is currently working on a series of volumes dealing with the lost language of symbolism as expressed in ancient and modern sacred architecture. This research has taken him to many parts of the world, often with students. He and his wife, Trina, are the parents of four children. They reside in Elk Ridge, Utah.

Eight, the Octagon, and Jesus Christ

Patterns in Sacred Architecture and Scripture

Val Brinkerhoff

THE SAVIOR SAID, "AND BEHOLD, ALL THINGS HAVE THEIR LIKENESS, and all things are created and made to bear record of me" (Moses 6:63). Numbers serve as important witnesses for the Lord Jesus Christ in scripture and in sacred architecture. Many of the more common symbolic numbers convey not only *quantitative* meaning but also *qualitative* ideas: for example, three is often used to symbolize the divine; seven, fullness; eight, rebirth; twelve, priesthood; and forty, purification. Certain shapes such as the circle, triangle, square, pentagram, and octagon also stand as symbols of Christ (fig. 1). The number eight and its associated shape, the octagon, appear so frequently in sacred Christian architecture, both around the world and in Latter-day Saint temples, that I began an intensive search for their symbolic meaning in scripture. What I found were subtle yet consistent correlations to Jesus Christ and the various roles of his mission.[1] Modern Latter-day Saint temples today showcase a return to the ancient language of visual symbolism, including patterns involving eight and the octagon. This paper explores the unique connection these patterns have to Christ in scripture, in ancient sacred architecture, and both historic and modern Latter-day Saint temples. Examples of eight in scripture and architecture presented hereafter are representative rather than exhaustive. Searching reveals many more examples.

Fig. 1 Design on a metal door near the altar inside Chartres Cathedral, France. This figure combines squares, circles, an octagon, and a five-pointed star—shapes that each represent Christ. © Val Brinkerhoff.

The number eight frequently appears in the Old and New Testaments in consistent ways connecting it to Christ. A few are found in the Book of Mormon. As a type for Christ, eight played an important role in ancient Israelite rites, especially sacrifice, with consistent connection to the related concepts of purification, rebirth, resurrection, rebuilding, and the Melchizedek Priesthood, all of which are realized through the Atonement of Jesus Christ, helping us transition to the next level.

Sacrifice

The Law of Moses required many sacrifices, each of which pointed to Jesus Christ, the Lamb of God, the ultimate sacrifice. Patterns in scripture connecting the number eight to sacrifice, include both *time* (the eighth day) and

amount (eight things). For example, many important sacrifices occurred on what scripture refers to as the "eighth day," the completion of a seven-day cycle, or the first day of a new, reborn week. The eighth day brought the week full circle, providing continuity. It was on the eighth day that the firstlings of the harvest and flock were given to the Lord for sacrifice. The Lord also commanded ancient Israel to hold solemn assemblies on the eighth day, a day when various sacrifices and offerings were to be made, including meat, drink, sin, and burnt offerings (Num. 29:35–40). The Lord instructed, "Seven days ye shall offer an offering made by fire unto the Lord: on the eighth day shall be an holy convocation unto you; and ye shall offer an offering made by fire unto the Lord: it is a solemn assembly; and ye shall do no servile work therein" (Lev. 23:36). Other "eighth day" examples in scripture consistently point to purification, a rebirth or renewal through the sacrifice of Christ.

Passover was a special time of sacrifice for Israelites celebrating their deliverance from Egypt and from bondage and sin. They remembered when the blood of a lamb on the lintel and the two doorposts of their homes protected and delivered them. Christ is connected to Passover symbolically, as the death of the lamb represents his sacrifice, and also literally, as many important events in his life (most of which point to his atoning sacrifice) occurred at this symbolic time of year. Passover has many connections to the number eight. Josephus described the Feast of Passover as "a feast for eight days," as it started and ended on the Sabbath.[2] In addition, God commanded that the lamb sacrificed at Passover, representing the Savior, meet eight specific requirements (Ex. 12):

1. The lamb had to be male (Ex. 12:5).
2. It had to be a firstborn lamb (Ex. 12:5).
3. It could not have any spots or blemishes (Ex. 12:5).
4. It was to be slain at a certain hour on a particular day (Ex. 12:6). (Christ was sacrificed at the very hour—the sixth hour—that Passover lambs were being sacrificed in Jerusalem; see John 19:14–15.)
5. It had to be roasted with fire (Ex. 12:9).
6. No bone of it was to be broken (Ex. 12:36). (The two men crucified with the Savior had their legs broken, but Jesus did not, as he had already died; see John 19:32–36.)
7. The lamb had to be eaten with bitter herbs (Ex. 12:8).
8. Nothing was to be wasted (Ex. 12:9). It was to be totally consumed.

According to Alfred Edersheim, later guidelines also required that this lamb not be younger than eight days or older than one year.[3] The Mosaic law required that eight priests bring the separate pieces of a sheep or she-goat sacrifice to the altar for burning after it was flayed: "Six priests carried the sacrifice, one more the meat offering, and one the drink-offering (eight in all)."[4]

Certain sacrifices in ancient Israel required "lifting and waving" of the offering before the Lord.[5] This movement may have been in eight divisions of space. Waving was right to left and forward to back (the four horizontal directions); heaving was up and down, passing through a central area (three vertical positions); and a final motion was potentially around, thus making a total of eight possible divisions of sacred space to move the sacrifice within. All movement symbolized giving and receiving.

Purification

Under the Law of Moses, the number eight pointed to purification through Jesus Christ. Purification for the unclean, such as those with an issue of blood or other impurity, was complete on the eighth day (Lev. 15). After an initial seven-day period of purification, a leper could bring an offering to the priest, who offered this sacrifice to the Lord on the eighth day as an atonement for the leper: "And he shall bring them on the eighth day for his cleansing unto the priest, unto the door of the tabernacle of the congregation, before the Lord" (Lev. 14:23).

Purification for priests was also achieved on the eighth day. Seven days were required for consecration of the priests, during which they were not to leave the tabernacle. On the eighth day, however, they were to offer a sacrifice unto the Lord, an atonement for the priests and all Israel: "And it came to pass on the eighth day, that Moses called Aaron and his sons, and the elders of Israel; And he said unto Aaron, Take thee a young calf for a sin offering, and a ram for a burnt offering, without blemish, and offer them before the Lord" (Lev. 9:1–2).

The Day of Atonement was a very special day of purification for all Israel. This was the most sacred of all holy days, when all of Israel was reconciled to God through the mediation of Christ as provided by the high priest. All of the events of this day pointed to the future sacrifice of the Son of God, represented by the high priest, who took center stage in the rituals of the day. It was on the Day of Atonement that the high priest wore eight pieces of sacred clothing for entrance into the Holy of Holies of the temple (Lev. 16:4 and Ex. 28–39): (1) the golden crown on his forehead, (2) the square breastplate with the twelve different stones on his heart (with

the Urim and Thummim inside), (3) the outer one-piece blue robe decorated with pomegranates and bells (blue is associated with priesthood and the heavens), (4) the apron, (5) four white undergarments made from flax, or white linen (as described in Rev. 15:6), (6) the belt, (7) the turban, and (8) the pants. Angels have also been described in some nonbiblical ancient sources as having eight garments.[6]

The high priest then passed, in westward movement, eight increasingly holy items in progressive fashion, each of them symbolizing the Savior:[7]

1. The altar, where the lambs and other animals were sacrificed, their blood shed. The lamb symbolized the pure, innocent, first born of the Father, and the Savior as the sacrificial lamb (Exodus 29:38–42).
2. The laver of water, where the priests "washed" and purified themselves. The laver pointed to purification through the atonement. He is the source of living water (John 4:13–14).
3. The single door of the tabernacle. The Savior is the only door to forgiveness, purification, and renewal, and therefore to the Father, eternal life, and exaltation (John 10:9).
4. The vine symbol above the door. The Savior is the true vine providing life sustaining nourishment and rebirth via the sacramental wine of the Atonement (John 15: 1, 5).
5. The table of shewbread at right or north. The Savior is the bread of life (John 6:32–35).
6. The menorah at left or south. The Savior is the light of the world (1 Tim. 2:5). We look to him for knowledge, revelation, and inspiration.
7. The altar of incense at the veil. The Savior is the mediator between man and God. Righteous prayers rose to God and were symbolized by the smoke of fragrant incense rising to the heavens (1 Tim. 2:5).
8. The stone in the Holy of Holies (replacing the Ark of the Covenant, which had been stolen. It symbolized the Lord himself, the "stone of Israel," and had his name inscribed upon it [Gen. 49:24]). The Savior is the rock, the sure foundation, the chief cornerstone, the source of revelation, and all that is solid and true (1 Cor. 10:4).

Purification on the Day of Atonement was represented by the sacrifices. In the second temple period (Herod's Temple), the high priest entered the Holy of Holies on the Day of Atonement and sprinkled the blood of a sacrificed bullock eight times on the stone of foundation. The high priest sprinkled the blood once upwards towards where the mercy seat would have been, and seven times downwards: eight times total. He repeated this

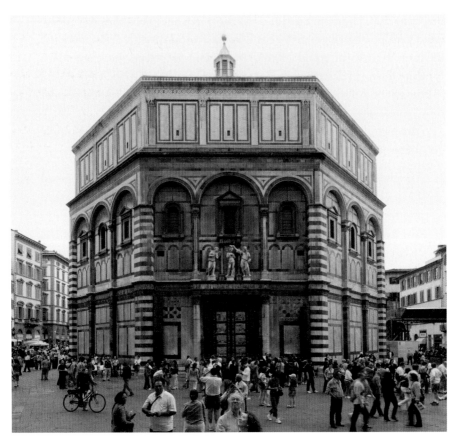

Fig. 2 Battistero di San Giovanni (Baptistery of St. John) near the Duomo, Florence, Italy, circa 1059. The octagonal design of this baptistery reflects its function as a place of rebirth. © Val Brinkerhoff.

eight-part sprinkling first with the blood of a sacrificed goat, and then again outside the Holy of Holies with the blood of both animals, sprinkling the blood towards the veil.[8]

Rebirth

Numerous scriptures also point to renewal or rebirth in the eighth time period, after purification is complete (fig. 2). Seven-part time cycles symbolized a full or complete revolution of time, whether seven days (the week), seven years (sabbatical year), or seven thousand years (the millennium). The eighth time period signaled renewal. In agriculture, for example, the land was given rest on the seventh or sabbatical year so that it would be renewed and become more productive from the eighth year onwards. Peter healed a

man at Lydda who had been in bed eight years, sick of the palsy. Peter gave him new life through Christ the Lord and his priesthood, saying, "Æneas, Jesus Christ maketh thee whole: arise, and make thy bed" (Acts 9:33–34). Nephi and his family spent eight years in the wilderness before building a ship and going to the Promised Land, initiating the rebirth of a new people (1 Ne. 17:4). Alma and his people, after being baptized, traveled eight days to escape King Noah so they could worship freely, beginning life anew (Mosiah 23:3).

Rebirth as a member of God's kingdom on earth was demonstrated in ancient times by circumcision (at eight days) and today by baptism (at eight years). Males in the Old Testament were circumcised when eight days old: "Abraham begat Isaac, and circumcised him the eighth day" (Acts 7:8; emphasis added; see Lev. 12:3). John the Baptist, the great forerunner of Christ, was ordained by an angel and circumcised when eight days old in preparation for his great mission to prepare the way before the Lord (D&C 84:28). Six months later, Jesus was circumcised and named on the eighth day after his birth (Luke 2:21). Circumcision was an ancient symbol of entering God's kingdom on earth through the Abrahamic covenant, a promise of celestial glory and eternal lives that would be realized in the eighth age after the seven thousand years of the earth's existence. This eighth age is the time when the righteous will be resurrected, inheriting a reborn, celestialized earth.

Some early Christian writers suggest that the ancient Saints were baptized at age eight. 1 Peter 3 hints at this, connecting baptism of the earth with the survival of eight righteous souls during the great flood; a rebirth of both the human and the animal families in Noah's time: "[Christ] went and preached unto the spirits in prison; Which sometime were disobedient . . . in the days of Noah, while the ark was a preparing, wherein few, that is, eight souls were saved by water. The like figure whereunto even baptism doth also now save us . . . by the resurrection of Jesus Christ" (1 Pet. 3:19–21).

Today, baptism at eight years of age is a covenant and sign accompanying young Latter-day Saints entering the kingdom of God, a rebirth through Christ's Atonement. Alma of the Book of Mormon utilized eight elements to teach the makeup of the baptismal covenant when encouraging his people to be baptized: (1) "if ye are desirous to come into the fold of God," (2) "to be called his people," (3) "are willing to bear one another's burden's, that they may be light," (4) "are willing to mourn with those that mourn," (5) "comfort those that stand in need of comfort," (6) "to stand as witnesses of God at all times, and in all things, and in all places," (7) "that ye may be redeemed of

God and be numbered with those of the first resurrection," (8) "that ye may have eternal life" (Mosiah 18: 8–10).

Joseph Smith encouraged the Saints to make their calling and election sure, which results in receiving the second comforter, personal visitation from Christ himself and potentially the Father also. In 2 Peter, the Saints are exhorted to make their calling and election sure through eight refining steps: (1) faith, (2) virtue, (3) knowledge, (4) temperance, (5) patience, (6) godliness, (7) kindness, and (8) charity (2 Pet. 1:5–7). Thus baptism represents entrance into God's kingdom here on earth, where making your calling and election sure points to entrance into his presence in this life, as well as the assurance of eternal life in the celestial kingdom in the world to come. Both involve eight characteristics signaling purity and rebirth.

Resurrection

Just as the number eight points to spiritual rebirth, it also represents physical rebirth in the resurrection. The early Christian writer Ignatius pointed out that Christ was resurrected and entered his kingdom on the eighth day, Sunday, the first day of a new, reborn week. He urged the Saints, "Let every friend of Christ keep the Lord's Day . . . the resurrection-day, the queen and chief of all days."[9] The four Gospel writers are united in asserting that Christ was resurrected on this day (Matt. 28:1; Mark 16:1; Luke 24:1; John 20:1). This is why most Christians today, including Latter-day Saints, celebrate the Sabbath on Sunday and not Saturday (the ancient Hebrew holy day). Some early Christian writers point out that the Resurrection of Christ on the eighth day was reflected in circumcision by the Hebrews on the eighth day after birth, a sign of Israel being reborn into God's kingdom on earth.[10] Some early Christians also wrote that Christ being resurrected on the eighth day pointed to all the faithful entering their glory in the eighth age after the Millennium.[11]

Melchizedek Priesthood

"This 'Melchizedek Priesthood . . . is the channel through which all knowledge, doctrine, the plan of salvation and every important matter is revealed from heaven' 'The power and authority of the higher, or Melchizedek Priesthood, is to hold the keys of all the spiritual blessings of the church.'"[12] It was named for the righteous king of Salem, Melchizedek, who gave it to Abraham (D&C 84:14). "Before his [Melchizedek's] day it was called *the Holy Priesthood, after the Order of the Son of God*" (D&C 107:3; emphasis in

original). This priesthood was called after Melchizedek because he significantly magnified his calling and because the new name avoided using God's name too frequently. Both Christ and Melchizedek have been referred to as great high priests in scripture (Heb. 4:14–15; D&C 84:14). Both have also been called "prince of peace" (Alma 13:18; Isa. 9:6).

The ordinances of purification, sacrifice, baptism, and resurrection listed previously are all connected to the number eight, each of them made possible through the power of the Melchizedek Priesthood held by Christ and his representatives.

How is priesthood connected to the number eight? (1) There are eight priesthood offices in the Church: deacon, teacher, priest, bishop, elder, seventy, high priest, and apostle. (2) Joseph Smith's plans for the New Jerusalem

Fig. 3 Design on wall at the Baptistery of St. John, Florence, Italy. This design may be a Seal of Melchizedek, two squares at a forty-five degree angle. © Val Brinkerhoff.

temple complex in Missouri originally featured twenty-four separate temples, three temples each for the eight priesthood offices. Each of the temples was to have twenty-four pulpit-altars like those of the Kirtland Temple, where priesthood leadership were to be seated. Each of the pulpits was to measure eight feet wide, elevated in multiples of eight; the first 8 inches, the second 16 inches, the third 24 inches, and the fourth 32 inches, and so on.[13] (3) The Seal of Melchizedek is a graphic motif used in and on many LDS temples connecting the ordinances of the temple to priesthood power. This motif is made up of two overlapping square outlines set at a 45 degree angle to one another (fig. 3). An octagon rests at the center of the motif.

The Seal of Melchizedek

In addition to being associated with sacrifice, purification, rebirth, and resurrection, the number eight symbolizes the higher priesthood held by Christ and those serving as types for him, including Melchizedek, the King of Salem, via the Seal of Melchizedek, an eight-pointed variation of the octagon. The seal points directly to the great governing power of this priesthood and is found in and on a number of LDS temples including the Salt Lake, San Diego, and Albuquerque temples, among others. According to architect Bill Lewis, more than ten thousand octagon-based motifs were used in and on the San Diego Temple, many with a circle at center (fig. 4). Lewis (now a San Diego Temple sealer) had the unique opportunity to work closely with President Gordon B. Hinckley (First Counselor to President Benson at the time) in designing this unique, towering white temple, which some two hundred fifty thousand cars pass by each day. Even though Lewis's design team had no prior knowledge of the octagon's ancient symbolism, they integrated the octagon motif as a primary unifying symbol throughout the structure: even the aerial perspective of the temple mirrors this motif in the outline of the two square towers. At one point, Stan Smith, a representative of the Church's Temple Construction Department, became curious about the motif and asked Hugh Nibley (a professor at BYU at the time) if any ancient meaning was attached to the symbol. Nibley explained that in antiquity the motif (without the circle or beehive at center) is typically referred to as the Seal of King Melchizedek. Lewis excitedly related this discovery to President Hinckley in a letter, after which President Hinckley confirmed the meaning himself in a phone conversation with Nibley. Placement of this symbol on the San Diego Temple represents one of its first uses upon any Latter-day Saint temple.[14]

Fig. 4 An entrance door at the San Diego California Temple. Here are a few of the thousands of octagonal Seal of Melchizedek patterns featured on this temple. © Val Brinkerhoff.

The motif is also found in a number of ancient Christian churches in Europe, the two most notable being the octagonal sixth-century San Vitale in Ravenna, Italy (fig. 5), and Sant'Apollinare in Classe, Italy (fig. 6). Both contain beautiful mosaics in their most sacred interior spaces, mosaics portraying this seal positioned on an altar between Abel and Melchizedek, both wearing robes.

The Seal of Melchizedek is prominently featured upon the etched glass entrance doors of the new annex of the historic Salt Lake Temple and is the first thing patrons encounter as they visit the temple. This motif features an eight-tiered beehive at the center of a circle, which rests in the center of the two overlapping squares. According to Hugh Nibley, the beehive was an ancient symbol of kingship.[15] Early settlers in the Salt Lake Valley named their new land Deseret ("honeybee," Ether 2:3) and used the beehive motif as a visual symbol for the kingdom of God on earth.[16] Later the beehive symbol became linked to the idea of "organization and industry," a safer, secular connection which Utah state government felt more comfortable with. Thus the seal on the annex doors may feature three nested important concepts:

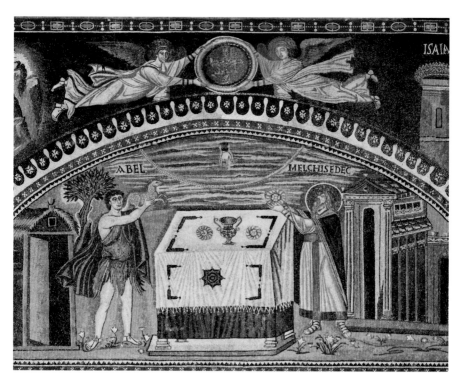

Fig. 5 Mosaic at San Vitale, Ravenna, Italy, sixth century. Here Abel and Melchizedek make offerings to God. On the cloth is a prominent Seal of Melchizedek. © Val Brinkerhoff.

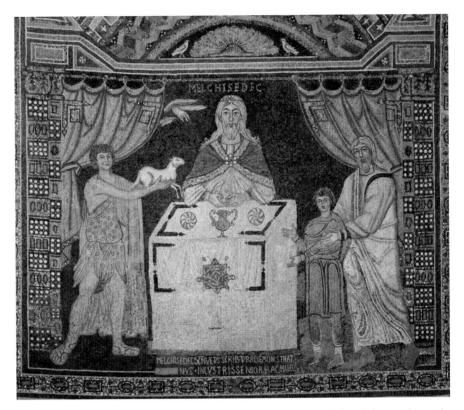

Fig. 6 Mosaic at Sant'Apollinare, Classe, Italy, sixth century. Melchizedek presides at the altar, accepting offerings. Again, on the cloth is a prominent Seal of Melchizedek. © Val Brinkerhoff.

(1) the greater priesthood in the Seal of Melchizedek, (2) the temple as meeting place between man and God in the circle in square motif, and (3) the Church as the Kingdom of God on earth in the eight-tiered beehive, with Christ as king.

The Octagon in Temple Towers

The octagon is the perfect transitional shape between the square and circle. When the circle and the square are joined together, they become a universal archetype the world over for the meeting place of God or heaven (the circle) with man or the earth (the square). Historic examples include the Pantheon in Rome, *stupas* throughout Asia, Islamic mosques, and half-domes above square rooms in many European cathedrals, including St. Peter's Basilica in Rome. In sacred Christian architecture, including that of the Latter-day Saints, the octagon is an intermediate connecting shape between the circle

Fig. 7 Towers of St. Louis, Vernal, and St. George temples. These three towers exemplify many octagonal towers found on LDS temples and meetinghouses. © Val Brinkerhoff.

above and the square below (fig. 7). It can thus serve as a visual metaphor for Christ as mediator between man and God: "For there is one God, and one mediator between God and men, the man Christ Jesus" (1 Tim. 2:5). Octagonal towers are found on sacred structures worldwide (including LDS temples and meetinghouses). In many historic European churches, baptisteries, small fonts for baptisms, and holy water fonts are octagonal.

Eight-Pointed Stars

When the eight-sided outline of the Seal of Melchizedek is filled in, it forms an eight-pointed star. In similar ways to stars orienting ancient travelers, stars on temples today symbolically guide us to the Father. In Christian architecture, eight-pointed stars are often associated with Jesus Christ, "the bright and morning star" (Rev. 22:16).[17] They appear in many churches, often in the most sacred areas, including Santa Maria in Trastevere and Sant'Ignazio in Rome. Eight-pointed stars are found in or around many modern LDS temples (figs. 8 and 9). The Holy of Holies of the Salt Lake Temple features numerous eight-pointed sun symbols or "stars" on its dome.[18] Stars possessing twelve points, six points, and five points, both upright and inverted (some with elongated points) are also found on LDS temples, each with their own meaning based on context (fig. 10). Typically, upright and inverted five pointed stars are associated with the righteous, including Jesus Christ. The Savior has special connection to Venus, the evening and morning star, often symbolized by the inverted pentagram with an elongated point. It takes exactly eight years and one day (two four-year cycles) for the planet Venus to move within the vault of the heavens, its path forming a pentagram.[19]

Fig. 8 Entrance to Sacramento California Temple. This eight-pointed star may represent Christ through two 4-year Venus cycles. © Val Brinkerhoff.

Fig. 9 Winter Quarters Nebraska Temple, east side, art glass window. This design combines an eight-pointed star (with two 4-part divisions) with a sun, moon, and five stars. © Val Brinkerhoff.

Inverted pentagrams are found on the Nauvoo, Salt Lake, and Logan temples and other LDS structures.

Eight Divisions of Sacred Space

Not only do shapes such as stars and octagons carry important symbolism, but the very structure of sacred architecture is often very symbolic. Gothic cathedrals, for example, featured horizontal division of space in outer courts, inner courts, and the holiest place, the location of the altar. This pattern was first seen in the graduated sacred space of the Old Testament Tabernacle, which was oriented to the east, but which featured the high priest moving to the west, the location of the Holy of Holies where the Ark of the Covenant resided. This movement mirrored the path of light itself.

Many sacred places feature eight divisions of sacred space for orientation of the structure and movement within it, all of them moving towards God. Four of these divisions are horizontal (the four cardinal directions), gathering and taking initiates first inward to the center place. Throughout the Bible movement has symbolized either rebellion and sin (movement to the east) or righteousness and blessing (movement to the west) (Gen. 4:16; 13:11–13; Ex. 10:13, 19; Num. 32:19; Matt. 2:1; Rev. 7:2–3; Alma 25:5; D&C 136).

Three additional vertical divisions of space have a more obvious space-time component, taking initiates upward, from the past (below), through the present (middle area), to the future (above). Modern LDS temples are consistent with this pattern, as progression proceeds from the baptistery below ground level (associated with the past, death, burial) to endowment rooms in the middle (the present) and finally to sealing rooms above (future blessings). The eighth division is around, as seen in spiral staircases (eight in the Salt Lake Temple) and sacred temple cornerstone ceremonies. President

Gordon B. Hinckley has described how this ceremony begins at the one corner and proceeds to the other cornerstones in rotation.[20] All eight types of movement within sacred space focus attention on the center place of the temple where contact is made with God.

Eight in LDS Temples

During Moses' forty days on Mount Sinai, God gave a very detailed description of the ancient tabernacle to him. The "pattern" for modern temples has also been given to Joseph Smith, Brigham Young, and other latter-day prophets, who with the assistance of inspired architects and artisans have created modern LDS sacred architecture. The interior spaces of Latter-day Saint temples repeatedly use the number eight and the octagon, part of

Fig. 10 Art glass window and stonework, Nauvoo Temple. The inverted five-pointed star (representing the righteous) has a highlighted pentagram, associated with Venus, whose pattern in the sky forms a pentagram over eight years. © Val Brinkerhoff.

an inspired pattern. In this section I will look at the use of eight in LDS temples generally, then look at six temples specifically, including both historic and modern temples. I have gleaned this information from personal observation of thirty-one (to date) LDS temples. The majority of the patterns involving eight or the octagon in modern LDS temples are found in two of the temple's most sacred areas—the first, lowest area, the baptistery, and the last, highest area, the celestial room (also the sealing rooms and the Holy of Holies).

Baptisteries. Baptism symbolically represents purity and rebirth made possible by the Atonement of Christ. Since the font represents rebirth through Christ's mediation, it is appropriate that the baptistery room is usually octagonal while the font is usually round, a symbol of heaven. The octagon encompasses the primary and secondary directions of the compass, eight in total. In the baptistery the octagon can symbolize the directions in which the gospel is to be spread and from which the elect are to be gathered to the stakes of Zion in the last days. Ultimately, the Saints gather to the

mountain of the Lord's house, where they receive covenants and promises, making it possible for them to one day dwell with God himself. Below the oxen (an ancient symbol for the tribe of Joseph who is primarily responsible for taking the restored gospel to the world) and usually on floors of stone, an octagon, eight-pointed star, or eight-sided Seal of Melchizedek is often found, especially in the most modern temples. The ceiling above the font frequently features an octagon motif as well, as do many small decorative details in and around this important symbol of rebirth. Many LDS temple baptisteries also feature eight pillars surrounding the room, two at each of the four cardinal directions.

Upper Rooms. As temple patrons advance to more elevated spaces, the principle of progression is expressed symbolically by greater artistry, more space (higher ceilings), greater levels of illumination, and a general increase in beauty and complexity. Designs become more elaborate and colorful, including octagonal patterns, many in gold. Many sealing room ceilings feature horizontal figure-eight designs, chains, and intertwining circles. These are gold-leaf designs symbolizing the endless and eternal nature of the sealing ordinances, which bind families together eternally.

Steeples. The midsections of many LDS temple single towers are octagonal, located between a square base below and a circular or spherical shape above. The octagon thus serves as a mediating shape between these two perfect forms, symbolizing the Savior Jesus Christ as mediator, on the highest points of our meetinghouses and temples. The Kirtland, Nauvoo, and St. Louis Temples are good examples, as are many modern LDS meetinghouses.

Lights. In the first and last ordinance rooms of many LDS temples, there are frequently eight individual lights on chandeliers or other fixtures. Sometimes there are eight sets of lights, such as in the Holy of Holies of the Salt Lake Temple. Christ is the primary provider of light (revelation, knowledge, and the Spirit). He said, "I am the light of the world" (John 8:12).

Pillars and Tree of Life. The tree of life is a sacred symbol utilized throughout the ancient world. Pillars possibly representing tree trunks and the tree of life frequently appear in groupings of eight in Latter-day Saint temples in both the baptistery (rebirth) and the celestial room (presence of God). Nephi learned that the tree of life represents God the Father's love for mankind through the sending of his Only Begotten Son to earth to atone for our sins (1 Ne. 11:21–22). The first Greek temples utilized tree trunks for support rather than stone pillars.[21] In much of ancient Christianity, the cross (often portrayed in green in stained glass windows) has replaced the tree of life symbol.[22] While Latter-day Saints don't use the cross

as a symbol, they do use pillars in their architecture, perhaps representing stability and strength of priesthood covenants with Jesus Christ. The scriptures promise that "the righteous shall flourish like the palm tree. . . . Those that be planted in the House of the Lord shall flourish in the courts of our God" (Ps. 92:12–13). "Him that overcometh will I make a pillar in the temple" (Rev. 3:1). Tree of life stained glass windows are found at the end of the journey in the exterior windows of the celestial room at both the Palmyra New York and Winter Quarters Nebraska Temples. This room symbolizes the presence of God. The tree of life is mentioned eight times in three different books of the Bible: Genesis, John, and Revelations. Genesis and Revelations are the first and last books of the Bible. Christ has frequently referred to himself as the first and the last, "I am Alpha and Omega" (Isa. 44:6, D&C 35:1, 38:1, 39:1). The Apostle John addressed the topic of the love of God the Father, in connection with Jesus Christ, a total of eight times in the fourth book of the New Testament (John 3:16; 3:35; 5:20; 10:47; 13:1; 17:13; 17:26; 21:15–17).

Increments of Eight. Ezekiel's vision of a temple in the heavenly city included descriptions of eight tables where atoning sacrifices were made, and three progressive courts, each of them with eight steps leading to the next court. Many LDS temples, including the Cardston, St. George, and Manti temples, feature eight steps from one ordinance room to the next, potentially symbolizing rebirth in vertical progression. In the Billings Montana Temple, the rise from the endowment room to the celestial room is eight inches, a typical measurement for subtle height increases in many of the smaller LDS temples.

The Kirtland Temple

The first temple of the Restoration, although a preparatory temple with a limited "endowment," features usage of the number eight in ways consistent with modern LDS temples, namely the use of eight pillars inside one of its most holy areas and its single octagonal tower (fig. 11). The general design for this temple was revealed in June 1833 to Joseph Smith, Sidney Rigdon, and Frederick G. Williams. Orson Pratt testified that the Kirtland Temple was not built "in accordance with architecture devised by men" but "according to the heavenly pattern that [the Lord] by his voice had inspired to his servants."[23]

The single tower of the Kirtland Temple has a belfry section that is octagonal. This section is supported by a square section below it on top

of the temple roof, and capped by an implied half dome that touches the sky, making the octagon belfry a transitional shape between the square below and the circle above. Inside the first floor "holy area" of the temple there are eight square pillars carved with eight flutes on each of the pillars' four sides.

Eight elements were part of the preparatory Kirtland Temple endowment:[24] (1) solemn assemblies for receiving instructions on the doctrines, principles, and laws of the gospel, (2) the ordinances of washing and anointing, (3) a sealing ritual, (4) the making of covenants, (5) partaking of the sacrament in commemoration of the marriage supper of the Lamb, (6) the employment of ritual gestures and language, (7) the ordinance of the washing of feet, and (8) the reception of power from on high in the form of spiritual manifestations.

Fig. 11 Tower, Kirtland Temple. The octagonal shape of the tower is a transition from the square, representing earth, to the dome, representing heaven, just as Christ is a mediator between earth and heaven. © Val Brinkerhoff.

The Nauvoo Illinois Temple

Dedicated in 2002, the new Nauvoo Temple (fig. 12) is a re-creation of the original 1845 temple design. It was at Nauvoo that Joseph Smith implemented not only the complete endowment, but a unique Latter-day Saint symbol system, much of it prominently displayed for the first time on the Nauvoo Temple. Brigham Young would later intensify this practice with an explosion of symbols on the Salt Lake Temple.

The first baptismal font designated for proxy baptisms for the dead was in the lowest level of the original Nauvoo Temple. It measured eight by twelve feet. These are two of the most commonly used numbers in LDS temples as well as many ancient Christian churches; eight pointing to rebirth and twelve pointing to priesthood. Plans for the original Nauvoo Temple show eight twelve-pointed stars in the lower round windows, four on each side of

Fig. 12 The west face of the Nauvoo Illinois Temple. Like its 1845 counterpart, this temple has a single octagonal tower. © Val Brinkerhoff.

the temple. It is not known whether these were actually included as part of the original historic temple.

In the new temple, eight pilasters are found in the first floor assembly room. Eight-pointed stars are found in the terrestrial room. The stained glass window at the top of the celestial room is eight sided and has eight divisions. It is surrounded by a chainlike series of interlaced figure eights, most likely pointing to eternal family union. The two chandeliers in the Nauvoo Temple celestial room are also eight-sided. The fabric design on the chairs of the first three ordinance rooms features flowers with eight petals.

The single west tower of the Nauvoo Temple is eight sided and also has eight columns surrounding it, two facing in each of the four cardinal

directions. The acanthus leaves on each of the columns may have ancient reference to resurrection.[25] On the temple grounds, the cement base below the Joseph and Hyrum Smith statue is made of eight sections, as are circular viewing areas east and west of the temple.

The Salt Lake Temple

The extensive use of eight (as well as other numbers such as twelve) on the historic Salt Lake Temple is significant, as this temple is the primary symbol of the Church worldwide (fig. 13). LDS temple architects look to the Salt Lake Temple as model for their symbolism. According to Dr. Dale C. Mouritsen, "The leaders of the Church believed that the Salt Lake Temple was the model and standard for the others. Indeed, the Salt Lake Temple was viewed throughout the Church as the archetype for all the temples."[26]

The Seal of Melchizedek is the first motif patrons encounter when entering the Salt Lake Temple. It is seen on the main glass doors into the annex and features an eight-tiered beehive inside the octagonal Seal of Melchizedek. There are eight spiraling staircases in the Salt Lake Temple—one at each of its four corners, and four more at the corners of the assembly hall main floor.[27] Designs above the doorways of the Salt Lake Temple creation, world, telestial, and other rooms feature four sets of opposing spirals (eight total). Floral motifs in the telestial room have eight petals. The celestial room of the Salt Lake Temple has eight chandeliers, each with eight bulbs. Originally each of the six towers had eight incandescent light bulbs atop them.[28] All of the lights in the celestial room and the single chandelier in each of the three sealing rooms next to them have eight bulbs. Eight-pointed star designs are featured on all of the walkway lamps, barrier poles, and general exterior decor throughout Temple Square. Even the lampposts are eight sided. The Holy of Holies of the Salt Lake Temple is a circular room with a half-dome above, utilizing a variety of items in

Fig. 13 Design on the entrance to the annex of the Salt Lake Temple. This pattern combines the beehive, circle, and overlapping squares—all associated with Christ. © Val Brinkerhoff.

groups of eight. Eight pilasters appear to encircle its interior circular space, each with a light fixture of three individual lights.[29] The domed ceiling features sunlike motifs (stars), each with eight rays.

The north and south exterior walls of the Salt Lake Temple feature eight basic divisions, between nine pilasters, each division or section having four windows (two round and two rectangular). There are eight doors at ground level on the Salt Lake Temple exterior—four on the east and four on the west, each them four feet wide, making each combination of two doors eight feet wide. There are eight layers on the beehive symbols found on each of the Salt Lake Temple exterior doorknobs (fig. 14). Twenty-four-pointed stars on these doors also have beehives with eight

Fig. 14 Exterior doorknob at the Salt Lake Temple. This beehive, an ancient symbol of kingship, has eight layers, combining kingship and divinity. © Val Brinkerhoff.

layers. At the corners of all the Salt Lake Temple towers are eight-sided turrets, each with eight-sided pinnacles. There are eight sets of three celestial bodies (planet, sun, and moon) on the north and south exterior walls of the Salt Lake Temple. A total of eight twenty-four-pointed stars are found on the intricate grillwork of the beautiful east and west exterior doors of the Salt Lake Temple. These are found on the two upper circle-in-square designs of each door. The foundation for the Salt Lake Temple is eight feet wide at its largest, lowest, strongest point. The temple walls are ninety-six feet high (eight times twelve).

The San Diego California Temple

As mentioned earlier, no Latter-day Saint temple features as many octagonal designs as does the San Diego Temple. The motif is found throughout the temple and the surrounding area, including its fence, on and around all doors, in the windows below and above the font, on the floor below the

Fig. 15 A close-up of an exterior wall of the San Diego Temple. This pattern of interlocking squares forms two examples of the Seal of Melchizedek. © Val Brinkerhoff.

spiral staircase, on all exterior walls (fig. 15) , and in the cement roadway at the front of the temple (fig. 16).

The entrance doors to the temple feature etched glass full of interlaced square designs from top to bottom. Upon entering, patrons encounter a large octagon design in the tiled floor. The four corners of each door also feature an octagon design with a circle at center, with the octagon serving as a transitional shape between the square at its perimeter and the circle at its center. Below ground level under the east tower is the circular baptismal font sitting on the back of twelve oxen, all of which stand atop an octagon or eight-pointed star design in the tiled floor. An eight-sided column supports the font. The design above the font is also eight sided. Surrounding the font are interlaced squares forming an octagon, each of which features a gold circle—sun symbol—at center.

Just inside the main entrance is a stairway leading to the next floor, where the endowment rooms are located. Above this stairway is a large octagon with a circular dome at its center. Fabric designs in the seats of this room feature the octagon. A beautiful, large spiraling staircase takes patrons from the endowment rooms below to the celestial room above. At the base of this grand staircase is a large octagon enclosed within a circle. The elaborate stained glass windows in the bright, white celestial room, located in the east tower, face the rising sun, the direction from which the Savior will return. These tall windows feature numerous octagon designs, including interlaced squares. All windows in the temple feature this octagon design prominently. There are eight pilasters surrounding the celestial room.

There are eight sealing rooms in this temple. The altars in the sealing rooms are eight-sided. On the same floor of the sealing rooms is an eight-sided glass-enclosed terrarium. Above this is an eight-sided structure with a

Fig. 16 San Diego Temple. This temple and its exterior feature more than ten thousand octagonal Seals of Melchizedek, including this one in the entry roadway. © Val Brinkerhoff.

circle at its center, allowing visitors to view the sky and the towers.

The Bountiful Utah Temple

The circle-in-square motif and the number eight appear extensively in the Bountiful Utah Temple. There are eight circle-in-square motifs on each of the two sets of brass entrance doors (fig. 17). Above these two entrances is an elongated octagon. The room where the font is located is eight sided, with the circular font resting atop a square tile design below. The ceiling and floor of this room feature eight-sided designs. This room also features eight pillars, two at each of the four cardinal directions. Below the oxen is the Seal of Melchizedek. On the ceiling, near the main floor elevator, is another Seal of Melchizedek motif, this one in gold leaf. There are eight-pointed stars in the forecourt-like waiting room. Square designs in the endowment rooms feature eight painted perimeter points, and within each is a circle at center. The main window in the celestial room features an eight-part stained glass window. Eight pillars (symbols of covenant making) surround the celestial room, and atop each one is a circle-in-square design. The baptistery also features eight pillars surrounding the room. There are eight sealing rooms in this temple.

Fig. 17 Brass entrance door, Bountiful Utah Temple. Eight circle-in-square patterns greet patrons. © Val Brinkerhoff

The Albuquerque New Mexico Temple

The glass entrance doors to the Albuquerque temple (west side) feature two interlaced squares with a circle at center in gold—the Seal of Melchizedek (fig. 18). This is very similar to the design on the glass annex doors leading into the Salt Lake Temple. In the baptistery, below the baptismal font a large octagon features the Seal of Melchizedek—one line of dark tile and one line of light tile. Floral motifs on the outside of the font are eight-sided,

featuring four dark petals intersected with four light petals, possibly suggesting the need for opposition in all things. The ceiling above the font is an eight-sided dome.

In the endowment rooms there are eight arches, four on each side of the room, each with beautiful light fixtures in them. One of the most beautiful chandeliers in all of the Church is found in the Albuquerque New Mexico Temple celestial room. This huge gold chandelier hangs at room center and is eight sided, featuring eleven primary levels, with one small point at the bottom. Eight pilasters surround the celestial room. With the exception of two on the east side, the pilasters feature a gold Seal of Melchizedek with a circle at center near their top. The white carpet of the celestial room features a large rectangular sculpted border with a repeating octagon motif made up of double interlaced squares with a circle at center. Similar eight-sided motifs are also found on the ceiling of the celestial room. The fabric design on many of the celestial room chairs also features eight-sided designs. At the east and west ends of this room, beautiful stained glass windows feature eight-pointed stars at the top.

Fig. 18 A door at the Albuquerque New Mexico Temple. This design combines a stylized Seal of Melchizedek with a circle. © Val Brinkerhoff.

Secular Uses of Eight

Besides sacred Christian architecture and scripture, usage of the number eight is elemental and frequent in many secular settings. The musical scale is made up of eight primary notes in the octave. The octave is a unit, at the end of which one starts over, replicating the organization of the eight primary notes at lower or higher frequencies. Beautiful music itself is a primary conveyor of the spirit of God and is used extensively in religious settings worldwide. There are eight main groups of elements on the periodic table of the elements: "Atoms strive to combine with other elements that

will give them 8 electrons in their outermost orbit, making them stable and satisfied elements with a full shell."[30] Modern computer software is written in binary code, which makes use of eight combinations of eight bits to the byte. Color on the typical modern computer system is made up of three channels (red, green, and blue), each with eight bits per channel, providing over sixteen million colors total. In outer space, navigation requires a point of origin and seven points for the destination: four horizontal and three vertical points—making eight points total. Geographic directions horizontally are divided into four cardinal directions and then subdivided into four more (eight total). An eightfold path is featured in Buddhism. The eightfold way of Buddha requires right views, right intention, right speech, right action, right livelihood, right effort, right mindfulness, and right concentration.[31] An ancient Egyptian coffin text reads, "I am one, who becomes two, who becomes four, who becomes eight, and then I am one again,"[32] demonstrating the rebuilding nature of eight. And eight was the number of the Egyptian god Thoth, the regenerator, who poured the waters of purification on the heads of the initiated.[33]

Eight-pointed stars are common motifs in Islamic architecture (fig. 19). When placed near each other in tile-fashion, they create a pattern of expanding and contracting shapes. The expanding eight-pointed stars and the contrasting x-shaped spaces between them form a pattern of alternating positive and negative shapes or spaces, which represent the expanding and contracting rhythms of nature, or the "Breath of the Compassionate [God]."[34] The chessboard is square and has eight columns of eight squares. Its black and white squares are thought to represent universal opposing forces. Its four sides most likely represent the four corners of the world. Its twenty-eight outside squares correlate to time via the phases of the moon.[35] Classic proportion of the human body in ancient Greece and Egypt was documented by Vitruvius and was measured in eight heads of height: three above the navel and five below it.[36]

Returning to God's Presence

God the Father is the master architect of our universe, and Jesus Christ is the divine contractor. He created the temple of the human body to house our spirits and later gave Moses, Solomon, and Joseph Smith exact plans for the construction of sacred temples where his disciples are instructed in the mysteries of godliness. Both "temples" serve the same purpose: to provide us a way to become like God, returning us to his presence, and allowing us

Fig. 19 Dome before the Mihrab, The Great Mosque at Cordoba, Spain, AD 756. © Val Brinkerhoff.

to rejoin God's heavenly family, a status we once enjoyed in the premortal existence.[37] The word *rebuild* and others starting with *re* imply bringing back, joining again, or bringing things full circle, producing a kind of at-one-ment or unity; a spiritual rebuilding. Additional *re* words implying spiritual rebuilding include restore, return, reunite, rejoin, reconnect, regenerate, refresh, renew, remind, resurrect, and remember—all made possible by the great redeemer. These words imply the rebuilding of a relationship, which once existed between us and our Heavenly Father, a union reinstituted by teachings and covenants made only in the sacred architecture of temples. This instruction and the covenants connected to them are reinforced each time we return to the House of the Lord.

Temple teachings assist us in rebuilding our relationship with God the Father through Christ as mediator. We reconnect with him through temple covenants, the last of which allows us to pass through the veil, reentering his symbolic presence in the celestial room, a beautiful room which in most LDS temples is surrounded by eight pillars. It is there that we are spiritually renewed, reenergized, rejuvenated and recharged. In addition, genealogy work is brought to completion in the temple, reestablishing strong chainlike

links (figure-eight motifs in the sealing rooms) with our ancestors, re-creating or reconnecting family bonds. Like the Master, we become saviors on Mount Zion to them.

The whole purpose of the covenants made within the sacred and symbolic architecture of temples is to provide an opportunity for us to rejoin God's heavenly family, to reenter his presence, there to enjoy the blessings of eternal life. As we draw closer to him and submit our will to his, we willingly take upon ourselves his name. We become his. We are then renamed, a representation of complete change, a rebirth.

The repeating patterns of eight we experience in scripture and upon sacred architecture serve as important witnesses of Christ, providing aesthetic experiences which can enhance spiritual experiences. They are not the object of worship but serve as subtle reminders of the Savior in his holy house.[38] It is my hope that individual testimonies of Christ will increase through development of greater sensitivity to these and other witnesses found in and on the temple and supported by scripture.

NOTES

1. Only the number three rivals eight in its consistent connection to Christ in scripture. The number three is associated with the divine, including divine time periods such as Christ's thirty-three years in mortality, the three years of his ministry, the three days of darkness and destruction in the western hemisphere during his crucifixion, and his three days in the tomb.

2. Alfred Edersheim, *The Temple: Its Ministry and Services,* updated ed. (Peabody, Mass.: Hendrickson, 1994), 162.

3. Edersheim, *Temple,* 173.

4. Edersheim, *Temple,* 84.

5. Edersheim, *Temple,* 82. Although no evidence exists for circular movement in the waving of sacrifices, the likelihood of circular motion is consistent with the importance of the circle in sacred settings.

6. James H. Charlesworth, ed., *The Old Testament Pseudepigrapha,* 2 vols. (Garden City, N.Y.: Doubleday, 1983), 1:265, cited in Matthew B. Brown, *The Gate of Heaven: Insights on the Doctrines and Symbols of the Temple* (American Fork, Utah: Covenant Communications, 1999), 103 n. 12a.

7. Brown, *Gate of Heaven,* 169.

8. Edersheim, *Temple,* 251–252.

9. Alexander Roberts and James Donaldson, eds., *The Ante-Nicene Fathers* (Grand Rapids, Mich.: W. B. Eerdmans, 1987), 63, quoted in Lenet Hadley Read, *The Lord's Holy Days: Powerful Witnesses of Truth* (Orem, Utah: Granite Publishing, 2002), 76.

10. Justin Martyr, quoted in Roberts and Donaldson, *Ante-Nicene Fathers,* 206, 215; Saint Ambrose, quoted by Grace Vlam, "The Mormon Doctrine of Baptism as Reflected in Early Christian Baptistries," *Dialogue* 3 (Spring 1968): 150, in Read, *Lord's Holy Days,* 78, 84.

11. "The Epistle of Barnabas is one. The translation given in Maxwell Staniforth, trans., *Early Christian Writings* (New York, N.Y.: Penguin Books, 1968), 214–215." Read, *Lord's Holy Days*, 84.

12. Bruce R. McConkie, *Mormon Doctrine*, 2d ed. (Salt Lake City: Bookcraft, 1966), 475–476, quoting *Teachings of the Prophet Joseph Smith*, 166–167, and D&C 107:18.

13. Steven L. Olsen, "The Mormon Ideology of Place: Cosmic Symbolism of the City of Zion, 1830–1846" (PhD diss., Brigham Young University, 1999; Provo, Utah: BYU Studies, 2002), 108.

14. Bill Lewis, interviewed by Val Brinkerhoff, August, 11, 2006, typescript, 27–29, in author's possession; Hugh Nibley, *Temple and Cosmos* (Salt Lake City: Deseret Book, 1992), 10.

15. Hugh Nibley, *The World of the Jaredites*, Part 5, *Improvement Era* 55 (1952): 22–24. Commenting on the bee symbol in Egypt, Nibley says, "The founders of Egyptian Second Civilization had the bee as the symbol of their land, their king, and their empire, to all of which they also applied the designation *deseret*, or something very close to it. . . . Though they never call the bee itself *dsrt*, the sign which is often 'for superstitious reasons' written in its place is so designated. . . . The bee sign was always regarded by the Egyptians as very sacred, always being placed before any of the others. . . . [The sign for deseret is] the oldest known symbol of sovereignty in the world. It stands for *the Red Crown of Lower Egypt, the Crown on the head of Re, the King of Lower Egypt, the Lord of the Red Crown*, esp. Atum the Creator—god of Heliopolis (identified by some Egyptologists with Adam)" (23, 22).

16. Heber C. Kimball, in *Journal of Discourses*, 26 vols. (Liverpool: F. D. Richards, 1855–1886), 5: 129, August 2, 1857; Heber C. Kimball, in *Journal of Discourses*, 5:164–165, August 30, 1857.

17. The evening and the morning star is not a star at all but is the planet Venus. It looks like a star because it reflects so much light, being close to the sun (like the Son reflecting the will and light of the Father). This makes Venus easy to observe as the first "star" at dusk, or at other times the last "star" seen before sunrise: an evening and morning "star," alpha and omega (see Rev. 22:13). The evening and morning star is sometimes symbolically represented on LDS temples (the Nauvoo, Salt Lake, and Logan temples) by the inverted pentagram, because as the planet Venus moves through the dome of the heavens its orbit forms a perfect pentagram over an exact eight year period: "The pentagram within a circle . . . can be called a design-iconic symbol for the planet Venus. This planet is the only one in our system that can clearly be identified with a graphic structure unambiguously derived from a plotting of its astronomical movements in space . . . [after] exactly eight years plus one day have passed. If we then draw a line from the first point marked to the second point marked, then to the third, and so on, we end up with a pentagram." Carl G. Liungman, *Dictionary of Symbols* (Denver: ABC-CLIO, 1991), s.v. "Pentagram within a circle." According to John Pratt, Latter-day Saint astronomer, this eight-year cyclical movement may also symbolize the quickening, birth, death, and resurrection of the Savior—movements expertly documented by the Mayans. Pratt has calculated that Christ's birth, death, baptism, and resurrection dates align with the Mayan astronomical Venus calendar holy days. When the planet Venus disappears, or symbolically dies, it does so for eight days, and then reappears, or resurrects. John Pratt, "Afterwords," *BYU Studies* 23, no. 2 (1983): 252–254; John Pratt, "Venus Resurrects This Easter Sunday," January 18, 2001, at http://www.meridianmagazine.com/sci_rel/010227easter.html or at johnpratt.com.

18. James E. Talmage, *The House of the Lord: A Study of Holy Sanctuaries, Ancient and Modern* (Salt Lake City: Bookcraft, 1962), 140.

19. Liungman, *Dictionary of Symbols*, s.v. "Pentagram within a circle." According to Walter Burkert, the eight-pointed star in ancient Sumeria was associated with Venus and the Sumerian Goddess Ishtar. This association may be due to the eight-year movement of Venus in the heavens. Walter Burkert, *Lore and Science in Ancient Pythagoreanism* (Cambridge, Mass.: Harvard University Press, 1972).

20. Gordon B. Hinckley, "The Cornerstones of Our Faith," *Ensign* 14 (November 1984): 51.

21. Carl Boetticher, *Der Baumkultus der Hellenen* (Berlin, 1856), 9, cited in George Hersey, *The Lost Meaning of Classical Architecture* (Cambridge, Mass.: MIT Press, 1988), 11–13.

22. For most non-Latter-day Saint Christians the cross is a widespread symbol. However, it was not seen commonly in Christian iconography for the first three centuries of Christianity, most likely because it was connected with the grotesque public execution method of impalement. The fish symbol, on the other hand, was a more common early Christian motif used secretly for the purpose of identifying fellow Christians. Early Christian writings from the first part of the second century onward identify some usage of the cross as a symbol, with more frequent usage by third century. Clement of Alexandria, in his incomplete *Stromateis* or "Miscellanies," book 6, referred to the cross as "the symbol of the Lord." Tertullian (a contemporary), called believers of his time "devotees of the Cross" (Apologetic, chapter 16). In the fourth century, Emperor Constantine had the cross placed on the shields of his soldiers. It did not appear in churches until the seventh or eighth century. E. A. Wallis Budge, *Amulets and Talismans* (New Hyde Park, N.Y.: University Books, 1961), 50. Many ancient Christian cathedrals are built in cruciform shape, or in the shape of a Latin cross. There are many variations of this basic symbol throughout Christianity, all pointing to the great sacrifice made by Jesus Christ. As crosses are typically made of wood, the original cross is also connected to the tree of life, a representation of the love of God.

 Pillars represent five potential layers of meaning in sacred settings, as deduced from patterns in scripture, ancient Christian architecture, and Latter-day Saint temples. First, pillars appear to mark, separate, and guard sacred space, signaling holy ground or a temple. Second, pillars appear to serve as witnesses and guardians of sacred covenants and events. Third, most pillars are made of enduring stone, making them effective memorials for covenants and other sacred events over time. Fourth, the strength, stability, and support of stone pillars appears closely tied to sacred priesthood covenants, mirroring the eternal nature of the priesthood itself. And fifth, like most inspired symbols, pillars ultimately point to Jesus Christ, potentially through his role as mediator of the new covenant and his connection to the tree of life and to pillars of light.

23. Elwin C. Robinson, *The First Mormon Temple: Design, Construction, and Historic Context of the Kirtland Temple* (Provo, Utah: Brigham Young University Press, 1997), 8.

24. Brown, *Gate of Heaven*, 209.

25. The foliage at the top of each of eight Corinthian pillars encircling the Nauvoo Temple octagonal tower appear to be acanthus leaves. Much of sacred architecture uses traditional Greek pillars adorned with this leaf to symbolize rebirth, resurrection, or victory over death. According to the Roman architect Vitruvius, the Corinthian order was inspired when a Greek architect saw a basket containing possessions of a young woman placed at her tomb. Acanthus leaves had grown up through the basket, showing the power of life over death. Vitruvius, *Ten Books on Architecture*, book 4, chap. 1. See also Steven Olderr, *Symbolism: A Comprehensive Dictionary* (London: McFarland, 1986), 1, cited in Matthew B. Brown and Paul Thomas Smith, *Symbols in Stone* (American Fork, Utah: Covenant Communications, 1997), 146.

26. Dale C. Mouritsen, "A Symbol of New Directions: George Franklin Richards and the Mormon Church, 1861–1950" (PhD diss., Brigham Young University, 1982), 206–207.

27. Talmage, *House of the Lord*, 151–153.

28. Richard N. Holzapfel, *Every Stone a Sermon* (Salt Lake City: Bookcraft, 1992), 98.

29. Talmage, *House of the Lord*, 139. Although the photograph shows only a portion of the room, it is possible from it to assume that the room most likely has eight total pilasters. This is consistent with usage of eight in the "blue room" of the Manti Temple, also once most likely used as a Holy of Holies.

30. Michael Schneider, *The Beginner's Guide to Constructing the Universe: The Mathematical Archetypes of Nature, Art, and Science* (New York: Harper Collins, 1994), 279.

31. Schneider, *Beginner's Guide*, 269.

32. Tom Cryer, *Visual Testament and the Israelite Indian* (N.P.: n.d., 1999), 71, discussing the Coffin of Petamon, Cairo Museum number 1160.

33. Harold Bayley, *The Lost Language of Symbolism*, 2 vols. (London: Williams and Northgate, 1912), 1:46.

34. Schneider, *Beginner's Guide*, 274.

35. Schneider, *Beginner's Guide*, 292–296.

36. Vitruvius, *Vitruvius: Ten Books on Architecture*, trans. Ingrid D. Rowland, ed. Ingrid D. Rowland and Thomas Noble Howe (New York: Cambridge University Press, 1999), 47. This canon was documented by the ancient Roman architect Vitruvius in book 3 of his ten volumes on Greek and Roman temple architecture.

37. Yvonne Bent, "Number Pattern Summary," unpublished, 2007, copy in possession of the author.

38. In another interesting connection between Jesus and eight, we can observe an alphanumeric system called Gematria used by some early Christians to produce names for Christ via numbers. "Jesus" and "I am the Life" both come from 888 in this ancient sacred number system based on New Testament Greek. John Michell, *The Dimensions of Paradise* (London: Thames and Hudson, 1988), 61.

Index